**Books are to be returned on or before
the last date below.**

"Law a⸍ ⸍ry,
social hi tter
still, the -be
lawyer and
respons ffer
entertai ⸍ a
lawyer, ⸍, I
would h

 ian;
 ism

"Law a⸍ ant
classic. law
and lav and
interpre ⸍ok
provide ⸍hat
can be for
teacher ant
connections of law and popular culture."

—*Austin Sarat, William Nelson Cromwell
Professor of Jurisprudence and Political Science,
Amherst College, Amherst, Masachusetts*

Law and
Popular Culture

Politics,
Media &
Popular Culture

David A. Schultz, *General Editor*

Vol. 8

PETER LANG
New York • Washington, D.C./Baltimore • Bern
Frankfurt am Main • Berlin • Brussels • Vienna • Oxford

Michael Asimow & Shannon Mader

Law and
Popular Culture

A COURSE BOOK

PETER LANG
New York • Washington, D.C./Baltimore • Bern
Frankfurt am Main • Berlin • Brussels • Vienna • Oxford

Library of Congress Cataloging-in-Publication Data

Asimow, Michael.
Law and popular culture: a course book / Michael Asimow
and Shannon Mader.
p. cm. — (Politics, media, and popular culture; v. 8)
Includes bibliographical references and index.
1. Culture and law. 2. Lawyers in motion pictures. 3. Lawyers on television.
4. Justice, Administration of, in motion pictures. 5. Justice, Administration of,
on television. 6. Popular culture—United States. I. Mader, Shannon. II. Title.
III. Politics, media & popular culture ; v. 8.
K487.C8A935 340'.115—dc21 2003006821
ISBN 0-8204-5815-5
ISSN 1094-6225

Bibliographic information published by **Die Deutsche Bibliothek**.
Die Deutsche Bibliothek lists this publication in the "Deutsche
Nationalbibliografie"; detailed bibliographic data is available
on the Internet at http://dnb.ddb.de/.

© 2004 Peter Lang Publishing, Inc., New York
275 Seventh Avenue, 28th Floor, New York, NY 10001
www.peterlangusa.com

Michael Asimow dedicates this book to Bobbi and to Dan, LeAnn, Ian, Paul, Craig, Hillary, Courtney, Lev, Naomi, Eli, and Jacob

Shannon Mader dedicates this book to Russell Charles Mader

Contents

Detailed Contents

10 Constitutional Rights in Criminal Cases
Assigned film: *The Star Chamber* (1983) 149

11 The Death Penalty

PART III
CIVIL JUSTICE

12 The Civil Justice System

13 Civil Rights

14 Family Law

Preface

We're in a segregated Alabama courtroom in the mid-1930s. The packed room is hushed as Atticus Finch rises to begin his closing argument to the jury in the case of Tom Robinson. Robinson, a young black man, is falsely accused of raping a white woman. The film is *To Kill a Mockingbird* (1962).

Two white eyewitnesses (the alleged victim and her father) have testified against Tom Robinson. The jury is all male and all white. Finch's closing is brave and eloquent. He says: "In our courts all men are created equal. I'm no idealist to believe firmly in the integrity of our courts and our jury system. That's no ideal to me. That is a living, working reality." But the case is hopeless. The jury quickly convicts Tom Robinson. Soon he is dead, supposedly shot while trying to escape.

With his stirring but futile defense of Tom Robinson, Atticus Finch became the patron saint of lawyers. The heroic character of Atticus Finch inspired countless young people to become lawyers. It has the same power to inspire them today.

Now we're in a different courtroom. It's in Boston and the time is the early 1980s. The film is *The Verdict* (1982). Frank Galvin staggers to his feet to deliver his closing argument. Galvin's client, Deborah Ann Kaye, went into the hospital to give birth. Something terrible happened during anesthesia and she is in a permanent vegetative state. Galvin is a hopeless alcoholic, a loser who ignored the case almost until the trial began. His opponent, Ed Concannon, is a big firm partner who represents the Archdiocese of Boston which operated the hospital. Concannon has pulled every dirty trick in the book to defeat Galvin. The judge seems to be in Concannon's pocket. Galvin's inspiring closing argument ignores the facts of the case and urges the jury to do justice. The jury returns with a stunning verdict for the plaintiff. We leave the theater with the satisfied feeling that justice was done, but the film paints a dark picture

of the character and ethics of the two lawyers. Few would be inspired to take up the legal profession after seeing this film.

This book is designed to be used as the reader for a course in Law and Popular Culture. The course studies movies like *To Kill a Mockingbird* (chapter 3), *The Verdict* (chapter 4), and many others. It explores the interface between two subjects of enormous importance to the lives of everyone—law and popular culture.

Law pervades modern society. Increasingly, courts decide some of the most fundamental social and economic problems of society, including such hot button issues as abortion, the death penalty, the right of privacy, gun control, homosexual marriage, affirmative action, or public support of religious schools. Indeed, the U.S. Supreme Court decided that George W. Bush rather than Al Gore won the 2000 election.

So many aspects of our lives are profoundly affected by laws, police, judges, and lawyers. We want the police and the courts to catch and convict criminals to keep us safe, but we want our privacy to be protected and the rights of the accused to be safeguarded. We want our legal system to deliver justice, but sometimes it fails to do so. What is justice anyway and why can't the legal system deliver it? Lawyers are among the most despised of all professions. Why is this? Is it justified? What do lawyers actually do, anyway? Everyone needs to know much more about law, lawyers, and the legal system than they do now.

Popular culture is even more pervasive than law. All of us swim in a sea of films, television shows, books, songs, advertisements, and numerous other imaginative texts. During thirty minutes of watching television, we consume more images than a member of pre-industrial society would have consumed in a lifetime. Our political life seems to be reduced to sound bites on television, and we rely for our entertainment on the torrent of words and images that flow from movie screens or TV sets. Everyone needs to know a lot more than they do about popular culture in order to understand, interpret, and fight back against the onslaught of images that assault us every day.

The course in law and popular culture is intended to deepen students' understanding of both law and popular culture and the many ways in which they influence each other. The wall between law and popular culture allows a lot of traffic to pass in both directions. In particular, we believe that popular culture both *constructs* our perceptions of the law and *changes* the way that the players in the legal system behave.

In addition to considering questions of legal practice and legal history, this course also focuses on filmmaking, film history, and film theory. As we watch these legally themed movies, what can we learn about film writing, directing, editing or scoring? How are these narratives constructed? How is point of view used? What's the filmmaker's hidden agenda? What makes a film seem "realistic"? What genre do these films fall into, and do they respect the rules of that genre? How did the business practices of the industry or the cultural trends of the time influence the film's production and reception?

Law and Popular Culture originated as a law school course, but we believe that the same model will work very well in a wide range of undergraduate or graduate programs. For example, we can imagine Law and Popular Culture courses being offered in programs as diverse as American studies, criminal justice, mass media, and film and television studies, or within such traditional departments as history, political science, or sociology.

We do not assume that the people who will be teaching this course will necessarily have any formal training in law, filmmaking, film theory, or history. The book is written in plain English, without theoretical jargon, and it can be taught by anyone who enjoys popular culture and is interested in law. Our job is to supply the materials to make the course work, no matter what the background of the person who is teaching it.

At UCLA School of Law, the seminar in Law and Popular Culture is enormously popular and heavily overenrolled. Frequently, sixty or seventy students apply for the sixteen open slots. Each class (and each chapter in this book) is based on careful study of a particular film or television show involving law and lawyers. The materials treat the movie or TV show both as a cultural text and a legal text and consider it from multiple points of view.

The class might consider the techniques of film writing or filmmaking, or it might consider film history or theory. It will also deal with many issues of criminal and civil law and law practice or legal strategies. It tackles such institutions as law school, the jury, the legal mega-firm, and the economics of law practice. Moreover, it addresses all of these issues and institutions in a critical and challenging way.

When students are brought face to face with popular culture, the result is very different from the typical college-level course. Normally, the teacher is the expert and the students passively soak up as much of the teacher's knowledge as they can absorb. However, in a course based in the media of popular culture, the students share expertise with the instructor. Every student in the room is already an expert in interpreting popular culture. They know the language of film. They have been practicing that language since before they learned to talk, much less read. Every student has seen hundreds of movies, thousands of hours of television shows (not to mention their exposure to music or the Internet). In many cases, the students will have consumed far more popular culture than the instructor has (Denver 1996).

The result is electrifying. The students bring with them deeply felt opinions about pop culture. They are moved and inspired, or infuriated, by films like *To Kill a Mockingbird, Anatomy of a Murder, Indictment, The Verdict,* or *Philadelphia.* They are full of ideas, arguments, and interpretations. They speak up in class. They argue with each other and with the instructor. They are not overawed by the instructor's interpretation of a film because their interpretation may be just as valid. The level of interactivity in the classroom far surpasses what normally occurs even in the most engaging and best-taught classes.

Appropriately to the world of film and television, this preface is an ill-disguised pitch. It's pitched to the people who decide what courses they want to teach and what books to assign for those courses. We hope that a course based on these materials will be enormous fun to take and to teach. But it's not all fun and games and it certainly isn't fluff. As we said, the twin subjects of law and popular culture are two of the most meaningful in the lives of our students. Students deserve and will benefit from a critical and serious examination of these subjects and the many ways they interface with each other.

We wish all students and teachers of law and popular culture an enjoyable and stimulating tour through these two vitally important and constantly intersecting worlds.

Michael Asimow
Shannon Mader

Acknowledgments

The authors gratefully acknowledge the contribution to this book by Norman Rosenberg, DeWitt Wallace Professor of History at Macalester College, St. Paul, Minnesota. Professor Rosenberg was originally one of the collaborators on this book and wrote significant parts of the text, including substantial parts of chapters 1, 3, 4, 8, and 9. He also was instrumental in working out the organization of the book and deciding which films to discuss. Ultimately he had to drop out of the project because of conflicting commitments. However, we are extremely appreciative of Professor Rosenberg's contributions and his generous decision to allow us to use them in the book.

Paul R. Joseph, Professor of Law at Shepard Broad Law Center, Nova Southeastern University, in Fort Lauderdale, Florida, was one of the original collaborators on this book. He also had to withdraw because of other commitments. Professor Joseph wrote part of chapter 8 and we are most grateful that he allowed us to use this material in the book. Tragically, Professor Joseph passed away in 2003. We mourn his loss.

We have discussed the material in this book with far too many people to name here, but we always benefited greatly from their insights. In particular, we gratefully acknowledge the assistance of Richard Abel, Dyanne Asimow, Stuart Banner, Paul Bergman, Samantha Black, Drew Casper, Kimberle Crenshaw, John Denver, Steve Derian, Sharon Dolovich, Jennifer Factor, Sam Feldman, Steve Greenfield, Gillian Lester, Stefan Machura, Carrie Menkel-Meadow, Francis Nevins, Guy Osborn, Peter Robson, Charles Rosenberg, William Rubenstein, Gary Schwartz, Andrew Schepard, David Schultz, Brad Sears, Rafael Simon, Rob Waring, Dan Watanabe, and Steven Yeazell. We are particularly appreciative for the wonderful services provided by the staff of the Law Library of the UCLA School of Law.

We gratefully acknowledge permission from Tristar Pictures and from Tom Hanks for use of the photograph that appears on the front cover.

Lastly, we would like to thank the students in Asimow's seminar on Law and Popular Culture at UCLA School of Law and in the undergraduate Fiat Lux program. These students inspired us to believe that it actually made sense to write a course book for a course that doesn't yet exist. So many of their ideas and comments have found their way into this book.

Of course, we bear the responsibility for any errors or omissions.

LAW, LAWYERS, AND THE LEGAL SYSTEM

CHAPTER 1

Introduction to Law and Popular Culture

1.01 *Plan of the book*

This book is meant as the reader for a course with the general theme of "Law and Popular Culture." It is suitable for undergraduate and graduate classes in film studies, American studies, criminal justice, political science, or other academic programs, as well as in law schools. Therefore, it provides material on the study of popular culture that may be unfamiliar to most law students, as well as material on law, lawyers, and the legal system that may be unfamiliar to most non-law students. Each chapter, with the exception of this introduction, is based on a particular film or television show that students should view before class discussion begins. The chapters include readings that provide background information based on the respective movie or TV show. Individual instructors, of course, can substitute different films or readings for those suggested.

The authors have prepared a teacher's manual and will make it available on request to instructors who contact Asimow by e-mail. His e-mail addresses are asimow@law.ucla.edu and michael@asimow.com.

1.02 *What is "popular culture" and "popular legal culture?"*

Although the definition of popular culture is contested, it is essential to provide working definitions of "popular culture" and "popular legal culture."

1.02.1 The double meaning of popular culture and popular legal culture

We use the terms *popular culture* and *popular legal culture* in this book in two distinct ways (see Friedman, 1989):

First, popular culture refers to the entire universe of knowledge, behaviors, beliefs, and attitudes that circulate in a particular society or subgroup of that society. This definition is often referred to in this book as the *broad meaning* or *broad sense* of the term. Using a similar broad meaning, popular legal culture refers to everything people know or think they know about law, lawyers, and the legal system.

Common usage often employs the broad meaning of popular culture. We sometimes hear, for example, that America has a "culture of violence," meaning that there is a lot of violent behavior in America. The Supreme Court's statement in *Dickerson* (¶1.05.1) that *Miranda* warnings have become "part of our national culture" is an example of the broad sense in which the term culture is often used.

Second, "popular culture" signifies all of the commercial texts or *media* (whether in the form of motion pictures, television, print publications, stage plays, songs, and so on) that are produced and marketed for popular consumption.[1] This is often referred to in this book as the *narrow meaning* or *narrow sense* of popular culture. Using the second (and narrow) definition, "popular *legal* culture" includes commercial texts (such as movies, TV shows, or novels) about law, lawyers, or the legal system.[2]

1.02.2 Popular culture and high culture

There is a well-understood distinction between "popular culture" and "high culture." Popular culture, in the narrow sense, covers commercially produced works intended for the entertainment of mass audiences. The producers assume that consumers will enjoy and quickly forget them. In contrast, "high culture" refers to works that are produced and marketed for consumption by elite rather than popular audiences. For example, high culture incorporates classical music and opera, paintings, and other works of visual art, poetry, or serious fiction—usually older fiction that has succeeded in being recognized as literature. Works of high culture are intended to have lasting rather than merely transitory value. Generally, the production of works of high culture is less collaborative and commercial than the production of works of popular culture. However, many works that began as popular culture are later promoted to high culture status such as the novels of Dickens or the plays of Shakespeare.

Of course, countless academics have researched and taught about high culture, as if it were the only kind of cultural product that counts. Other academics have scorned popular culture as escapist trash that imparts false consciousness to the masses while capturing profits for its producers. Along with many others in the cultural studies movement, we believe that popular culture should be taken seriously and subjected to the same sort of critical analysis that is traditionally accorded to high culture.

1.03 Why a course in law and popular culture?

In the preface to this book, we argue that both law and popular culture are pervasive in the lives of nearly everyone. Therefore a college course or seminar devoted to the interface of law and pop culture in our society is certain to be relevant and valuable to students. As the preface also argues, students bring with them literacy in popular culture that is certain to produce lively and contentious class discussion of particular films or television shows.

American courts rule on nearly every major question of social policy. The United States has more lawyers per capita (close to a million at last count) and more litigation than almost any other country. It also has the unenviable distinction of confining more people in penal institutions than any other western country (about 2 million people in custody and an additional 4.5 million on probation or parole).

Some scholars think that law pervades and structures all social relations. As Paul Kahn wrote: "We experience the rule of law not just when the policeman stops us on the street or when we consult a lawyer on how to create a corporation. The rule of law shapes our experience of meaning everywhere and at all times. It is not alone in shaping meaning, but it is rarely absent" (1999, 124). For example, many highly personal decisions relating to sexuality and marriage are reduced to legal questions: Can same sex couples marry? Are gay people protected from job discrimination? Can a lesbian retain custody of her child? Can someone who has cohabited without getting married assert legal rights when the relationship breaks up? Thus every American needs to know about the legal system, what lawyers do, and how courts and other legal institutions work. This course will help non-law students learn a great deal about law, lawyers, and the legal system.

Popular culture is even more pervasive than law. In all western countries, people are subjected to a torrent of sounds and images designed to entertain them, mold their opinions, and persuade them to buy things. Vital political, social, and economic issues seem to be reduced to the cacophony of images on television screens. Almost everyone is accustomed to spending large amounts of their precious leisure time seeking various kinds of pleasures from consuming media. We hope that a film or a TV show will help us experience for a little while particular emotions and sensations (such as laughing or crying or being scared, angry, puzzled, or aroused) without the risk of really feeling these emotions. Pop culture allows us to revisit familiar characters or actors, alter our mood, escape from routine, or simply spend time with friends or family.

The pervasiveness of popular culture seems to be accelerating with the vast multiplication of channels available on television and with the infinite variety of information available in cyberspace. Without question, most people who read this book have already spent thousands of hours in movie theaters or in front of their television sets, reading popular novels, surfing the net, or hearing popular music. All of this incessant media consumption produces important effects in those who consume it and in society

generally. Everyone needs to know more about popular culture, and particularly popular legal culture, in order to be able to better understand its implications and effects and to criticize and deconstruct it where necessary.

As James Snead wrote, "we have to be ready, as film-goers, not only to see films, but also to see through them; we have to be willing to figure out what the film is claiming to portray, and also to scrutinize what the film is actually showing. Finally, we need to ask from whose social vantage point any film becomes credible or comforting, and ask why" (1994, 142).

While all forms of popular culture are important and instructive, this book focuses primarily on feature films and secondarily on television. This approach is largely employed for reasons of pedagogical convenience—the videotape or DVD versions of the films are easily available for rental or purchase and thus can be economically used as the objects of classroom study. Particular television shows are difficult to obtain for classroom purposes, and some television series may have disappeared by the time this book is actually used.

This book does not attempt a definitive discussion of the vast array of literary or cultural or film theories, any more than it attempts definitive discussion of topics in law and legal theory.[3] We draw on literary, cultural, and legal theories where we believe they will be helpful to teachers and students in discussing and understanding the interface between law and popular culture. The book is intended for a diverse group of academic programs, both graduate and undergraduate. Extensive treatment of any particular set of theoretical materials would make the book much longer and probably much less useful for most of its readers. Of course, we expect that particular teachers will enrich class discussion by drawing on and infusing their own political orientation, theoretical background, and specialization (and they may wish to add supplementary written materials to enhance such discussions).

1.04 The relationship between popular culture and the law

Popular legal culture has a complex relationship to law, lawyers, and the legal system.

1.04.1 Popular culture as reflection

First, popular culture in the narrow sense reflects popular culture in the broad sense. In other words, the works of popular culture often illuminate what real people actually do and believe, or at least what the producers of popular culture think they do and believe.

Popular culture in the narrow sense is never a perfect reflection of popular culture in the broad sense. Works of popular culture are informed by a variety of factors—everything from the commercial constraints under which they are produced to the ideological bias of their creators—that complicate their relationship to popular cul-

ture in the broad sense. Filmmakers, for instance, always distort reality, including the operation of the legal system, for dramatic, commercial, or ideological purposes. Nevertheless, popular culture, in the narrow sense, can still tell us a lot about popular culture, in the broad sense. For example, if movies usually show lawyers who are greedy and dishonest, this is evidence that many people share this view—or, at least, that filmmakers believe that they do.

1.04.2 Effects of popular culture on consumers

Second, popular culture has effects on the people who consume it that go far beyond entertainment or pleasure. Most people learn most of what they think they know about law and lawyers from consuming popular legal culture. Indeed, pop culture often invites viewers to work as surrogate police, jurors, judges, and lawyers, allowing them to vicariously experience the practice of law from the inside. In addition, viewers are invited to draw conclusions about whether law as they experience it in film or television promotes or undermines the search for justice. This form of experiential learning occurs even though the works of popular culture are fictitious and often wildly out of sync with what lawyers believe are the realities of law and law practice. We refer to this process as the way that ordinary people construct reality out of the raw materials of the stuff of popular culture. This second view of popular culture is very important and is discussed in greater detail at ¶4.05.

1.04.3 The cultural study of law

Third, a study of popular culture can help us understand law differently from the way we would understand it from reading standard references such as appellate cases, statutes, and articles in legal journals. This book views law from a *legal realist* perspective, meaning that law is what judges, jurors, lawyers, legislators, police, and others involved in making or applying statutes or case law actually do as distinguished from what the law books say they should do. This is often called "law in action" as opposed to "law in the books." What these lawmakers and law appliers do depends critically on what they believe; and what they believe is heavily influenced by the popular legal culture they have consumed. Thus, to understand how law is actually applied on the ground, as well as to understand why and how law changes, it is necessary to consider factors outside the formal written law, including popular legal culture.

The works of popular culture can be studied as legal texts—as authoritative and as contestable in their own way as the more familiar texts such as cases and statutes. We call this the cultural study of law, and we believe it can be valuable to students and lawyers alike.[4] In many situations, seeing movies or TV shows about law and lawyers can place legal issues or issues of professional practice in a different perspective. Do we feel differently about the insanity defense after seeing *Anatomy of a Murder* (discussed

in Chapter 2)? About law enforcement and prosecutors after we see *Indictment* (chapter 8)? About law school after *The Paper Chase* (chapter 6)? The jury system after *12 Angry Men* (chapter 9)?

1.05 The (many) meanings of cultural texts

This subsection introduces some basic principles of cultural theory that are drawn on throughout the book.

1.05.1 The interrelationship between legal practice and visual media—Miranda *and* Dragnet

The Supreme Court's decision in *Miranda v. Arizona* (1966) established that persons in police custody can remain silent and consult an attorney before being questioned. Many people thought that the present conservative Supreme Court would overrule *Miranda,* but they were wrong. In *Dickerson v. United States* (2000), the Supreme Court reaffirmed *Miranda.* Chief Justice William Rehnquist insisted that the *Miranda* rights not only rested on firm constitutional foundations but were "part of our national culture." The *Dickerson* opinion is an example of the interpenetration of law and culture in America—a legal decision (*Miranda*) created a popular culture usage (using culture in the broad sense referred to in ¶1.02.1); that cultural usage then has an impact on the law (*Dickerson*).

Dragnet was initially a hit TV show during the 1950s, and it returned to the network schedule in 1967, a year after *Miranda.* Many believe it introduced *Miranda* rights into "our national culture." *Dragnet*'s creator and star, Jack Webb, always insisted his program mirrored the actual procedures of the Los Angeles Police Department, whose case files provided the material for the weekly episodes. Consequently, on *Dragnet,* Webb's character, Sergeant Joe Friday, and his partner, Bill Gannon (Harry Morgan), informed everyone they arrested of their *Miranda* rights. Other TV programs and films quickly followed suit, thus entrenching in popular culture the notion that suspects must be told their *Miranda* rights.

1.05.2 The process of meaning-making—signifier and signified

The interpenetration of legal practice and visual media, though more intense and pervasive now than at any time in the past, is hardly a new phenomenon. Artistic depictions of the Roman goddess Justitia, for example, have long provided a popular visual image of the relationship between law and justice. Justitia is portrayed as a blindfolded woman with an unsheathed sword (to symbolize the state's power) in one hand

and a scale (to represent the goal of fairly measured justice) in the other. However, medieval representations of Justitia almost always imagined her without a blindfold.

The evolution of Justitia suggests that visual images change over time and do not have inherent, stable, and easily determined meanings. Rather, meanings are actively produced through a process of meaning-making that is called "signification." Students of visual media, drawing on linguistic concepts also used to interpret written texts, treat Justitia—whether in the form of a name or the image of a blindfolded woman with a sword and scale—as a *sign*. In the field of semiotics, which is devoted to the study of signs, a sign is treated as the basic building block of human communication. Each sign contains two parts. The first is the *signifier,* the image, word, or sound (or, as in the case of films and TV shows, the combination of these) that people encounter. The *signified,* the other half of the sign, refers to the various possible meanings that a signifier generates as it circulates among readers and viewers.

In most cases, people expect that others will comprehend the meaning of commonly used signs. The producers of TV commercials, for example, assume that every viewer will understand that the visual image of an automobile signifies a real-life "car," a four-wheel vehicle in which people move from place to place. This type of association, which is generally called *denotative,* produces rather straightforward, literal meanings that are widely shared. Viewers make sense of signs through the use of codes that are systems of meaning that help the viewer to organize and understand the world. Thus, to make sense out of the car commercial, the viewer makes use of a code of commercials (that explains that somebody is trying to sell you something) and a code of transportation equipment (that distinguishes cars from skateboards).

The image of Justitia produces another kind of association that is called a "connotative" meaning having something to do with the legal system. Although the connotative dimensions of a familiar image such as Justitia or l-a-w are not entirely random, they involve a far wider range of meanings than denotative ones. More importantly, these connotative meanings proliferate and overlap as signs come together to make up a written or visual text. The connotative meanings of a visual text often stimulate controversy—or, as students of visual culture like to say, the construction of meanings takes place on contested terrain.

1.05.3 Justitia's blindfold

The story of how visual renditions of Justitia changed over time provides a good example of the way in which the connotative dimension of meaning making is a contested, social/cultural/historical process. Addition of a blindfold during the fifteenth and sixteenth centuries signified important changes in—and conflicts over—the legal systems of Western Europe. Initially, the blindfold over Justitia's eyes may have connoted a critical message—the legal system was reneging on its promise to invoke the

power of the sword only after carefully balancing all sides of a dispute. The law unleashed the sword, this new image of blinded justice suggested, without a clear view of the issues in dispute or to serve the interests of the powerful against the powerless.

This same image, however, could also suggest very different connotations. A blindfolded Justitia could carry a positive meaning. It could mean that law was impartial, blind to differences in rank and status. Even though the critical meanings never disappeared, images of blind justice became a familiar sight in town squares and public buildings during the sixteenth and seventeenth centuries and increasingly signified that a modern legal system would treat everyone equally.

1.05.4 How do films and TV shows produce contested meanings?

Accounts of the signification process can help us explore how textual signs produce a broad range of meanings. In addition, some attention to media theory can help students of film and law place texts in specific historical and cultural contexts.

When *Dragnet* showed the LAPD advising suspects of their *Miranda* rights, it joined an ongoing process of signification that extends into our own times—and beyond. To some TV viewers of the late 1960s, the set of signs that appear in a scene involving a *Miranda* warning might mean that the police were following the law of the land. In addition, because the program claimed to realistically depict police work in the City of Angels—"only the names have been changed to protect the innocent" the show's famous voice-over claimed—the image of the Miranda warnings could plausibly be seen as another sign of *Dragnet*'s "authenticity."

However, this same text, and the series of signs that it contains, could have produced quite different meanings. Even during the 1950s, *Dragnet* attracted media comics. A hit record by the satirist Stan Freeberg lampooned the program's minimalist, staccato-like dialogue such as "book him on a 385." Some viewers could interpret *Dragnet* ironically, as more of a satire than an accurate reflection of law enforcement practices. The show would be enjoyable and funny precisely because it seemed so silly.

The comic connotations became more prominent when *Dragnet* returned to network television in 1967. Joe Friday, whose whole life apparently involved bureaucratic police routines, could seem, especially to younger viewers, as out-of-touch with the freewheeling cultural values and practices of the late 1960s. A biography of Jack Webb, entitled *Just the Facts, Ma'am* (invoking a line of dialogue used, almost incessantly, by Sergeant Friday), suggests that *Miranda* warnings appeared so often that some viewers likely interpreted them to be ridiculing, rather than reflecting, the LAPD's practices.

Subsequently, it became even more difficult to see *Dragnet* as a serious police drama. A 1987 motion picture version, starring Dan Ackroyd as Joe Friday, was a flat-out comedy. Later, as the LAPD appeared permanently mired in controversy and corruption, *Dragnet* attracted a new set of comical connotations as it circulated in re-

runs. In fact, TVLAND, the "retro" cable channel, which regularly featured the 1967–71 episodes, surrounded them with tongue-in-cheek promotional spots that cued viewers to watch *Dragnet* as a parody of the law in action.

Although *Dragnet* had become a source of parody, some people think the basic concept retained its dramatic power. In 2003, Dick Wolf (the successful producer of *Law & Order* and its numerous spinoffs) brought a serious and updated version of *Dragnet* back to television. Once more Sgt. Jack Webb tells suspects and witnesses "just the facts, ma'am." Perhaps the pro-police and pro-security atmosphere of the time, together with the comforting nostalgia value of *Dragnet,* can catapult the new show into successful ratings and thus distinguish it from all of the other police dramas on TV.

As the example of *Dragnet* suggests, media texts, and the signs within them, are often transformed by changing circumstances. Viewers watching a 1970 episode today will instantly identify it, as a result of clothing and automobile styles, as "history," a set of signs from the past. However, at the same time, *Dragnet* remains, in all of its many connotations, part of our present (and likely our future) culture as well. Most importantly, *Dragnet* and all of the other legal films and TV shows about law in circulation today rely on a historically rooted set of media forms and practices that go back to the earliest days of the movies. These forms and practices (discussed in ¶1.06) continue to shape what viewers expect to encounter in a legally themed film or TV show.

1.05.5 Spectator response

In reader response theory, the consumer of a text makes its meaning. This approach (labeled "spectator response" in the case of visual media like film or television) rejects the claim that anyone, including the authors or creators of an item of popular culture, know some "correct" way of interpreting it, or deciding "what it is about," or "what it means" (Fish 1980; Staiger 2002). Any text both invites and yields more than a single, authoritative meaning. As a result, the meaning encoded by the creator of a text may be entirely different from the meaning decoded by spectators. Reader or spectator response analysis is common in cultural studies; numerous writers have sought to determine empirically the responses of particular spectators to particular texts.

How a person is likely to interpret a text, and make a rational or emotional connection of that text to his or her own life, depends critically on such factors as the person's class, race, gender, or political views, the other texts that the person has previously consumed, the viewer's expectations and mood, and the time and place that the interpretation occurs (Staiger 1992, 2000). Feminist writers, for example, often argue that men and women are likely to interpret texts such as films differently and complain that critics often privilege a phallocentric or male-centered reading. (For additional discussion, see ¶12.02.7.) Some viewers will interpret a film in accordance with the "dominant" view, one based on a conservative ideology that the way things are is the

right way, whereas others will interpret it in accordance with a "resistant" view, one based on an ideology that would change the existing power relations of class, race, sexuality, or the like. Some may interpret it seriously, others ironically, so that the meaning is the opposite of what the filmmaker may have intended.

Thus, according to David Papke (1996a), Francis Ford Coppola intended in *The Godfather* (1972) to challenge the myth that the United States was a pluralistic society living by a rule of law that could serve as a model for the rest of the world. Instead, Coppola intended *The Godfather* to present the lawless and criminal Corleone family as a symbol for the American legal system and its ruthless and predatory business practices as a metaphor for capitalist America. However, viewers interpreted the films in a manner completely at odds with Coppola's demythologizing intention. They believed that it valorized the mythic family and old-fashioned notions of community. Vito Corleone's story, they thought, illustrated that a poor man, through drive and diligence, could become successful. They approved of the apparent endorsement of power over law. Since police are on the take, judges in the Mafia's pocket, and family lawyers make offers that cannot be refused, the Corleone family's violent version of justice seemed appealing. In his public statements, Coppola expressed disappointment that viewers took from his film a meaning that completely contradicted the intended meaning.

Spectator response theory argues against trying to find any universal standard for evaluating arguments about the possible meanings of a text. Stanley Fish (1980) argues that "interpretive communities," whose members share similar educational and experiential backgrounds, tend to ascribe similar meanings to a given text. Nevertheless, such communities may be unable to persuade others of the "truth" of their view. People, in short, can make valid and interesting judgments about the nature of the cultural and legal texts concerning law or any other institution or social practice, without believing that they possess immutable standards to which everyone else must assent. We have tried to take that fundamental insight seriously in this book, leaving to our readers the responsibility of interpreting the many cultural texts we will be discussing.

1.06 Filmmaking and reality

Most members of the audience at mainstream movies or consumers of TV series expect to experience a sense of realism or verisimilitude, meaning that the story should somehow match up with the viewer's own experiences (or at least approximate the viewer's prior experiences with popular culture media). The story should feel as if it could actually happen in the world, and the characters should behave like people the viewer recognizes and they should react emotionally as the viewer would. Of course, some movies or TV shows, such as horror or fantasy stories or cartoons, are not designed or expected to feel realistic, and some viewers don't care about verisimilitude. They seek an emotional response or have something different in mind altogether.

We recognize, of course, that what we see in the theater or on TV is not "reality." We know that filmed images are not the same as people and things in the real world and they don't accurately reflect what goes on in the real world. We understand that we see only what the filmmaker chose to put in front of the camera, edited to condense many hours of film down to two hours or so, and even shorter for TV shows, and spooled out for us by the projector at the rate of 24 frames per second. We know that the film or TV show was probably filmed on a set, not in the place where it pretends to be located.

Still, if the film or TV show is successful in imparting a sense that it is realistic, something magical occurs: We "suspend disbelief" and make believe that the story involves real people with real emotions experiencing real events. Indeed, because of the large size of a movie screen and the skillful direction, music, and acting, the film may seem (and we hope it will seem) more real than just real. We experience an emotional, an "affective," response. We identify intensely with the characters; we weep when terrible things happen to them and we're delighted when good things happen. Because we make believe that these stories are true, skillful filmmakers can often feed us their version of the world or of history, or their political or ideological point of view, and we may very well accept it because it all seems so real. Of course, there are nonrepresentational or antirealistic films, just as there are nonrepresentational paintings or literature, but these kinds of film remain in the experimental category and are not the types of films discussed in this book.

As we discuss in ¶8.02, the subject of "realism" in film is actually quite complicated and contentious. Ideas of what is realistic in movies have changed greatly over time. Realism often turns out to be more a matter of style and filmmaking technique than actual fidelity to events and characters in the real world.

1.06.1 Making legal films and TV shows seem "real"

Courtroom films represent their narratives by means of a series of cinematic *conventions*—shorthand methods for conveying narrative information that, despite their artificiality, are generally accepted by audiences. For instance, the *establishing shot* for a trial film usually comes from a considerable distance away from the action (i.e., a *long shot*) and often looks upward at a courthouse or a courtroom. The judge usually is introduced in a similar, upwardly tilted long shot. This form of filmic representation helps to certify the authority of courts and judges.

Once a long shot has established the *represented space* in which the trial narrative will unfold, a film or TV show uses the standard shot-scale and changes in *camera angles* to tell a story. Trial films often cue viewers to moments of high drama and acute tension through *close-ups,* which are supposed to reveal a character's private, emotional state. The sudden swelling of a musical soundtrack offers a tried-and-true way of adding a further cue about the intended meaning of a certain shot. A close-up can

also heighten dramatic tension during exchanges between witnesses and lawyers or between opposing counsel. In addition, by changing the angle from which the camera shoots characters and situations, the filmmaker provides additional cues. Film and TV viewers enjoy an *omniscient, god-like view* from which to observe the represented space and dramatic situations. In trial films, the camera is often positioned so that viewers seem to be watching from the jury box and hearing and seeing everything that the jury in the film hears and sees.

Everything that a viewer sees in the finished film, including characters, props, costumes, and sets, embellishes the sense of the reality of the story. Students of cinema refer to the framing of the picture, and of everything in it, as *mise-en-scene* (pronounced "mize on seen"). The mise-en-scene of a trial film, for example, generally imitates the arrangement of a "typical" courtroom: raised judge's bench, a reporter, a gavel, and a jury box with a rail. All these items are necessary to make us believe we're looking at a real courtroom.

1.06.2. The editing process

In addition to the shot scale, film and TV reality also depends on the conventions that regulate the editing process. Editing refers to the ways in which individual camera shots are spliced together or cut in order to make the final version of a motion picture. Hollywood has generally favored a type of editing called classical or continuity cutting. Classical or continuity cutting tries to paper over the spatial or temporal gaps between shots in order to achieve a sense of continuity so that the finished film will appear seamless, natural, and realistic. For instance, in cutting between two scenes in two different places at two different times, editors will sometimes use a similar gesture or action (such as a character lighting a match) to paper over the gaps.

Another editing technique known as *montage* splices together a series of brief, separate shots. For example, montage could be used to show the testimony of a lengthy list of witnesses in a matter of seconds. ("Montage" sometimes refers more broadly to the entire editing process; see ¶11.02.2 for further discussion of montage.) Though obviously artificial (the witnesses may have testified over the course of several days), audiences accept this convention because it makes narrative sense (there's no point in showing the testimony of each witness) and because the characters are performing a similar action (that is, testifying) and this provides a sense of visual continuity to the shots. Further, by rapidly cutting from one witness to another, the montage may suggest that the prosecution has built an imposing case against a defendant.

Editing allows the compression of "real-life" time into "reel-life" time. The simplest technique is the *cut*. A neatly dressed attorney begins to address an attentive jury. Abruptly, the film cuts to a shot of the same attorney, now disheveled, rambling on to a group of nodding jurors. Contemporary viewers do not need a printed insert telling them that "many hours pass" in order to understand what has been happening. The

passage of time can also be shown through a *dissolve,* where a second shot is superimposed on the first one, or through a *fade out/fade in,* where the picture gradually darkens until it fades to black and then gradually brightens to a new shot.

The editing process also heightens the sense of reality of conversations among characters through a convention known as the *shot-reverse shot system.* Rather than capturing two people talking to one another in the same shot, individual shots are edited so that the finished film alternates between characters. There will be a shot of one character talking and a reverse shot of the other replying. The shot-reverse shot convention provides viewers with a variety of different looks at the unfolding story while still enabling them to imagine that they are watching a real event.

1.06.3 Filmmaking today

The conventions outlined above still prevail. Virtually every film and TV production uses them. However, they have been supplemented by new ways of creating film and TV narratives. Digital equipment speeds the editing process, thus allowing for the densely edited films that audiences became accustomed to in the 1990s. Computer-generated graphics promote a more elaborate, more cluttered mise-en-scene because all manner of "stuff" can be inserted into the final print.

The way in which viewers see film is also changing. Introduction of VHS and DVD technology means that people are watching films amid the distractions and according to the rhythms of their own daily lives rather than in the darkened quiet of a theater. As viewers become more accustomed to a media-saturated environment, most films and TV programs have adopted a more frenzied, edgy pace than older Hollywood films. Images flow by with increased speed and viewers are expected to make meanings in much less time than did their parents and grandparents.

1.06.4 Intertextuality

The sheer volume of visual imagery about the law means that many people's ideas about legal issues are formed through a phenomenon called intertextuality. Generally, intertextuality refers to one text's habit of referring to another text, as the gangsters on *The Sopranos* often do when they refer to events and characters in *The Godfather.* The process of intertextuality allows people to judge the authenticity and meanings of pop cultural texts such as *The Practice* by comparing it to other law-related TV programs and movies they've seen. More importantly, intertexuality has begun to span the divide between "real" and "reel" legal institutions. People increasingly ask questions such as "why can't judges run trials like Judge Judy?" or "why don't lawyers give concise closing arguments like they do on *Law & Order?*" Media representations, in other words, sometimes provide the basis on which people evaluate the work of the law. This phenomenon is explored further in ¶¶4.06 and 10.02.

CHAPTER 2

The Adversary System and the Courtroom Genre

Assigned film: Anatomy of a Murder *(1959)*

2.01 Anatomy of a Murder—*The film and the book*

We might have chosen many films to launch the course—and many instructors will make other choices.[1] However, we chose *Anatomy of a Murder* because we think it is the best courtroom movie ever made. *Anatomy* is one of a group of outstanding films made between the late 1950s and early 1960s that are sometimes called the golden age of legal films.

Everything about *Anatomy of a Murder* is memorable: the tense up-and-down courtroom drama, the stunning jazz score by Duke Ellington (who also played Pie-Eye), the direction of Otto Preminger, the crackling screenplay by Wendell Mayes, and even the clever "anatomy" titles. The performances of James Stewart (Paul Biegler), Arthur O'Connell (Parnell McCarthy), Ben Gazzara (Lt. Manion), George C. Scott (Claude Dancer), and Lee Remick (Laura Manion) are all outstanding. Indeed, Stewart, O'Connell, and Scott were nominated for Academy Awards, and the film was nominated for seven Oscars altogether, although it didn't win any. Most of all, we see a striking picture of the adversary system at work (see ¶2.05.2).

The film was adapted from a bestselling 1958 book by John D. Voelker (under the pseudonym of Robert Traver). Voelker, a retired Michigan Supreme Court justice, supposedly based the book on a real Michigan murder case. In the introduction to the 25th anniversary edition of the book, Voelker explains that he had worked many years as a prosecutor, defense lawyer, and judge and wanted to write a book that showed criminal trials as they really were, rather than in the overdramatized way they often appeared in the movies (Traver 1983).

Joseph N. Welch. Welch, who played Judge Weaver, was a real judge who had never acted professionally. Welch became a media celebrity during the televised Army-McCarthy hearings of 1954. These hearings put on display the demagogic conduct of Senator Joseph N. McCarthy of Wisconsin. The hearings looked into McCarthy's improbable charge of Communist infiltration of the U.S. Army. Welch's performance as the lead attorney for the Army, especially his emotional response to McCarthy's attempt to slander a young associate in Welch's Boston law firm—"Have you no sense of decency, sir? At long last, have you left no sense of decency?"—was widely credited with hastening McCarthy's downfall.

Director Otto Preminger (1905–86) studied law at the University of Vienna, although it is not known whether he graduated. His father was a lawyer. He made several legally themed movies besides *Anatomy: Advise and Consent* (1962), *The Court Martial of Billy Mitchell* (1955), and *Daisy Kenyon* (1947).

2.02 *Film theory and cinematic technique in* Anatomy of a Murder

2.02.1 Signification in Anatomy

As an example of a "sign," (see ¶1.05.2), what might the reference to Laura Manion's panties have signified to audiences in 1959? What does it signify now? Identify another signifier in the film and explain what it signifies to you and what meanings it might signify to others.

2.02.2 Editing—Quick cutting

TV and movies of today rely heavily on quick cutting. Consider, for instance, almost any episode of *Law & Order*. Instead of filming a cross-examination in one *long take* (meaning a continuous, uninterrupted shot of substantial length), the scene will be broken into a series of brief close-ups or medium close-ups (shots of persons from their chest up). For instance, the scene may begin with a close-up of prosecutor McCoy asking the defendant a pointed question. As he is posing the question, the camera may cut to a medium close-up of the defendant squirming. The camera may then cut to a close-up of the defendant's attorney looking on with evident concern. As the defendant begins to respond, the camera may cut back to a close-up of the defendant. However, as the defendant continues speaking, the camera may cut to a close-up of a juror listening intently or to a close-up of a relative of the victim listening with obvious disdain and skepticism.

Although cumbersome to describe, such a sequence of shots flows naturally on screen and provides viewers with an appreciation of the psychological dynamics that

pervade a courtroom scene. Furthermore, by cutting back and forth between prose-cutor and defendant in a *shot/reverse shot* pattern (an editing technique in which a shot of two people talking is broken down into alternating close-ups of each person), the editing conveys the give-and-take, back-and-forth nature of a cross-examination.

2.02.3 Editing—Preminger's long takes and deep focus

Contemporary viewers may find *Anatomy* somewhat slow. With the exception of portions of Dancer's cross-examination of Lt. Manion and Laura Manion, the trial sequences are not shot or edited in the way described above. Instead of using quick cutting, Preminger shoots most of the trial scenes in long takes in which the camera follows the lawyers as they walk to and from the bench, the jury box, and the witness stand. Furthermore, instead of employing numerous close-ups, Preminger uses mostly long shots (shots of persons from their feet up) and medium long shots (shots of persons from the waist or knees up), in which the various characters are simultaneously present within the filmic frame. The result is that the frame is often filled with multiple figures—some in the foreground, some in the middle ground, and some in the background.

The long takes in *Anatomy* reflect Preminger's directing philosophy. In an interview with Peter Bogdanovich, Preminger said: "I have a great belief in the intelligence of the audience. I try to do things as subtly and with as little punctuation as possible . . . Every cut interrupts the flow of storytelling. When I want a close-up, I either have the people come closer to the camera or move the camera closer to them." Bogdanovich 1997, 626, 634.

Anatomy also features *deep-focus photography*. Deep-focus photography is a way of shooting a scene such that both the background and the foreground of the shot will remain in sharp focus. The opposite of deep-focus is shallow-focus. Most scenes in a movie are shot in shallow-focus, meaning that only the foreground or the background is in sharp focus. The rest of the scene is out of focus. When a scene is shot in deep-focus, however, the figures in the background are as crystal clear as those in foreground. Theorists of the 1940s and 1950s saw deep-focus photography, made famous by Orson Welles in *Citizen Kane* (1941), as a way to make a movie seem more "realistic." The technique gradually lost its cultural cachet, but Stephen Spielberg helped restore some of its appeal by using it in his early movies such as *Jaws* (1975).

Preminger photographs the trial. The effect of *Anatomy*'s use of deep-focus and long takes is illustrated in the scenes in which the camera faces the attorneys' tables as one of the attorneys questions a witness. Consider, for instance, Biegler's cross-examination of Dr. Raschid. Although Biegler is in the foreground, dominating the frame, Lodwick, Dancer, Lt. Manion, Laura Manion, Maida, Parnell McCarthy, and the crowd of spectators are visible in the background at various points in the scene.

Instead of being riveted on Biegler, our eyes are thus free to roam. Notice, however, that when Preminger wants us to concentrate on Biegler he stops using deep-focus, thus rendering the background figures indistinct.

2.02.4 Distance and objectivity

Anatomy tries to represent at least two effects by shooting the trial scenes in the way it does: distance and objectivity. Because we seldom see witnesses in close-up, we cannot read their facial expressions and reactions as clearly as TV shows such as *Law & Order* encourage us to do. Thus, the subtle twitches or lip biting that often undermine a witness's credibility are barely perceptible. As a result, *Anatomy* doesn't cue us in as to how we're supposed to assess a witness. This gives us greater latitude to decide for ourselves who is telling the truth and who isn't.

Because there are so few close-ups, we are also likely to feel more detached from the characters than in many other trial films where we are invited to become emotionally invested in the defendant or the victim. In *Anatomy of a Murder,* however, we develop little emotional investment in Lt. Manion or Laura Manion. We seldom see either of them in close-up. Instead, we observe their reactions from a distance, which denies us the intimacy we expect in trial films. Consider, for instance, the scene in which Dancer cross-examines Laura Manion about whether she always wears panties. Instead of cutting to a close-up of Laura as she is asked such an intrusive question, the camera follows Dancer as he steps away from the witness stand and goes back to his table to take a drink of water. The result of such techniques is to shift our attention away from the plight of the defendant and the truth or falsity of the witness's statement to the trial strategy and tactics of the contending attorneys.

Perhaps these techniques help explain why *Anatomy* is the favorite trial film of many lawyers. Unlike many trial films, *Anatomy* is primarily about the trial process itself, rather than one person's quest for vindication or a detective-style whodunit. As film critic V. F. Perkins has observed, *Anatomy* "is designed to examine the mechanism by which a verdict is reached, not to establish the accuracy or the fallibility of the verdict itself" (Perkins 1972, 148). As we shall see in chapter 9, *12 Angry Men,* another golden-era trial movie, offers a similar perspective on jury deliberations.

2.03 The trial genre

Students of popular culture use the term *genre* to refer to a body of films or other texts that share important themes, subjects, or stylistic motifs. Filmmakers, film publicists, film critics, and spectators all rely heavily on genres (such as the western, the musical, or the historical epic) in order to predict what ideas and images might prove marketable and to select which films to watch. Pop culture creators expect audience members

to recognize, and to feel comfortable with, the recurring narrative structures and conventions, the familiar character types, and the expected endings.

However, genres are no more stable than the individual texts that comprise them. Moviemakers constantly play with even the most successful and familiar genres. By varying generic codes and upsetting audience expectations, filmmakers can introduce novelty and update genres that have become tired or unprofitable. As a result, historians can use generic changes as a window into changing popular culture in the broad sense of that term.

Film scholars often devote their efforts to considering genre issues. They draw boundaries between genres, chart their changing forms and box office fortunes, and use genre theory to compare and contrast films. Academic and media critics sometimes identify new genres by discovering common links between films.

The "trial film" (sometimes referred to as "courtroom film") is such a creation. Classical Hollywood filmmakers never set out to make a "trial movie." They called a product such as *Marked Woman* (1937) a "melodrama" or, less charitably, a "woman's weepie." Today, however, many students of law and popular culture see trial films as a coherent genre, with a recognizable history.[2] These films include dramas, comedies, and even musicals. The genre seems to be thriving. Every year, the film industry produces several trial films, and there have been countless courtroom dramas on television.

To qualify for membership in the trial genre, a trial should consume significant time within the film or be central to the film's narrative. Silbey (2001) discusses the genre and its typical conventions and signifying practices. Trial films are normally set in a specific physical space: the massive courthouse (usually shown in long-distance establishing shots), its hallways, and courtrooms (though a few trial films occur elsewhere than in courtrooms). Trial films usually position viewers as if they were the actual decision makers—in the jury box, for example, during closing arguments. This positioning suggests that the viewer should participate along with the judge, lawyers, and jurors in finding out the truth. The protagonist is usually one of the lawyers who triumphs over various obstacles and somehow achieves justice. The lawyers square off against each other, each spinning a particular story or version of the facts; a neutral judge presides and enforces procedural and evidence rules. The trial process brings out various secrets and hidden relationships between the characters. The film ends with a decision, usually a jury verdict, that resolves the conflicts of the trial.

Anatomy of a Murder has become an honored member of this club, especially because a remarkably high percentage of the film's running time is set in the courtroom. Does *Anatomy of a Murder* depart in any respect from the conventions of the courtroom genre?

This book will consider several movies that clearly fit the courtroom genre, but it will also discuss films that contain no trial scenes. Popular legal culture (in the narrow sense) includes far more than films or television shows about trials.

2.04 Anatomy *and the Production Code*

2.04.1 Hays, Breen, and the Production Code

Between 1934 and 1968, Hollywood maintained a rigid system of self-regulation called the *Production Code*.[3] The Code was first adopted in 1930 by the Motion Picture Producers and Distributors of America (known today as the Motion Picture Association of America). Former postmaster general Will Hays then headed the MPPDA so that the Code is often referred to as the Hays Code. Hollywood producers agreed to be bound by the Code because they were being subjected to tremendous pressure to clean up the movies. Much of this pressure came from state and local government censorship boards which often cut newly released movies to ribbons. At that time the movies were not protected from government censorship by the First Amendment (*Mutual Film Corp. v. Ohio Industrial Commission* 1915). Additional pressure came from various private groups, particularly the Catholic Church. The producers felt that they were better off with a system of industry self-censorship than letting hostile outsiders do it for them. Thus, the Code was an important victory for conservatives who wanted to clean up the movies. It can be viewed as an early skirmish in the "culture wars" that have been fought out between contending forces on the field of popular culture right down to the present day.

The Code was mostly ignored from 1930 to 1934, but in 1934 the industry set up an administrative body called the Production Code Administration (PCA) that enforced the Code with great effectiveness. For many years, the PCA was run by a shrewd and knowledgeable man named Joseph Breen. Under Breen's guidance, the PCA reviewed every line of dialogue, as well as every costume and song lyric, to make certain that the Code was observed. Especially during the first twenty years or so that the PCA existed, no film could be displayed in any American theater without first receiving a seal from the PCA. As we watch films made during the Hays Code era, we should always keep in mind what effect the Code had on the final product.

Rules of the Hays Code. Among the various rules in the Hays Code, crime could never pay. Thus, criminals had to be punished or killed by the end of the film. Sex outside of marriage had to be punished, generally by death or disgrace of the transgressor—usually the woman. In addition, sex had to be handled with extreme discretion; on-screen brief closed-mouth kisses were permitted but all other action was supposed to occur off-screen. Moreover, serious treatment of certain subjects was ruled out of movie plots entirely, including homosexuality, abortion, divorce, and miscegenation (sex between people of different races). These subjects could sometimes be subtly suggested if filmic codes prescribed by the PCA were observed. We consider this aspect of the Code further in chapters 13 and 14.

2.04.2 The decline and fall of the Production Code

The PCA exercised unchallenged power during the 1930s, 1940s, and early 1950s, but the enforcement process became less rigid by the late 1950s and early 1960s. This change occurred for several reasons. First, Breen's successors as PCA directors were somewhat more tolerant. Second, the U.S. Supreme Court held that movies were protected by the First Amendment (*Joseph Burstyn, Inc. v. Wilson* 1952). This decision greatly reduced the powers of state and local government censorship boards. Third, European art movies (which were much more explicit and were never subject to the Code) began to attract large audiences.

Preminger's rebellion. Some American producers and directors rebelled against the Code. The most prominent rebel was Otto Preminger, producer and director of *Anatomy of a Murder*. Preminger (an independent producer who had broken away from the studios) despised the Code or any other form of censorship. Before *Anatomy,* he had produced, directed, and successfully released two movies without PCA approval. The films were *The Moon Is Blue* (1953), a racy comedy that created a sensation by using the word "virgin," and *The Man with the Golden Arm* (1955), a brutal drama about heroin addiction. Preminger showed other filmmakers that it was possible to flout the PCA and get away with it, and make some serious money in the process. Numerous other independents followed Preminger's lead in the late 1950s.

By the mid-1950s, the Code seemed a relic of the past. Filmmakers tired of negotiating artistic nuances with the PCA. Facing stiff competition from television, Hollywood's moguls fought back by making movies that featured "mature" depictions of hot-button issues. Hollywood released a number of "adult-themed" movies, including *A Streetcar Named Desire* (1951), *A Place in the Sun* (1951), *Baby Doll* (1956), *Tea and Sympathy* (1956), and *Cat on a Hot Tin Roof* (1958). These films dealt candidly with issues such as homosexuality, abortion, impotence, and adultery (see Klinger 1994, 37–51) in ways that the TV networks could not duplicate. The industry accompanied these films with lavish and suggestive advertising campaigns that cued ticket-buyers what to expect. The lobby card for *Tea and Sympathy,* a film that dealt with homosexuality, proclaimed that "Even the Most Daring Story Can Be Brought to the Screen with Courage, Honesty, and Good Taste."

In the late 1950s and 1960s, the Code became an embarrassment and more and more films were released without PCA approval. Ultimately, in 1968, Jack Valenti, the newly appointed czar of the MPAA, ditched the Code and substituted the ratings system, a descendant of which remains in use today.

In a perverse way, the Production Code actually helped Hollywood portray the kinds of controversial issues presented in *Anatomy of a Murder*. By complying with the PCA's rules, directors could deal with matters such as legal corruption and sexuality without incurring a massive counterattack from even more puritanical local censorship boards, such as Chicago's.

For example, *Marked Woman* (1937) was a courtroom drama starring Humphrey Bogart and Bette Davis. It fictionalized the prosecution of a group of New York mobsters who ran a fabled prostitution ring. It changed the occupation of its female characters from hookers to "party girls." The film avoided any direct portrayal of sexual activity. At the same time, by using familiar movie conventions, such as a fadeout just at the point where a specific, sexualized image might violate the Code, the film could connote the kind of "parties" that the women such as Bette Davis's character were really attending.

By working with the PCA on dialogue and visual imagery, Hollywood could satisfy the informed moviegoer. Such spectators could easily decode the sexuality that was connoted, but never explicitly denoted, by the filmic conventions employed in movies such as *Marked Woman*. By the late 1940s, particularly after the PCA approved a film version of James J. Cain's steamy novel, *The Postman Always Rings Twice* (1946), filmmakers recognized that, if filmed in a certain way, most material could be crafted to satisfy the PCA and local censorship boards.

Nevertheless, Breen would have required drastic changes to a film like *Anatomy of a Murder* if it had appeared before the mid-1950s. Its dialogue about the details of the alleged rape (such as spermatogenesis, vaginal medical examinations, contraception, and ejaculation), as well as the concentration on Laura's panties, would never have gotten by the censors. Indeed, all this was quite startling even to late 1950s viewers. By that time, however, the PCA had relaxed its standards. It insisted on little more than substitution of the word "violation" for "penetration" (Preminger put up a fight on this point, but finally gave in). In addition, the movie hints that a killer avoided legal punishment and that an adulterous spouse got away with her transgression; each of these treatments would have violated the Code as Breen had administered it. Thus the PCA's laxity in approving *Anatomy* was partly the result of changing standards. However, the PCA also knew that Preminger would fight back and release the film without its approval if necessary.

***Anatomy* in Chicago.** Preminger's autobiography claims that the police chief of Chicago attempted to censor the film, not for any of these reasons, but because it mentions contraception! The chief stated that he would not want his 18-year-old daughter to hear the word. Preminger rejoined that if he had an 18-year-old daughter, he would make sure that she understood as much as possible about contraception. The next day he went to court; a federal judge viewed the film and ordered the City to release it without any cuts (Preminger 1977).

2.05 Law and justice

If popular legal culture teaches viewers about law and lawyers, as we assert in ¶1.04.2 and ¶4.06.2, what does *Anatomy of a Murder* actually teach? About prosecutors and defense lawyers? About the insanity defense? About whether an adversarial trial is a good way to ascertain the truth about events that occurred in the past, such as the question of what led up to the shooting of Barney Quill?

Popular legal culture almost invariably raises issues about the relationship of law and "justice."[4] In many films, the law is followed, and the result is unjust. Sometimes a just result is achieved, but in spite of the law. What is the relation of law and justice in *Anatomy of a Murder*?

2.05.1 Definitions: Substantive and procedural justice

First some definitions:

We define "law" to include not only the binding rules and procedures set forth in statutes and court decisions, but also in the legal realist sense of what judges, lawyers, and other actors in the legal process *actually do,* as discussed in ¶1.04.3. (Many forests have been sacrificed in pursuit of the meaning of "law," but we won't enter any further into that debate here.)

There are numerous definitions of justice.[5] One major distinction is between "substantive" and "procedural" justice. *Substantive justice* means that persons have received what they are "due," meaning that the "truth" has been discovered and the "correct" result has occurred. The guilty have been convicted and appropriately punished, the innocent set free. Substantive justice also means that persons are treated in a consistent manner; those whose circumstances are alike are treated alike. *Procedural justice* is quite different from substantive justice. Procedural justice means that the proper procedures are followed, whether or not the trial reaches the correct result or discovers the truth about what happened.

Many lawyers are uncomfortable with notions of substantive justice because they understand how difficult it is ever to find out the truth, especially about events that occurred in the past. Who is telling the truth, who is lying? What did happen, for example, between Barney Quill and Laura Manion or between Laura and Lt. Manion? What was Lt. Manion's state of mind when he gunned down Quill? We, the audience, never learn for sure, because the movie lacks the customary flashbacks to the bloody events. Neither do Biegler, Dancer, Judge Weaver, or the jurors. Lawyers are also uneasy discussing substantive justice because, in the real world, human behavior defies easy representation; there are at least two sides to every question worth talking about. Even when we claim to be certain about what happened, it can still be hard to know for sure what would be a "correct," "just," or a "moral" response.

Therefore, lawyers would rather talk about procedural rather than substantive justice. Lt. Manion receives procedural justice because he gets a fair trial by jury, with a good lawyer doing everything ethically possible in his defense. The prosecution does everything ethically possible to win a conviction. All procedural constitutional rights are respected. This is our familiar "adversary system" which has been glorified in countless movies and television shows.

2.05.2 The adversary system

The underlying assumption of the adversary system is that the best way to find out the truth is to have two skilled, committed lawyers battle it out.[6] The lawyers choose the jurors because each one can exercise a substantial number of peremptory challenges (see ¶9.10.4). The lawyers control what the issues will be, who the witnesses will be, in what order they will be called, and what questions will be asked. The trial proceeds according to a strictly prescribed order the judge cannot alter: opening statements, prosecution's case, defense's case, closing arguments. (For more detail, see ¶8.09.4 on criminal trials and ¶12.03.6 on civil trials.) The trial judge acts as an umpire, keeps order, and rules on evidentiary objections but otherwise is neutral and mostly passive. In England, judges are more active. They can sum up the evidence for the jury, which may influence the verdict. In the U.S. most judges are not permitted to express any opinion on the evidence or, if they do have that power, are very reluctant to exercise it.

Each lawyer spins the evidence into a story that hopefully will engage with the jury's own experience.[7] Dancer's story is that Lt. Manion exacted cold-blooded vengeance for his wife's affair with Quill. Biegler's story is that Manion was overcome with an irresistible impulse when he found out that Quill had raped his wife. A jury makes the final call. If the proper procedures are followed, say most lawyers, that's as close to justice as any legal system can get.

Stephen Landsman, a proponent of the adversary system writes:

> The central precept of the adversary process is that out of the sharp clash of proofs presented by adversaries in a highly structured forensic setting is most likely to come the information upon which a neutral and passive decisionmaker can base the resolution of a litigated dispute acceptable to both the parties and society. (1984, 2)

Do you agree that a trial conducted under the adversary system is the best way to find out the truth and reach a just result? How about the assumption that the battle is between two equally competent and equally well-funded lawyers? What happens when the lawyers are not equally competent or one is backed up by much greater resources than the other?

What accounts for the popularity of the adversary system in the United States beyond the fact that it is traditional and most people don't understand the alternatives?

Certainly the system is good for lawyers, but is it good for society? Does our reverence for the adversary system reflect our commitment to individualism and free enterprise capitalism? Does it reflect our distrust of government officials in general and judges in particular? Could pop culture have anything to do with our attitudes on this subject? Do films like *Anatomy*, or countless television shows about lawyers (beginning with *Perry Mason* and extending to *Law & Order*) serve the function of legitimating the adversary system in the minds of viewers?[8]

2.05.3 The inquisitorial system

The adversary system is used in English speaking countries—the United States, Britain, and Commonwealth countries such as Australia, Canada, South Africa, or India. The adversary system visualizes the dispute as a contest between two sides (prosecution and defense in a criminal case, plaintiff and defendant in a civil case). The adversary system depends on the lawyers to investigate the case before trial and to present the strongest possible case for their side at the trial. If either side gives up (for example, if the defendant pleads guilty) or if the dispute is settled (for example, through a plea bargain), the case is over. If neither side gives up and the case is not settled, a passive decision maker (judge or jury) decides which side wins. A judge ordinarily states the reasons for the decision, but the jury states no reasons for its decision.

European and Latin American countries that follow the Napoleonic Code employ an entirely different system in both civil and criminal cases called the *inquisitorial system*.[9] Despite its name, this system is nothing like the "Spanish inquisition" and might better be described as the "inquiry system." Under the inquisitorial system, the goal is to find the truth, not to settle a dispute between the two sides.

Although each country using the inquisitorial system differs in details, the pattern is consistent. In the case of a serious crime, in most countries magistrate judges (rather than police or prosecutors) supervise the investigation and assemble a written dossier. The magistrate judge interrogates the accused and directs the police and prosecutors how to investigate the case. Prosecutors regard themselves as impartial officials whose job it is to assist the magistrate judge to determine the truth; they do not see themselves as an adversary of the defense.

In these countries, judges are on a separate career track from lawyers; they have trained as judges from the time they graduated from law school and were selected as the best and the brightest. They are promoted to higher courts based on their performance. Thus the judges are likely to be professionalized and nonpolitical. If at any point during the investigation, the investigating judge decides the defendant is innocent or has a legal defense, the judge terminates the case. If the judge does not dismiss the case, it goes to trial. In most countries, there are no plea bargains or guilty pleas; all criminal defendants are tried unless the judge has dismissed the case.

Much of the evidence at the trial is presented in written form. The judge is in charge of the proceedings and calls and questions the witnesses in whatever order the judge deems best, although the prosecutor and defense lawyers are also allowed to question witnesses. There are no strict rules of evidence. The defense lawyer generally is not permitted to engage in pretrial investigation; instead, the defense lawyer's main responsibility is to argue for a more lenient penalty. In most inquisitorial systems, there is no jury; many countries employ a combination of judges and lay assessors to find the facts. The lay assessor system is further discussed in ¶9.07.3.

Our adversarial system assumes, and the players in it are socialized to believe, that the truth can best be discovered and justice achieved through the clash of skillful lawyers, one or both of whom have an incentive to obscure the truth. The parties (prosecution and defense lawyers or the contending lawyers in a civil case) would find it highly inappropriate for the judge to take over the process. This dynamic is illustrated by a scene in *The Verdict* (chapter 4); the plaintiff's lawyer Frank Galvin is outraged when the judge takes over the questioning of his expert and discredits the witness. In contrast, the basis of the inquisitorial system is a belief that a proceeding controlled by the judge, rather than the lawyers, has a better chance to discover the truth and do justice.

2.06 *Legal ethics in* Anatomy of a Murder

The film bristles with images relating to criminal law, trial practice, and the rules of evidence, as well as about prosecutors and defense lawyers, but we will reserve further discussion of these issues to later chapters. However, we intend to address issues involving legal ethics and professional responsibility whenever they emerge in the films we highlight.

Anatomy of a Murder contains a famous scene that raises profoundly important ethical issues. This is the scene in which Paul Biegler meets his client, Lt. Manion, in jail and gives him what sidekick Parnell McCarthy describes as "the lecture." Biegler coaxes Manion into coming up with the insanity defense. As Biegler leaves, he tells Manion to think about how crazy he really was.

The ABA and the Model Rules. The American Bar Association is a voluntary nationwide organization consisting of more than 400,000 lawyers. It offers its members a wide range of educational programs and publications and engages in efforts to improve and reform the law through resolutions adopted by its House of Delegates. One of the ABA's most important functions is to write and interpret a set of ethical rules for lawyers.

The current version of these rules is called the ABA Model Rules of Professional Conduct which were adopted in 1983 and have been amended on several occasions since

that time. (American Bar Association 2003) Although the Model Rules are not binding, most states have adopted them as ethical rules that are binding on the lawyers admitted to practice in those states. Each state has a mechanism to investigate violations of ethical rules and to discipline violators. Generally, the state bar associations handle this chore. In theory, lawyers who violate binding ethical rules are subject to various forms of discipline up to and including disbarment (which means cancellation of the lawyer's license to practice law). Historically, however, these state enforcement mechanisms have not been very effective. Generally, only the worst sort of ethical violations (such as stealing clients' money) have resulted in serious disciplinary sanctions. Nevertheless, most lawyers take the ethical rules seriously and try to understand and comply with them.

There is a fine line between advising a client about what the applicable law provides (which is proper) and suborning perjury by helping the client concoct a false version of the facts (which is improper). Rule 3.4(b) of the ABA's Model Rules (see box) states: "A lawyer shall not . . . counsel or assist a witness to testify falsely. . ." Obviously, this rule is difficult to enforce because conversations between lawyers and clients or witnesses that might violate the rule occur in the privacy of the lawyer's office. Besides, the rule is vague and many possible violations are, like Biegler's lecture, on the border between proper and improper conduct. (We consider another potential violation of Rule 3.4(b) in ¶4.08.1.)

Did Biegler violate Rule 3.4(b)? If so, could Biegler have conducted the interview with Manion in a way that would not have violated the rule?

2.07 Review questions

1. Describe a scene in *Anatomy* in which Otto Preminger uses a "long take" (other than the scenes described in ¶2.02.4 and 2.02.5).
2. What is the function of the unusual musical score in *Anatomy*?
3. Treating Laura Manion's panties as a signifier (see ¶1.05.2), what did the panties signify to viewers of the film in 1959? What do they signify now?
4. What elements should a film have to be placed in the "courtroom genre?" Does *Anatomy of a Murder* depart from the conventions of other courtroom movies you have seen?
5. Why do you think trial films have such enduring popularity?
6. Legally themed films often focus on the relationship between law and justice. How is this relationship worked out in *Anatomy of a Murder*?
7. If you could design our legal system from scratch, would you adopt the "adversary system" or the "inquisitorial system"? Why?
8. Did Biegler violate Model Rule 3.4(b) in his meeting with Lt. Manion?

CHAPTER 3

Lawyers as Heroes
Assigned film: To Kill a Mockingbird (1962)[1]

3.01 To Kill a Mockingbird—*The book and the film*

Harper Lee's only book, *To Kill a Mockingbird,* appeared in 1960 and has sold more than thirty million copies. Countless students in high school or college American literature classes have read it. The character of Atticus Finch was based on Lee's father, A. C. Lee, a lawyer in Monroeville, Alabama. Harper Lee grew up in Monroeville, and the set used in the film as the Maycomb County courtroom duplicates the courthouse in Monroeville (which is now preserved as a museum). The character of Scout resembles the young Harper Lee herself; that of Dill is based on the writer Truman Capote whom Lee knew as a child. The story of Atticus and Tom Robinson is fictitious, although Mr. Lee once represented two blacks who killed a merchant and were hanged in the Monroeville jail. Harper Lee attended the University of Alabama Law School but dropped out before graduation.

The film received eight Academy Award nominations, including best picture, best director (Robert Mulligan), best musical score, and best supporting actress (Mary Badham, who played Scout). It won three: best screenplay, best art direction, and best actor (Gregory Peck). By any account a classic film, it is the only legally themed movie to make the American Film Institute's top 100 list (at 34th). Many lawyers claim that this film influenced their decision to attend law school. Atticus Finch has become an iconic, heroic attorney, and several newspaper articles that questioned his ethics or strategy in *Mockingbird* triggered a deluge of criticism from his many fans.

3.02 *Filmic analysis of* Mockingbird

3.02.1 Robert Mulligan

To Kill a Mockingbird was directed by Robert Mulligan, a former divinity student from the Bronx. A veteran of live TV productions, Mulligan made his Hollywood debut with *Fear Strikes Out* (1956), a biographical picture about the nervous breakdown of baseball star Jimmy Piersall. This movie focused on Piersall's troubled relationship with his demanding father, and critics praised Mulligan for his sensitive handling of the father-son theme.

3.02.2 Memories of childhood

In addition to being a courtroom drama, *To Kill a Mockingbird* is also about a father-child relationship. In fact, trial sequences take up less than half of the film. The rest focuses on the childhood exploits and experiences of Jem and Scout, Atticus Finch's children.

The opening credits immediately establish the film's focus on childhood. The film opens with an overhead shot of a cigar box. A pair of hands (perhaps those of the adult Scout) enters the frame and opens the box. Inside the box are Jem and Scout's childhood bric-a-brac—marbles, jacks, crayons, old coins, a harmonica, a whistle, a clothespin, and Atticus's watch. The camera lingers on each object in extreme close-up as Elmer Bernstein's beautiful score plays in the background and a child's voice is heard off-screen.

The enlarged objects and the off-screen voice suggest a child's perspective on the world. At the same time, the score, the slow dissolves, the lingering camera movements, and the presence of Atticus's watch (note the sound of it ticking) all suggest *memories* of childhood—a childhood colored by the passage of time and filtered through the nostalgic reminiscences of an adult. *To Kill a Mockingbird*'s point of view is thus a complex one: On the one hand, the point of view is that of a child; on the other, it is that of an adult looking back at her childhood.

The movie reminds us that we are seeing the events as they are filtered through memory by having Scout, as an adult, narrate the film but from a child's perspective. Theorists would describe the story as "focalized" through the consciousness of both the child Scout and the adult Scout.

Framing scenes through windows. Visually, the film highlights the fact that we are seeing events through the filter of Scout's childhood memories by framing scenes through windows. Take, for instance, the scene early in the film in which Scout reads in bed while Atticus looks on. Instead of shooting the scene entirely from inside Scout's room, Mulligan begins the scene with the camera looking in

through Scout's window. The scene is thus framed by Scout's window. Filmmakers often use windows and doors as frames to give a scene the look of a framed photograph. Furthermore, although the camera eventually penetrates the window and enters Scout's room, its placement at the beginning of the scene has a distancing effect—we are distanced from the characters, just as Scout is distanced from her own childhood.

The final shot of the film repeats this device—with one important difference. As in the earlier scene, the camera begins the scene by looking in through a window. (This time we see Atticus cradling Scout as they sit up, watching Jem). Instead of entering the room, however, the camera pulls back, retreating from the Finch house altogether. The poignancy of this final shot derives in large measure from the receding camera movement, suggesting as it does that the film is leaving the world of Scout's childhood and consigning it to the past once and for all.

3.02.3 Between two worlds—Childhood and law

To Kill a Mockingbird is, of course, about more than just childhood and growing up. It is also about the law. There is, however, a tension between the film's focus on childhood and its focus on law. The legal system—with the exceptions of family court and juvenile court—is almost exclusively an adult world. Children have almost no role or voice in it. Children, on the other hand, generally have little exposure to, interest in, or understanding of the law. The world of cops and robbers, not lawyers and judges, is featured in children's books, games, and movies. For a film or a novel to tackle both of these themes at once is unusual.

The film straddles these two worlds by shifting perspectives and styles when it shifts between them. When it focuses on the world of Jem and Scout, the film adopts a rather florid visual style. Oblique angles, close-ups, and *low-key lighting* (that is, a lighting scheme that leaves large parts of the image in darkness and shadow) are used to suggest a child's exaggerated perspective on the world. The children's nocturnal visit to the Radley house illustrates the use of these techniques. In fact, the use of shadow is so extensive in the scene that Arthur "Boo" Radley (Robert Duvall) is literally reduced to a shadow. Similarly, when Bob Ewell (James Anderson) attacks Jem and Scout in the forest, the scene plays out in a series of close-ups of struggling hands and Scout's eyes—neither Bob Ewell's nor Boo Radley's face is seen. In this way, the scene restricts our point of view to Scout's.

Another scene in which our perspective is limited is Tom Robinson's arraignment. The arraignment is viewed from the children's perspective—which is to say it's not viewed at all. The arraignment occurs off-screen because neither Scout nor Jem can see it; only Dill, whom they have hoisted above them, can see it. Mulligan refrains from showing us what Dill sees, however, because he wants to anchor us in Scout and Jem's perspective.

In the trial, our perspective extends beyond Scout's or Jem's. Indeed, except for the occasional point-of-view shot from their perspective in the balcony, the trial is filmed "objectively"—meaning that it is not filtered through anyone's consciousness. Thus, unlike the rest of the film, there are no shadows, no slow dissolves, no oblique angles, no lingering camera movements, and very few extreme close-ups. The absence of these features may make the trial sequence seem rather flat, visually speaking, as compared to the rest of the film, but it also serves to differentiate the legal world from the children's world.

In addition, the movie suggests how adults view the world differently from children. Scout and Jem see Bob Ewell as a kind of boogeyman—a sinister, almost spectral figure who comes out at night. (Note the scene in which Ewell peers into Atticus's car while Jem is inside—the car window distorts Ewell's features, making him look something like a leering ogre.) At the trial, however, Ewell comes across as something more prosaic—a poor, uneducated bully. Less melodramatic than the children's vision of Ewell, this sequence provides an equally horrifying vision of Ewell.

The trial sequences thus function as stylistic counterpoints to the rest of the film, and viewers can see them as offering a more mature, more distanced perspective on the world than the earlier scenes. The trial represents the culmination of the film's concern with childhood and growing up. It is a key moment of maturation in Scout's life. By dropping the children's point of view, Mulligan suggests that Scout is dropping that point of view as well. She is, for the first time, seeing the world as an adult sees it. In this regard, what Scout sees—the conviction of an innocent man—is ultimately less important than *how* she sees: objectively and from a distance.

3.03 Melodrama and Mockingbird

3.03.1 The melodramatic mode in American movies

According to film scholar Linda Williams, melodrama is not merely one genre among others in American cinema but "the fundamental mode of popular American movies" (Williams 1998, 42). She means that a great many American movies are melodramas, at least to some degree.

The word *melodrama* generally suggests heightened emotionality. Despite the negative connotations that the word carries, heightened emotions are the very stuff of American movies. Such recent American films as *Gladiator, A Beautiful Mind,* and *Titanic* are good examples. There is more to movie melodrama than emotionality, however; its importance lies in the narrative form in which these heightened emotions are situated and the narrative function they serve.

In delineating the melodramatic nature of American movies, Williams draws on Peter Brooks's account of melodrama (Brooks 1976). According to Brooks, melodrama

is a uniquely modern narrative form that seeks to establish moral clarity in a world in which religion no longer provides a shared moral framework. Melodrama does this by situating the struggle between villain and hero within a social context in which the villain's viciousness and the hero's virtue go unrecognized at first because of their social standing. The villain is typically a respected member of the dominant social group, whereas the hero is usually a member of a subordinate social group. The eventual triumph of the hero thus brings about not only a victory for virtue but also a process of moral clarification for society as a whole. The role that heightened emotionality plays in this is as a signifier of moral virtue. We (and the movie's other characters) come to recognize the hero's virtue by witnessing the hero's suffering (which is manifested in displays of emotion). The villain, on the other hand, rarely experiences any suffering, and the only emotion the villain typically expresses is relish at the hero's suffering.

Williams gives a concise description of how this process operates in the typical Hollywood film:

> [T]he basic vernacular of American moving pictures consists of a story that generates sympathy for a hero who is also a victim and that leads to a climax that permits the audience, and usually the other characters, to recognize that character's moral value. This climax revealing the moral good of the victim can tend in one of two directions: either it can consist of a paroxysm of pathos (as in the woman's film or family melodrama variants) or it can take that paroxysm and channel it into the more virile and action-centered variants of rescue, chase, and fight (as in the western and all the action genres). (Williams 1998, 58)

This analysis accurately describes a great many legally themed films. In most legal films the role of the hero is split into two characters: the passive victim (typically the plaintiff in a civil trial or the defendant in a criminal trial) and the active lawyer who represents the victim. The client's status as a victim makes the lawyer's cause morally praiseworthy. Make the client a victimizer (as happens, for instance, in *Primal Fear*), and the virtue of the lawyer is called into question. Moreover, the client in legal films is typically someone with less money and power than the party on the other side. This scenario, too, is a fundamentally melodramatic convention. In addition to *Mockingbird* (discussed below), numerous other films discussed in this book fit the melodramatic model, including *The Verdict* (chapter 4) and *Philadelphia* (chapter 13), although others, like *Anatomy of a Murder* (chapter 2) might not.

3.03.2 Melodrama in films with racial themes[2]

In another book Williams examines narratives about race (e.g., *Uncle Tom's Cabin, Birth of a Nation, Gone with the Wind, Roots*) in the light of the melodramatic framework (Williams 2001). She concludes that racial stories are structured in melodramatic

terms and that narratives about race can be broken down into two basic traditions: the Tom and anti-Tom traditions.

The Tom tradition originated with Harriet Beecher Stowe's *Uncle Tom's Cabin,* one of the most popular and widely adapted American novels of the nineteenth century. The significance of the novel, according to Williams, consisted in its "interweaving of a conventional sentimental story of youthful female suffering on the model of Dickens (Little Eva's death by consumption) with a more distinctively American story of a racialized Christ-like passion (Tom's death by beatings from his white master)" (47). Moreover, as Williams astutely observes, it is a black man (Tom) who witnesses and empathizes with Eva's suffering, while it is a white man (George Shelby) who witnesses and empathizes with Tom's suffering. The depiction of cross-racial sympathy was a signal event in the history of the American novel. As Williams points out, this was "the first time in popular American culture that a white man we[pt] over the racial suffering of a slave" (1998, 55). Even more resonant than the depiction of cross-racial sympathy was the depiction of a black man suffering in distinctly Christ-like terms. Never before in the American novel had the horrors of slavery been so starkly presented.

At the heart of the Tom tradition is thus the image of a black man being victimized by a white man. At the heart of the anti-Tom tradition, however, is the image of a white *woman* being victimized by a black man. The anti-Tom tradition first began to take shape in the wake of the success of *Uncle Tom's Cabin*. Southerners who were incensed at the sympathy engendered for blacks by Stowe's novel and its many adaptations created their own novels and plays in response. Instead of depicting blacks as victims, these novels and plays portrayed blacks as victimizers.

Clarification—"Uncle Tom". In current usage, the term Uncle Tom has taken on negative connotations of passivity and obsequiousness. However, the character of Tom in Uncle Tom's Cabin is anything but obsequious; his master beats him to death precisely because Tom refuses to obey. He is, however, a passive figure; for Stowe, Tom's passivity was a sign of his Christ-like virtue. The term Uncle Tom acquired negative connotations because passivity in the face of white domination became despised during the civil rights movement. In addition, some of the anti-Tom books and plays purported to be adaptations of Uncle Tom's Cabin; these works appropriated the figure of Tom and portrayed him as a grotesquely obsequious and submissive slave.

***The Clansman* and *The Birth of a Nation*.** Perhaps the most famous anti-Tom novel was Thomas Dixon's *The Clansman: A Historical Romance of the Ku Klux Klan* (1905). A virulently racist novel that portrayed blacks as subhuman brutes who lusted after and raped white women, *The Clansman* was turned into a film by the premier director of his era, D. W. Griffith. The resulting film, *The Birth of a Nation* (1915), broke

box office records and revolutionized the art of film, while at the same time portraying blacks in the most viciously racist terms ever seen in American film.

In the 1930s, the anti-Tom tradition was updated and softened by Margaret Mitchell's *Gone with the Wind* (1936) and David O. Selznick's film version (1939). The novel was the runaway bestseller of the 1930s, and the film was the biggest money-maker in film history until that time. In the 1970s, the Tom tradition was modernized by Alex Haley's novel *Roots* (1976) and the TV miniseries based on it (1977). Haley's novel was a bestseller, and the miniseries was *the* television event of the 1970s.

In the 1990s, the Tom and anti-Tom traditions were played out in real life. The racial divisiveness of the O. J. Simpson trial, Williams contends, lay in its ability to mobilize both narratives. The prosecution's story was about a white woman's victimization at the hands of a black man; the defense's story was about an innocent black man unjustly prosecuted by white police officers and a white criminal justice system. The power of the videotaped beating of Rodney King, on the other hand, lay in its visualization of one of the most potent images in the Tom tradition: the beating of a black man by white men.

The continuing significance of the Tom and anti-Tom traditions cannot be understated. Indeed, they continue to live on in trial films as well as in real-life trials. A legal film like *Just Cause* (1995), for instance, mobilizes both traditions at once, turning what seems like a Tom narrative into an anti-Tom one by the film's end.

To Kill a Mockingbird is the quintessential trial film in the Tom tradition (Harper Lee's choice of Tom Robinson's first name may be no coincidence). Indeed, Williams claims that the novel and the film version "constitute what we might now call the contemporary national consensus version of the Tom story." According to Williams, contemporary versions of the Tom story (e.g., *A Time to Kill, The Green Mile, The Hurricane*) are "typically told from either a safe historical or geographical distance, permitting the racial victims and villains to be clearly marked as figures out of a racially prejudiced time (the past) or place (the deep South) . . . We know that even if justice is not done, that we, as audience-jury, will feel righteously condemnatory about the racial injustice—it is southern, it is archaic. If put in the position of the jury we can be certain that we would judge more fairly" (Williams 2000, 258). *Mockingbird,* of course, was set in both a remote time (the mid-1930s) and place (a deep-South small town).

The *Mockingbird* version of the Tom story splits the victim role between a passive victim (Robinson) and an active hero (Atticus Finch). Robinson's moral virtue derives from his victimization at the hands of whites (the Ewells and the prosecutor). The moral virtue of Atticus Finch, on the other hand, derives from his sympathy for and willingness to fight on Robinson's behalf.

Some commentators have criticized these types of films for portraying their black victims in largely passive terms. *Mockingbird* is emblematic in this regard. Although on trial for his life, Tom Robinson does not play an active role in his defense. The

more active hero of these films is the white lawyer (or, in the case of *The Green Mile,* the white prison guard) who fights on behalf of the black defendants.

Seen in this context, *Philadelphia* (chapter 13) is an interesting variation of the Tom tradition. In that film, a white man is the passive victim and a black man is the active hero. The white victim in *Philadelphia,* however, plays a far more active role than the black victim in *Mockingbird.* Not only is Beckett portrayed in more multidimensional terms (we learn very little about Tom Robinson's private life), but he plays a far more active role in litigating his case than does Robinson. He is constantly whispering to Joe Miller or jotting down notes on his tablet. Notice, too, that Miller usually sits at the table with Beckett when he examines a witness, whereas Finch typically stands or walks about when he questions witnesses. Do you think *Philadelphia* would have done anything differently if Andrew Becket had been black and Joe Miller white? As discussed in ¶13.04.4, very few films (other than *Philadelphia)* have significant black lawyer roles. Also discussed in ¶13.04 are the stereotypical roles available to blacks during most of the history of the movies.

3.04 Harper Lee and the Scottsboro boys

3.04.1 Messages from the author and filmmaker

The late 1950s and early 1960s were an important time for the civil rights movement and an era of fierce racial conflict in the South. Many white southerners bitterly resisted the decision of the U. S. Supreme Court in *Brown v. Board of Education* (1954). *Brown* established that legally segregated schools violated the Constitution. The struggle to secure black voting rights and to end segregation of schools and other public facilities became intense and bloody. Demagogic racists such as Governors George Wallace of Alabama and Orval Faubus of Arkansas made opposition to integration the centerpiece of their political appeal.

Harper Lee's book addressed racism in Alabama and the limitations of the southern legal system in cases of alleged black-on-white crime. Writing in the late 1950s and publishing in 1960, Lee set her tale many years in the past. This was a strategy to defuse the criticism that would have erupted in Alabama had she located the story in the present. What *was* Harper Lee's book trying to say to her readers (and filmmaker Robert Mulligan and screenwriter Horton Foote to viewers of the film)? How did these visions compare to those of the civil rights activists who were marching during the late 1950s and early 1960s?

3.04.2 The Scottsboro boys—The events[3]

To Kill a Mockingbird recalled the real and tragic story of the "Scottsboro Boys," which unfolded in Harper Lee's home state of Alabama in 1931 and for years thereafter. The

Scottsboro Boys were a group of young black men (aged 13 to 19) who had been "riding the rails" in a railroad boxcar in hopes of finding a job somewhere "down the line," a fairly common practice during the Depression years of the 1930s. A fight with some white men, who were either thrown off or jumped from the train, left these young black men alone with two young white women, Victoria Price and Ruby Bates, who later accused them of committing gang rape. The black men were pulled off the train and thrown into jail in Scottsboro, Alabama. As an angry crowd of whites gathered at the jail, the governor of Alabama called in the national guard to protect the men from being lynched, an all too common occurrence in those days.

There is strong reason to believe that the two women lied about having been raped. They might have concocted the rape story to gain publicity or to justify their presence in the train with black men. Medical examinations showed evidence of sexual intercourse involving Price but no scratches or bruises on either of the women's bodies. The men faced the southern legal system with woefully inept legal representation (the entire county bar was appointed to represent the defendants which amounted to no defense at all). After hasty trials, conducted amidst threats of mob violence, eight of the defendants were sentenced to be executed for rape.

3.04.3 Scottsboro—The struggle for control

The convictions produced a firestorm of protest and controversy outside Alabama. The International Labor Defense Committee (ILDC), which had close ties to the U.S. Communist party, and the staunchly anticommunist National Association for the Advancement of Colored People (NAACP), vied with one another to control the appeals. The NAACP accused communists in the ILDC of being more interested in using the Scottsboro case for their own political propaganda aims, especially for securing the communist party a broad base of black support in the South, than in winning the legal battle. In fact, the ILDC and the communist party did see the Scottsboro episode as more than just a case of legal injustice and insisted that the southern courts could never provide fair and impartial justice in such a circumstance. Indeed, the Scottsboro episode helped black and white communists win support within churches, lodges, and clubs in the African American community, and it briefly elevated the status of the ILDC.

3.04.4 Scottsboro—The legal battle continues

In a groundbreaking decision, the U.S. Supreme Court, in *Powell v. Alabama* (1932), set aside the original convictions. It held that Alabama's failure to provide adequate legal counsel in death penalty cases violated the due process clause of the Fourteenth Amendment (which provides that no state "shall deprive any person of life, liberty, or property without due process of law"). This decision was the first to impose due

process restrictions on state criminal trials, a trend that continued throughout the rest of the twentieth century.

In March 1933, Alabama began retrying the Scottsboro boys. The ILDC hired Samuel Leibowitz, a noncommunist New York lawyer specializing in criminal law, to represent the defendants. At the trial of Hayward Patterson, Leibowitz produced powerful evidence of innocence. The evidence included a denial of any sexual assaults by Ruby Bates. Leibowitz also conducted a slashing cross-examination of Victoria Price. He assailed Price's reputation, suggesting that her own sexual history (which included prostitution) displayed a badly soiled version of the ideal of southern white womanhood. (Present law contains "rape shield" provisions; these prohibit introduction into evidence of an alleged rape victim's prior sexual history, but such evidence was customary before the 1980s.) Possibly more angered by Leibowitz's attacks on southern ideas and folkways than swayed by his legal arguments, an all-white jury quickly found the Scottsboro defendants guilty, a result that bolstered the ILDC's claim that the southern legal system could never provide justice for southern blacks.

3.04.5 Scottsboro—Judge Horton's decision

Alabama's legal system tested this claim in the courtroom of Judge James E. Horton. After Patterson's conviction in April 1933, Judge Horton postponed any further trials because of the inflamed local atmosphere. Then, in June, in the wake of nationwide demonstrations on behalf of the Scottsboro boys, Judge Horton set aside the jury verdict against Patterson.

Judge Horton's decision was based in part on an evaluation of the evidence. Once Ruby Bates had recanted her earlier statements, the judge set aside Victoria Price's uncorroborated testimony because he found it evasive, contradictory, and likely false. He also invoked a troubling gender-based argument. He claimed that "history, sacred and profane, and the common experience of mankind teach us that women of the character shown in this case are prone for selfish reasons to make false accusation . . . of rape . . . upon the slightest provocation for ulterior purposes." In contrast to the jurors, he banished Bates and Price from the category of unsullied "white womanhood." In time, other Alabama officials began to doubt Price's story, but she never recanted it. Alabama officials immediately took the other Scottsboro cases away from Judge Horton and assigned them to another judge. The remaining defendants were again convicted of rape.

3.04.6 Scottsboro—Jockeying continues

Meanwhile, the political-legal maneuvering continued. Leibowitz broke with the ILDC and formed, with the support of noncommunist groups, the American Scottsboro Committee (ASC) in 1934. Subsequently, the ILDC, ASC, NAACP, and American Civil Liberties Union (ACLU) joined forces as the Scottsboro Defense Commit-

tee, and increasingly focused on narrower legal strategies in preference to the political agitation that the communist party had earlier mounted.

The Scottsboro convictions were again reversed by the U.S. Supreme Court in 1935, this time because blacks had been excluded from the jury pool. *Norris v. Alabama* (1935). Eventually, in 1937, Leibowitz and his allies agreed to a compromise: Four of the defendants secured their release, but the other five remained in prison. Astoundingly, the last defendant was not freed until 1950, only ten years before the publication of *To Kill a Mockingbird*. He was ultimately pardoned by Governor George Wallace in 1976.

The role of the ILDC remains controversial. One view, adopted in a recent PBS documentary, sees the activities of the ILDC and the communist party as a distraction, part of a self-interested effort to use the Scottsboro episode to advance a radical, class-based politics (*Scottsboro: An American Tragedy*). An opposing perspective, offered by historians of grass-roots politics in the Black Belt of the South, argues that the political organizing generated by Scottsboro was as significant as the legal activity. The work of the ILDC and the various Scottsboro committees, in this view, might be seen as precursors to the civil rights strategies firmly in place when Harper Lee published *To Kill a Mockingbird*.

3.04.7 Scottsboro and Mockingbird

Many of the issues involving legal strategy that swirled around the Scottsboro cases seem applicable to the trial of Tom Robinson in *To Kill a Mockingbird*. Atticus Finch tries a lower-key approach than Samuel Leibowitz. He does not attack Mayella's chastity, but his charge that she tried to seduce a black man is just as much a challenge to the social and sexual mores of the White South and just as likely to fail as Leibowitz's all-out attack on Victoria Price's sexual history. (There are numerous excellent Web sites devoted to the Scottsboro episode.)

3.05 Lawyers as heroes[4]

The American Film Institute named Atticus Finch the greatest hero in the history of the movies in 2003.[5] What do we mean when we call a real or fictitious character a "hero"? What elements of Finch's character might cause a film viewer to see him as a hero?

3.05.1 The revisionist view of Atticus Finch

Not everyone sees Finch as a heroic character. Osborn (1996, 1141–42) argues:

> Atticus cannot see beyond his law books. Indeed, he seems scared to do so, as if it would
> unleash the real demons in the town. He plays along with the system. Atticus is a willing

participant in a ritual that he knows to be absurd . . . Atticus Finch is as childlike as his daughter Scout. His vision of law is as unrealistic and yet as touching as her vision of childhood. Both hold views that are more eccentric than the town's identifiable eccentric, Boo Radley. . .

In a town like this, willful, if nonviolent, disobedience to the 'law' is the only possible alternative . . . In fact, [*Mockingbird*] is the first great film of the Sixties that makes a convincing case that a new kind of lawyer is needed, one who will fight to eliminate the 'system' rather than participate in it. The film shuts the door on the Fifties, while illuminating the hypocrisy of the decade's child-like vision.

Does Osborn's argument reprise the debate between the ILDC and the NAACP over how to conduct the Scottsboro case during the 1930s?

3.05.2 Heroic intertextuality—Young Mr. Lincoln and Mockingbird

Mockingbird is often compared to director John Ford's masterpiece *Young Mr. Lincoln* (1939), which centers on Abraham Lincoln as a young lawyer. Heroically, Lincoln (played by Henry Fonda) steps forward to defend two young white men accused of murder, first from a lynch mob, and later from what seems to be an overwhelming legal case against them. Like Fonda's Lincoln, Gregory Peck's Atticus moves his long, lanky body slowly and deliberately; he weighs issues carefully; and his character commands filmic space by its sheer presence.

Atticus's struggle to achieve justice in a racially charged atmosphere invokes the spirit of Lincoln, especially as Lincoln's image has been constructed through popcultural representations of U.S. history. Through its powerful visual imagery, the film seems to offer a larger political context that critics such as Osborn find to be absent.

The intertextuality between *To Kill a Mockingbird* and *Young Mr. Lincoln* goes beyond the Lincolnesque iconography. During the 1930s and 1940s, the Production Code Administration forbade moviemakers to portray the lynching of blacks. Consequently, movies such as *Fury* (1937), *The Oxbow Incident* (1943), *They Won't Forget* (1937) and *Young Mr. Lincoln* used various devices to suggest, but not squarely address, the lynch-law problem. Each film involves lynching themes but the victims of mob violence are white. *Young Mr. Lincoln* suggests racial themes by portraying its young white defendants, like the Scottsboro boys, as "outsiders" who are just passing through. The movie ends with metaphorical images of the coming of the Civil War, the bloody conflict that liberated the slaves.

As another example of intertextuality, we discuss in ¶9.03 whether a viewer who saw Fonda's earlier role as Lincoln might ascribe similar characteristics to his later role as "Juror No. 8" in *12 Angry Men*.

3.06 Tom Robinson was clearly innocent, right?

Why are you so sure? Are those who feel Robinson was innocent unfairly denigrating the testimony of a woman who claims she was sexually assaulted? Would you feel any differently about Atticus Finch if he suspected that Robinson might not be innocent?

3.07 The trial strategy of Atticus Finch

Regardless of whether he qualifies as a hero, Atticus Finch lost the Tom Robinson case. Shortly after the jury delivered its verdict, Robinson was dead, supposedly shot while trying to escape. If you had represented Tom Robinson, would you have done anything differently from Finch? Here are some possible strategies that you might consider:

- Move for a change of venue. Why didn't Finch try to move the case out of Maycomb County into some other Alabama county where the jury wouldn't have known the Ewells and where public opinion might not have been inflamed against Robinson? Indeed, some members of the jury were part of the lynch mob.
- Dismiss the jury. Robinson might have received a fairer trial if the judge had been the finder of facts rather than a jury. Alternatively, after the jury verdict, move that the judge set it aside as unsupported by the evidence (hoping for a Judge Horton-like decision—see ¶3.04.5).
- Attempt to negotiate a plea bargain before trial. The vast majority of criminal cases are plea bargained, not actually tried (see ¶8.09.3). In a plea bargain, the defendant agrees to plead guilty in return for a reduction of the charges or a promise of a reduced sentence. Perhaps Finch could have cut a deal in which Robinson pleaded guilty to assault or some such lesser crime. Of course, Robinson might have refused to go along with this strategy, but surely he appreciated the odds against him if the case went to a jury. Harper Lee's book says that the county attorney was "prosecuting almost reluctantly" (201). Given community sentiment, however, the prosecutor might not have felt able to agree to a plea bargain.
- Don't allow Mayella to cut short her cross-examination by refusing to say anything more. Ask the judge to hold her in contempt if she refuses to testify. Further draw out the Ewells' family history to make clear the physical abuse and possible incest between father and daughter.
- Perhaps Robinson should not have taken the stand. His testimony only served to inflame the jury against him. In most criminal trials, the defendant does not testify and the defense strategy is to argue that the prosecution has failed to prove its case beyond a reasonable doubt. At least, Finch could have done a better job of preparing Robinson so he would not have said that he "felt sorry" for Mayella.

- Argue to the jury for a lesser-included offense. Finch should have given the jury a chance to convict Robinson of a lesser charge such as assault. As the case was presented, the jury had only two choices—guilty of rape or acquittal.
- Challenge the exclusion of blacks from the jury pool in order to lay the foundation for an appeal on this issue, as Leibowitz did in the Scottsboro trial.
- Make a less confrontational closing argument. As a white southerner, Atticus should have realized that the argument that Mayella tried to seduce Tom was guaranteed to alienate the jury. Similarly, the suggestion that our courts should be the "great leveler" was also likely to be a loser. Lower-class white jurors don't want to hear about "leveling" when they at least enjoyed a higher status than blacks. Instead, Finch might have stayed with the argument that Robinson was a humble, hardworking and respectful Negro who has lived in this town all his life and never caused any trouble.
- Take the closing down a few notches. The members of this jury don't use phrases such as "unmitigated temerity" very often.
- Ask the jury for mercy as well as justice. If Robinson had made a terrible mistake and actually touched Mayella Ewell against her will, it was a mistake that surely does not justify the death penalty.

3.08 Atticus Finch and Boo Radley

At the end of the film, Finch and the sheriff cover up the fact that Boo Radley killed Bob Ewell, and they lie about what really happened. Even though Boo might have been acquitted of murder, because he acted in the defense of another, the exposure and a public trial would have destroyed this fragile man. Did Finch act unethically or immorally? Some critical commentators have noted that Atticus and the sheriff act differently toward Boo Radley, a white man, than toward Tom Robinson, a black. Do you see a significant difference?

ABA Model Rule 4.1 (see boxed material in ¶2.06 for an explanation of the Model Rules) deals with the obligation of lawyers to be truthful. It says: "In the course of representing a client a lawyer shall not knowingly: (a) make a false statement of material fact or law to a third person . . ." Does this rule of ethics apply to the Boo Radley cover-up?

3.09 Review questions

1. What messages are book author Harper Lee, screenwriter Horton Foote, and director Robert Mulligan sending to the audience for this film?

2. What parallels do you see between the saga of the Scottsboro boys and the trial of Tom Robinson?

3. Choose a different film from *Mockingbird*. Is it a "melodrama" as defined by Williams and Brooks? Explain why the film fits or does not fit their definition of melodrama.

4. Recall the different meanings for the word *justice* discussed in ¶2.05. Did Tom Robinson receive "justice"?

5. Assume that Tom Robinson wasn't killed and that Finch appealed. The Alabama Supreme Court reversed and called for a new trial. Finch is unavailable this time and you have agreed to represent Robinson at the new trial. Will you do anything differently than Finch?

6. Do you agree with Osborn's analysis of the character of Atticus Finch? Why or why not?

7. Aside from Atticus Finch, please identify your favorite "heroic" lawyer in popular legal culture (print, film, or television). What makes that person heroic in your eyes?

Lawyers as Villains
Assigned film: The Verdict (1982)[1]

4.01 The Verdict—Book and film

Barry Reed's novel *The Verdict* was published in 1980.[2] Reed (1927–2002), a successful Boston lawyer and author of four legally themed novels, stated that the book is not based on a real case. In the book, Galvin and Concannon appear much as they do in the film, but the other characters and many plot details differ. For example, in the book Galvin didn't ignore the case until ten days before trial; he did take some depositions. In addition, in the critical scene near the end of the film, the judge allows the copy of the admitting report to be accepted as evidence.

David Mamet, the outstanding dramatist and director, adapted Reed's book into a screenplay. Mamet's father, stepfather, and two siblings were lawyers. Mamet himself worked on other movies with legal themes, including *The Winslow Boy* (1999). *The Verdict's* director, Sidney Lumet, made numerous legally themed movies in his distinguished career, including *Night Falls on Manhattan* (1997), *Guilty as Sin* (1993), *Q&A* (1990), *Prince of the City* (1981), *Serpico* (1973), *Daniel* (1971), and *12 Angry Men* (1957). He also co-wrote, co-produced and directed the cable television series *100 Centre St.*

The Internet Movie Database. The authors generated this list of Lumet's movies in an instant by a search on the Internet Movie Database, http://us.imdb.com. This essential tool has information on every person ever involved with the movies or television. It also contains easily searchable information on every movie or TV show ever made, including a plot summary, the cast, and others involved such as writers or directors. For newer films, it contains newspaper reviews, reader ratings, and comments, and business information. Try it! It's free of charge.

The Verdict received five Academy Award nominations: best picture, best director (Sidney Lumet), best screenplay (David Mamet), and acting nominations for Paul Newman and James Mason. However, it garnered no Oscars.

4.02 Paul Newman's career

During a career spanning more than half a century, Paul Newman created an identifiable character type who moves from movie to movie: a flawed, often amoral and self-absorbed hero who sometimes rebels against the establishment and often is at war with himself. In *The Young Philadelphians* (1959), Newman played an ambitious tax lawyer who shrugs off the displeasure of his elite law firm and successfully defends an old college friend accused of murder. In *Hud* (1963) and *Cool Hand Luke* (1967), he portrayed charming but irresponsible loners who confront uncomprehending father figures and uncaring bureaucracies. His role as a middle-aged con-man in *The Sting* (1973) anticipated his portrayal of the middle-aged ambulance chaser in *The Verdict*. In both movies, his character sobers up enough to pull off one great performance—an intricate "sting" in the former film and an improbable legal victory in the latter. In both cases, he triumphs over opponents even more ethically soiled than himself. Moreover, in *Absence of Malice* (1981), a legally themed movie replete with bad prosecutors and irresponsible journalists, Newman plays an innocent everyman smeared by a newspaper story, who fights back against these evil forces to clear his name.

4.03 The Verdict *as a conventional Hollywood drama*

4.03.1 The classical Hollywood narrative[3]

There are many ways to tell a story, but Hollywood has traditionally favored what is known as the "classical Hollywood narrative" or the "classical Hollywood style." This style dates back to the 1910s and is closely associated with the Hollywood film industry. (Note that not all Hollywood films employ this mode of storytelling, while many foreign and independent films do use it.)

David Bordwell (1985, 127) describes the classical Hollywood narrative as

> present[ing] psychologically defined individuals who struggle to solve a clear-cut problem or attain specific goals. In the course of this struggle, the characters enter into conflict with others or with external circumstances. The story ends with a decisive victory or defeat, a resolution of the problem and a clear achievement or non-achievement of the goals.

As Bordwell indicates, the classical Hollywood narrative features "psychologically defined individuals," meaning that the characters possess a set of more or less

consistent traits and behaviors that reveal their underlying psychology and personality. The characters of Frank Galvin and Ed Concannon in *The Verdict* are defined in this way.

In a classical Hollywood narrative, one character will be deemed more important—and thus, more richly characterized—than the others. This character (Frank Galvin in *The Verdict*) is the *protagonist,* the character around whom the story revolves. The protagonist seeks to achieve a goal and to overcome obstacles in the path of achieving that goal. His struggle to surmount the obstacles propels the story forward. Other characters have goals, too, but the story will not be structured around the pursuit of their goals. Some films do not have a clearly identifiable protagonist. In *Nashville* (1975), for instance, the story follows 24 different characters, none of whom is singled out as more central to the story than the others. Needless to say, *Nashville* is not a classical Hollywood film.

The classical Hollywood narrative establishes the protagonist's goal and the reason he strives to achieve it (his "motivation"). Galvin's goal is to win his lawsuit against the hospital; his motivation (the reason he seeks the goal) is to seek justice for his client and redeem himself. Of course, Galvin must overcome numerous obstacles (his alcoholism, Concannon's tricks) to achieve the goal.

The goal-oriented protagonist distinguishes classical Hollywood films from art films in which the protagonist does not actively pursue an established goal. In some art films, the protagonist has no objectives or only ill-defined ones. In others, he has a clear-cut goal but lacks the motivation to pursue it. In either case, he is passive, not active. This is one reason why art films often seem "slow" and "aimless" to viewers accustomed to classical Hollywood films.

In a classical Hollywood narrative, events are linked together by a chain of *cause-and-effect.* Typically, this chain begins with an event that causes the protagonist to desire something for the first time (perhaps Galvin's visit to the hospital where he sees his vegetative client). This event causes the protagonist to identify his goal and to pursue it. The pursuit of this aim causes the protagonist to take certain actions. In taking these actions, he causes other characters to react, and their actions in turn trigger his reaction.

Ultimately, the protagonist either achieves or fails to achieve his goal, and this is called *closure.* Closure brings an end to the chain of causation that comprises the film's plot. A classical Hollywood narrative almost always provides closure. Indeed, an *open ending* (that is, one that fails to provide closure) is forbidden in the classical Hollywood cinema.

In addition to having a narrative based on a cause-and-effect structure, a classical Hollywood story typically has a *dual- or double-plot structure,* meaning that two plot lines are concurrently developed. The first plot line is a generic plot line, such as a mystery or an adventure story. The second plot line is usually romantic: the protagonist falls for another character (the relationship between Galvin and Laura Fischer in *The*

Verdict is an example of a romantic subplot). At the film's conclusion, both plot lines reach closure, often simultaneously.

As a result, spectators of classical Hollywood narratives usually get two happy endings for the price of one: the protagonist achieves his goal and falls in love too! *The Verdict*, however, doesn't stick to this script: Galvin and Fischer don't end up forming a couple at the film's end. Indeed, a high percentage of films from the 1930s and 1940s end with a shot of the protagonist and his beloved kissing. Why do you think this was the case? Generally speaking, films no longer end with kissing scenes, but the dual- or double-plot structure is as pervasive as ever. Why do you think this is the case, given the profound social and cultural changes that have taken place since the 1930s and 1940s?

Romantic subplots in legal movies. As you may have noticed, romantic subplots are rather infrequent in legal films. Neither Paul Biegler nor Atticus Finch seems to have any romantic interests at all. Why do you think this is the case?

4.03.2 Narrative about narrative

In a courtroom, each lawyer is trying to persuade the fact-finder (judge or jury) to accept a particular version of disputed events. In other words, each lawyer has a particular story to tell that links together all of the facts presented in evidence into a plausible account with a beginning, middle, and end.

A film also tells a story with a beginning, middle, and end that the filmmaker hopes an audience will accept as plausible. Thus, as David Black (1999) points out, courtroom films are storytelling about storytelling, narrative about narrative. Black calls these films *reflexive*. He asserts that identifying and studying reflexive films is an alternative theoretical tool to the more common approach, which is to define and describe the courtroom genre (see ¶2.03).

Courtroom films like *The Verdict* and *Anatomy of a Murder* are interesting examples of storytelling about storytelling because they dwell in such detail on the events in the courtroom and the strategies used by the lawyers in getting their stories across to the jury. Such films often contain an explicit or implicit critique of law and the legal system. Does *The Verdict* offer such a critique?

Black's book reminds us to distinguish between the two levels of narration in courtroom films. First come the narrative techniques that the attorneys are using to persuade the jury that their story should be believed (and the opposing attorney's story should be disbelieved). Second come the narrative techniques that the filmmaker is using to persuade the audience that the film's story is sensible and believable. At each narrative level, we should ask whether the lawyer or the filmmaker succeeded.

4.04 *Visual design in* **The Verdict**

4.04.1. Interiors in The Verdict

The world inhabited by Frank Galvin in *The Verdict* is a world of cramped interiors and muted colors. Consider, for instance, the opening shot of the film. Galvin is playing pinball while nursing a beer. The pinball machine could have been placed anywhere in the bar; instead, it is up against a window. Thus, Galvin is literally up against a wall. The primary source of illumination in the scene is the light coming from the window. The interior of the bar seems totally devoid of light. As a result, Galvin is reduced to a silhouette—making him, visually, a mere shadow of a man. Additionally, the image is almost totally devoid of color. Aside from the scarlet red credits, the only sources of color are the red and green windowpanes, the Christmas spirit of which serves only to underscore how dark and depressing the rest of the image is. Finally, notice how the window looks out onto an empty street and an overcast sky. Thus, far from providing a respite from the dreary, lonely interior, the window extends the loneliness and dreariness of the inside into the world outside.

In this single, brief shot, the film economically establishes the cramped, cold world of Frank Galvin. Almost every location Galvin is associated with (the bar, his office, his apartment) is similarly confined and lacking in color. The first time we see Galvin's office it is nothing but a narrow hallway with a dirty sink at its end. When we finally see his office (which he immediately proceeds to ransack), it is hardly more impressive—small, confined, and virtually colorless. Drab browns (the sofa, the desk), subdued greens (the filing cabinets), and dull blacks (the chairs) dominate. Moreover, by filming the scene from an extremely low angle (the camera is at floor level), Lumet makes the office seem even smaller and more confined than it actually is. (Many of the scenes in Galvin's office and apartment are shot from low or high angles for the same reason.)

Galvin's apartment is equally cramped and cold. The furniture is drab and almost colorless and is claustrophobically arranged. Notice, for instance, how the chair Galvin is sitting in is pressed against the radiator. Lumet shoots the scene from a high angle. This position further reduces the size of the room. Finally, the bars on the window add an aura of entrapment.

In contrast, the locations associated with Galvin's nemeses—the Archdiocese, Concannon, Judge Hoyle, and the legal system itself—are almost palatial. Take, for instance, the massive conference room that Concannon uses to prepare for the trial. The conference table can seat sixteen, and the room can hold even more, as we can see when Concannon rehearses Dr. Towler's testimony. In contrast, Galvin prepares Dr. Thompson's testimony in the confines of his own apartment, a difference that underlines the vastly unequal resources of the two sides.

The film is not lacking in bold colors. Notice, for instance, the brightly colored clothes the children are wearing when Galvin drops in on Kaitlin Costello Price at Chelsea Child Care. Moreover, although dominated by shades of brown and green, the film is repeatedly enlivened by bursts of red. Consider, for instance, the following examples: the credits are in red; the first funeral home Galvin visits has a red carpet; the sofa in Galvin's waiting room—which we see for the first time when client Sally Doneghy comes to see Galvin—is red; Sally Doneghy has reddish brown hair and is wearing a blouse with red sleeves when we first encounter her; the first time we see Laura Fischer she is wearing a red scarf (a bit of costuming that serves to direct our eyes to her even before we know that she will play a role in the scene); Bishop Brophy wears a red miter; the Diocese has red carpets, red chairs, and red curtains; Bishop Brophy gets into a red car; the carpet in Judge Hoyle's chambers is red; Dr. Gruber lives in a red house with a red brick driveway; Judge Hoyle's home has red wallpaper, and he is wearing a red bathrobe when Galvin visits him; Sally Doneghy is dressed in red on the first day of the trial; Dr. Towler's textbook—Methodology and Practice in Anesthesia—is red; and Kaitlin Costello Price not only has red hair but wears a red dress when she testifies.

Because red is associated with both sides, it can't be reduced to any single meaning, though it has certain obvious associations (e.g., blood, fire, hell). Rather, it is being used to throw the drabness of Galvin's life into stark relief. Red colors are always associated with other characters, not Galvin. Visually speaking, therefore, the lawsuit literally brings warmth (in the form of the hot colors worn by Doneghy and nurse Price) into Galvin's life. Red is associated with the other side, too, but that only serves to underscore the fact that it is the trial itself—not just his clients—that brings Galvin back to life.

4.05 Public opinion of lawyers

Public opinion polling suggests that lawyers have plummeted in public esteem during the last several decades. A survey in 1973 indicated that only 13% of respondents strongly agreed that "most lawyers would engage in unethical or illegal activities to help a client." An additional 23% agreed slightly and 57% disagreed slightly or strongly. That was then. A 1998 Gallup Poll indicates that only 14% gave lawyers high or very high ratings for honesty and ethics. Similarly, the Harris Poll indicated in 1977 that almost 75% of respondents believed that the legal profession had either very great or considerable prestige. Twenty years later, 47% ranked the legal profession as having only some prestige or hardly any at all.

In 1999, the American Bar Association commissioned a poll on the public's opinion of lawyers. Only 14% of respondents were extremely or very confident about lawyers; 42% had *little or no* confidence in lawyers. Attorneys were soundly beaten by state legislatures, prison systems, and Congress; only the media came in behind lawyers. The negative public opinion data were accompanied by a flood of quite nasty lawyer jokes.

Granted, lawyers have never ranked as the most trusted professionals. One reason is that the most prominent public role of lawyers involves criminal defense. The public will always blame lawyers for helping defendants whom the public fears and detests (even though only a tiny fraction of all lawyers engage in criminal defense). A second reason is that people most often deal with lawyers during stressful times such as when they are going through bankruptcy, a divorce, or a lawsuit. People naturally tend to blame the lawyers for the miserable and expensive experience (particularly the lawyer on the other side but often their own lawyer as well). However, these reasons for disliking lawyers have *always* been there; they did not suddenly pop up during the last twenty or thirty years.

Can you think of other reasons why public opinion of lawyers might have declined so sharply during the last two or three decades?

4.06 Bad lawyers in the movies

Asimow's Nova article (2000a) documents another important trend. It surveys almost 300 movies made between 1930 and 2000 that feature significant lawyer characters (not necessarily courtroom films or even legally themed films).

The article classifies all these movie lawyers as either "good" or "bad." A "good" lawyer in this study is one that you want *both* as your friend (meaning you see the lawyer as a good human being) *and* as your lawyer (meaning the lawyer appears to be competent, ethical, and dedicated to clients). A "bad" lawyer is one that you would not want *either* as your friend *or* as your lawyer. For example, the study classifies *Anatomy of a Murder* as a "good lawyer" movie because Biegler, Dancer, and Lodwick all seem like decent people and good lawyers. However, it classifies *The Verdict* as a "bad lawyer" movie since both Galvin and Concannon can be classified as "bad," though for different reasons.

The article breaks down the movies by decades. From 1930 to 1970, around two-thirds of movies represented the lawyers as "good." However, since 1970, only about one-third of the lawyers seem "good." There are obvious problems with the methodology used in drawing this conclusion. For example, the good/bad judgment of particular characters is subjective; other viewers might well disagree. In addition, most interesting filmic characters are nuanced, with both good and bad elements. This

makes them difficult to classify on any binary good/bad scale (Greenfield, Osborn & Robson 2001, 99–115). Still, even if one disagrees with a particular classification or even the classification scheme in general, the trend from favorable to unfavorable lawyer portrayals during the last twenty to thirty years is unmistakable.

So what? Does the fact that most movies treat lawyers negatively mean anything? As discussed below, if most movies feature bad lawyers, this circumstance might be a further indicator that the public hates and distrusts lawyers because pop culture tends to reflect prevailing public attitudes. The trend toward negativity in film might also be reinforcing that negative public attitude. We explore this double relationship between pop culture and public attitudes further in the next section.

4.07 The relationship between works of pop culture and public attitudes—The cultivation effect

4.07.1 Popular culture as follower of public opinion

Popular culture in the narrow sense tends to reflect popular culture in the broad sense (see ¶1.02.1 for the broad and narrow definitions of popular culture and ¶1.04.1 for discussion of works of popular culture as representations of how people see and interact with the world). If filmmakers believe that most people dislike and distrust lawyers, they will make movies about unlikable and dishonest lawyers. Films that track popular viewpoints are more likely to resonate with viewers than those that challenge them. In other words, ticket buyers are more likely to accept as realistic and true a "bad" lawyer movie than one about bad grandmothers, algebra teachers, or rabbis. It seems fairly clear that the stunning fall in the public opinion of lawyers over the last twenty to thirty years has paralleled the increasingly negative movie representations of lawyers during the same time (see ¶4.06).

4.07.2 Popular culture as leader of public opinion

The assertion that movies tend to reflect public opinion is less controversial than the reverse assertion. Are bad lawyer movies *one of the factors* that have negatively affected the public opinion of lawyers? Do bad lawyer movies cause people to acquire negative feelings about lawyers? Do they reinforce the negative feelings they already have?

We believe that the answer to these questions is yes. Try this thought experiment: Do you know what it was like to fight in Vietnam or World War II? If your answer to that question is yes, what are your sources of information? Could one of the most important be the various war movies you have seen? Do you know anything about the life of cowboys or detectives? If so, where did you get this information? Not, we'll wager, from any real cowboys or detectives or even from nonfiction books about the

Old West or about private investigators. Instead, it probably came from movies or television (or possibly novels).

Alternatively, consider TV commercials. Commercials offer slick and appealing little stories and memorable images to make you want to buy something. Similarly, thirty-second political sound bites offer up neatly packaged little dramas about candidates or issues. At one level, most people understand that these commercial and political stories are likely to be superficial at best and bogus at worst. We all know they should never be relied on as our sole source of information about the product or the candidate. On another level, though, these cleverly produced messages exert a powerful impact on how we see the world. Otherwise, business and political candidates are wasting billions of dollars. We do not think their money is wasted.

In short, we see popular culture (in the narrow sense) as one of the most powerful "teachers" ever invented, and all of us have acquired information or misinformation (popular culture in the broad sense) from this source. In other words, we all "construct" our view of reality by working with information that is derived in part from works of popular culture.

4.07.3 The cultivation effect[4]

In trying to relate pop-cultural images to the way in which people view reality, cognitive psychologists have documented what they call the "cultivation effect" (Gerbner 2002). Film theorists refer to the cultivation effect as "cognitivism," a methodology that employs the insights of cognitive psychology to understand the effect on spectators of particular cultural products. Cognitivist theories help us predict how particular spectators will interpret cultural products, but the interpretations of particular spectators will still vary greatly, depending on such factors as class, race, or gender.

The cultivation effect comes into play when we are called on to perform "heuristic reasoning." Heuristic reasoning means decision-making where there is no reward for a right answer or penalty for a wrong answer—such as answering a question on a poll. When we engage in heuristic reasoning, we don't spend time or money researching the answer (as we might if we were choosing a college or a new car). Instead, we use mental shortcuts, called "heuristic devices," to come up with a quick answer. One such shortcut is called the "availability heuristic," meaning that we rely (perhaps too much) on whatever information is readily available. The most easily available sources are large files or "bins" of more or less relevant information and images already stored in our brains. We tend to pull the information from the top of the bin. Whether we will access a particular piece of data or image from the bin depends on how recently it has been placed in the bin and how frequently similar material has been deposited there. It also depends on the vividness of the event that placed it there.

Popular culture deposits information on a vast number of subjects into millions of "bins" in our brains. In addition, and this is the key point, we don't always "source discount" this information. In other words, we may forget that the information came from fictitious stories in film or television, and we tend to treat such information as if it were true.

4.07.4 Studies of the cultivation effect

Many studies have documented the cultivation effect. For example, suppose the question is whether you are likely to get mugged if you visit New York City. People who watch a lot of television are much more likely to answer yes to this question than people who watch less frequently. In general, heavy TV watchers think this is a "meaner" world than people who do not watch much. The heavy watchers think there is a higher crime rate, and there are more police officers, lawyers, or prostitutes, and more alcoholism or drug abuse, than light watchers.

Cultivation effects—*L.A. Law* and *Judge Judy*. One interesting cultivation effect study (Pfau 1995) compared people who were heavy watchers of *L.A. Law* and people who never or almost never watched the show. Heavy watchers thought that lawyers had more power and better character, were more physically attractive and more sociable than people who didn't watch the show. Watching *L.A. Law* seemed to make viewers admire lawyers more than the general public does. This effect even applied to lawyers themselves; attorneys who watched the show had more favorable views about their profession than lawyers who didn't watch the show.

Another study (Podlas 2001) focused on jurors who were waiting to be called for jury panels. One group of jurors frequently watched the TV show *Judge Judy*. A second group seldom or never watched it. There were dramatic differences in the way the two groups viewed the role of the judge. For example, 83% of frequent viewers thought the judge should ask questions during the trial and should be aggressive with litigants. Only 38% of nonviewers thought that the judge should ask questions and be aggressive with litigants. Another question was whether the judge's silence means that the judge believed a witness's answer. Of the frequent viewers, 74% thought that silence meant belief; of nonviewers, only 13% thought that.

The numerous "bad" lawyer movies may have contributed—along with many other factors—to the declining public image of lawyers. The strength of the cultivation effect, remember, depends on the frequency, recency, and vividness of exposure to particular representations. Bad lawyer movies have been both recent and frequent during the last couple of decades. Moreover, the vividness of movie portrayals is undeniable—the characters are played by skilled, charismatic actors, and the films are directed and scored by consummate professionals.

4.07.5 Lawyers on television v. lawyers in the movies

Televised portrayals of lawyers have been far more favorable—and far more prevalent—than movie portrayals. *L.A. Law, Perry Mason,* and such contemporary lawyer shows as *The Practice* and *Law & Order,* seem to offer, on balance, relatively favorable pictures of lawyers. The cultivation effect from these TV shows may enhance the public's opinion of lawyers.

Nevertheless, we should not dismiss the negative cultivation effect of bad lawyer movies, even though people watch many more hours of television than of movies. A particular movie can offer a far more vivid exposure—a much greater emotional impact—than a TV show can. Consider the many differences between watching a movie at the theater and watching a TV show. Do these differences suggest that a movie will have a greater emotional impact? Obviously, that impact will be much reduced if people see a movie on cable or in a VHS or DVD format at home.

4.07.6 Uses and gratification theory[5]

Cognitivist approaches such as cultivation theory tend to treat media consumers as passive sponges who indiscriminately file away bits of dubious information. In many instances, this sort of approach does not adequately describe the experience of consuming popular culture media. Certainly, serious fans (such as Trekkies or fans of particular movie or TV stars) pay close attention to their favorite shows or actors, often viewing films or TV shows repeatedly. Fans actively produce their own interpretations of the narratives and characters, often fiercely debating the readings of other fans or critics. Sometimes, fans resist the intended messages of the text, complaining that a particular episode (or incident in a film) is unfaithful to their concept of the show or film or that a particular role is unsuitable for an actor. Fans are sometimes referred to as textual "poachers" because they help themselves to bits and pieces of the works, making new meanings for themselves at variance with those intended by the makers of the film or TV show.

Some communications theorists pursue a "uses and gratification" (or "active audience") model of media consumption by viewers who do not qualify as fans. The idea is that viewers are not simply passive recipients of whatever is served up to them ("cultural dopes") but instead are actively interpreting and remaking the material. In consuming films or television, they seek pleasures and entertainment of various kinds, such as experiencing a desired emotion (laughing, crying, being scared, aroused or puzzled), altering a mood, or escaping from normal routines. They may be trying to acquire information of various sorts or to enjoy a social experience with friends or family while viewing.

According to uses and gratification theory, consumers do not simply soak up fictitious stories, failing to distinguish them from documentaries or news shows. These

theorists believe that viewers are deliberately and actively making their own meanings from culture products (meanings that may be quite different from those intended by the producer of the product). Viewers can, if they choose to, meaningfully distinguish truth from fiction and the substantial from the ephemeral. Indeed, these theorists believe that viewers are capable of rejecting the messages embedded in the narratives (particularly those reflecting dominant white/male/middle class discourses) and of substituting their own meanings and interpretations that are opposed to such discourses. These active audience theories are consistent with and complementary to the spectator response approach discussed in ¶1.05.5.

The cultivation effect discussed in ¶4.07.4 and the uses and gratification model discussed in ¶4.07.6 are not necessarily inconsistent with each other because of the enormous differences among the consumers of any particular pop culture product. Many viewers and watchers may be passively soaking up information dispensed by fictional stories in the manner suggested by cultivation theorists. For example, they may be watching a television show while doing something else at the same time or while dozing on the couch. Other viewers may be actively resisting or modifying the messages served up by the media producers as suggested by uses and gratification theorists. Some viewers may be doing both at the same time—unthinkingly accepting some messages, resisting others. Some cultural products invite viewer reinterpretation, others discourage it. Both approaches to the study of media effects may be equally valid, depending on the particular viewer's social situation and media competency, the circumstances of the particular act of viewing, and the particular movie or TV show being viewed.

4.08 Ethical issues in The Verdict

Galvin and Concannon do some very bad things. How many can you list? This section asks whether some of the lawyers' bad conduct violated the rules of legal ethics.

4.08.1 Witness coaching

Consider the scene in *The Verdict* in which Concannon prepares Dr. Towler for trial and compare it to the "lecture" scene in *Anatomy of a Murder* discussed in ¶2.06. Witness preparation can present difficult ethical problems. ABA Model Rule 3.4(b) states: "A lawyer shall not . . . counsel or assist a witness to testify falsely."

On the one hand, it is appropriate (indeed mandatory) to prepare a witness for a deposition or a trial by going over the witness's direct testimony and preparing the witness for cross-examination. This sort of preparation enables the witness to present testimony clearly and forcefully, in a way that the jury can understand and believe.

However, it is improper to cause the witness to testify to something substantively different from what the witness would otherwise have said. Sometimes even a subtle suggestion by the lawyer can influence the witness to testify in a way he or she might not have done. This probably occurred in *Anatomy of a Murder*. Did Concannon cross this line in *The Verdict* with Dr. Towler?

4.08.2 Ambulance chasing

Galvin tries to hustle business by handing out his business cards at the funerals of strangers. When doing so, he falsely states that he knew the deceased. This form of business-getting is improper.

The legal and ethical rules relating to attorney advertising have changed radically over the last thirty years. Historically, any form of advertising was forbidden. However, in *Bates v. State Bar of Arizona* (1977), a 5 to 4 majority of the U.S. Supreme Court held that a blanket prohibition on truthful advertising violated the free-speech rights of lawyers. (This is one of many post-1970 decisions protecting "commercial speech" under the First Amendment.) The *Bates* decision touched off the vast amount of attorney advertising we see today on television, radio, yellow pages, bus benches, and so forth.

Under ABA Model Rule 7.1, advertising messages or any other communication designed to get business must be truthful. Such messages cannot contain a misrepresentation of law or fact or create an unjustified expectation about results the lawyer can achieve. Galvin's false statements to grieving relatives that he was acquainted with the deceased violated Rule 7.1.

The First Amendment's protection for truthful attorney advertising does not extend to "ambulance chasing." This term refers to signing up clients (usually victims of an accident) by directly soliciting the victims or their surviving relatives. In *Ohralik v. State Bar of Ohio* (1978), the Supreme Court held that a lawyer could be disciplined for directly approaching accident victims and their parents in the hospital.

A direct pitch to victims, as in *Ohralik,* is completely different from anonymous newspaper or television ads. The direct pitch involves the application of pressure by sophisticated attorneys or their employees—"sign here now!"—on unsophisticated victims and demands an immediate response. Movies such as *The Rainmaker* and *The Sweet Hereafter* (both 1997) contain vivid images of direct pitches to injured or grieving victims. Thus, business solicitation through truthful newspaper or TV ads is permitted, but face-to-face pitches to strangers are not.

ABA Model Rules and ambulance chasing. Model Rule 7.3(a) generalizes the *Ohralik* ruling: "A lawyer shall not by in-person or live telephone contact solicit professional employment from a prospective client with whom the lawyer has no family

or prior professional relationship when a significant motive for the lawyer's doing so is the lawyer's pecuniary gain." (ABA 2003) This rule certainly covers Galvin's activity in handing out business cards at the funerals of strangers.

Rule 7.2(c) also prohibits the payment of compensation to anyone for recommending the lawyer's services; this rule prohibits payments to nurses, ambulance drivers, bail bondsmen, and the like for referring clients to the attorney. This traditional form of obtaining business remains common practice despite the rule against it.

Today, virtually all attorneys engage in some form of solicitation of business. The competition for desirable clients is fierce. How do you think Concannon's firm solicits business? Could Galvin refine his solicitation methods by sending letters to the surviving relatives of deceased strangers, truthfully advertising his availability to perform whatever legal work the survivors needed?

4.08.3 The settlement offer

Television and the movies give the false impression that most civil and criminal cases are resolved through jury trials. In fact, only a tiny percentage of all legal cases (civil or criminal) ever go to trial. The lawyers always try to settle cases before, or even during, trial and are often forcefully urged to do so by judges (as occurs in a famous scene in *The Verdict*).

Galvin committed a breach of legal ethics by failing to stay in touch with the Doneghys and by failing to communicate the settlement offer to them. Model Rule 1.4(a) provides: "A lawyer shall keep a client reasonably informed about the status of a matter and promptly comply with reasonable requests for information." The comment to Rule 1.4 states: "A lawyer who receives from opposing counsel an offer of settlement . . . should promptly inform the client of its substance unless prior discussions with the client have left it clear that the proposal will be unacceptable." In addition, Rule 1.2(a) states: "A lawyer shall abide by a client's decision whether to accept an offer of settlement of a matter."

Galvin's ethical problems run deeper than his failure to communicate the settlement offer. He has breached the lawyer's obligation of loyalty to the client. Because he seems so focused on pursuing his own moral redemption by winning rather than settling the Kaye case, he may have forgotten that his ultimate duty is to his clients, not to himself.

4.09 The two hemispheres of law practice[6]

4.09.1 Distinguishing the hemispheres

Sociologists of the legal profession have observed that law practice is divided into two completely different worlds ("hemispheres"). One hemisphere is represented by Galvin,

as well as by Paul Biegler and Atticus Finch (chapters 2 and 3) and Jed Ward's small firm in *Class Action* (chapter 12). Practitioners in this hemisphere make their living by representing individuals or small businesses without much wealth. For example, both Galvin and Jed Ward mostly represent the victims of personal injuries. Lawyers who practice employment law (on the employee's side), family law, immigration, criminal defense, landlord-tenant, or probate, or who represent small business, fall into this category. The other hemisphere is represented by firms like Concannon's or Maggie Ward's in *Class Action*. Generally lawyers in the second hemisphere practice in large to very large firms, although there can be some small firms or even solo practitioners in the second hemisphere. The factor that defines lawyers in the second hemisphere is that they represent wealthy individuals or institutions, including medium to big business as well as governments and large nonprofits such as the Catholic Church in *The Verdict*.

Heinz and Laumann's study of Chicago lawyers (1982) demonstrated that the two hemispheres of law practice are almost completely separated from each other. The members of each hemisphere belong to their own professional associations, and they seldom mingle socially with lawyers from the other hemisphere. The lawyers who practice in the first group went to non-prestigious law schools, whereas the lawyers who practice in the second group mostly attended the top-ten or top-twenty law schools.

4.09.2 Ethical issues in the two hemispheres

The ethical and moral issues suggested by *The Verdict* can be related to the two hemispheres of law practice. Lawyers in group one tend to get into different kinds of trouble from lawyers in group two. Galvin engages in unethical ambulance chasing; Concannon would not be caught dead chasing ambulances, but he'll be hustling clients in other, more sophisticated ways. Alcoholism and other substance abuse (particularly cocaine) are common in both hemispheres, but there is a major difference. Galvin can turn for help only to his old friend Mickey. He practices law while drunk, greatly harming his unfortunate and helpless clients. In a big firm like Concannon's, steps will be taken to prevent alcoholic or drug abusing lawyers from harming clients, out of concern for malpractice liability if nothing else. Thus, big firm substance-abusing lawyers will be quietly placed in rehab or fired. Their ability to harm clients will be contained.

4.09.3 Contingent fees and hourly billing

In personal injury cases like the Kaye matter, Galvin will receive a contingent fee (meaning he gets a percentage, perhaps one-third or more, of any money Kaye recovers). In other words, Galvin gets a financial windfall if he wins or settles the case, but he will earn nothing if he takes it to trial and loses. That's why it is startling when he

turns down the $210,000 settlement offer which would have yielded a $70,000 fee (given the customary 1/3 arrangement). If Galvin takes the case to trial and loses (and the Kaye case was anything but a sure winner), he would get nothing, would waste the time he worked on the case, and would have to eat any amounts he has paid out in costs (for example, to hire expert witnesses).

Lawyers in the second group seldom work for contingent fees. Concannon's firm charges by the hour; they get paid whether they win or lose. Obviously, however, if they lose a case they should have won or are caught overcharging the client, the client is likely to take future business to competing firms.

This "hemispheric" difference between Galvin and Concannon has great significance. Galvin does nothing to prepare for the upcoming Kaye trial, such as taking depositions of the various witnesses. Although this is partly attributable to his alcoholism, he also needs to be very careful in spending time or money since it is his own time and money that he's spending. His mentor Mickey hoped he would settle the case for some paltry sum without doing any work on it.

In Concannon's firm, however, the incentives are radically different. The firm is paid by the hour by its wealthy and well-connected client. Consequently, it has an incentive to maximize the time it spends on the case. Note the scene in which Concannon prepares Dr. Towler to testify in front of a huge number of associates. There is no need to have any of them present; this is just a gimmick to run up the hours that can be billed to the case.

The professionalism and business models of law practice. In ¶13.05.03, we discuss the professionalism model and the business model of law practice. Briefly, the professionalism model stresses the lawyer's duty to the client and the justice system. The business model treats law as just another profit-making business in which lawyers do anything legally and ethically possible to maximize profit. The business model is in the ascent and the professionalism model is in decline. This is true for lawyers in both hemispheres. Note the wonderful scene in which Concannon is talking to Laura Fischer and slips her a check for her "services" in spying on Galvin. He speaks reverently about his mentor, who once told him that he wasn't paid to do his best; he was paid to win. Winning pays for the firm's beautiful offices, the lawyers' fine clothes and whiskey, their pro bono cases. As we see in the film, Concannon's firm uses its superior resources and total lack of ethics to play every dirty trick in the book in order to win. This is a caricature of the business model, but a very effective one.

4.10 Review questions

1. Choose a movie you have seen (other than *The Verdict*) and explain in what respects the film fits or does not fit the "classical Hollywood style."

2. Assume *The Verdict* is your only source of information about what lawyers are like. Therefore, the only lawyers you know anything about are Frank Galvin, Ed Concannon, Laura Fischer, or Judge Hoyle. A friend has told you that lawyers are scum. What is your response?

3. ¶4.05 gives polling data that indicate a sharp decline in the public's perception of lawyers since around 1980. What do you believe are the most important reasons for this phenomenon? Try asking your friends and family what they think has caused the decline.

4. The article discussed in ¶4.06 classified film lawyers as "good" if the author wanted that person both as his friend and as his lawyer, but as "bad" if he didn't want the person either as friend or lawyer. Then he counted up the good and bad lawyers in each decade. Do you agree with this methodology? Using this methodology, how do you classify the lawyers in any movie or TV show you have seen that has significant lawyer characters?

5. "The portrayal of lawyers on television is much more favorable than in the movies." ¶4.07.5. Do you agree or disagree? Why? Give examples.

6. "A particular movie can offer a far more vivid exposure—a much greater emotional impact—than does a TV show." ¶4.07.5. What are the differences between movies and television (and the experience of watching them) that might account for the greater emotional impact of a movie?

7. The "uses and gratification" or "active audience" models are discussed in ¶4.07.6. Please give an example of a movie or TV show in which you rejected the message embedded in the narrative and created your own interpretation.

8. How does your viewing experience in watching TV shows such as *Buffy the Vampire Slayer*, *The X-Files*, *Star Trek*, *Enterprise*, or *Xena: Warrior Princess* differ from your viewing experience when watching shows like *Law & Order*, *The West Wing*, or *The Practice*? How does it differ when you watch a soap opera? Is your experience in watching any of these shows better described by "cultivation theory" or by "uses and gratification" theory?

9. "Galvin and Concannon do some very bad things." ¶4.08. How many can you list?

10. Why would a plaintiff's lawyer like Galvin put as little time and money into a case as possible while a defense lawyer like Concannon would put as much time and money into the case as possible?

CHAPTER 5

The Life of Lawyers
Assigned film: Counsellor at Law (1933)

5.01 Filmic analysis of Counsellor at Law

5.01.1 William Wyler[1]

The director of such classics as *The Letter* (1940), *The Little Foxes* (1941), *The Best Years of Our Lives* (1946), and *Ben-Hur* (1959), William Wyler (1902–81) is one of the most acclaimed directors in film history. Over the course of his 45-year career, Wyler was nominated for best director twelve times and won three times.

Wyler was born in the Alsace-Lorraine region of Germany. Carl Laemmle, the president and founder of Universal Pictures, was a cousin of Wyler's mother. In 1920, Wyler's mother arranged with Laemmle to have Wyler shipped off to America to work for Universal. Wyler started out in the mailroom but worked his way up to the rank of director by 1925.

After cutting his teeth on short westerns, Wyler graduated to feature-length films in 1928. *Counsellor at Law* was the most prestigious project of Wyler's career up to that time, and his success in adapting the play elevated him to the top ranks of Universal's directors. Wyler, however, was growing restless with Universal's relatively low budgets, and he left the studio after two more pictures.

Wyler's directorial career entered a new phase when he signed with Samuel Goldwyn in 1935. Goldwyn was one of the leading independent producers of the time. Known for his lavish production values, Goldwyn gave Wyler the opportunity to direct films with budgets far in excess of those he directed at thrifty Universal. During his years with Goldwyn, Wyler established his reputation as a director of literary and theatrical adaptations, including such acclaimed literary and dramatic works as *These*

Three (1936) (an adaptation of *The Children's Hour*), *Dodsworth* (1936), *Dead End* (1937), and *Wuthering Heights* (1939).

Wyler first worked with cinematographer Greg Toland on the production of *These Three*. This marked the beginning of one of the most productive director-cinematographer collaborations in the history of American film. Toland, who would later photograph *Citizen Kane,* introduced Wyler to deep-focus photography. As discussed in ¶2.02.4, deep-focus cinematography is a way of photographing a scene so that objects and people within the frame that are far from one another remain in sharp focus. This allows a director to shoot a scene in a single take instead of cutting back and forth between the various characters. Wyler and Toland brought this technique to perfection in such masterpieces as *The Letter* (1940), *The Little Foxes* (1941), and *The Best Years of Our Lives* (1946).

French film critic Andre Bazin regarded Wyler as one of the great realists of American movies. Instead of predigesting the scene for the viewer by chopping it up into a series of close-ups and medium shots that spell out the exact meaning of every facial expression and hand gesture, Wyler's use of deep-focus cinematography allowed the spectator to "edit" the scene for herself. If she wanted to look at a minor character in the background instead of the star in the foreground, she could. Bazin believed that this allowed the spectator to take a more active role in the production of the film's meaning.

Counsellor at Law is a relatively early film in Wyler's career. He had not yet signed with Goldwyn or begun collaborating with Toland. Not surprisingly, the film does not display the sort of deep-focus cinematography for which Wyler would later become famous. Nonetheless, it is strikingly directed and well worth a closer examination.

5.01.2 Composition in Counsellor at Law

In *Counsellor at Law,* Wyler arrays his actors so as to create multiple planes of action (meaning that several different things are happening simultaneously within the frame). He sometimes uses this technique to suggest bustle and activity. At other times, he uses it to imply the interpersonal dynamics between characters.

A striking example of the use of multiple planes of action to create the impression of bustle occurs early in the film when Mr. Moretti arrives. The camera is facing Bessie, the telephone operator, when Moretti enters the frame from the left. A conversation between Bessie and Moretti ensues. Moretti is in the center of the frame, Bessie on the left. As Moretti and Bessie converse, Henry crosses the frame behind them. On the right in the background is a woman sitting on a sofa. She plays no role in the shot. Her presence serves merely to fill screen space; Wyler is making it seem as if there is something happening in all corners of the frame.

When Moretti finishes talking with Bessie, he begins walking to his right and the camera pans with him. A previously unseen man on the right side of the frame gets up

to greet Moretti. As they converse in Italian in the center of the frame, someone exits Tedesco's office, which is visible behind Moretti and the other man. Henry can be seen on the right side of the frame sorting the mail, though he plays no narrative role in the shot. Rather, Wyler uses these characters to suggest how busy and crammed with people the office is.

Multiple planes of action—The Becker meeting. A memorable example of multiple planes of action to suggest the interpersonal dynamics between characters occurs when Becker, the communist, meets Simon in his office. In one particularly striking composition, Becker's profile dominates the left side of the frame in the foreground while Simon occupies the center of the frame and Joe, the shoeshine man, is barely visible on the bottom of the far right side of the frame. In this one image, Wyler nicely conveys the interpersonal dynamics of the scene. Because Simon is having his shoes shined, he is turned away from Becker. While he occasionally turns around to talk to Becker, Simon betrays his lack of interest in Becker's case by facing away. Moreover, although Simon is ostensibly the person of power in the scene, it is Becker who dominates it visually. Because he is placed in the foreground and on the left side of the frame, our eyes are constantly drawn back to his haunting countenance. By composing the shot in this way, Wyler is able to convey on a visual level the moral force of Becker's convictions and how heavily his words weigh on Simon.

5.02 Elmer Rice²

Elmer Rice wrote the stage play *Counsellor-at-Law* (1931) and adapted the play into the 1933 film. Rice (1892–1967) was a prominent, successful, and innovative Jewish-American dramatist who worked during the first third of the twentieth century. Born Elmer Reitzenstein, he grew up in poverty in New York, dropped out of high school, than took evening courses at New York Law School from which he graduated in 1912. He clerked in a Manhattan law office while writing his first play, *On Trial* (1914), which introduced flashbacks to the theater and was a sensational success. This accomplishment enabled Rice to quit his $15 per week job and devote the rest of his working life to the theater. *On Trial* was adapted into one of the first sound films in 1928 and was remade in 1939.

Rice was a very inventive dramatist. In *Street Scene* (1929), he recreated the life of a tenement neighborhood, representing its multicultural population with 75 characters. After the complex play was abandoned by its director, Rice directed it himself, and the play won the Pulitzer Prize in 1929. In collaboration with Kurt Weill, Rice adapted *Street Scene* into an opera in 1947. It was made into an excellent 1931 movie directed by King Vidor.

Rice and censorship. A lifelong liberal and champion of the working man, Elmer Rice (along with Clifford Odets, S. N. Behrman, and Lillian Hellman) spoke out about the rise of fascism and wrote several plays focusing on the Nazis and anti-Semitism. He worked as a regional director of the Federal Theater Project which employed thousands of theater professionals during the Depression, but resigned in protest over government censorship. The film *Cradle Will Rock* (1999) depicts the struggle between theater professionals and political censorship in the Federal Theater Project. In 1951, Rice withdrew *Counsellor-at-Law* from a television production as a protest because John Garfield, who was to play the title role, had been blacklisted and the network insisted on replacing him with another actor.

The play *Counsellor-at-Law* (the hyphens were dropped in the movie version) opened in November 1931 with Paul Muni in the role of Simon and was critically and financially successful. It ran for 396 performances on Broadway and sold out a national tour. Muni turned down the role of Simon in the film (he was trying to get away from Jewish roles) so the definitely non-Jewish John Barrymore got the part.

5.03 Lawyer movies of the early 1930s

During the silent film era, there were relatively few lawyer or courtroom movies (it is hard to imagine lawyers being silent). With the arrival of sound in the late 1920s, however, there was a great outpouring of movies in which law and lawyers played prominent parts. Indeed, Nevins (2004) dubs the era of 1928 to 1934 as the "first golden age of juriscinema." The first golden age ended in 1934 with the adoption of the Production Code (see ¶¶2.04, 13.03.2, 14.05, 14.06), which required filmmakers to sanitize stories concerning sex and crime. The Code required that films respect, rather than mock, law enforcement personnel such as police and judges. The result was that few powerful lawyer films were made until the late 1950s, by which time the Code was beginning to fizzle out.

Nevins's article breaks down lawyer movies in the early 1930s into two large categories: First, so-called "women's movies," whose plot revolves around women. These films tended to be slow and emotional and have often been derided as tearjerkers. They usually featured good lawyers, all of whom were men. Second, "men's movies" featuring stories that focus on men. These films tended to be fast-paced, full of action, unemotional, and cynical about law and lawyers as well as legal and governmental institutions.

A number of the films in the men's movie category were based on the career of William J. Fallon, a notorious New York lawyer who specialized in representing mobsters and other rich clients. Fallon was a master at manipulating juries and would stop at

nothing to win his cases. He employed many famous courtroom tricks and was not above bribing jurors. Some of the films inspired by Fallon's career are *States Attorney, The Mouthpiece, Lawyer Man,* and *Attorney for the Defense,* all released in 1932. Each of these enjoyable films involves tricky, sleazy, shyster lawyers.

Nevins singles out *Counsellor at Law* for extended discussion, much of which forms the basis for this section of the book. Nevins describes it as by far the best lawyer movie of the period. Clearly the film falls into Nevins's second category—it's a man's picture as Nevins defines that category—but the personal and professional characterization of George Simon has far more nuance than any of the other lawyer films he discusses. The film is also free of the gimmicky courtroom sequences typical of other lawyer-oriented men's movies of the period.

5.04 Life of lawyers

Counsellor at Law is unique in the entire history of motion pictures in its grimly realistic depiction of the daily life of the practicing lawyer.

5.04.1 A lawyer's day

George Simon is a gifted trial lawyer. At the beginning of the film we see him basking in the glory of winning an acquittal for the most grateful Zedorah Chapman who was almost certainly guilty of murdering her husband. Here is Simon, the master manipulator of juries in the William J. Fallon tradition. However, we never actually see him in court—indeed we never see him out of his office.

Consider the huge variety of legal matters we observe Simon working on in the course of his day. Aside from his own legal and personal problems (which become the focus of the movie), Simon makes a phone call trying to settle the Lillian LaRue breach of promise suit against the Schuyler family (this is an action based on breach of contract to marry, a legal claim that has been abolished in most states for reasons that are pretty obvious from the scene in the film). There is the Crayfield will contest, which he abandons out of deference to his wife's wishes. He bails Becker out of jail and negotiates a plea bargain for him that Becker rejects. He lobbies a U.S. senator concerning legislation that affects a business client. He wraps up negotiations in the Richter divorce case. He urges the local political party hack to appoint his partner Tedesco to the bench. Finally, at the end of the film, he gleefully gets involved in another high-profile murder case.

Simon's day consists of juggling phone calls and numerous client and personal matters. The waiting room is full of people who need to see him. He has a law firm to manage and plenty of personal problems of his own to deal with. He is often doing several things at once. That is exactly the way most lawyers spend their day. Very few

lawyers actually go to court (only prosecutors and public defenders spend most of their days physically trying cases in court). Almost all lawyers spend their days in the office, solving problems for clients, writing or reviewing documents, doing research, and settling or trying to settle cases rather than taking them to court (as Simon does for LaRue, Richter, and Becker). Some of their work, such as lobbying public officials on behalf of clients, does not involve legal disputes at all.

Watching this film, we cannot avoid concluding that a lawyer's work is hectic and sometimes extremely stressful. Indeed, most lawyers say that today the practice of law is even more stressful than in prior years because of advancing technology: fax, e-mail, pagers, cell phones, and other methods of instant communication now place them at the mercy of their clients. They must give immediate attention to the client's needs and wishes. In the old days, lawyers communicated mostly by sending letters, and there was more time to think about problems and to manage conflicting time commitments.

Sometimes a lawyer's work is personally distasteful because the clients are themselves sleazy, dishonest people or because the lawyer must try to secure a result that seems unjust or wrong. The lawyer must be harsh, sometimes cruel, toward opponents and people with whom he negotiates, even if he is by nature a kind and considerate person. On this point Simon has a revealing exchange with his wife when she tries to persuade him to give up the Crayfield will contest. Cora says that she does not see "why it isn't possible to practice law like a gentleman." Simon responds that "I never laid any claims to being a gentleman." Obviously, Simon despises Lillian LaRue and Zedorah Chapman and disagrees profoundly with Becker's politics. He is perfectly prepared to fight the Crayfield case, even though it will offend Cora's friends. Lawyers do not have the luxury of being generous to opponents, or acting like "gentlemen," or representing only clients they like or of only seeking outcomes that they believe are just and fair.

5.04.2 Lawyers and money

Lawyers must think about money all the time—and not just their client's money, but their own. A law firm is a business, above all else, and it must generate revenues to pay the heavy expense of compensating the staff and, of course, the lawyers themselves (obviously Simon is paying himself very well). The gorgeous office suite and the huge library are all very costly to maintain. This inconvenient detail is omitted from almost all movies about lawyers. However, *Counsellor at Law* emphasizes that law is a business and it often shows Simon sending bills and collecting fees. He occasionally works pro bono (meaning for free), as he did for Becker, but everyone else pays the freight. At first, he tells Rexie to send Mrs. Richter a bill for $5,000 while she is still grateful for his work; later he boosts the fee to $7,500 to compensate for a worthless loan to the deadbeat Darwin (discussed below); and he is extremely reluctant to give up the Crayfield matter which will yield a $100,000 fee.

Today, if anything, lawyers concentrate even more intently on the business end of their practice (see ¶13.04.3 for discussion of the business and professional models of law practice). Modern-day lawyers, on average, make much more money (even adjusting for inflation) than they did in the 1930s and later years, and they must work very hard to earn the big fees that add up to their high incomes. One major difference is time sheets. Simon seemed able to set his fees more or less arbitrarily, but today a lawyer must document and charge for every working minute, including the huge number of phone calls typically fielded every day. If time is used for personal matters—a personal phone call or errand, even a trip to the bathroom—it is not supposed to be charged to clients. Most lawyer's fees are based on the number of billable hours they spend on a matter; many clients scrutinize their bills and require the lawyers to justify every meeting or other use of time. Lawyers often feel enslaved by the endless need to keep track of their time and to justify every dollar of their fees.

Many lawyers say that *To Kill a Mockingbird* inspired them to become lawyers. What effect did *Counsellor at Law* have on you? Did it make you want to be a lawyer, or did it make you want to do just about anything else but?

5.04.3 Simon and Tedesco

This law firm has two partners and numerous employees:

- Weinberg is an associate lawyer (meaning a paid employee, not a partner like Tedesco). Note that Weinberg is engaging in what we would today describe as sexual harassment of Rexie.
- secretaries (like Goldie who may also be the office manager).
- paralegals (Rexie seems to do work well beyond a secretary's competence).
- Bessie, the unforgettable receptionist and switchboard operator (the stage play makes clear that Bessie is pregnant, which explains her tummy problems).
- A variety of other clerical employees, messengers, and investigators like Charley McFaddin (even a shoe shine boy).

Thus, a small two- or three-lawyer firm is a good-sized business enterprise and, as pointed out above, meeting the payroll requires that the lawyers generate a constant cash flow from client fees.

In the past the vast majority of lawyers tended to practice alone or in small firms like Simon & Tedesco. Here the lawyers know each other well and tend to have long term business and social relationships with each other and with their staff. However, things are very different today. A much smaller percentage of the total bar practices alone or in extremely small firms, although there are still plenty of solos and small firms left. Many lawyers in private practice work in much larger firms and an increasing number work in mega-firms with hundreds or even thousands of lawyers. We discuss law firms in ¶13.04.

In the 1930s, most lawyers were generalists like Simon who seemed prepared to practice every kind of law. Today, most lawyers specialize in only one area of law (although there are plenty of solos like Simon left, especially in smaller towns, who are prepared to help every client who walks through the door).

5.05 The character of George Simon

Simon is beautifully and painstakingly developed as a lawyer and as a human being. There is no better defined lawyer character in the entire history of the movies. (Recall ¶4.06 which establishes criteria for distinguishing "good" from "bad" lawyers by asking whether you would want the lawyer character as a friend and as your lawyer.)

5.05.1 Simon as a lawyer

What do we learn about Simon as a lawyer? He is very hard working (his mother and his wife commiserate about how hard he works). Apparently, he seldom goes home to see his wife and stepchildren. Today we would call him a workaholic (plenty of lawyers are). Simon is firmly loyal to his clients (too loyal in the Breitstein matter). He is skillful in handling the clients and getting them to trust him (an absolutely necessary skill for a lawyer); recall his question to Mrs. Richter about the baby's cough. Although sometimes gruff, he cares deeply about his colleagues in the law firm—recall how he tells Bessie to go home when she doesn't feel well and how he tries to get Tedesco a judicial appointment and Weinberg a job as a judicial clerk.

Simon is an extremely skillful lawyer, as we learn from the Zedorah Chapman matter. He is well connected in the New York and national legal and political establishment. He is pretty ethical most of the time. For example, he turns down an attractive piece of business representing a creditor in a bankruptcy because his partner is the receiver—a serious conflict of interest. However, he certainly does not act ethically all the time, as discussed below. Simon thus exemplifies all aspects of what our society likes—and hates—about lawyers. He is caring, compassionate, loyal, and skillful. Yet he is also tricky, manipulative, greedy, and sometimes dishonest.

Beyond all this, Simon is a lawyer to the very bone. When he contemplates his possible disbarment, in conversation with Tedesco, Simon thinks for a moment that he will just retire and play golf—but only for a moment. He soon tells Tedesco: "I'd go nuts in six months. How am I going to spend the rest of my life? I'm no golf player, and I don't know an ace from a king. I don't even know how to get drunk. All I know is work. Take work away from me and what am I? . . . a living corpse." These few sentences say it all, and Simon's insight about himself would be equally valid for a lot of lawyers. They have no life outside the office. If you told them to "get a life," they wouldn't know what you meant.

As a human being, Simon is much less successful than he is as a lawyer. He is extremely loyal to his old friends from the East Side (like Mrs. Becker) and he adores his mother, although he is thoroughly fed up with his nogoodnick brother. Even so, he seems to lack normal human perception and emotions. He is completely oblivious to the fact that his assistant, Rexie, is madly in love with him. He is a fool in love with Cora, even though she seems to despise him, and her ultra-obnoxious snotty children despise him even more. When he finally catches on to her affair with Darwin, his reaction is extremely immature: He is about to throw himself out the window. Rexie saves him, and Simon is brought back to life by an exciting new client matter, which reveals a lot about the imbalance in his life between the personal and the professional.

5.06 Religion, ethnicity, and class in Counsellor at Law

The film is loaded with references to conflicts arising out of religion, ethnicity, and class. For this reason, the film would have been significantly altered if it had been made after the Production Code Administration came into force in 1934 and regulated the content of all American films. (See ¶5.03 as well as ¶¶2.04, 13.03, and 14.05–06.)

Simon is clearly Jewish, even though played by a non-Jewish actor, and even though the film never explicitly says so. His mother is a stereotyped yiddische momma, and he occasionally drops Yiddish words (such as "gonif" meaning thief). The stage play is more explicit about Simon's religion. Weinberg's ethnicity is more obvious than Simon's.

Hollywood moguls, who were mostly Jewish, tried to avoid the subject of anti-Semitism in the movies, partly to avoid drawing attention to themselves and partly because they wanted to avoid alienating a predominantly non-Jewish audience (Gabler 1989). In addition, Germany was a prime export market for American films; according to Neal Gabler, by the mid-1930s, the German censors would not allow distribution of a film favorable to Jews. This reluctance to confront Jewish themes continued even into the post–World War II period. Samberg (2000) claims that the various Jewish film executives tried to dissuade the non-Jewish Darryl Zanuck from making *Gentleman's Agreement* (1947) (the all-time leading film on anti-Semitism) because it would "rock the boat." Thus, it is hardly surprising that the film only suggests Simon's Judaism but never makes it explicit.

Simon clawed his way upward from the very dregs of society. He came from the old country in steerage (the packed below-decks section of a ship) and grew up on the lower east side of New York. Now he has achieved great success and even a tentative

entry into upper class society. Simon is neither the first nor the last person for whom the law has served as a vehicle of upward mobility. Nevertheless, Simon remains an outsider to the Wall Street legal establishment, which is controlled by people like Baird. Even though married to the socially prominent Cora, Simon remains a social interloper, and the power structure is delighted to seize on the Breitstein case in order to get rid of the upstart Jew.

Indeed, in the 1930s, and for many years thereafter, anti-Semitism was taken for granted in the world of legal education and law practice and in society generally. In the play, for example, Lillian LaRue complains that Schuyler's lawyer is trying to "Jew me down a few thousand dollars after all the pearls and Rolls-Royces he was goin' to buy me." Law schools had Jewish quotas. Jewish lawyers were respected for their skills and tolerated in areas like personal injury practice but were never hired by big city firms (on Wall St. or elsewhere) or by wealthy business clients. (See also the discussion of Jewish lawyers in popular culture in ¶5.07.)

The film is full of references to ethnic conflict. In addition to Jews, we see people from numerous immigrant groups—Irish, Italians, and Germans—all of them unified in despising WASPy people like Baird (the ill-feeling was, of course, entirely mutual). As Malone says, "Those guys who came over on the Mayflower don't like to see the boys from Second Avenue sitting in the high places."

5.06.2 The Depression

The film is set in 1931, the very darkest days of the Great Depression which began with the stock market crash in October 1929, and continued all through the 1930s until the American entry into World War II at the end of 1941. Today, we can hardly imagine the absolute chaos and desperation of this period. Unemployment reached about 25%, and businesses and banks failed by the thousands. The stock market plummeted by over 90% from its peak. Prices and wages fell steadily (we refer to this today as "deflation"). Millions of people lost their homes, their farms, everything they owned. Hunger and misery stalked the land.

The Depression was a time of intense economic and political conflict. Many desperate people turned to communism and preached revolution. Others turned to fascism and embraced the philosophy of Mussolini, which seemed to be working in Italy. America did neither; instead, it elected Franklin D. Roosevelt during the dark days of 1932. Roosevelt's New Deal involved new systems of government regulation of the economy and help for the neediest. It seemed to offer a way out of the misery without embracing some totalitarian ideology.

NIRA. Note the "blue eagle" sign that pops up before the titles of *Counsellor at Law*. It denotes that the filmmakers were complying with the Code set out for the movie industry under the National Industrial Recovery Act (NIRA). NIRA was an

early New Deal measure that provided authority for government officials to reorganize the entire economy. Under NIRA, committees of business and labor for each industry were empowered to adopt Codes that set wages and prices for that industry as well as all manner of other rules. NIRA was far too ambitious and quickly dissolved into chaos. It was invalidated by the Supreme Court (*Schechter Poultry Co. v. United States* 1935). *Schechter Poultry* is often referred to as the "sick chicken" case because the rule in question required retail poultry sellers to take every chicken offered to them by wholesalers even if they were sick.

Amidst this period of economic catastrophe, some people did well, the law firm of Simon & Tedesco among them. The firm appears to be prosperous and earning high returns for its partners. However, now and then we glimpse the desperation in the world outside the posh law office. Bessie is distraught because she has seen someone leap from an office window. Indeed, there were countless suicides during the Depression; many people simply couldn't cope with the economic disaster that engulfed them and their families. Often these suicides were people who had been rich and prosperous—and were then wiped out in a flash. Darwin hits up Simon for a $2,000 "loan" because a company whose stock he owned omitted its dividend. Thus, even members of the idle rich were feeling the pain. Simon's brother is so desperate that his mother has to beg Simon for a handout.

5.06.3 Class

Class struggle is also a major theme in the film, as it was in many films of the early Depression years, particularly before the Production Code became enforceable in 1934 and muted political controversy in the movies. Among many such memorable films is *Employees' Entrance* (1933), involving the brutal management of an exclusive department store and the helpless women who worked as shop girls and were subject to exploitation and sexual harassment. In the memorable *Wild Boys of the Road* (1933), four boys hit the road looking for work and encounter every manner of brutality and repression from the ruling classes and the police.[3]

Class struggle is a major element of *Counsellor at Law*. George Simon is the epitome of American class mobility; he has risen from the lowest classes of society to the highest. His mother, who remains firmly moored in the lower class, is forced to beg him for a few dollars to support his wretched brother, who reminds Simon of everything about the lower classes and the struggle for survival he has tried to leave behind.

Simon and Becker. The brilliant scene between Simon and Harry Becker dramatizes the intense class conflicts that dominate the film. Simon is having his shoes shined when Becker comes into the office, his head bandaged from blows struck by the cops during a demonstration. Becker, a rabble-rousing communist, scorns Simon's

help, saying "I'm on one side of the class war and you're on the other." When Simon debunks Becker's "half-baked communist bull," and reminds Becker of how he (Simon) has risen from the gutter, Becker replies: "How did you get where you are? I'll tell you! By betraying your own class, that's how! Getting in right with bourgeois politicians and crooked corporations that feed on the blood and the sweat of the workers . . . You're a renegade and a cheap prostitute, that's what you are! You and your cars and your country estate and your kept parasite of a wife . . . and her two pampered brats! Comrade Simon of the working classes, who's rolling in wealth and luxury while millions of his brothers starve. You dirty traitor, you." (He spits on Simon's desk and walks out.)

5.07 Jewish lawyers in popular culture [4]

George Simon is one of many Jewish lawyers in popular culture. These representations demonstrate persistent stereotypes. The stereotype of the Jew (and Jewish lawyer) as both more clever and more greedy than other men dates back to Joseph in Genesis. Joseph advised Pharaoh that there would be seven years of plenty followed by seven years of famine. As a result, Pharaoh imposed food rationing during the years of plenty and blamed it on Joseph. This ultimately led to the enslavement of the Jews.

In England, France, and Germany, Jews were allowed to work as moneylenders (because the restrictions on usury prevented Christians from doing this work) but were barred from carrying on other careers. They were both respected and despised. In popular culture, Sir Walter Scott's *Ivanhoe* is a gripping critique of medieval anti-Semitism; two key characters are a Jewish moneylender and his daughter. Shakespeare's *Merchant of Venice* focuses on Shylock, a clever but vengeful and greedy moneylender.

George Simon exemplifies the stereotype of Jews in general and Jewish lawyers in particular. This stereotype is double-sided. The positive side is that the Jews and Jewish lawyers are well educated, crafty, clever, and loyal. The negative side is that they are greedy and exploitative. As in Joseph's case (and Simon's as well), the positive side of this stereotype is dangerous to the Jews; it breeds resentment and anti-Semitism. A famous episode of Norman Lear's *All in the Family* (Jan. 26, 1971) pushed this stereotype to the limit (as the show did with every taboo and stereotype). Archie Bunker, an unabashed bigot and anti-Semite, is injured in a car accident with a Jewish woman and insists on hiring a Jewish lawyer since they are smarter than gentile lawyers. He calls the firm of Rabinowitz, Rabinowitz, and Rabinowitz, but when they send him a waspy lawyer (Whitney Fitzroy IV), he throws the guy out and demands a real Jewish lawyer. When Sol Rabinowitz finally arrives, he is an older man with a classic Jewish face and glasses. Bunker, who detests Jews and all other minorities, fawns over his Jewish lawyer.

Tony Soprano, star of *The Sopranos,* also has a Jewish lawyer, Neil Mink, who is a trusted adviser who will keep Tony's secrets. Mink can also be relied on to hold a bagful of cash and dispense it to Carmela Soprano if Tony has to disappear for a while. Also important in the series is the character of Hesh, an older Jewish friend and adviser to Tony and his father. Hesh is not a lawyer but a successful and wealthy businessman. The character of Hesh dates all the way back to Joseph—smart, crafty, nonviolent, trustworthy, protected by the power structure, but not actually part of that structure. Stuart Markowitz, the Jewish tax lawyer on *L.A. Law,* fit the stereotype because he was shrewd and good with numbers, but he was less mercenary and more principled than some of the other lawyers at the firm.

5.08 Ethical issues in Counsellor at Law

5.08.1 The stock tip

Simon receives a tip, apparently from someone inside the Supreme Court, that the Court is about to decide a case in a way that will benefit a particular company. He immediately buys shares in that company for himself and Tedesco. His conduct indicates that he is uncomfortable doing this and worried about getting caught. He swears Tedesco to secrecy and he tells his broker to purchase the stock a little at a time (this might also have been intended to avoid driving up the price of the stock). When the news comes out, Simon sells the stock, earning a $40,000 profit for himself and Tedesco.

Price levels. Note the difference in price levels between 1931 and the present. One dollar in 1931 is worth $12.11 in 2003. Thus, the $40,000 profit on the stock tip was about half a million dollars based on today's prices. The $100,000 fee in the Crayfield will case, which Simon turned down because of Cora's objections, was worth about $1.2 million in present day dollars.

Was Simon's action illegal? Present law deals clearly with inside information about stocks that is passed on by a "tipper" (like Simon's source in the Supreme Court) to a "tippee" (like Simon). If the tippee knows or should know that the tipper has breached a legal duty by disclosing the information, the tippee cannot take advantage of the information by buying or selling the stock. In the film, someone at the Supreme Court has breached a legal duty by disclosing the information (Simon would surely know that Supreme Court employees are sworn to secrecy).

If either the tipper or the tippee makes use of the information by dealing in the stock, he violates Rule 10b-5 of the Securities Exchange Commission (SEC). Thus, today Simon's conduct would be clearly illegal. If caught, he would have to give up his

profit, pay heavy penalties, and he could even go to jail. His conduct would probably also be the basis for discipline by the bar association.

However, things were quite different in 1931. The legal and ethical question of whether it was proper to use inside information to make money in the stock market was not settled. In fact, there were no federal securities laws until 1933 and 1934 (Rule 10b-5 is based on a section of the 1934 Act). Even under Rule 10b-5, it was unclear until quite recently whether a tipping situation like the one in the film, which does not involve a tip from a corporate insider, was a violation of the Rule.

Thus, Simon probably did not violate the law or legal ethics by using the tip to make money in 1931. However, there were many corporate scandals in the 1920s involving the use of inside information and millions of people blamed Wall St. excesses for the Great Depression. Thus, the movie reflects popular culture at the time in giving the impression that Simon's conduct was wrong and unethical.

The 1919 Supreme Court scandal. The stock trading episode in *Counsellor at Law* was probably inspired by a real case occurring in 1919. A Supreme Court law clerk named Ashton Fox Embry leaked information about pending Supreme Court decisions to businessmen who profited from the information. Embry was fired from his job at the Court and criminally prosecuted but, for various reasons, was never tried and convicted. Owens (2000) provides a detailed account.

5.08.2 The Richter fee

Simon was planning to bill Mrs. Richter for $5,000 for services rendered in the divorce case (her retainer had been $2,500, but Simon told Rexie to bill $5,000 while she was still grateful for the work). A "retainer," incidentally, is an amount paid in advance by the client. Normally, if the lawyer's work turns out to be worth less than the retainer, the difference will be refunded to the client; if the work is worth more than the retainer, the client will pay the difference.

After shelling out $2000 to Darwin, Simon increases Mrs. Richter's fee to $7,500 (remember, that's about $90,000 in present dollars). As stated above, Simon apparently had no fee arrangement with Mrs. Richter and was accustomed to billing whatever he thought his services were worth (lawyers seldom get away with this today, as discussed in ¶5.04.1).

Was it unethical to increase the fee from $5,000 to $7,500? Under the Canons of Professional Responsibility that were in effect in the 1930s, "Lawyers should avoid charges which overestimate their advice and services, as well as those which undervalue them. A client's ability to pay cannot justify a charge in excess of the value of the services . . . In fixing fees, it should never be forgotten that the profession is a branch of the administration of justice and not a mere money-getting trade" (Canon 12).

Certainly, we suspect that Simon is "overestimating" the value of his services, and charging the high fee because of the client's "ability to pay." After all, the Richter divorce wasn't tried; Simon settled the dispute by negotiating the issues of property division, alimony, and child support with the husband's lawyer. It is hard to imagine how a fee of $90,000 in current dollars could possibly be justified for these services unless Simon did a great deal more work than we know about. However, lawyers often charge affluent clients very high fees in order to be able to provide low cost or even free services for clients who are unable to pay. Thus, what Simon did here is probably not so different from what many attorneys do in setting their fees.

The current rule, Model Rule 1.5, contains no statement equivalent to the last sentence of Canon 12 (in fixing fees, it should not be forgotten "that the profession . . . is not a mere money-getting trade"). Such a statement would probably be viewed as hypocritical in light of the prevalence of the business, profit-seeking model that now animates the profession (see ¶13.04.3).

Present-day Model Rule 1.5 states "A lawyer's fee shall be reasonable" (ABA 2003). It then sets out a series of factors to be used in establishing reasonableness. It also provides: "When the lawyer has not regularly represented the client, the basis or rate of the fee shall be communicated to the client, preferably in writing, before or within a reasonable time after commencing the representation." This latter provision is extremely important in avoiding fee disputes. Lawyers and clients must discuss the fee in advance of doing the work. Had Simon and Mrs. Richter agreed in advance on the amount of the fee, Simon could not have arbitrarily boosted the amount. In some states (including California), a lawyer cannot collect the agreed-upon fee unless the fee agreement is reduced to writing and signed by both parties. (If there is no signed agreement, the lawyer is entitled to receive the value of his services, which might be found to be much less than the agreed-on fee.)

5.08.3 Perjury in the Breitstein case

In the Breitstein criminal case, Simon introduced evidence of a phony alibi for Breitstein (who otherwise faced a very long prison sentence because he had four prior convictions). Breitstein claimed he was at Cushman's home, but this was untrue (Cushman was in the hospital that day). Apparently Simon was well aware that the alibi was false. Putting on testimony that the lawyer knows is false is an extremely serious ethical violation and would indeed justify severe sanctions by the bar—possibly even disbarment. Loyalty to the client is no excuse for deceiving the court.

Present Model Rule 3.3(a)(4) is quite clear on this point: "A lawyer shall not knowingly . . . offer evidence that the lawyer knows to be false." Normally, when a lawyer knows that the client intends to commit perjury, the lawyer must try to persuade the client not to do it and, if this is unsuccessful, must withdraw from the representation.

The defendant who insists on committing perjury. If withdrawal is not possible (because the case is too far along), and the client insists on giving perjured testimony, a criminal defense lawyer is presented with a difficult, perhaps impossible dilemma. Most lawyers believe that a criminal defense lawyer is not required (or even entitled) to disclose the perjury to the court. The lawyer may allow the client to testify falsely without asking the client questions. The client simply tells the story in narrative form without guidance from the lawyer's questioning. (This is a clear tip-off to the court that the attorney knows the narrative is false.) The lawyer is then forbidden to rely on that false narrative testimony in closing argument. In a civil case, the lawyer must disclose the perjury to the court (see Comments 4 to 10 to Model Rule 3.3).

In trying to block the bar association from disbarring him, Simon resorts to even more unethical, probably criminal behavior. He threatens the stuffed shirt Baird with disclosure of the fact that Baird has a hidden wife (apparently bigamous) and secret family in Philadelphia. This threat would be considered criminal extortion in most states. Extortion means obtaining property or obtaining the official act of a public officer (such as Baird who is representing the bar association), induced by a wrongful use of force or fear. Fear, for this purpose, involves a threat to "expose any secret" affecting the recipient. Commission of a serious crime such as extortion would itself be the basis for severe discipline, up to and including disbarment.

5.09 Review questions

1. In ¶4.06, the text suggests distinguishing "good" from "bad" lawyers by asking whether we would want a lawyer character as our friend and as our lawyer. Would you want George Simon as your friend? As your lawyer? Explain.
2. *Counsellor at Law* is so full of character and plot, and so skillfully directed and edited, that it is packed with interesting signifiers (see ¶1.05.2). Identify a signifier in the dialogue, art design, costumes, or events of the film. Explain your interpretation of the signifier.
3. Does the movie make you want to become a lawyer, or does it make you want to avoid the profession at all costs? Explain.
4. Director William Wyler frequently uses multiple planes of action in this film. Describe one of these scenes (other than those discussed in ¶5.01.2) and explain the function of the multiple plane of action in the particular shot.
5. Note the large number of personal relationships described in *Counsellor at Law*. Simon has relationships with his wife and her children and her friends, with his mother and brother, with lawyers and staff members at Simon & Tedesco, with

numerous present and former clients, and with lawyers outside the firm. Which relationship did you find most interesting? Why?

6. Becker was harshly critical of Simon. Does the film portray Becker favorably or unfavorably? Do you agree with his criticisms of Simon? Why or why not?

7. Most professionals or other business people are free to set the price for their services at whatever the market will bear and to charge gullible consumers unreasonably high fees. Should lawyers be prohibited from charging clients unreasonable fees? Why or why not?

CHAPTER 6

Legal Education
Assigned film: The Paper Chase (1973)[1]

6.01 The generic context of The Paper Chase—*The "youth" movie*

Although we discuss it as a film about legal education, moviegoers in 1973 would have perceived *The Paper Chase* as a youth—or what was known then as a "youth-cult"—movie. The film's poster explicitly linked the film to such successful youth-oriented films as *The Graduate* (1967), *Goodbye, Columbus* (1969), and *The Last Picture Show* (1971). The scene in which Hart (Timothy Bottoms) calls Kingsfield (John Houseman) a "son of a bitch," modeled as it was on the scene in *Five Easy Pieces* (1970) in which Jack Nicholson tells off a snooty waitress, would have left no doubt that the film was trying to appeal to anti-authoritarian youths. In addition, the scene in which Hart and Ford outwit an uptight hotel manager is couched in youth-versus-authority terms.

6.01.1 The movie industry in the 1970s

The movie industry first became aware of the youth market in the 1950s, but despite the success of American International Pictures and other B-level studios in appealing to this market, the major studios were reluctant to embrace a business strategy that concentrated on the youth market. By the late 1960s, however, the studios were forced to do just that.

The late 1960s and early 1970s witnessed one of the worst recessions in the history of the American film industry. Due in large part to a series of spectacular flops in the late 1960s, the studios staggered under huge losses. Twentieth Century-Fox alone lost $65 million in 1968, $81 million in 1969, and $76 million in 1970. A number of factors

contributed to the industry-wide recession, but the single most important reason was the trend toward big-budget musicals. As a result of the astronomical success of *The Sound of Music* in 1965, the studios invested heavily in overproduced musicals, almost all of which flopped.

Many of the financially weakened studios were taken over by conglomerates (companies engaged in various unrelated businesses). The trend began in 1966 with the takeover of Paramount by Gulf & Western, a manufacturer of automobile bumpers. Transamerica Corporation, a financial services company, followed suit with its takeover of United Artists in 1967. Kinney National Services, a conglomerate with tentacles in everything from parking lots to funeral homes, absorbed Warner Brothers in 1969. Also in 1969 Kirk Kerkorian, a Las Vegas developer, bought MGM.

Owing in part to the restructuring and reorganization brought about by new managerial regimes, the industry stabilized by 1972, but the period from 1968 to 1971 was a time of unprecedented chaos and turmoil. With traditional genres such as the musical foundering, the studios were ready to try anything. The success of *Bonnie and Clyde* (1967), *The Graduate* (1967), and *Easy Rider* (1969)—the protagonist of which was a lawyer—led the studios to conclude that box office magic lay in youth movies that tried to capture the spirit of the counterculture.

6.01.2 Watering down countercultural films

The earliest youth-oriented films, such as *Zabriskie Point* (1970) or *The Strawberry Statement* (1970), were explicitly attuned to the radical political sensibilities of the counterculture and bombed spectacularly. Thereafter, the studios avoided explicitly political youth films. Instead, countercultural themes were rendered more palatable by being:

- depoliticized;
- shorn of their prodrug content;
- relocated to more distant times or unexpected places (such as the 1950s or the Old West);
- refracted through the perspective of a more mainstream character such as a middle-aged, middle-class housewife.

The Paper Chase exemplifies these strategies: To begin there is no reference to the premier political issue of the day—the Vietnam War; there is no drug use; the setting is located—of all places—at Harvard Law School; finally, countercultural themes are refracted through a law student who actually seems to like law school and the daughter of a law professor who is the embodiment of everything the counterculture despised.

The dilemma faced by *The Paper Chase* and other youth movies was how to appeal to the youth market in spite of so many concessions to mainstream audiences. *The*

Paper Chase resolved this dilemma by focusing on a protagonist who occupies a middle ground between mainstream society and the counterculture. On the one hand, Hart is attending law school—the last place on earth one would expect to find a member of the counterculture. Moreover, his favorite class is Contracts, a subject the counterculture would have disdained because it so thoroughly rooted in the capitalist system.

On the other hand, Hart is not an egghead like Bell, a preppy like Ford, a stuffed shirt like Anderson, or a careerist like Brooks. He has long, curly hair, seems a bit more laid back than his classmates, is sleeping with a woman he barely knows, hangs posters on his wall that seem at least vaguely countercultural (notice the poster he is hanging early in the film when the 3L resident adviser chats with him), and wears a T-shirt and jeans when he studies (notice what Ford wears when he studies). Clearly, none of these things make Hart a hippie, but they do make him a possible convert, which is the direction in which the film often seems to be going (Kingsfield's daughter ironically serves as a spokesperson for countercultural values).

Many youth films, such as *The Landlord* (1970), focused on characters like Hart who straddled the line between the establishment and the counterculture, but who eventually ended up rebelling against the conformity and materialism of mainstream society. Such endings were inevitably polarizing because they involved a rejection of mainstream society. As a result, the later, watered-down youth films avoided such endings. As the film scholar Robert Ray has observed, Hollywood films typically embody a "consensus" ideology that strives to paper over political and ideological differences by having endings in which the characters do not have to make stark either/or choices. (1985, 55–69). *The Paper Chase* cannily achieves such a compromise ending by allowing Hart to achieve a counterculture-like state of indifference to grades (he throws his grades into the ocean) while at the same time getting the precious A (we see Kingsfield give him an A).

Understanding the generic context of *The Paper Chase* thus allows us to understand why the film ends the way it does and why it focuses on the characters it does. In contrast, a film about law school made today would likely focus on a less countercultural character as in *Legally Blonde* (2001).

6.02 Sound design in The Paper Chase

6.02.1 The functions of sound

Sound is a critically important part of the cinematic experience. Just imagine your favorite film without sound—that is, without dialogue, music, and sound effects—and you will begin to appreciate just how much sound contributes to your experience of a film (and how very different silent film was as an art form from sound film). Nevertheless, sound rarely receives the critical attention that the visual elements of a film do.

There are three principal components of a soundtrack: first, the vocals (dialogue, voice-over narration, and any other sounds created by a human voice); second, music; and third, sound effects (such as birds chirping or leaves rustling). When all three of these components are missing—when, that is, the soundtrack is devoid of any sound—we have what's called a *dead track*. Films often use a dead track in pivotal moments (for instance, at the moment of impact in a car crash).

Sound serves a number of purposes in a film. First, it conveys story information. Most dialogue serves this function. Second, sound conveys character. What actors say and how they say it tells us about their character, but so do the sound effects that accompany the vocals (such as the grating sounds associated with Kingsfield, as discussed below). Third, sound adds to the sense of realism of a film. Take away the sound effects in a scene (even something as minor as the sound of a teaspoon hitting the side of a teacup), and the scene will seem hollow and unrealistic. Fourth, sound creates mood and atmosphere. Even more than the visuals of a film, sound can set the mood of a scene. Simply adding the sound of wind can add menace to an otherwise placid scene; on the other hand, simply adding the sound of wind chimes can help create a serene, peaceful mood. Fifth, sound can help an editor mask the transitions from one scene to the next.

The Paper Chase illustrates many of these uses of sound. (The film was nominated for an Academy Award for best sound.) Notice, for instance, how sound is used to convey the character of Professor Kingsfield. Kingsfield is associated with jarring, grating sounds. On the day Hart intends to volunteer in class, for instance, Kingsfield's arrival is announced by a series of loud sounds—Kingsfield slams the door shut, slams his book down, and slams his papers down. Any of these sounds in isolation would have been irritating, but the cumulative effect is particularly grating. As a result, we experience in a direct, sensory way just how nerve-wracking it is to be in Kingsfield's class and just how intimidating a figure Kingsfield is. (Notice, however, that the sound that Kingsfield makes when he slams his book shut becomes noticeably softer in the last third of the film. This is meant to suggest that the students have become acclimated to Kingsfield and that he is not as menacing a figure.)

6.02.2 Sound editing

In Hollywood cinema, editing is supposed to be invisible. (See ¶1.06.2.) Filmmakers want audiences paying attention to the story, not the editing. That's why "seamless" editing is so highly prized in Hollywood: It keeps the audience from being distracted by the cuts from one shot to the next. Sound can help an editor achieve this illusion of seamlessness. For instance, one technique editors often use is the sound bridge. This is a sound (e.g., a piece of music) that is carried over from one shot to the next. This technique makes the transition between the shots seem less jarring, less noticeable. In *The Paper Chase*, classical music is often used as a sound bridge.

Another transitional sound editing technique is the *sound dissolve*. The sound that ends one shot fades out while the sound that begins the next scene fades in. For a brief moment, the two sounds overlap, creating the sense that the two sounds are the same sound. Generally, similar sounds are used, making the transition between them almost imperceptible.

Take, for instance, the opening scene of *The Paper Chase*. The scene ends with Hart running into a bathroom stall and vomiting. The sound that climaxes the scene is the sound of the toilet flushing (we don't hear Hart vomiting). The sound that opens the next scene is the sound of a man (the "Screamer") screaming. The sound of the toilet flushing dissolves into and briefly overlaps with the sound of the screaming, making the two sounds seem like one continuous sound and, in the process, smoothing the transition between the shots. In addition, because the two sounds abut one another and briefly overlap, the sound of the man screaming is associated with Hart in a way it would not have been had it been placed in the middle of the next scene. As a result, we get the feeling that the man's scream is expressive of Hart's feelings even if Hart himself is not actually screaming (though, at first, it does sound as if Hart is the person screaming).

Sound editing is used to convey Kingsfield's character by combining sounds in jarring, discordant ways. As noted above, Hollywood films generally strive to make the transitions between scenes invisible. When a film wants to frighten us or jangle our nerves, however, it will violate this rule. In horror films like *The Exorcist* (1973), for instance, the transitions between scenes will be made even more jarring through the use of sound. Instead of dissolving between two similar sounds so as to paper over the transition between shots, a film like *The Exorcist* will cut between two totally dissimilar sounds. As a result, our nerves will be kept on edge.

Although it is not a horror film, *The Paper Chase* uses this technique at several points to convey just how unnerved the students in Kingsfield's class are by him. Take, for instance, the scene in which Hart storms out of Kingsfield's party after discovering that the woman he has been sleeping with is Kingsfield's daughter. Later that night, he shows up at Susan's house to make up with her. He jumps into bed next to her, undoes his tie, and is about to kiss her when the film cuts to a shot of Kingsfield slamming his casebook shut. The effect of the cut is jarring. Even more jarring than the clashing images, however, are the clashing sounds: We go from a piece of classical music to the sound of a book being slammed shut. Jarring enough on its own terms, the sound of the book being slammed shut also subtly suggests Kingsfield's disapproval of Hart's relationship with his daughter. Thus, even though we don't know whether Kingsfield is aware of the relationship, we are clued in to Hart's perception that he does. Other jarring cuts include the cut from the sound of Hart, Ford, and Anderson showering to the sound of the alarm clocking ringing and the cut from Kingsfield telling Anderson "personal comment is not necessary" to the sound of Hart springing up out of the pool water.

6.03 American legal education

6.03.1 Harvard Law School

American and Canadian legal education is a graduate program (meaning that law students have already received an undergraduate degree). It lasts for three years, but at part-time or night law schools it may take four or five years to graduate. After graduating from law school and passing the bar examination, a lawyer is theoretically qualified to start practicing any kind of law. In most other countries, the situation is quite different. Law is an undergraduate major. Most students who graduate with a law degree never practice law. In order to practice law, students generally must complete some form of postgraduate training (sometimes provided by bar associations) and must apprentice with practicing lawyers.

Harvard Law School is depicted in *The Paper Chase* as well as in several other movies including *Legally Blonde* (2001), *Just Cause* (1995), *Reversal of Fortune* (1990), and *Soul Man* (1986). Harvard is one of the most prestigious American law schools, always ranking within the top three in polls such as those published every year in *U.S. News and World Report*.

It is difficult to get into a top law school like Harvard. Admittees have very high undergraduate grades and scores on the Law School Admissions Test (LSAT). According to the school's Web site, for the class entering in 2002, the undergraduate GPA medians were 3.76 (25th percentile) to 3.94 (75th percentile). Its LSAT score medians were 167 (25th percentile) and 173 (75th percentile). A perfect score on the LSAT is 180.

6.03.2 The Paper Chase *and* One L

The film was adapted from a novel written by John Jay Osborn in 1971. Osborn based the novel on his own experiences as a Harvard law student during the late 1960s. (James Bridges was nominated for an Oscar for his adaptation of Osborn's book.) John Houseman won an Oscar as best supporting actor in the film. *The Paper Chase* was continued in a network television series that ran for one year and was later revived on Showtime. In the final episode in 1986, Hart accepts a law firm job after failing to secure a position as a law professor. Houseman, who appeared in the various TV incarnations of *The Paper Chase,* died in 1988.

Another excellent book about Harvard Law School written from a student's point of view is *One L* by Scott Turow (1977). Turow's book is based on the journal he kept while enduring the first year.

Some people think that every first-year law student should see *The Paper Chase* before starting law school. One of the authors of *Brush with the Law* (Marquart and Byrnes 2001, 22, 64) claims that *Paper Chase* (which he saw at least a dozen times) influenced him to go to law school and got him through the first day.

Legal education today is different from the world we see in *The Paper Chase* or *One L,* so different that the film may be useless as a guide to aspiring law students of what they will face. Those differences will be one of the themes sounded in this chapter. One superficial difference is how people dress; it would be a bit startling to see anyone wearing a jacket and tie (especially a bow tie) in today's law school classroom (except on days when law firms are doing job interviews).

One thing that has not changed from the days of *The Paper Chase* to the present is the required first-year curriculum. All, or virtually all, of the courses a first-year law student takes are required. One of those courses is always Contract Law, the course taught by Professor Kingsfield in *The Paper Chase.* Typically first-year classes are quite large (often between 75 and 150 students).

Hawkins v. McGee. In Hart's first class, Kingsfield cold-called him from the seating chart and asked him to recite the facts and analyze the holding of *Hawkins v. McGee. Hawkins,* the famous hairy-hand case, was decided by the Supreme Court of New Hampshire in 1929 and it is still used as the first case in at least one course book. Hart was completely unprepared (he didn't know that first-day assignments are posted in advance), but Kingsfield continued to grill Hart about the case.

Hawkins is a case of medical malpractice by a doctor. Malpractice is normally studied (along with other harm-causing negligent behavior) in the course in torts, not contracts. However, in this case the doctor stated: "I will guarantee to make the hand a hundred per cent perfect hand." As a result, the plaintiff sued for breach of contract and the court held he could do so. Doctors don't normally guarantee the results of medical procedures—and this case shows one good reason why they shouldn't.

The problem in the case was the *remedy*—the measure of plaintiff's damages. Remedies in torts and contracts are not the same. In contracts, the remedy is normally "the benefit of the bargain," meaning the value of what was promised. To award plaintiff the benefit of his bargain, the court decided that the measure of damages was the value of a perfect hand less the value of the hairy hand after the surgery. Obviously, setting monetary values on perfect and on damaged hands is quite subjective, leaving a great deal of discretion for the jury. Hart's guess that the damages would be limited to the much smaller amount representing the difference between the value of the burned hand before the surgery and the hairy hand after the surgery was sensible (and in fact has been used in later cases) but not a correct statement of the decision in *Hawkins*.

6.04 Law school teaching methodology[2]

Kingsfield employs what is often referred to as the "Socratic method." Based on Kingsfield's classroom style, what are the elements of the Socratic method?

Why doesn't Kingsfield give a lecture about contract law in which he lays out the rules relating to remedies for breach of contract? Why aren't the students assigned to read a book that sets forth the rules of contract law instead of a bunch of confusing old opinions by appellate courts? Why does Kingsfield call on students from a seating chart and fire questions at them? Why doesn't he rely on volunteers instead? Why doesn't he give the answers to his questions? Why does he berate the students?

6.04.1 Kronman's defense of the Socratic method

In *The Lost Lawyer* (1993), Anthony Kronman, Dean at Yale Law School, offers a tentative defense of the Socratic method (which he sometimes refers to as the "case method"). Kronman does not defend the bullying tactics employed by Kingsfield, but he does think the case method is valuable. By the "case method," Kronman means heavy reliance on studying appellate court opinions and treating these opinions in a critical manner. Appellate opinions are efficient teaching vehicles because they state both the facts of the dispute and the applicable legal principles in a concise manner.

However, why not study a treatise or textbook instead of appellate opinions? Surely that would be even more efficient. Kronman explains that class time is best spent on tough boundary problems (meaning that the law is unsettled and good arguments can be made on both sides), rather than on well-settled applications of the law. Appellate opinions are much better than textbooks for focusing on this type of problem. This concentration on gray areas provides excellent training for practicing lawyers who must often apply unsettled law to the complex, real-life dilemmas of their clients.

In addition, Kronman argues, the classroom methodology in which students are cold-called and asked to defend particular positions (with which they may or may not agree) promotes development of rhetorical skills that are essential in law practice. Finally, he claims that this method forces students to learn to see legal problems from many different perspectives—not just the one the student favors. This habit also is essential in law practice because the position that favors the client and that must be argued is often not the one the lawyer believes in. Gradually, this habit becomes habitual and is a part of what is often referred to as "thinking like a lawyer." Kronman concludes (114–15):

> The effort to entertain unfamiliar and disagreeable positions may at first cause some awkwardness and pain. But in time it increases a person's powers of empathic understanding and relaxes the boundaries that initially restrict his sympathies to what he knows and likes . . .

Some students find this experience disturbing and complain that the case method, which makes every position respectable, undermines their sense of integrity and personal self-worth . . .

This experience, which law students sometimes describe, not inappropriately, as the experience of losing one's soul, strongly suggests that the process of legal education does more than impart knowledge and promote new perceptual habits. In addition it works—is meant to work—upon the students' dispositions by strengthening their capacity for sympathetic understanding. The strengthening of this capacity often brings with it the dulling or displacement of earlier convictions . . . It is this unsettling experience that underlies the law student's concern that his professional education threatens to rob him of his soul—an anxiety no mere increment in knowledge or refinement of perception can explain.

6.04.2 Origins of the Socratic method—And its future

The teaching method traditionally employed in law school is called the "Socratic method," because Socrates is said to have taught his disciples by engaging in a dialogue with them without ever furnishing any answers (or in some cases without knowing the answers himself). The Socratic method was developed by Christopher Columbus Langdell, who became Dean at Harvard in 1870. Langdell believed that law was a science, like a natural science, and obeyed the laws of logic. Legal principles could be logically derived by studying actual legal cases, just as a scientist derives the laws of physics from studying empirical phenomena.

Very few people believe this Langdellian notion today. Oliver Wendell Holmes (1881) observed that the life of the law is not logic but experience. The school of legal philosophy called "legal realism" effectively demolished the idea that legal principles and their application were based on logic and immutable principles. Instead, the realists proclaimed that law was what judges actually did, and legal principles were often open-ended enough to allow the judges to do pretty much as they pleased in deciding individual cases.

More practically, the Socratic method is efficient in an economic sense. It allows a single professor to teach a very large class with minimal one-to-one contact. This high ratio of students to faculty is much cheaper than other forms of graduate education or tutorial systems like those employed in British universities. It also frees up the faculty to do other work such as scholarly research by minimizing their face-time with students.

There are probably as many variations of the Socratic method as there are law teachers. Even though legal realism has swept away Langdell's notion that law is a science, the Socratic method (or some version thereof) remains as the primary method of first-year law school instruction because it can be used to show the law's indeterminacy quite as well as showing that law is logical. Some instructors focus on appellate cases but use a lecture-discussion method instead of questioning students. Others have abandoned the case method partially or entirely and teach instead from practical

problems (the "problem method"). Still others make use of small groups to work together on a problem or role-play exercises. Kerr (1999) found that only five of twelve Harvard professors teaching in the first year use even a watered-down version of the Socratic method.

6.04.3 Calling on students

What justifications does Kronman offer for cold-calling on students and firing questions at them, as opposed to relying on volunteers or letting the professors do most of the talking? What's wrong, in short, with lecturing?

6.04.4 Kingsfieldism

Kingsfield has become the symbol for the bullying approach to the Socratic method that Kronman chooses not to defend. In past years, law professors like Kingsfield routinely berated and humiliated students in front of the class. This part of Socratic teaching has largely (though not entirely) passed into history. Today, most law professors conduct their dialogues with students with tact and consideration for the students, recognizing the vast gulf in knowledge and power between teacher and student. The consensus among law teachers is that no valid pedagogic purpose is served by hazing students. Thus, someone watching *The Paper Chase* would be badly misinformed about what happens in most law school classrooms today. Nevertheless, even when it is handled with the utmost tact, Socratic questioning can be very embarrassing for students who are unprepared, panicky, or who miss the boat.

6.05 Gender and legal education

The classroom in *The Paper Chase* was almost all white and primarily male. During the 1960s, women typically formed less than 5% of law school classes (the film distorts reality by showing considerably more than 5% female law students). Ethnic minorities, including African Americans, Hispanics, and Asian Americans were very scarce.

Today the demographic picture has changed radically. Women typically approach and often exceed 50% of entering law school classes. Numerous students belong to ethnic minority groups (although the numbers of African Americans or Hispanics are far less than their percentage of the overall population). Asian Americans are now well represented. This section concentrates on the issues of gender, rather than race, in legal education. It examines whether the law school experience is the same for men and women.

A number of scholars believe that men's and women's law school experiences are quite different, particularly Lani Guinier at the University of Pennsylvania Law School (Guinier 1997). A good summary of the literature is contained in Ramachandran's student note (1998). Guinier found that men's law school grades are better than women's. For example, men were three times as likely to be in the top 10% of their class and 1.5 times more likely to be in the top half of the class. In addition, Guinier discovered women participate much less in class than men do and suffer more psychological harm from the law school experience than do men. One follow-up study at Stanford argues that women students are significantly more likely to cry, have nightmares, or suffer from insomnia than male students. Guinier found that women were five times more likely to seek professional help for law school concerns.

6.05.2 Difference v. equality feminism

Ramachandran's note links Guinier's research to two different schools of feminist thought—the "equality" theory and the "difference" theory. Equality theorists argue that women and men should be treated alike. Difference theory adherents, on the other hand, assert that women are different from men in fundamental ways, and these differences should be appropriately reflected in the way institutions treat men and women. In particular, difference feminists argue that the law school environment is worse for women than for men.

Those who write about difference theory draw heavily on the work of Professor Carol Gilligan (1993). Gilligan argues that the moral development of men and women is quite different. Women are more focused on the context of a dispute and preserving relationships than men. Contrasting two children, Jake and Amy, Gilligan found that Amy "uses the ethic of care" and demands more information about "the persons involved" instead of making an abstracted decision based on "universal" principles. Scholars see Gilligan's work as "stress[ing] the importance of relationships in explaining attributes historically linked with women" and have termed it "relational feminism."

Carrie Menkel-Meadow (1985, 50–55) argued that Amy's "different voice" could alter the "adversarial model [of litigation], in which two advocates present their cases to a disinterested third party who declares one party a winner." Amy might disfavor "binary win/lose conception[s]" and replace a neutral decision maker, who decides only on the basis of the information presented by the parties, with "direct communication" between the parties. Further, Menkel-Meadow suggested that "the female voice of relationship, care and connection" might lead women lawyers to adopt a different style of lawyering, in which a "more contextualized understanding" of issues might have more importance than the "creation of a precedent of universal applicability."

Continuing in this vein, Menkel-Meadow concluded that a feminist law school classroom could employ a less "hierarchical," more participatory structure in which "[r]eactions on the feeling level are as important as reactions on the 'thinking' level." (1988, 77–79) Ultimately, Menkel-Meadow's classroom would emphasize "experiential learning, collaborative teaching, and a greater range of voices [so] students might feel connected both to each other and to the parties in the cases . . ."

6.05.3 Is there a gender gap?

Guinier's work has been questioned by later articles. Linda Wightman (1996) conducted a broad-based study that included data from 80% of American law schools. She found that the gender difference was only 7% of a standard deviation and the difference disappeared in the higher reaches (that is, women were as likely to perform as well as men).

In *Through the Gender Gap,* Richard Sander and Kris Knaplund of UCLA Law School studied twenty law schools for which they had complete data. They found a slight gender gap of 11% of a standard deviation in first semester grades. They also found that this difference disappeared entirely when controlled for entering credentials. It turns out that women have slightly lower LSAT scores but slightly better undergraduate grades than men, and the LSAT scores are better predictors of first-year law school grades than undergraduate GPAs. Sander and Knaplund found that rates of depression in law school are substantial and that more women students than men report symptoms of depression. These results are close to those in the general population, in which depression levels are also substantial and women suffer disproportionately from depression.

6.06 After the first year

The Paper Chase shows that first-year students (often referred to as 1Ls) are deeply involved with their classes (and fixated on their professors). They are overstressed, perhaps, but intensely engaged in the educational process. After the first year, however, things change sharply. Many students lose interest in their classes, attend less regularly, prepare less for class, and focus their efforts on other things—part-time jobs in law firms, working on student organizations (such as moot court or law reviews), or just goofing off. What explains this change in attitude?

6.06.1 The walking wounded

Dolovich (1998) argues that second- and third-year law students (2Ls and 3Ls) at Harvard are the "walking wounded"—demoralized, dispirited, and profoundly disengaged

from the law school experience. They think only of making money in large law firms and forget that they came to law school to learn how to help people less fortunate than themselves. Drawing on Granfield's work (1992), Dolovich blames the Socratic method, which teaches students that law is not a set of rules designed to achieve justice but that it is indeterminate and subject to manipulation. This interpretation causes students to become cynical about using law to achieve social change. In addition, students adopt a "professional" attitude that treats all points of view as equally valid (a way of thinking similar to Kronman's "losing one's soul"). This attitude makes students forget the ideological approach they took to legal and social problems before coming to law school.

In addition, Dolovich and Granfield point to the negative impact of Harvard's grading system. Harvard law students are highly elite and accustomed to getting the best grades. They come prepared to compete and are deeply preoccupied with their grades. At Harvard about 13% of students get an A and 23% get A-; 33% get a B+, 23% get a B, and 8% get B- or lower. (At the time of the Dolovich article, there were very few As and almost all Bs.) Even under the current system, about 64% of students get grades of B+, B or B- (with a very few Cs or Ds). This is the first mediocre academic performance that the B students have ever encountered. They realize that there is no point in going to class or worrying about grades. Thus, they are easy picking for big business-oriented law firms that recruit at Harvard and happily hire the B students.

The Law Review. Another factor cited by Dolovich to explain the demoralization of 2L and 3L Harvard students is that most fail to make the Harvard Law Review. Law reviews are journals published by law schools and edited by law students. They contain a mixture of articles by professors and lawyers and student articles (generally referred to as notes or comments, such as those written by Ramachandran and Dolovich). Traditionally, law students with the best first-year grades were selected to work on the review; today some students are selected by first-year grades, others by a writing competition. Membership on the law review is highly prized because it may lead to a better job or to a clerkship with a judge. In the television series of *The Paper Chase*, Hart makes the *Harvard Law Review* and ultimately becomes editor-in-chief.

6.06.2 Gulati's critique

Gulati and his collaborators (2001) conducted an empirical study of third-year students. They confirmed that 3Ls were disengaged from law school (with low class attendance and class preparation rates). However, the study found that 3Ls were quite satisfied with their law school experience. This latter finding sharply contradicts Dolovich's account.

The Gulati study explains this outcome by arguing that what law students really care about is landing highly paid jobs that will offer good experience. The critical factors in landing a good job are the prestige of the law school and grades. Thus, the function of law school is *sorting and credentialing* students for the job market. Basically, the job decision that counts is being hired for a summer job between the second and third years of law school (or, in many cases, between the first and second years). These summer jobs typically turn into permanent jobs after graduation. The hiring decisions are made in the fall of the second year, so first-year grades are critical in determining who gets summer jobs. In addition, after the first year, grade point averages tend to change relatively little. For these reasons, many students find law school classes and grades irrelevant after the first year.

Gulati and his co-authors justify the students' decision to focus on jobs. Big corporate law firms often provide students with solid experience in solving sophisticated legal problems. The clients of big firms are large institutions (usually corporations), and they can afford to pay high fees to obtain legal work of high quality. The law firms often invest heavily in training students. This training becomes a form of human capital that can be used in getting the next job. Moreover, students can make excellent contacts with clients or other lawyers while at the big firm; then they can easily change jobs, either to a much smaller firm or to a client's in-house law department (see ¶13.05 for a critical examination of big law firms).

6.06.3 The cost of legal education

In addition to the fact that law firms offer an excellent way to build human capital, the cost of legal education is also an important factor in the decision by many students to pursue high paying jobs. In the 2003–4 school year, Harvard's tuition was $31,250 and the total cost of a year at Harvard was about $51,150. Even with help from one's family, very few can pay such costs. Financial aid is usually limited to the neediest students.

It is difficult to work part-time during the first year of law school. After the first year, many law students work part-time in law firms. Even so, the staggering cost of elite legal education means that students simply must take on crushing debt burdens. Once they graduate, sometimes owing more than $100,000, they must take the highest paying job they can find in order to service their debt. That path leads straight to the very high-paying big law firm.

6.07 Review questions

1. ¶6.01 argues that *The Paper Chase* was designed to appeal to a youthful audience and to send a watered-down countercultural message. Would it be perceived today as countercultural?

2. ¶6.02 discusses sound design in *The Paper Chase*. Please select and discuss a particular use of sound in the film (other than one described in the text).

3. Please select a particular "signifier" (see ¶1.05.2) in *The Paper Chase* and indicate your interpretation of that signifier.

4. Did *The Paper Chase* make you want to attend law school—or to avoid it at all costs? Why?

5. Kronman defends the "Socratic method." If you got a law school teaching job, would you use the Socratic method? If so, would you copy Kingsfield's style?

6. What does Kronman mean by saying that law students find that law school has caused them to "lose their souls?" Do law students really lose their souls? If so, is this a bad thing? If it is, what strategies should law students pursue to avoid losing their souls?

7. Dolovich argues that 2Ls and 3Ls are the "walking wounded." Gulati agrees that most of them are disengaged from law school; however, he argues that they are satisfied with law school because they got what they paid for. Which account do you think is correct? Or is neither correct?

8. Several authors (¶6.06.1) argue that law school is bad for women. They argue that the law school experience should be restructured in ways that would be better for women. What are some concrete changes that might be made in legal education that would put these ideas into practice? Are you in favor of these changes?

CHAPTER 7

Law on Television
Assigned film: L.A. Law (1986)[1]

7.01 Lawyers on television and L.A. Law

The television series *L.A. Law* ran from 1986 to 1994 and was very successful, especially in its earlier years.[2] It is still playing in syndication in many major markets (syndication means that independent television stations and cable channels purchase and telecast old shows). The video of *L.A. Law* is available for purchase either new or used from Amazon.com and sometimes on ebay.com. It contains material from the pilot of the series and some material from later shows. It is likely that *L.A. Law* will become available on DVD, although it was not yet available when this book was written.

The show was nominated for 89 different Emmys over the course of its run and won 15 (including 20 nominations in its first season). It was named Outstanding Drama Series in 1987, 1989, 1990, and 1991. The ratings of the show never dropped out of the top 25 during its first five seasons. The series was created by Steven Bochco and Terry Louise Fisher, a former deputy district attorney in Los Angeles. Bochco was also responsible for such critically acclaimed series as *Hill Street Blues, Doogie Howser, M.D., NYPD Blue,* and *Murder One*. Over the course of his career, Bochco has received 38 Emmy nominations and won ten (including six for *Hill Street Blues* and three for *L.A. Law*). David E. Kelley (creator of *The Practice* and *Ally McBeal* among other shows) took a leave from his Boston firm to work on *L.A. Law* and later became its producer.

7.01.1 The Defenders[3]

Many dramatic series about lawyers on television preceded *L.A. Law*. Probably the finest was *The Defenders* which ran from 1961 to 1965. It involved a two-person law

partnership consisting of Lawrence and Kenneth Preston who were father and son. The lead actors were E. G. Marshall and Robert Reed. Each week, the Prestons tackled a different social or legal issue and always from a liberal point of view. Some of their most famous shows involved issues that were never discussed on television at the time, including the anticommunist blacklist in the entertainment industry, abortion, the insanity defense, women's rights, and a whole range of free speech and criminal procedure issues. The show sent the message that lawyers could help attain justice and solve social problems (messages that perhaps were more plausible during the Civil Rights era than today). The Prestons never seemed to worry about getting paid, and the show made no pretense of trying to describe the real life of lawyers.

Unfortunately, *The Defenders* has never gone into syndication, so the old shows can be seen only in television archives (such as the invaluable Museum of Television and Radio in New York City and Beverly Hills). However, Showtime produced several modern-day single-show updates of *The Defenders* and these shows can be purchased. The shows were called *The Defenders: Payback* (1997) and *The Defenders: Choice of Evils* (1998). In these shows, E. G. Marshall returned as the grandfather in a three-generation firm. Unfortunately, Robert Reed was dead and was replaced by Beau Bridges as Don Preston, another of Lawrence Preston's sons. In addition, Martha Plimpton plays Mary Jane Preston, Lawrence Preston's granddaughter.

7.01.2 Perry Mason[4]

The most successful lawyer in the history of American popular culture was Perry Mason. Erle Stanley Gardner (a former lawyer and a very prolific writer) wrote 82 lawyer/detective novels about Perry Mason (all of which are titled *The Case of the* . . .). Six of the novels were adapted into films during the 1930s (four of them starring 1930s matinee idol Warren William).[5] In the films, Mason was quite different from the way he later appeared on television. He was a wisecracking smart aleck like William Powell in *The Thin Man* (1934) and a heavy drinker. In the film *The Case of the Howling Dog* (1934), the client arrives for an appointment with Mason and finds him passed out under the desk. Gardner hated the films and retained creative control over the subsequent incarnations of the Perry Mason character, such as the radio show that ran for 3,221 episodes in the 1940s and 1950s.

The television show *Perry Mason* ran on television from 1957 to 1966 for a total of 271 episodes. The character was also the subject of 30 made-for-TV movies in the 1980s and early 1990s. Raymond Burr played Perry Mason in virtually all of the original TV shows as well as all but a few of the later made-for-TV movies. Burr's death in 1993 finally ended the Perry Mason character, but both the 271 original shows and 30 TV movies live on in syndication on cable channels.

In the radio and television series, Mason was an asexual and humorless fellow who appeared to lack entirely any semblance of a personal life. Mason was a solo practi-

tioner who functioned partly as a lawyer, partly as a detective. In every novel, radio show, television show, or movie, the formula was always the same. An innocent person is prosecuted for murder by the inept police Lt. Arthur Tragg and the hapless district attorney Hamilton Burger. Mason and his staff (secretary Della Street and investigator Paul Drake) sleuth out the identity of the real killer (who had usually framed Mason's client). At the preliminary hearing (see ¶8.09.3 for explanation of preliminary hearings), Mason's adroit questioning destroys the prosecution's case and reveals the truth. Generally, the real killer is sitting in the courtroom and breaks down and confesses to the evil deed. *Perry Mason* made no attempt to describe what real lawyers actually do or how the criminal justice system actually functions. *Matlock* (1986–95) was a successful clone starring Andy Griffith that imitated the *Perry Mason* formula in a small town Southern setting. These shows sent a message similar to *The Defenders:* Lawyers defeat the stupid cops and prosecutors and ordinary people receive justice. Through the efforts of these great lawyers, the actual truth about the crime is revealed in full.

7.01.3 L.A. Law *as a breakthrough*

A large number of less successful shows tried to explore the life of lawyers (Stark 1987). Almost all of the TV lawyers practiced criminal defense. *L.A. Law* departed almost entirely from this pattern. It tried to dramatize law practice as it really exists today — in *law firms* rather than as solo practitioners or two-person partnerships (see ¶13.05). The firm of McKenzie, Brackman, Chaney, & Kuzak involved a number of partners and a number of associates (that is, lawyers employed by the firm and working for a salary rather than a partnership share). It had a substantial staff of non-lawyer employees and a beautiful suite of offices. The firm was profitable and the partners enjoyed lavish lifestyles. They spent their days working on fascinating cases. Indeed, many people believe that *L.A. Law* produced a surge of applications to law school as thousands of young people decided that law practice was in their future.

The show tried to illuminate the problems of working with difficult or repulsive clients and opponents and it frequently focused on cutting-edge ethical issues. *L.A. Law* never forgot that a law partnership is, first and foremost, a profit-making business. The firm must select cases that will pay well, a point illustrated during the staff meeting in which an associate wants to handle a $750 collection matter over the objection of managing partner Brackman. Some of the partners, such as Brackman and Becker, place making money above everything else; other partners have different priorities. As a result, the partners often clash about financial and ethical decisions and other problems of law firm management. Indeed, some of the partners in McKenzie, Brackman thoroughly dislike each other; this is often the case in real law firms. These sorts of management problems become more severe and difficult to resolve as the law firm grows larger and spreads out across state or national borders.

L.A. Law showed that lawyers spend relatively little time in court and a great deal of time in their offices; it made clear that many matters do not involve litigation and those that do are more often settled (like the Graham divorce) than actually tried. It also involved a substantial number of women lawyers and black and Hispanic lawyers—a real breakthrough for television. (We discuss the problems of women and African American lawyers in ¶¶12.02 and 13.04.) Victor Sifuentes remains one of the very few Hispanic lawyers to appear in any television show or in the movies.

In some respects, *L.A. Law* resembled a soap opera. It paid close attention to the personal lives of the lawyers and staff members, many of which were quite unhappy. As in real life, its lawyers have love affairs with other lawyers in and out of the firm, as well as with staff members and clients. In numerous episodes Arnie Becker carried on affairs with his clients (since then, many states have adopted disciplinary rules that ban lawyer-client sex). A few of them (like Markowitz and Kelsey) marry each other. Many homosexual lawyers and staff members, like Norman Chaney and Georgia, feel they must conceal their sexual orientation from their co-workers. (We discuss the problems of gay lawyers in ¶13.03.) The underlying cultural message of the show was that working in a law firm is a stimulating and profitable way to make a living (even if the lawyers have unsatisfying personal lives). It transmitted only a mixed message about whether lawyers were heroes or villains or whether law firm lawyers helped to promote justice or to thwart it.

7.01.4 *After* L.A. Law

L.A. Law cleared the way for the modern, sophisticated lawyer shows of today. These shows are commercially successful not only in the United States but throughout the world. None of them are campy, formulaic nonsense like *Perry Mason* or *Matlock* or piously liberal sermons like *The Defenders*. In particular, *The Practice,* created by David E. Kelley, a former Boston public defender who wrote many of the shows, debuted in 1997. The show has won numerous Emmys and has a loyal following. It seems like a direct descendant of *L.A. Law* because it involves an ensemble cast in a small law firm (Kelley was a writer and producer for *L.A. Law* in its later years). The stories often dwell on the personal lives of the lawyers, reflecting on the damage that law practice can do to a lawyer's self-esteem, psychological health, and personal relationships. Many shows probe thorny issues of legal ethics (both of criminal defense and criminal prosecution). Often, law and justice do not coincide in episodes of *The Practice.* The guilty are sometimes acquitted and the innocent are convicted. In contrast to the upscale and affluent firm of McKenzie Brackman, however, the firm in *The Practice* is definitely down-market, scratching to get by with criminal defense (often of very shady characters) and personal injury cases.

Kelley also created *Ally McBeal* (1997–2002), a female buddy show that was set in a small law firm.[6] The lead character, Ally McBeal (Calista Flockhart) was far more con-

cerned with her love life and her biological clock than her work life. Often the viewers were able to experience what was going on inside Ally's mind through the use of computer-animated snippets of her emotions. Unlike the other shows discussed, *Ally McBeal*'s treatment of legal issues was usually silly and played for laughs. The show could have been set in any sort of workplace; probably Kelley put it into a law firm because he was most familiar with that environment. For whatever reason, *Ally McBeal* was quite successful commercially, developing a strong following among young single women who identified with Ally or the other characters.

The amazingly successful *Law & Order,* created by Dick Wolf, debuted in 1990 and is going strong. It is one of the few shows that present new episodes while older ones are running daily in syndication in the same markets. It has also inspired several successful spinoff shows. *Law & Order* combines a police story (catching the crooks) with a legal story centering on prosecutors (trying to convict them). *Law & Order* does not fit the mold of successful television shows about law and lawyers because it is not at all like a soap opera. It says almost nothing about the personal lives of the police and lawyer characters who appear each week; the stories are complex and involve technical legal issues, often drawn from real cases. The writers try hard to get the legal issues right. It is difficult to understand how such a serious show could draw a mass audience. Somehow the format continues to attract large audiences despite numerous cast changes over the years.

In addition, there are almost endless dramatic and comedic series about lawyers, some of them now cancelled. These series center on big firms (*The Lyon's Den, The Girls' Club, The First Years*), military law (*JAG*), prosecutors (*A.U.S.A.*), family law (*Family Law*), and child protection law (*The Guardian*—involving a corporate lawyer doing community service at legal aid). There are shows about judges, including *First Monday* and *The Court* about the Supreme Court, and *Judging Amy, 100 Centre St.,* and *Queens Supreme* about trial judges. A range of shows involve sympathetic lawyer characters in mostly nonlegal stories, such as *Ed, Will and Grace, The Cosby Show,* or *Sex and the City.* Lawyer characters are fixtures on the soap operas. In addition, of course, the genre is vastly larger than just fictional series about lawyers. During the daytime *Judge Judy* and her many clones command huge ratings. *Court TV* shows every minute of real trials. The O. J. Simpson trial dominated the airwaves.

Legal popular culture on television is vast and diverse, as much as the television medium itself. It constructs reality about law, lawyers, and the legal system for millions of viewers every day of the week.

7.02 L.A. Law *and the rise of the workplace drama*

In an era in which shows like *The Practice, ER,* and *The West Wing* dominate the prime-time lineup, a show like *L.A. Law* may not seem that unique. However, it was

only in the 1980s and 1990s that workplace dramas like *L.A. Law* and *The Practice* came to occupy a central place in prime time programming. Previously, hour-long dramatic series tended to fall into one of four categories:

- anthology programs like *Studio One;*
- family-centered dramas like *The Waltons* and *Little House on the Prairie;*
- male-oriented detective, western, or action-adventure shows shows like *Kojak* and *The Six Million-Dollar Man;*
- professional dramas like *Ben Casey* and *Marcus Welby, M.D.*

It was only with the success of shows like *Hill Street Blues, St. Elsewhere,* and *L.A. Law* in the 1980s that the workplace drama, which is distinct from the professional drama, came to occupy such an important place in the prime-time lineup.

7.02.1 Workplace dramas[7]

As the name implies, workplace dramas are situated in a workplace, which distinguishes them from soaps such as *Dallas* and *Dynasty.* Typically, the locus of drama in a soap opera is the family or a close-knit community (although, as *General Hospital* indicates, there are exceptions). Moreover, while issues of family life pervade workplace dramas, so do career and workplace issues. Indeed, such issues take center stage. The characters are preoccupied with balancing work and family in these shows, and the workplace operates as a surrogate or quasi-family.

Indeed, the centrality of family and family issues separates workplace dramas from detective series like *Hawaii Five-O* and *Perry Mason* and professional dramas like *Ben Casey* and *Marcus Welby, M.D.* In a workplace drama, the private lives of the characters consume almost as much screen time as their on-the-job activities. Conversely, in shows such as *Hawaii Five-O, Perry Mason,* and *Law & Order,* we learn very little about the private lives of the characters. They appear to have almost no life outside of their jobs. The same holds true for professional dramas such as *Ben Casey* and *Marcus Welby, M.D.*—the storyline is resolutely focused on the *professional* lives of the characters.

In the workplace drama, however, the storylines are split along two equally important axes—the professional lives of the characters and their personal lives. Furthermore, these axes are integral to one another: The characters' personal lives are intertwined with their professional lives. Because they spend so much time at work, their relationships with their co-workers are as important to their happiness and satisfaction as their relationships with their spouses, lovers, and families. Indeed, they seem to derive even greater emotional satisfaction from their work relationships. The characters share their feelings and private lives with their coworkers, and there is an intimacy and camaraderie to their workplace relationships that does not necessarily exist in their personal relationships.

Ironically, the workplace dramas of the 1980s and 1990s grew out of the workplace *comedies* of the 1970s (though there were a handful of workplace dramas in the 1970s such as *Police Story* and *Lou Grant*). Comedies like *M*A*S*H, Barney Miller,* and *The Mary Tyler Moore Show* revolutionized the television sitcom by shifting the focus from family to work. Instead of concentrating on the comedic misadventures of a family or couple, shows such as *The Mary Tyler Moore Show* and *M*A*S*H* focused on the comic misadventures of a particular group of co-workers. In the process, marriage and parenthood became less central to the sitcom, and career and the single life became more important. This represented a major shift in the values underlying the sitcom. The family comedy embodies a basically suburban vision of the world in which marriage and parenting are the focal points of people's lives. The workplace comedy, on the other hand, embodies a fundamentally urban or cosmopolitan vision of the world in which career and friendship are the source of meaning in people's lives. Whether one prefers family or workplace comedies depends in large measure on which vision of life one prefers.

7.02.2 Television economics and the rise of the workplace drama

Many factors played a role in the rise of the workplace comedy and, later, the workplace drama. The entrance of women into the workplace and the rise of divorce are certainly important. Perhaps the single most important factor, however, was the emergence of demographics-driven television programming.

In 1969, when Robert Wood took over at CBS, CBS was the number-one network on television. Its prime-time lineup consisted of such hit shows as *Mayberry R.F.D., The Beverly Hillbillies,* and *Hee Haw.* However, as Todd Gitlin has chronicled in *Inside Prime Time* (2000), Robert Wood was acutely aware of the fact that the audience for these programs was largely rural and over 50—precisely the demographic segment shunned by advertisers. As a result, advertisers began drifting over to NBC where, despite the smaller audience, they could reach a more advertiser-friendly demographic group—young, urban professionals.

In response, Wood revamped CBS's entire schedule, dropping shows such as *Mayberry R.F.D., The Beverly Hillbillies,* and *Hee Haw* and putting in their place shows like *All in the Family, The Mary Tyler Moore Show,* and *M*A*S*H.* A more dramatic change in programming can hardly be imagined: CBS went from having the most politically conservative and generically unadventurous shows on television to having the most politically liberal and generically innovative ones. In the process, CBS achieved something of a miracle: It managed to maintain its number-one status while at the same time reaching the younger, more urban, more upscale audience its advertisers wanted.

Central to CBS's success were workplace comedies such as *The Mary Tyler Moore Show.* The production company behind *The Mary Tyler Moore Show* was MTM

Enterprises, which Mary Tyler Moore and her husband Grant Tinker co-founded. Due in large part to his success as head of MTM, Tinker became the president of NBC in 1981.

NBC entered the 1980s in third place. By the end of the decade, it occupied first place. Tinker and his chief programmer, Brandon Tartikoff, are usually given a large share of the credit for reversing NBC's fortunes, and central to their strategy were workplace dramas such as *L.A. Law* and *St. Elsewhere* and workplace comedies such as *Cheers* and *Night Court*. A program conceived by Tinker's predecessor, Fred Silverman, and produced by MTM during the last days of Tinker's reign there, *Hill Street Blues,* provided the template for the workplace dramas that were to form the centerpiece of NBC's prime-time lineup. Like them, it featured an ensemble cast, a workplace setting, a focus on the personal as well as the professional lives of the characters, and an adroit mixture of comedy and drama. More importantly, it drew critical accolades, high ratings, and the kind of demographics advertisers paid big money for (Mercedes-Benz was an early sponsor). Recognizing the potency of the formula, NBC followed up *Hill Street Blues'* success with two more workplace dramas, *St. Elsewhere* and *L.A. Law,* both of which proved popular. The recent sustained success of shows like *The Practice*, *ER*, and *The West Wing* suggests that the workplace drama will be around for a long time to come.

7.03 Ethical issues in L.A. Law

The *L.A. Law* lawyers struggled constantly with ethical issues—as real-life lawyers do all the time.

7.03.1 Moral dilemmas of the lawyers—Cavanaugh in the rape case

Some of the issues in the *L.A. Law* pilot involve serious moral dilemmas, but the lawyers' conduct does not violate the rules of legal ethics. For example, Cavanaugh tears rape victim Adrienne Moore to shreds during the preliminary hearing—a process she describes as a second rape. Because she is terminally ill, this horrible experience causes her to decide she cannot remember the details of the rape. Her inability to testify as to the details requires the judge to dismiss the case.

What Cavanaugh did was not unethical, regardless of whether he thinks his client was guilty and whether he not he believes Moore was truthful. The preamble to the ABA Model Rules states, "As advocate, a lawyer zealously asserts the client's position under the rules of the adversary system." Vigorously cross-examining the crime victim is what criminal defense lawyers are expected to do. However, many people, including Kuzak himself, find it morally objectionable. This issue is also discussed in ¶¶2.05 and 8.11.

7.03.2 Moral dilemmas—Becker in the Graham divorce

Lydia Graham wants a noncontentious, friendly divorce. She believes that her marriage broke up because she and her husband grew apart, not because another woman is involved. Lydia is satisfied with the deal that she has worked out with her husband, but just to make sure nothing has been overlooked, she asks Becker to review the deal. Without the client's permission, Becker hires an investigator who discovers the husband's affair and the fact that he is hiding assets and probably defrauding the IRS. This turns a friendly divorce into an all-out war. Husband and wife now hate each other, with obvious long-term negative consequences for the children.

Of course, Becker and the firm stand to profit handsomely from the matter (whereas the friendly divorce would have resulted only in a small fee). Lydia takes the money, but she criticizes Becker for turning her ex-husband from a friend into a bitter enemy. How does Becker defend himself? What is your view about the morality of his behavior?

Normally, the lawyer-client interaction in divorce cases is the opposite of what we see in this episode of *L.A. Law.* The lawyers have to cool down vengeful divorce clients who want to go to war against their ex-spouses. Long drawn-out divorce proceedings are a huge waste of money and can be emotionally devastating. Good lawyers try to prevent such disasters from occurring, rather than try to encourage them. We return to the problems of divorce practice in ¶¶14.09 and 14.10.

7.03.3 Kuzak's behavior in the Pregerson case

Kuzak told the police that his client Pregerson had a gun, thus violating his parole. This action seems morally right because it took a gun-waving drug offender off the streets, was triggered by a crime (armed robbery) perpetrated by Pregerson against Kuzak himself, and resulted in a more just resolution of the rape case. However, did it violate legal ethics? Leland McKenzie obviously thought so.

One of the most fundamental of a lawyer's ethical obligations is confidentiality—the obligation to keep a client's secrets. ABA Model Rule 1.6 provides that "A lawyer shall not reveal information relating to representation of a client unless the client consents . . ." A comment to the rule explains that "the confidentiality rule applies not merely to matters communicated in confidence by the client but also to all information *relating to the representation, whatever its source.*" If, for example, Pregerson had told Kuzak during his interview in jail that he owned a gun that he kept for protection, in violation of the terms of his parole, Kuzak could not have revealed this information.

Here, however, Kuzak learned about the gun when Pregerson robbed him. Did this information "relate to the representation of a client," or did Kuzak obtain this information in a way that had nothing to do with his representation of Pregerson?

One of the exceptions to Rule 1.6 allows the lawyer to disclose confidential information "to prevent the client from committing an act that the lawyer believes is likely to result in death or substantial bodily harm." This exception is intended to allow the lawyer to go to the police if the client tells the lawyer of plans to hurt or kill someone. If Kuzak had learned about the gun from a confidential communication by Pregerson, could he have gone to the police with the information?

No clear answers. The Preamble to the ABA's Model Rules states: "Within the framework of these rules many difficult issues of professional discretion can arise. Such issues must be resolved through the exercise of sensitive professional and moral judgment guided by the basic principles underlying the Rules." This is a polite way of saying that the ethical rules seldom give lawyers clear answers in solving the dilemmas arising out of law practice.

7.04 Review questions

1. *L.A. Law* was vastly different from the TV shows about lawyers that preceded it and was a huge commercial and critical success. What do you think accounted for this success?
2. What accounts for the success of *Law & Order?*
3. The text describes *L.A. Law* as a workplace drama. What is another workplace drama or comedy that is currently on television? Why do you consider it a workplace drama or comedy?
4. Many movies have portrayed lawyers and law firms in a harshly negative light, but the treatment of lawyers and law firms on television is much more favorable. What accounts for this difference?
5. Do you think that Arnie Becker's work in the Lydia Graham matter was (a) moral and (b) ethical?
6. Are the lives of the lawyers depicted on *L.A. Law* different from the lives of the lawyers depicted in *Anatomy of a Murder* (chapter 2), *To Kill a Mockingbird* (chapter 3), *The Verdict* (chapter 4), or *Counsellor at Law* (chapter 5)? Choose one of these films and compare the lives of the lawyers in that film to those in *L.A. Law.*

CRIMINAL JUSTICE

The Criminal Justice System
Assigned film: Indictment (1995)[1]

8.01 Editing in Indictment

Editing is an aspect of the filmmaking process that rarely receives the attention it deserves. The Soviet film director and aesthetician V. I. Pudovkin once claimed that the foundation of film art is editing. [Pudovkin 1960] He meant that each individual shot derives meaning from its context. A shot of a man smiling, for instance, means one thing when it is followed by a shot of a kitten playing with a ball of string and quite another when it is followed by a shot of an attractive woman in a bathing suit. *Indictment,* a movie produced for television, contains a number of sequences that illustrate this principle.

Take, for instance, the sequence in which the film cuts from a reporter describing the testimony of a child who "told a rapt courthouse how he was forced to drink the blood of a slaughtered rabbit" to a close-up of a Bloody Mary being poured. By cutting from a description of a child drinking blood to a shot of a Bloody Mary being poured, the film undercuts the grisliness of the child's testimony by turning it into a joke. This may seem tasteless, but it effectively conveys the filmmaker's contemptuous attitude toward the accusations made against the McMartins.

In another sequence, the film cuts from Peggy Buckey telling her guards that she "want[s] to go home" to a close-up of the word "home" emblazoned on one of the boxes in the apartment the McMartins now call home. In this case, the cutting does not undercut what a character is saying; rather, it underscores the poignancy of it: Peggy wants to go home, but she no longer has a home. Her home has been reduced to the boxes in which the McMartins store their possessions as they move from one rented apartment to another.

In another sequence, the film cuts from a close-up of the crime-scene photographer's camera as it snaps a picture of Judy Johnson's nude dead body to a horde of photographers taking pictures of the joint press conference being held by Lael Ruben and Danny Davis. In this case, the film cuts from a shot of a photographer taking pictures of a corpse to a shot of photographers taking pictures of a press conference so as to taint the press conference with an air of cold-bloodedness and crassness—a woman has just died, and here are two attorneys using the occasion to get their pictures in the paper.

Perhaps the most remarkable use of editing to create an added layer of meaning occurs when Ray Buckey is finally released from prison and is engulfed by a sea of reporters and photographers. Over the bedlam of the photographers' cameras and reporters' questions, we faintly hear Danny Davis conducting a mock cross-examination of Ray. Danny's voice gradually becomes louder until, just prior to the cut, we hear him shout, "Please answer the question, Mr. Buckey." The film then cuts to an exasperated Ray crying, "Stop it! Stop it! I can't take it anymore." By overlapping the sounds of the reporters' questions and Danny's mock cross-examination and cutting directly from the one to the other, editor Richard A. Harris equates Ray's frustration with the prosecution with his frustration with the media. Indeed, in this one simple cut, Harris neatly encapsulates the film's theme, namely, the media's complicity in the prosecution and persecution of the McMartins. Given such bravura editing, it is no wonder that *Indictment* won an Emmy for editing for a miniseries or a special.

8.02 Realism in film[2]

The issue of realism in film is a notoriously complicated and contentious one. Throughout film history several film movements have claimed the mantle of realism—Italian Neo-Realism, English Free Cinema, *Cinema Verité,* Direct Cinema, and Dogma '95, to name just a few. Aside from their claims to realism, however, these movements have little in common. They adopt different cinematic techniques and narrative strategies in their quest for realism. What is and what is not "realistic" remains a subject of great debate within the film world.

8.02.1 The ordinary filmgoer's conception of realism

Among ordinary moviegoers there seems to be a rough consensus as to the meaning of realism. When the average filmgoer describes a film as "realistic," she generally means "true to life" (see ¶1.06.1 for discussion of the ordinary spectator's understanding of realism). Realism, in this sense, is a question of verisimilitude—is the world depicted in the film a close analogue of the world it claims to be depicting? Naturally, individual filmgoers will arrive at different answers to this question depending on their own experiences and ideologies.

This conception of realism begs the question of how we arrive at our notions of what constitutes "reality" or the "real world." After all, we routinely assess the realism of movies about events we never experienced. For instance, *Saving Private Ryan* was praised as the most realistic war movie ever by critics who had never served in the military, let along fought in a war. Similarly, *Schindler's List* was perceived as realistic by millions of filmgoers whose knowledge of the Holocaust extended no further than the newsreels and archival footage they had seen on television or in high school or fictitious movies or television shows about the Holocaust they had previously seen. What, then, made these films seem realistic? The answer, at least in part, is their fidelity to previous, generally accepted depictions of these events.

Viewed in this way, *Schindler's List* was perceived as realistic, in part, because it was filmed in black-and-white, and audiences associate black-and-white with realism for the simple reason that most of the World War II documentary footage audiences are familiar with were shot in black-and-white. Similarly, the grainy film stock and jittery hand-held camera work in *Saving Private Ryan* were equated with realism by audiences in large part because documentary films were, until recently, shot without tripods (which produced shaky hand-held camera work) and with light-sensitive fast film stock (that produced a grainy image). Thus, if *Saving Private Ryan* and *Schindler's List* were widely accepted as "realistic" films, it was not necessarily because they were faithful representations of reality—most filmgoers were in no position to judge this— but because they emulated the look and feel of documentaries or newsreels and documentaries and newsreels are a trusted source of realistic representations.

Realism in film is thus primarily a question of style and technique and only secondarily a question of substance. One way to prove this is the changing nature of realism in film. In post–World War II Italy, for instance, realism in film (as embodied in the films of the Italian Neo-Realists) was equated with naturalistic images of daily life and the use of non-actors. In post–World War II America, realism was equated with a theatricalized form of acting (that is, Method acting). Similarly, in the post–World War II era, realism in film was associated with long takes and a slow, deliberate pace. In the 1990s, however, realism was associated with quick cutting and a frenzied, manic pace. In the 1950s, *Dragnet* was widely praised for its realism. Today, the very techniques that made *Dragnet* seem realistic in the 1950s— the voice-over narration, the listing of dates and times, the flat, unadorned visual style—seem hopelessly affected.

Despite the transient nature of our notions of film realism, some generalizations are possible. First, realism has traditionally been associated with films about traumatic

historical events (such as Vietnam or the Holocaust) or contemporary social and political issues (such as race relations or drug addiction). Second, realism has traditionally been associated with films that subordinate style to content. Thus, films that adopt a florid cinematic style (like *Natural Born Killers* or *Moulin Rouge*) are typically viewed as highly unrealistic. Indeed, their florid style signals the audience not to expect or demand realism. Third, realism has usually been associated with some genres more than others—in particular, the social problem film, the war film, the gangster film, and the docudrama (the category into which *Indictment* falls). Fourth, realism has traditionally been associated with leftist politics or political causes. Fifth, realist films typically adopt a rhetorical mode of address, meaning that they are constructed like arguments: They are trying to persuade you, the viewer, of something.

In particular, realist films want to convince you of two things: First, that what they are depicting is accurate and true-to-life and, second, that you should adopt a certain stance toward the events they are depicting. In *Indictment,* the filmmakers are trying to convince you that the McMartin trial unfolded as they depict it. This is why the film assures us that "This story happened in America in our times—court transcripts and actual videotapes were among the sources used in telling the story." In addition, the filmmakers want you to believe that there was not an iota of evidence against the McMartins and that the whole thing was a witch hunt.

Thus, in watching a realist film like *Indictment,* it is important to keep in mind that realism is primarily a question of style and attitude, not substance. A film can be realist in style and yet completely untrue to real life. One need only recall that *Dragnet* was acclaimed for its realism to appreciate this concept. Furthermore, it is important to keep in mind that realist films are making arguments about reality, not simply depicting reality. Thus, instead of asking whether or not a realist film is true to life, you should ask such questions as: What techniques is the film using to try to convince me that it is a faithful representation of reality? Why do these techniques carry connotations of realism? What argument is the film trying to make concerning the events in question? How do the techniques it uses advance this argument?

8.03 Film as history[3]

Like *Indictment,* many movies and television programs are based on real people and real events. These films (referred to as docudramas or re-enactments) combine documentary and narrative filmmaking styles. Films based on actual trials are, thus, reality twice removed: They re-enact a trial, which is itself a re-enactment of actual events. Needless to say, there are bound to be large (sometimes huge) differences between the events on the screen and the actual events that gave rise to the trial in the first place. Filmmakers must always manipulate real events (much like trial lawyers manipulate real events) in order to compress them, eliminate untidy loose ends, create empathetic

or antipathetic characters, make the story more entertaining and dramatic, and, sometimes, make a political point.

8.03.1 The importance of films based on actual events

Why do films and TV programs based on actual events remain so popular? Somehow viewers find that true stories and real characters are more believable and empathetic than fictitious stories and characters. Indeed, a film based on real events can tell a story that might seem implausible if it were fictitious. Advertising for television docu-dramas or miniseries that boasts "based on a true story" seems to attract viewers. Top actors seek roles in which they play real people; in turn, the interest of a marquee actor can help a film get made. Finally, films based on real events and people often seem to take on additional importance and this makes them contenders for awards.

Films based on true stories are important for another reason: They are extremely powerful teachers. They put flesh and blood on historic events that are dryly described in books or history classes. Many people have acquired all of their information (or misinformation) about historic events and people (including World War II and the Vietnam War, the Holocaust, slavery, the Kennedy assassination, Watergate, the sinking of the Titanic, or the lives of Malcolm X or Shakespeare) from movies or television. When films that are "based on a true story" are gross distortions of historic reality, and are actually being employed to put across the filmmaker's political agenda, there are legitimate grounds for concern.

8.03.2 The accuracy of films based on actual events

Oliver Stone was one of the producers of *Indictment*. Stone's films often articulate his particular and very personal view of historical events, as in *JFK* (1991) and *Nixon* (1995). Numerous other historically based films have given risen to sharp controversy about misrepresentations of historic figures and events.

Criticism of *A Beautiful Mind* and other recent films. The film *A Beautiful Mind* (2001) was not faithful in many respects to the life of John Nash as described in Sylvia Nasar's biography. It was heavily criticized for this reason, largely by competing studios which ran an unsuccessful PR campaign to prevent the film from winning the "best picture" Oscar. People with personal or political agendas also were critical of the departures from historic fact in *The Hurricane* (1999), *Amistad* (1997), *A Civil Action* (1998), *The Insider* (1999), and *People v. Larry Flynt* (1996), just to mention some legally themed movies.

Obviously, as Rosenstone (1995) argues, a film is not a book or a documentary. Films are made to entertain and to sell tickets (or attract a large TV audience). In

order to capture the interest of viewers and create empathy for the characters, film-makers must take liberties with the basic factual material to compress it, make it visually compelling, and impose a narrative line on historic fact.

All this said, does a film maker have *any* responsibility to be faithful to historic facts about the subject matter of a film? *Indictment* departs from the actual facts about the McMartin case in many respects (see ¶8.05). Even so, the film opens with these words: "This story happened in America in our times—court transcript and actual videotapes were among the sources used in telling the story." Should these words mean anything at all?

8.04 Abby Mann

Indictment was written by Abby and Myra Mann. Like Reginald Rose, the writer behind *12 Angry Men* (chapter 9), Abby Mann began his career in live television, writing for such live dramatic series as "Studio One" and "Robert Montgomery Presents." Mann later wrote the screenplays to such films as *Judgment at Nuremberg* (1960), *A Child Is Waiting* (1963), and *Ship of Fools* (1965), all three of which were produced by Stanley Kramer and feature the socially conscious liberalism for which Kramer and Mann were known. Mann's screenplay for *Judgment at Nuremberg* earned him an Oscar.

Despite his feature film work, Mann is best known for his work in television. He was the writer behind such critically acclaimed miniseries and made-for-television movies as *The Marcus-Nelson Murders* (1973), *King* (1978), *Murderers Among Us: The Simon Wiesenthal Story* (1989), and *Teamster Boss: The Jackie Presser Story* (1992). Mann has been nominated for ten Emmy awards and won three, including one (in his capacity as executive producer) for *Indictment*.

Mann's work for television is deeply informed by his own unabashedly liberal views. Whether the topic is the criminal justice system or labor unions, Mann's theme is the abuse and misuse of power by powerful individuals and institutions and the plight of the ordinary people whose rights and interests are trampled in the process. A polemicist by nature, Mann makes no attempt to present both sides of an argument; rather, he presents his side in the hope that the viewer will end up sharing his indignation.

Throughout his career, Mann has gravitated towards legally themed projects. In addition to *Indictment,* Mann wrote the screenplays to two other made-for-television movies based on real-life criminal cases, *The Marcus-Nelson Murders* and *The Atlanta Child Murders. The Marcus-Nelson Murders,* the pilot for the police series *Kojak,* was based on the 1963 rape and murder of Janice Wylie and Emily Hoffert and the subsequent prosecution of George Whitmore, a young black man. *The Atlanta Child Murders* was based on the notorious Atlanta child murder case and the subsequent prosecution of Wayne Williams, a gay black man. Like *Indictment, The Marcus-Nelson*

Murders and *The Atlanta Child Murders* portray bungled criminal investigations; unlike *Indictment,* however, they end with their seemingly innocent protagonists being convicted.

8.05 The McMartin case—Indictment *and the real case*

Indictment was a movie produced for television. It presents a vision of an utterly dysfunctional criminal justice system. The real McMartin molestation case was indeed a legal nightmare of grotesque proportions, but it differed in important respects from the proceedings depicted in the film. Because the film is professionally made and is based on actual events, it will persuade most viewers that it speaks the truth. A person whose entire knowledge of the McMartin case is based on watching *Indictment* would surely find Ray Buckey not guilty. How is it, therefore, that there were hung juries in both of his trials?

8.05.1 The McMartin trials[4]

Judy Johnson filed a complaint with the Manhattan Beach Police Department in August, 1983, stating that her two-year-old son Matthew had been abused at the McMartin preschool. Ray Buckey was arrested, then released for lack of evidence. The police sent letters to 200 parents of current and former McMartin preschoolers asking about possible abuse. In November, Kee McFarlane and her associates began interviewing children at Children's Institute International (CII). In March, 1984, the police arrested four members of the McMartin family and three teachers at the preschool. They were indicted by the grand jury on 115 counts of sexual abuse.

In May 1984, the District Attorney filed a criminal complaint that superseded the indictment. It contained 208 counts involving 42 children. The defendants demanded a preliminary hearing that lasted an incredible 18 months—the longest in California history (see discussion of preliminary hearings and grand jury indictments in ¶8.09.3). (Under a recent change in California law, defendants cannot demand a preliminary hearing if they have been indicted by the grand jury.) Thirteen children testified. Some of them were on the stand for as long as 15 days and many of them told bizarre tales. In January, 1986, Judge Aviva Bobb ordered all seven defendants to stand trial on 135 counts. District Attorney Ira Reiner then dropped charges against five of the defendants in January 1986, calling the evidence against them "incredibly weak." In 1986, Judy Johnson, whose allegations about child abuse had triggered the whole McMartin mess, and who had been institutionalized for paranoid schizophrenia, died of liver damage brought on by chronic alcoholism.

The trial of Ray Buckey and his mother Peggy McMartin Buckey began in April 1987 and continued for over two and one-half years (then the longest criminal trial in

U.S. history). The child witnesses were grilled for days on end about differences between their current testimony and that given at the preliminary hearing or in earlier statements. Every detail of their memory was probed on cross-examination. On January 18, 1990, the jury acquitted Ray Buckey on 40 counts and deadlocked on 13 other counts. Peggy Buckey was acquitted on all counts. In 1990, Ray Buckey was tried a second time. Lael Rubin was not involved. Again the jury deadlocked, and the prosecution declined to try him a third time.

8.05.2 McMartin from the prosecutors' perspective

The prosecutors believed that Buckey was guilty of molestation, but they encountered severe problems in proving it. A prosecution witness testified that most of the original 42 children had suffered rectal or genital injuries that were probably caused by sexual abuse. This was a crucially important piece of evidence that was omitted from the film (and was misleadingly described in a scene involving DA Ira Reiner). The film also omits the trial testimony of the prosecution's child witnesses. As discussed below, it is difficult to prove sexual abuse of small children (or who committed the abuse, if any occurred) when the only witnesses are the children themselves. These problems were magnified in the McMartin case because parents allowed only 13 of the children to testify at the preliminary hearing and even fewer at either of the trials. Most parents understandably did not want to expose their children to more trauma. The manner in which McFarlane and CII had evaluated the children also severely hurt the prosecution's case. The obvious overcharging that occurred against the female defendants also harmed the prosecution's case against Ray Buckey.

8.05.3 McMartin—Effect on the participants

The McMartin case was a disaster for most of those concerned. The McMartin family was ruined financially, and their reputation was destroyed. Ray Buckey was held in jail for over five years, even though he was never convicted of anything. The case set off a hysterical reaction against day care centers and many were closed even though there was no hint of misconduct. Los Angeles County footed the costs of the preliminary hearing and two unsuccessful trials which ran well into the tens of millions of dollars.

Lael Rubin is still an L. A. County prosecutor; as the crawl at the end of the film states, her ambition to become a judge was thwarted by the lingering effect of the McMartin case. Danny Davis campaigned against her judicial nomination. Rubin made a comeback in 2001 under newly elected DA Steve Cooley and was given significant administrative responsibilities. The children who had to testify must have suffered serious emotional trauma (even more so, of course, if they actually had been abused). Robert Philibosian was defeated for re-election as District Attorney; Ira Reiner took his place and was defeated when he ran for California Attorney General.

Danny Davis went on to a successful career as a criminal defense lawyer. (The County paid him more than $1,000,000 in fees after the McMartins ran out of money.)

8.06 Cultural conflicts in notorious trials

Many times, notorious trials are culture-defining events—that is, a culture thinking about itself. In his book *When Law Goes Pop* (2000, 77), Richard Sherwin writes about notorious trials as the sites of cultural conflict. Writing of several famous trials, Sherwin states:

> Notorious trials in this respect are double trials. On the manifest level a particular event, some transgressive act of violence, let us say, is in dispute. Whodunit? Why? How? But on a symbolic level it is not about this particular victim or this particular defendant. It is about what it means, in some larger sense, for the event in question to have occurred at all.
>
> In approaching such trials we must be on the lookout for conflict in the way individuals and events are depicted. What kind of story is being told? What metaphors and stock characters are being evoked or silenced? In the clash of discourse, in court and out, lie clues to the battle of beliefs, values, and expectations that is being waged. For one of the hallmarks of the notorious case is its staging of competing world views . . . By trial's end some meanings will reign triumphant, some will hold on but for a little time longer, some may be nostalgically called into being within the mythic moment of trial and its publicly resonant aftermath, while still others will give way to the urgency of the new . . .
>
> In this view, then, notorious trials provide moments of great opportunity for collective insight and normative clarification. They are catalysts for increased dialogue and movement toward social and cultural change. Yet they often fail to realize that potential. Having been inadequately worked through, like a neurotic symptom, the underlying symbolic conflict is fated to return to haunt the public imagination anew. The ghost of unattended conflict will not rest until the urgency of its need subsides. (77)

The McMartin preschool case certainly qualified as a notorious trial. What cultural conflicts do you think were in play in the McMartin case? Were the conflicts "worked through" or will they "return to haunt the public imagination anew?"

8.07 Criticism of the media in Indictment

As its name implies, *Indictment* is just that—an indictment. It is an indictment of the criminal justice system *and* the media. The film's critique of prosecutorial abuse and overkill is interlaced with a critique of media misconduct and excess. From the moment of their arrest, the McMartins are hounded by television reporters and cameras. The coverage is so biased that the McMartins are tried and convicted in the court of

public opinion long before they are tried in a court of law. Wayne Satz, a local television reporter, parrots the prosecution's main theories by day while sleeping with the prosecution's main expert witness by night. Instead of questioning the credibility of some of the more outlandish accusations against the McMartins, the media lend them credence by whipping the public into a frenzy with far-fetched stories about a supposed national conspiracy of ritual child abuse by day care workers.

The film tries to convey the centrality of the media's role in fomenting public hysteria and demonizing the McMartins by building images of the media into almost every scene. Indeed, almost one third of the film's running time consists of scenes in which characters are either watching TV or video, being watched on TV or video, talking to the press, or standing in the vicinity of the press, a TV screen or a video monitor. Consider, for instance, the fact that the image of a television screen appears only four minutes into the film and the fact that Danny's first meeting with Ray is book-ended by two close-ups of the video camera filming them.

Perhaps nothing better illustrates the centrality of the role of the media than the way the filmmakers shot and edited the preliminary hearing. If they had wanted to portray the workings of the legal system, the filmmakers could have shot the entirety of the preliminary hearing from within the courtroom. Instead, they cut between the courtroom and the press room where the press is watching the hearing on closed-circuit television. Indeed, they even show a courtroom artist sketching the proceedings. In cutting back and forth between the hearing and the press watching the hearing, the filmmakers are trying to illustrate the way in which the media mediate reality. The public, after all, has no direct access to the preliminary hearing because it was not televised. Thus, the public is entirely dependent on the media's version of the event.

Danny Davis's marriage. One way that the film illustrates the pervasiveness of the media is through its representation of Danny's marriage. There are six scenes between Danny and his wife. Of the six scenes, four are structured around a television news story about the case. In the first scene, Danny is watching the initial news story about the McMartin case. The second scene is a brief shot of Danny saying goodbye to his wife as he leaves to visit Ray in jail; no television is present. In the third scene, Wayne Satz's interview with the jailhouse snitch is playing in the background as Danny pummels a punching bag and his wife comes home from shopping. In the fourth scene, Danny and his wife are at a bar watching Wayne Satz interview Kee McFarlane. In the fifth scene, Danny and his wife are watching Danny being interviewed on *Nightline*. The sixth and final scene between them is at breakfast when Danny shows his wife the newspaper story about Glenn Stevens's misgivings. Despite all the scenes between Davis and his wife before and during the trial, however, there are no scenes between them at the *conclusion* of the trial. Davis's wife simply drops out of the movie. It's almost as if she ceases to exist when the trial and the news stories about the case are over.

8.08 Prosecutors in popular culture

Indictment paints a harshly negative picture of prosecutors. Can you name other films or television shows that do the same thing? Have news reports about real trials cast prosecutors in an unfavorable light? Do some films or television shows show prosecutors in a favorable or even heroic light?[5]

8.09 The criminal justice process[6]

This section provides explanatory material on the criminal justice process. (Law students who are already familiar with criminal justice may wish to skip this part.)

8.09.1 Goals of the criminal justice process

The criminal process embodies a conflicting trilogy of goals. First, the state and federal governments have a monopoly on the legal use of force. We don't want the victims of crime to engage in personal vendettas. Instead, we want the police to catch criminals and prosecutors to cause them to be convicted and punished. Second, we want to protect individuals from being falsely accused of crimes and to assure that innocent people who are accused will be exonerated. Third, we want these two goals to be realized within a framework of limited government power.

This last point is particularly important. Some of the limits on government power in criminal justice are contained in a series of constitutional amendments called the *Bill of Rights*. Others are contained in other parts of the Constitution, state constitutions, federal and state statutes and rules of criminal procedure, and judicial decisions. For example, the police would probably uncover evidence of law-breaking if they randomly searched every home, but they are not allowed to do it. (See ¶10.05 on the law of search and seizure.) As a society, we would rather that crime go undetected than to allow the government so much arbitrary power.

8.09.2 Investigation, arrest, and first appearance

The criminal process usually begins with an investigation by the police that results in an arrest. As discussed in ¶10.05, searches, seizures, and arrests must be *reasonable* and sometimes require *warrants*. The reasonableness of the government's action in searching, seizing evidence, or making an arrest depends on a balance between the privacy rights of the individual and the strength of the government's evidence against the suspect. In general, to make an arrest or get a warrant, the police require *probable cause*, which means something more than mere suspicion.

In order to question a suspect in custody, the police must give the *Miranda* warnings which are discussed in ¶1.05.1. The suspect may stop the questioning and has a right to have a lawyer present if he wants one. Many suspects *waive* these rights and agree to talk with the police without the benefit of legal counsel.

After arrest, the suspect, who is often referred to as the *defendant* or the *accused*, will generally be taken to the police station to be processed (*booked*). Unless the suspect has already been released, he must be taken before a judicial officer *without unnecessary delay*, usually within 24 to 48 hours. Generally, a number of other preliminary matters are addressed at the first appearance. The suspect will be informed of his right to be represented by a lawyer (or to have a lawyer appointed if he cannot afford one), and the suspect will be informed of the charges against him. In some situations, the defendant will be asked whether he wishes to plead guilty or not guilty.

Bail. At the first appearance, the judge will also set *bail*. Bail is the amount the defendant must pay to be released from prison prior to trial (usually bail is advanced by a bail bondsman in return for a premium of about 10% of the total). If the defendant fails to appear for trial, the bail is forfeited. Generally, bail will be denied if the defendant is determined to be a flight risk or in the case of very serious crimes such as capital murder. In the case of minor crimes, the suspect may be released without bail—on his own recognizance.

8.09.3 Preliminary hearing or grand jury

The judge at the first appearance normally schedules a *preliminary hearing*. At the preliminary hearing the judge will rule on defense motions to suppress evidence because the evidence was unlawfully seized. If the evidence is suppressed, the case must often be dismissed because the prosecution has insufficient evidence to proceed. At the preliminary hearing, the prosecution must introduce sufficient evidence to persuade a judge that there is probable cause to proceed. The defense lawyer can cross-examine the prosecutor's witnesses (as Danny Davis did in the McMartin case), but often will not do so to avoid tipping the defense's strategy.

At the close of the preliminary hearing, the defendant may file a motion to dismiss the case on the basis that the prosecutor has failed to establish probable cause. The legendary Perry Mason won every case by demonstrating (almost always during the preliminary hearing) that the inept prosecutor had the wrong man. If the judge determines there is sufficient evidence to proceed, the prosecutor files an "information" which states the essential facts of the case and the charges against the defendant.

The grand jury. As an alternative to a preliminary hearing, the prosecution may choose to seek an *indictment* by the *grand jury.* In some states and in the federal courts, a grand jury indictment is mandatory for serious offenses. (In the McMartin case, there was both a grand jury indictment and a preliminary hearing; normally there will be one or the other.) The prosecutor presents evidence to the grand jury in a closed session and the defense has no opportunity to question witnesses. Sometimes prosecutors use the grand jury as an investigative tool (by compelling witnesses to show up and provide testimony) and often secure a grand jury indictment *before* arresting the suspect.

After the prosecution files the information or indictment, the defendant is *arraigned.* At the arraignment, the defendant will be asked how he pleads—"guilty" or "not guilty."

Plea bargains. In the great majority of cases (well over 90%), the prosecutor and the defense lawyer negotiate a *plea bargain,* in which the defendant agrees to plead guilty (often to a reduced charge or in return for a reduced sentence). Sometimes the defendant will agree to testify against other defendants in return for a reduced sentence. Plea bargaining is controversial but serves the interests of both sides. Given limited resources (judges, courtrooms, prosecutors, public defenders) the criminal justice system would grind to a halt if every case were tried.

8.09.4 The criminal trial

A defendant who pleads not guilty is entitled to be tried within a reasonable time. The defendant has the right to be represented by a lawyer in any case in which incarceration could occur. In the vast majority of cases, the defendant cannot afford to pay a lawyer so he is represented by a *public defender.* A defendant has the right to represent himself if the judge rules he is competent to do so.

The defendant has a right to a trial by jury for any crime carrying a potential punishment in excess of six months. Traditionally, there are twelve jurors, but the Supreme Court has allowed the states to use six-person juries and some states have done so. In federal criminal cases and in almost all the states, the jury must be unanimous to either acquit or convict. Anything short of unanimity is called a *hung jury;* the prosecutor can choose to dismiss the case after a hung jury or can try the case all over again (as occurred twice in the McMartin case). (A couple of states permit non-unanimous verdicts in criminal cases, and many permit non-unanimous verdicts in civil cases.)

The prosecution in a criminal case must establish the defendant's guilt *beyond a reasonable doubt.* This is a much higher standard than the *preponderance of the evidence* test used in civil cases (meaning a more-than-50% probability). The most common defense argument is that the prosecution has failed to prove its case beyond a reasonable doubt.

The trial begins by choosing a jury; in most states, the lawyers are allowed to question potential jurors (this is called *voir dire*) and can move to dismiss them *for cause* (for example, if the juror has made up her mind about the result of the case) or without cause (*peremptory challenge*). The next steps are opening statements, the prosecution's case, the defendant's case, sometimes rebuttal by each side, and closing arguments. The judge instructs the jury about the law and the jury retires, deliberates, and reaches a verdict.

Most of the evidence is introduced in the form of questions by the lawyers and answers by live *witnesses,* although *physical evidence* is usually introduced as well. The witnesses may be either *percipient witnesses* or *expert witnesses.* Percipient witnesses are those who actually saw events that are relevant to the case, such as the alleged abuse victims in the McMartin case. (Much scientific study indicates that eye-witness testimony, particularly identification of suspects, is frequently dead wrong.) *Expert witnesses* (discussed further in ¶¶8.10.5 and 12.03.6) assist the trier of fact by furnishing their opinion about issues that require expertise. Kee McFarlane in the McMartin case, the medical experts in *The Verdict,* or the psychiatrists in *Anatomy of a Murder,* are examples of expert witnesses. Each lawyer is allowed to *cross-examine* the witnesses put on by the other lawyer. A court reporter makes a verbatim transcript (*the record*) of everything said during the trial.

If the defendant is acquitted, he is released. If he is convicted, the judge will impose a sentence, usually at a separate hearing after reviewing relevant information. If the prosecutor seeks the death penalty, there is a separate "penalty phase" at which each side presents evidence as to whether the death penalty should be imposed (see ¶11.07). Defendants who are found not guilty by reason of insanity are normally committed to a psychiatric facility and kept there until the professionals decide that they are no longer a danger to society or themselves (this did not happen in *Anatomy of a Murder,* apparently because the insanity was temporary). If the defendant is convicted he may appeal to a higher court (sometimes all the way to the state or the U.S. Supreme Court), arguing that legal errors were made so that the verdict cannot stand.

8.09.5 Cameras in the courtroom[7]

Some state court trials are televised, particularly on Court TV, which offers gavel-to-gavel coverage. The Supreme Court upheld the constitutionality of televising trials over the objection of the accused. *Chandler v. Florida* (1981). However, the federal courts still ban cameras in the courtroom. Should this policy be changed?

8.10 Criminal procedure issues raised by Indictment

The McMartin case and *Indictment* raise a large number of legal and ethical issues.

8.10.1 Pretrial publicity[8]

Both sides in *McMartin* tried their case in the press, obviously attempting to influence potential jurors. The result was a media feeding frenzy (further discussed in ¶8.06). How to limit pretrial publicity presents difficult issues. On the one hand, some limits are necessary to protect the right of both sides to an unbiased jury that has not learned from the media about inadmissible evidence or made up its mind about the outcome. On the other hand, restrictions on pretrial speech interfere with the free speech rights of the lawyers and the defendant as well as the public's right to learn about the legal, social, or political issues in the case.

At the time of the McMartin case (or the O. J. Simpson trial), California imposed no formal restrictions on pretrial publicity (although judges often imposed "gag orders" on a case-by-case basis). Following the Simpson case, California adopted ABA Model Rule 3.6 relating to pretrial publicity (see box).

ABA Model Rule 3.6(a). This rule prohibits a lawyer from making an extrajudicial statement that is likely to be disseminated by the media "if it will have a substantial likelihood of materially prejudicing an adjudicative proceeding." Prosecutors can disclose information about the nature of the crime and the identity of the defendant (and his residence and occupation) as well as any other material that is a matter of public record. A defense lawyer can state the defense he intends to employ. In addition, a lawyer may make a statement required to protect a client from the prejudicial effect of publicity initiated by others (the self-defense exception).

Notice that Rule 3.6 inhibits only lawyers from speaking; it does not prevent the police from engaging in pretrial publicity or leaking information to the press. Prosecutors are required, however, to exercise reasonable care to prevent this from happening. When it does happen, the defense lawyer's right of self-defense should come into play.

8.10.2 Prosecutorial discretion[9]

Prosecutors have discretion to decide whether to prosecute a particular case brought to them by the police, how to investigate the crime, what charges to bring against the suspects, or whether to enter into a plea bargain. Obviously, not every person suspected of committing a crime is actually charged (or could be, given the limited resources of the criminal justice system). Prosecutors must allocate resources to the most serious offenses and the most culpable defendants, to cases in which justice

would be served through criminal prosecution (as opposed to some other method of remediation), and to cases in which they have better evidence and thus a better chance of securing a conviction.

Rules relating to prosecutorial discretion. ABA Model Rule 3.8 (a) provides that a prosecutor "shall refrain from prosecuting a charge that the prosecutor knows is not supported by probable cause." The comment to this rule states: "A prosecutor has the responsibility of a minister of justice and not simply that of an advocate. This responsibility carries with it specific obligations to see that the defendant is accorded procedural justice and that guilt is decided upon the basis of sufficient evidence." The ABA's Standards for Criminal Justice (which set forth nonbinding professional obligations) emphasize that a prosecutor's charging decision should take account of "the prosecutor's reasonable doubt that the accused is in fact guilty."

In practice, there are virtually no checks on prosecutorial discretion. In our system, there is no private prosecution. If a prosecutor refuses to charge someone with a crime, the victims are out of luck. In addition, if a prosecutor irresponsibly charges someone with a crime despite a lack of supporting evidence, there is little the accused can do about it except fight the charges in court or agree to a plea bargain. Prosecutors are immune from liability for damages brought by persons they might have wronged. They are very rarely subjected to professional discipline by state ethics boards or through internal proceedings in the District Attorney's office.

8.10.3 Bail

The fact that Ray Buckey, a suspect in a child molestation case, could not obtain release on bail for five years, was very unusual and appears to be an abuse of normal pretrial procedures. Several judges agreed with Lael Rubin's claim that Buckey might threaten or harm the children. At first, judges refused to set any bail; later, bail was set at $3.3 million, and Buckey could not raise it. Ultimately it was lowered to $1.5 million, which Buckey raised when 16 people offered their homes as collateral.

8.10.4 The duty to disclose exculpatory evidence

In *Brady v. Maryland* (1963), the Supreme Court held that due process requires prosecutors to disclose to the defense prior to trial "obviously exculpatory" evidence, even absent a request from the defendant. The word "exculpatory" means that the evidence would tend to clear the defendant.

Ethical rule. ABA Model Rule 3.8(d) requires a prosecutor to: "Make timely disclosure to the defense of all evidence or information known to the prosecutor that

tends to negate the guilt of the accused or mitigates the offense." This ethical rule requires disclosure of much more evidence than does the *Brady* standard. *Brady* is limited to evidence that would be admissible under the law of evidence and *Brady* only requires reversal of a conviction if the failure to disclose would probably have made a difference to the outcome of the trial. While the ethical standard is broader than *Brady*, it is rarely enforced through professional discipline of prosecutors.

Obligations of disclosure have been codified (that is, made the subject of a binding statute) in many states. Thus, in California, a statute (enacted after the McMartin case) requires prosecutors to turn over to the defense the names and addresses of witnesses the prosecution intends to call, any written or recorded statements of these witnesses, existence of felony convictions of key witnesses, items of physical evidence, and any exculpatory evidence. The defendant must turn over to the prosecution the names and addresses of its witnesses as well as their written statements and any physical evidence the defendant intends to offer as evidence. Did the prosecutors in *Indictment* violate rules relating to disclosure of exculpatory evidence?

8.10.5 Expert witnesses

A trial judge may allow an expert to testify and offer opinions in cases where scientific, technical, or other specialized knowledge will assist the trier of fact to understand the evidence or determine a fact in issue. The expert must be qualified by experience or training. Expert witness testimony is very common in contemporary trials; indeed, many trials come down to a battle of the experts. We saw expert witnesses used in *The Verdict* to prove medical malpractice and *Anatomy of a Murder* to prove insanity. Unfortunately, there is a good deal of suspicion about the impartiality of expert witnesses. They are well paid for their testimony and some people think they are mere "hired guns" who will say whatever the attorneys want them to say (or that they can be bought off, as apparently occurred in *The Verdict*).

Junk science. Before admitting expert testimony, a trial judge must assess whether the underlying reasoning or methodology employed by the expert is scientifically valid in light of such factors as testing, peer-review, publication and acceptance in the scientific community. So-called "junk science" is inadmissible. *Daubert v. Merrell Dow Pharmaceuticals* (1993).

Experts are needed in child molestation cases because the testimony of child witnesses is unreliable.[10] The children probably failed to report the abuse when it occurred, which undermines their credibility. Often they have not been completely consistent in their stories. Testifying at trial and facing cross-examination is stressful for anyone and exceptionally so for a small child. The children are trying to recall things

that happened to them months or years ago that they did not understand at the time. Often they must respond to baffling questions, so their testimony appears hesitant, confused, or inconsistent. Many times, the alleged abuser is someone the child loved and trusted (particularly in cases of parental abuse but also in case of abuse from teachers, day care workers, or religious figures). Perhaps the child has been subject to pressure or to suggestions from abusers, parents, police, social workers, and so forth. All these problems present tremendous difficulties for prosecutors in child abuse cases as it did in *Indictment*.

Because of these difficulties, expert witnesses play an important role in child abuse cases. The experts can explain why the child's behavior seems inconsistent with abuse (such as delays in reporting or recantation of allegations). The experts can also explain other aspects of the child's behavior that may corroborate the abuse, such as night-mares, sleep difficulties, or withdrawal from social relationships. The most controversial type of expert testimony (as in *Indictment)* occurs when the expert draws on her own evaluation of the child and testifies that the abuse actually occurred and the child is being truthful.

An expert who is trying to determine the truthfulness of a child's account of abuse looks for various clues. Some important indicia of trustworthiness are the explicitness and detail of the child's story, the apparent spontaneity of the child's description and choice of words, whether the child has a motive to fabricate the story, and the consistency of the story with the cognitive abilities and sexual awareness expected of a child of that age. Typically, the experts employ families of dolls with anatomically correct genitalia to allow the child to demonstrate what happened. Mental health professionals believe that they can determine whether the child has been sexually abused from the way a child plays with the dolls.

Questionable methodologies. The methodologies used by experts, particularly to determine the truthfulness of the children's accounts, have been the subject of intense controversy because young children are extremely suggestible. *Indictment* illustrates severe problems of leading questions, suggestions, or even intimidation or pressure by the interviewer. These techniques can easily create or change a child's memory of the events in question.[11] Research concerning the anatomically correct doll methodology casts doubt on its reliability. Several court decisions have required judges to exclude testimony in which the expert opines that the child is telling the truth; this kind of testimony interferes with the function of the jury and is extremely prejudicial to the defendant.

8.11 Defending the guilty

In the traditional courtroom narrative, criminal defense lawyers are represented as courageous defenders of the victims of police or prosecutorial misconduct. In fact,

however, the vast majority of criminal defendants are guilty of the crimes with which they are charged; the job of their defense lawyer is to negotiate the best plea bargain possible. Even when criminal cases go to trial, the defense lawyer is often aware that the client is probably guilty of the crimes charged, but the client decides to roll the dice rather than accept a plea bargain.

Many people ask how lawyers can represent clients who the lawyers believe are probably guilty or even whom they know for certain to be guilty. People also wonder how lawyers can cross-examine and discredit (even humiliate) witnesses, whom the lawyer knows to have testified truthfully. Certainly, in *Indictment* Danny Davis at first assumed that the McMartins were guilty of child abuse, but he enthusiastically agreed to represent them. Why?

Unpopular clients. A basic principle of legal ethics is that a lawyer can and should take on the defense of unpopular clients, especially those that cannot afford to pay. As ABA Rule 1.2 states: "A lawyer's representation of a client . . . does not constitute an endorsement of the client's political, economic, social or moral views or activities." Thus, it is possible for the most honorable of lawyers to represent the most despised or depraved clients because the mere fact of representation does not indicate that the lawyer approves of the client's views or actions.

Under legal ethics, the defense of the guilty is perfectly appropriate. ABA Rule 3.1 provides that a lawyer generally should not bring or defend a proceeding unless there is a non-frivolous basis for doing so. However, the rule for criminal defense lawyers is different. "A lawyer for the defendant in a criminal proceeding . . . may nevertheless so defend the proceeding as to require that every element of the case be established."

An earlier ABA Canon of Professional Ethics stated this well-accepted principle: "It is the right of the lawyer to undertake the defense of a person accused of crime, regardless of his personal opinion as to the guilt of the accused; otherwise innocent persons, victims only of suspicious circumstances, might be denied proper defense. Having undertaken such defense, the lawyer is bound, by all fair and honorable means, to present every defense that the law of the land permits, to the end that no person may be deprived of life or liberty, but by due process of law."

This is a key idea: In a government of limited powers, nobody can be convicted of crime unless the proper *procedures* have been followed; one of those procedures is that government must prove the accused guilty beyond a reasonable doubt. This is what might be called "procedural justice." Of course, procedural justice may conflict with "substantive justice," which calls for convicting and punishing the guilty.

The basis for procedural justice is that we often are not sure who is guilty and who is innocent, who is telling the truth and who is lying. Which members of the McMartin family are guilty and what are they guilty of? Which children are telling the truth and which ones are parroting lines made up for them by someone else? We are never sure,

and neither is Davis. A jury or judge should make that call, not the lawyer. To lawyers, justice consists of providing everyone with fair and appropriate procedural protections, making every legitimate argument on the client's behalf (as Biegler did for Manion in *Anatomy of a Murder*). This remains a lawyer's obligation even if the result is that some guilty people will go free (or receive punishment that is less than their due).

Another key justification for criminal defense arises from the great power of the state. The police and the prosecutors have enormous power, which they sometimes abuse. Every criminal defendant deserves to have a capable, zealous defender at his side to help offset the imbalance between the power of the state and the lack of power of the individual. Certainly, that's a major theme in *Indictment*.

Thus, it is clearly ethical to defend clients that the attorney knows are guilty. However, is it moral? From a *moral* point of view, how can an attorney justify taking action that might return a vicious criminal to the streets? How can an attorney justify discrediting a witness on cross-examination whom the lawyer knows to be telling the truth?

8.12 Review questions

1. Select an example of film editing in *Indictment* other than those mentioned in ¶8.01. What were the director and film editor trying to achieve?

2. A "realistic" film means a film that seems "true to life" to spectators. Such a film might or might not be based on actual historic events. Choose a "realistic" film (other than *Indictment*) and indicate whether it fits the "generalizations" set forth in ¶8.02.4. What techniques does the filmmaker use to make the film seem "realistic?" Is the filmmaker trying to get you to accept a particular point of view about the events in question? A particular political ideology? (Review ¶1.06 in answering this question.)

3. Many films or TV docudramas have been based on actual historic events or on people who really existed. Choose such a movie (other than *Indictment*) and explain what you learned from it about actual events or people. (You can use the films discussed in ¶8.03 or any others you have seen.)

4. If you were a juror and your only source of information on the McMartin case was the film *Indictment,* would you find Ray Buckey guilty or not guilty? Why? Does the information provided in ¶8.05 change your view?

5. The film *Indictment* criticizes both the criminal justice system and the media (but not itself). Select a scene (other than one described in ¶8.07) in which the film appears to criticize the media.

6. Sherwin describes notorious trials as arenas in which deep cultural and normative conflicts are played out and are either resolved or deferred (¶8.06). What cultural or normative conflicts were at war in the McMartin case and how, if at all, were they resolved?

7. Did the prosecutors in the McMartin case (as portrayed in *Indictment*) violate any legal or ethical duties?

8. If you had no source of information about prosecutors except for popular culture or television news reports about notorious trials, what would your opinion of the character, competence, and behavior of prosecutors be?

9. Do you think that high-profile cases like the O. J. Simpson case should be televised? Should the federal courts change their policy banning cameras in the courtroom?

10. Criminal defense lawyers frequently represent clients whom they know to be guilty. Do you believe that such action is unethical or immoral?

The Criminal Jury

Assigned film: 12 Angry Men (1957)[1]

9.01 12 **Angry Men**—*Prequel and sequel*

This motion picture is based on a critically acclaimed television drama of the same name.[2] Written by Reginald Rose (1920–2002) for CBS's anthology series *Studio One*, *12 Angry Men* aired on September 20, 1954, and garnered Emmys for Rose, director Franklin Schaffner, and lead actor Robert Cummings. Rose also wrote and produced the lawyer-centered television series *The Defenders* which ran from 1961–65 (see ¶7.01.1). A strong civil libertarian, Rose brought his political views into his work. The motion picture version of *12 Angry Men*, directed by Sidney Lumet[3] and starring Henry Fonda, received three Academy Award nominations (it won none), but sputtered at the box office. Late in 2003, the Internet Movie Data Base ranked it as the 22nd best movie of all time, based on rankings provided by its registered juror-users.

The many lives of *12 Angry Men.* *12 Angry Men* has become the best known Hollywood movie about juries. Sequences from it appear for comic effect in *Jury Duty* (1995) starring Pauly Shore. It is referred to in the 2003 Masterpiece theater miniseries *The Jury* (see ¶9.04); at one point, the jurors select a foreman because he looks like Henry Fonda. *12 Angry Men* itself was remade for television in 1997 by Showtime, with Jack Lemmon assuming the crucial role earlier played by Cummings and Fonda. The remake closely follows the original script, but casting changes distinguish it from the 1957 version. A woman plays the judge and the jury is ethnically diverse. Indeed, the most bigoted member of the jury is an African American nationalist who hates Hispanics. The jury remains all male—even though theater companies sometimes perform a Rose-adapted script entitled *12 Angry Jurors* containing jurors of both sexes.

9.02 Direction and cinematography in 12 Angry Men

9.02.1 Camera placement and movement

Many TV shows of the 1940s and early 1950s, including *Studio One,* were broadcast live. As a result, they gravitated toward material that could be shot in studio with a limited number of set changes (usually three or less). Rose tailored his script to these constraints: The teleplay was set indoors and required only a single set. Normally, Hollywood "opens up" stage plays when it adapts them to film. Most moviemakers feel that their work would lack "cinematic quality" if the action remained static and confined to two or three settings.

However, the film version of *12 Angry Men* did not open up the teleplay. Except for a three-minute precredit sequence, a brief interlude in the men's restroom, and a closing sequence on the courthouse steps, the film version takes place entirely in the jury room. One explanation for this unusual decision is that director Sidney Lumet had worked in live television. In addition, Rose and Lumet confronted budgetary restraints. They produced the film independently; it was released through United Artists.

Still, *12 Angry Men* distances itself from the earlier live television drama. Lumet orchestrated elaborate, intricate camera movements of a sort that would be impossible in live television. Consider, for instance, the extraordinarily long take—six and one-half minutes—that follows the pre-credit sequence. The camera begins the scene perched at a high angle above a fan on the wall. The camera remains in this position for the minute that it takes for the credits to roll. Then, after the jurors have filed into the small, hot room, the camera plunges viewers into the thick of things, roaming from character to character, picking up little snippets of conversation. Lumet returns to this roving-camera technique throughout the film as a way of isolating the brief, quasi-private exchanges that intermittently take place between the jurors. Although these exchanges do little to advance the story line, they flesh out the character and personalities of the jurors and create a sense of intimacy between them and the filmic audience. The aim, it seems, is to address viewers as if they were also sitting in this jury room. Additionally, with its camera almost constantly on the prowl, *12 Angry Men* seeks to counteract the sense of stasis that might otherwise pervade a movie filmed in such a confined setting.

Lumet also uses camera movement and placement to create a sense of spatial variety. Although the size of the room remains constant, Lumet expands and contracts screen space through camera movement. Scenes typically open wide, with several characters visible in the frame, but as the scene progresses, the camera slowly closes in on one of the characters until that character occupies the entire frame. Take, for instance, the scene in which Juror No. 10 (Ed Begley, Sr.) describes children from the slums as "real trash." Despite the fact that Juror No. 10 is speaking for most of the scene, Lumet shoots the scene from behind him. We see only the back of his right

shoulder and arm on the left side of the screen. The characters facing the camera are Juror No. 4 (E. G. Marshall) and Juror No. 5 (Jack Klugman). As the scene proceeds and Juror No. 10 continues his racist rant, the camera slowly closes in on Juror No. 5, who becomes progressively more perturbed by the tirade. The scene reaches a climax when Juror No. 5 finally speaks up. Lumet tries to convey the rising tension, as well as Juror No. 5's escalating indignation, by having the camera slowly close in on him until he occupies the entire frame in a medium close-up. What was once a two-shot of Jurors Nos. 4 and 5 thus becomes, almost imperceptibly, a one-shot of Juror No. 5.

9.02.2 Focus on one character while another speaks

This sequence also illustrates another technique used throughout the film. The camera focuses on one character while another is heard talking off-screen. For instance, at one point, the normally level-headed Juror No. 1 (Martin Balsam) loses his cool when he is called a "kid" by Juror No. 10. After being coaxed back into his chair, Juror No. 1 sits down, turns his back to the others, and pouts. At this point, Juror No. 8 (Henry Fonda) offers to explain his reasons for voting to acquit the defendant ("Well, if you want me to tell you how I feel about it, it's all right with me"). This is an important dramatic moment, as Fonda's character has previously refused to state the reasons for his "not guilty" vote, leaving it to the others to convince him to support a conviction. But instead of cutting to Fonda at this crucial moment, Lumet has the camera linger on Juror No. 1. We can hear what Fonda is saying, but we *see* Juror No. 1. This is an interesting filmic choice that illustrates Lumet's use of screen space as a way of conveying the psychological distances that separate these men from one another.

9.02.3 Close-ups and editing

Perhaps the film's most arresting technique, however, is the use of tight close-ups. When Juror No. 9 (Joseph Sweeney) announces that he has changed his vote to "not guilty," his face is framed in a tight close-up. (Tight close-ups are sometimes known as "choker close-ups.") Later, when Juror No. 3 (Lee J. Cobb) is forced to explain why he is the sole remaining vote for conviction, he is also framed in tight close-up. The use of choker close-ups at such moments provides a visual way of communicating the psychological isolation that the characters are then feeling. Choker close-ups also suggest a certain level of intensity and passion, which may explain why the mercurial Juror No. 3 is so frequently framed in choker close-ups while Fonda's icy, more rational Juror No. 8 is not. Although Fonda is no less intransigent than Juror No. 3 (indeed, he is more so!), his character, even in close-ups, is framed less tightly than Juror No. 3.

In contrast to *Anatomy of a Murder,* which relies heavily on long takes, *12 Angry Men* relies in almost equal measure on long takes and editing. (Notice, for instance, how the jury's voting is sometimes filmed in a long take and sometimes in a series of short

shots.) Generally speaking, though, the film tends to rely more heavily on long takes early in the narrative and more heavily on editing later in the film. In both instances, however, these techniques translate a rather static teleplay into a more dynamic cinematic experience.

9.03 Fonda's "star" image and intertextuality in legal films[4]

Henry Fonda had been a major Hollywood film star for more than twenty years before making *12 Angry Men* and had appeared in a number of other legal movies. Most famously, he starred in an earlier courtroom drama, *Young Mr. Lincoln* (1939), in which (as Abraham Lincoln) he represents two boys who, like the defendant in *12 Angry Men,* were on trial for murder.

Movie stars such as Fonda, John Wayne, Paul Newman, and Clint Eastwood become "iconic" or "representative" figures. As they move from role to role, film stars accumulate meanings that travel with them. Iconic figures such as Fonda, argues the media theorist S. Paige Baty (1995), help people see their nation's institutions and values in action. Baty suggests that representative figures can offer consumers of popular culture "a common means of relaying stories" and can "incorporate citizens into a representational nation," in which fictional tales and powerful images about law continually circulate.

The iconic Clint Eastwood. William Ian Miller (1998) argues that Eastwood might be seen as the popular, iconic embodiment of the heroic individual who acts alone in order to compensate for the supposed inability of the legal process to produce justice. As "Dirty Harry" Callahan or the aging gunfighter William Munny in *Unforgiven* (1992), Eastwood's character invariably does justice, even if he has to break legal rules and use violence to accomplish his goal.

Over his long Hollywood career, Henry Fonda became another iconic figure who often confronted the apparent limitations of the law. In movie after movie, Fonda portrays a kind of a populist everyman, a commonsense character who can see issues more clearly than other people, particularly those trained in the law, and who will stand up, alone if necessary, to address potential legal wrongs. In addition to Young Abe Lincoln, Fonda portrays Tom Joad, the idealistic, justice-seeking young "Okie" in John Ford's *The Grapes of Wrath* (1939). In *The Oxbow Incident* (1943), he is the only person willing to confront a lynch mob (though he is unsuccessful). The year before *12 Angry Men*, Fonda starred in Alfred Hitchcock's *The Wrong Man* (1956), portraying an innocent person trapped in a vast legal bureaucracy that nearly convicts him of armed robbery. Near the end of his life, he portrayed the famous defense law-

yer Clarence Darrow in a one-person play and another wrongly convicted criminal defendant in the made-for-TV docudrama *Gideon's Trumpet* (1981). Today, many viewers of *12 Angry Men* cannot help but see Fonda's performance in light of his other screen roles and, more broadly, the iconic character he constructed during more than forty years of motion picture stardom.

In contrast to the characters played by Clint Eastwood, those portrayed by Henry Fonda confronted injustice with words rather than gunplay. Fonda's famous speech in *The Grapes of Wrath,* where Tom Joad promises to "be around in the dark," standing up against illegal acts by the powerful, has become a classic argument on behalf of a populist idea of justice. Preserving legal forms and protecting rights is not, in this view, only the responsibility of lawyers and judges but of every citizen. Fonda's role in *12 Angry Men* updates his earlier portrayals of young Abe Lincoln and Tom Joad and anticipates his roles as Clarence Darrow and Clarence Earl Gideon.

Thus, it is not simply Juror No. 8 but Henry Fonda who steps forward in *12 Angry Men*. Regular movie-viewers expect his character to defend fundamental legal principles, such as the presumption of innocence and the necessity for evidence of guilt beyond a reasonable doubt. From the outset, viewers receive a powerful cue as to how this narrative will end. Much of the dramatic tension in *12 Angry Men* comes from *how* Fonda uses words and arguments to make the process of jury deliberation accord with legal and constitutional ideals.

9.04 The jury in the trial film genre[5]

In most courtroom films and TV shows, the jury must decide the defendant's fate; the uncertainty of its decision provides the necessary suspense element in the story. The jury verdict comes at or near the end of the film and provides a logical climax to the hard fought trial that preceded it. As Carol Clover (1998) points out, the genre calls upon us—the viewers of the film—to serve as the "thirteenth juror." We may or may not know more than the jury does about what actually happened, but we are almost always called upon to decide what our verdict would be. Guilty or not guilty? Prison or the death penalty? However, we seldom learn anything about the personality or background of our "fellow" jurors. Among the few exceptions are *The Jury* (2003), a TV miniseries presented by Masterpiece Theater that focused more on the murder-trial jurors than on the trial and a couple of films involving jury tampering—*The Juror* (1996) and *Trial by Jury* (1994).

12 Angry Men brilliantly overturns these genre conventions by devoting almost all of its screen time to the jury's deliberations and by focusing intensely on the personalities of the twelve jurors. At the start, the movie encourages us to agree with the eleven jurors who vote guilty. The evidence against the defendant seems overwhelming.

However, when Juror No. 8 and, later, some of the other jurors raise doubts about various elements of the prosecution's case, we begin to waver—just like the jurors in the film. In fact, the arguments made by the various jurors serve the same function as the prosecution and defense presentations in the typical trial movie. Fonda's Juror No. 8 justifies this substitution of jurors for lawyers by arguing that the defendant's lawyer seemed to have little interest or faith in his client's case. This is one reason for his own advocacy for the young boy's cause. Thus, the film is more like the typical courtroom drama than it might seem at first glance.

Finally, we, as the surrogate jurors, find ourselves voting "not guilty" as the film jurors do. However, should we have voted this way? Wasn't there enough evidence against the defendant to meet the reasonable doubt standard, despite everything that Juror No. 8 says to cloud the issue? Did Juror No. 8 do a number on us, just like a skillful defense lawyer sometimes manages to do? *12 Angry Men* suggests that we are more likely to get justice from a jury than from a judge—the judge we saw at the beginning of the film had trouble staying awake and surely thought the question of guilt was open and shut.

Certainly, the idea that the jury system promotes justice is a bedrock principle of our legal system. *12 Angry Men* and countless other films and TV shows have sent that message to generations of pop culture consumers. However, is that message correct? We examine arguments on both sides of that issue in ¶¶9.06 and 9.07.

9.05 Constitutional role of the American jury

The American legal system relies on juries as fact finders more than any other country in the world. In part, the reason for this is constitutional. The 6th Amendment provides: "In all criminal prosecutions, the accused shall enjoy the right to a speedy and public trial, by an impartial jury of the State and district wherein the crime shall have been committed . . ." In addition, the 7th Amendment, which deals with civil lawsuits, provides: "In suits at common law, where the value in controversy shall exceed twenty dollars, the right of trial by jury shall be preserved . . ." Both amendments were approved in 1791 as part of the Bill of Rights (the first ten amendments to the Constitution) to meet concerns of the Antifederalists that the original Constitution failed to protect basic rights and freedoms. The Bill of Rights was originally applicable only to the federal government, but the Supreme Court has applied most of its provisions to the states. The Court has not applied the Seventh Amendment to the states, but virtually all state constitutions protect the right to trial by jury in both civil and criminal cases.

As a result, most civil or criminal cases must be tried by a jury unless both sides agree to waive the jury and have the case heard by the judge (a "bench trial"). (In some

states, the defendant alone has power to waive a criminal jury.) The constitutional right to jury trial does not apply to "petty" criminal cases ("petty" means potential confinement of six months or less) or to civil cases that are not "suits at common law" (meaning a type of litigation different from the traditional suits for money damages recognized at the time the Constitution was written). Generally, under state and federal law, juries are still available even in "petty" criminal cases, although the Constitution does not require it. Even when criminal cases are plea bargained or civil cases are settled rather than tried (as the vast majority are), the lawyers who negotiate the deal are vividly aware of how a jury would likely size up the facts. In short, the jury is fundamental to any study of American law.

9.06 Conflicting visions of the jury—The brighter vision[6]

Beyond the constitutional imperative, the jury is deeply rooted in American consciousness as a bulwark against abuse of power by the state. The jury is supposed to be the conscience of the community. *12 Angry Men* offers an eloquent brief for the American faith that the jury system is the best way to achieve justice.[7]

The jury system seems an admirable example of deliberative democracy in action. Most government decisions are made by elites—governors, presidents, judges, legislatures—or by powerful government employees like the police or prosecutors. Ordinary people are represented only indirectly, if they are represented at all. The jury is quite different. Nowhere else in our society (except perhaps in a town meeting of a small town) do we find ordinary people deliberating with one another to resolve a vitally important government function—how the laws will be executed. (Until some time in the nineteenth century, this was truer than it is today since juries used to decide questions of law as well as fact.) Recall the remarks of Parnell McCarthy in *Anatomy of a Murder:* "Twelve people, with twelve different minds, with twelve different sets of experiences . . . and in their judgment they must become of one mind—unanimous. That's one of the miracles of man's disorganized soul, that they can do it, and in most instances do it quite well. God bless juries!"

Polling data. A recent survey commissioned for the American Bar Association (1999) showed that 78% of respondents agreed with the statement "The jury system is the most fair way to determine the guilt or innocence of a person accused of a crime." Only 12% disagreed. Sixty-nine percent of respondents thought that juries are the most important part of our judicial system. In contrast, only 30% of respondents had confidence in the U.S. justice system, 32% had confidence in judges, and 14% had confidence in lawyers.

9.07 Conflicting visions of the jury—The darker version

9.07.1 Rationality of jury verdicts

There is a darker vision of the jury system, one illustrated by the racist jury verdict in *To Kill a Mockingbird*. Subscribers to the darker vision portray juries as irrational decision makers who are governed by emotion, whimsy, prejudice, or by irrelevant considerations such as the ethnicity of the defendant or the victim or the personalities of the contending lawyers. Many of the statements by jurors in *12 Angry Men* show how race or class prejudice can enter jury deliberations. In addition, juries sometimes have difficulty keeping straight all the testimony they have heard in a long trial or understanding the judge's instructions about the law, so they must rely on their gut feelings in deciding the case.

Jerome Frank was an astute federal appeals judge and a respected legal scholar. In his 1949 book *Courts on Trial,* a classic work of legal realism (see ¶1.04.3 for discussion of legal realism), Frank expressed deep skepticism about the validity of fact findings by judges and juries. He pointed out that the trial process usually involves witnesses who are guessing about what really happened (and often witnesses are biased or just plain lying) and fact-finders who are guessing about which witnesses should be believed. Frank was particularly caustic in his appraisal of juries:

> Many juries in reaching their verdicts act on their emotional responses to the lawyers and witnesses . . . they like an artful lawyer for the plaintiff, the poor widow, the brunette with the soulful eyes, and dislike the big corporation, the Italian with a thick, foreign accent. We do not have uniform jury-nullification of harsh rules [see ¶9.12 for discussion of jury nullification]; we have juries avoiding—often in ignorance that they are so doing—excellent as well as bad rules, and in capricious fashion. (130)

> Now I submit that the jury is the worst possible enemy of this ideal of the "supremacy of law." For "jury-made law" is, par excellence, capricious and arbitrary, yielding the maximum in the way of lack of uniformity, of unknowability . . . Indeed, through the general verdict [meaning that jurors do not give their reasons, only their conclusions] coupled with the refusal of the courts to inquire into the way the jurors have reached their decisions, everything is done to give the widest outlet to jurors' biases . . .
>
> The jury system, praised because, in its origins, it was apparently a bulwark against an arbitrary tyrannical executive, is today the quintessence of governmental arbitrariness. The jury system almost completely wipes out the principle of "equality before the law" which the "supremacy of law" and the "reign of law" symbolize—and does so, too, at the expense of justice, which requires fairness and competence in finding the facts in specific cases. If we have a "government of men," in the worst sense of that phrase, it is in the operations of the jury system. (132)

Those who question the utility of the jury system point out that, under our current practices, the only jurors who are seated in notorious cases are the ones who claim

they know or have heard nothing about the dispute because they never read the papers or watch TV news. As a result, they probably do not know much about anything else. The doubters say that on the whole we would be more likely to achieve substantively correct results if judges rather than juries found the facts (or if the facts were found by a panel of judges and lay assessors as described in ¶9.07.3). Had there been no Juror number 8 (and usually there is no such person), the jury in *12 Angry Men* would certainly have rushed to judgment. In addition, many people criticize the jury verdicts in several high-profile criminal cases of the 1990s, such as those of O. J. Simpson, Rodney King, William Kennedy Smith, or in civil cases such as the famous McDonald's hot coffee case. Who knows how many irrational jury verdicts are never discovered or publicized?

9.07.2 Efficiency of the jury system

The jury system is highly inefficient. The process of selecting and instructing juries, the complex rules of evidence (which are primarily designed to keep certain types of evidence, such as hearsay testimony, away from jurors), and the time taken for jury deliberations all greatly slow down the trial process. Hung juries are not uncommon (perhaps 5% of criminal juries are hung—in some areas much more); a hung jury requires the case to be tried all over again. Juries greatly increase the cost of operating the judicial system and are partially responsible for significant delays and backlogs in that system.

Impact of the jury system on the jurors. Most of the jurors are conscripted to serve against their will. The pay for jury service usually amounts to a pittance. Jury service pulls the jurors away from their jobs, their businesses, and their lives, often for an extended period. Often, jurors suffer serious inconvenience and sometimes real financial hardship. The burden on individual jurors is worst if the jury is sequestered, as sometimes occurs in notorious cases. Generally potential jurors must sit around the courthouse for hours or even days while waiting to be called for a jury panel. Then, many are disqualified through peremptory challenges that, in effect, dispute their ability to be impartial. They have to sit through trials that may be unbearably tedious.

9.07.3 Decline of the jury worldwide[8]

Some countries (such as Canada, Australia, and Great Britain) use juries but only in serious criminal cases. In Britain, for example, about 25% of criminal trials are heard by juries, in Australia and Canada far less. Spain, Norway, and Denmark use juries in criminal cases but very rarely. Several of the countries of the former Soviet Union have recently introduced jury trials for serious offenses, but so far few jury trials have

occurred. Most European countries use a system in which professional judges and lay judges ("assessors") decide criminal cases together. In Germany, for example, in cases of serious crimes, there are three professional and two lay judges and a two-thirds vote is needed to convict. Local government bodies select a panel of lay judges who hear cases for several months. They are assigned to individual cases by lot. In France, very serious criminal offenses are tried by panels of three professional judges and nine lay jurors; conviction requires eight votes.

9.08 Empirical research on juries[9]

The most famous empirical study of criminal juries was conducted by Harry Kalven and Hans Zeisel (1966). Among their findings was that "with very few exceptions, the first ballot determines the outcome of the verdict" (488). The jury's deliberations after taking the first ballot had no effect on the final verdict in nine of every ten cases. When there were seven to eleven votes to convict on the first ballot, the ultimate verdict was guilty in 86% of cases, acquittal in 5%, hung jury in 9%. This finding shows that the thesis of *12 Angry Men* is unlikely, though not impossible. Where the first vote was lopsided (especially where it was 11 to 1), peer pressure almost always forced the holdouts to agree with the majority. However, Kalven and Zeisel found that in about ten percent of cases, the minority eventually succeeded in reversing the initial majority or in hanging the jury. Even so, these ultimately successful minorities usually had four or five votes, not just one (Abbott 1999). Generally, when there is a single juror who refuses to budge, the result is a hung jury, not the eleven changing their votes to join the one.

Kalven and Zeisel (Kalven 1964) found that judges would have reached the same verdicts as civil and criminal juries about 80% of the time. That obviously leaves a large number of cases in which the judges and juries disagreed. In criminal cases, the judges were much more likely to disagree with jury decisions to acquit the defendant than to convict the defendant. In civil cases, the differences between judges and juries split evenly between plaintiffs and defendants. However, juries awarded damages of about 20% more than judges would have in civil cases.[10]

9.09 Role of the jury[11]

The jury's job is to find the facts and apply the law (as explained to them in the judge's instructions) to those facts. (As observed in ¶9.06, juries used to find the law as well as the facts, which gave them vastly more power than they have today.) The jury cannot consider any information not presented to them during the trial. Thus, Juror No. 8's purchase of a knife and its use in jury deliberations was serious misconduct.

In previous eras, jurors could be expected to know the litigants. In *To Kill a Mockingbird*, for example, the jurors obviously were well acquainted with the Ewells and with Tom Robinson. This has now changed, at least in big cities and larger towns. Jurors are disqualified if they know the litigants or the attorneys or if they have any personal knowledge about the dispute. Thus, the jurors must depend on what they hear and see at the trial rather than their own personal knowledge about the facts of the case or the personalities involved.

Historically, the jury was expected to be totally passive during a trial. Many judges even prohibited jurors from taking notes. Jurors could not ask questions and were not allowed to discuss the case with one another (or with anyone else) until jury deliberations began. Because jurors have nothing in common with each other except for the case they are hearing, it is likely that the no-discussion rule was violated frequently.

These extreme "passivity rules" are beginning to change. Most judges now allow the jurors to take notes. Increasingly, the jurors are given notebooks containing copies of the trial exhibits. Often judges give instructions at the beginning of the trial, so jurors know what they're supposed to be looking for. Some jurors are given written copies of the judge's instructions. Increasingly, judges' instructions are written in plain English rather than inscrutable legalisms.

Arizona has taken the lead in rethinking the role of jurors. There, jurors are permitted to submit questions to the judge; after the attorneys have had an opportunity to object to the questions, the judge puts the jurors' questions to the witness. In addition, Arizona jurors are allowed to discuss the case during the trial provided that all of them are present for the discussion and they avoid committing themselves to a particular outcome.

9.10 Race and gender discrimination in jury pools

9.10.1 Historic discrimination in selection of jury pools

The jurors in the 1957 version of *12 Angry Men* are all male and apparently of European ancestry. Historically, American and British juries were composed exclusively of white males (in many places jurors were also required to be property owners and sometimes to be members of a particular religion). There is no recorded instance of a black juror in any state, North or South, until 1860. Women were ineligible for jury service in every state until 1898 when Utah allowed them to be jurors. Today, an all-male, all-Caucasian jury would be extremely unlikely; equal numbers of men and women serve as jurors and, at least in big cities, members of minority groups are certain to be well represented.

For many decades, the Supreme Court tolerated all-white jury panels as long as the law did not explicitly require that jurors be white. One key case in the Court's move

toward requiring nondiscriminatory jury pools was its second encounter with the Scottsboro Boys case in 1935 (see ¶3.03.6); the Court reversed the convictions on the basis that no blacks had ever served on juries in the Alabama county where the trials took place.

Blue-ribbon juries. Until recently, state and federal jury commissioners had great discretionary power to decide whose names would be in the jury pool. In many states and in most federal courts, the commissioners chose people that they knew were educated and responsible (so-called blue-ribbon juries). This process, of course, tended to keep minorities, women, and working people off of juries. In 1968, a federal statute required that federal court jurors had to be drawn randomly from a pool that would constitute a cross-section of the community; that was the end of the blue-ribbon jury in federal court.

Finally, in *Taylor v. Louisiana* (1975), the Supreme Court extended this rule to the states. *Taylor* held that the pool from which the names of jurors are randomly drawn (ordinarily voter registration lists and sometimes driver's license lists) must represent a fair cross-section of the community, including women, minorities, and working people. In particular, women could not be excluded from the pool. No jury could be impartial, the Court held, unless it was drawn from sources representative of all segments of the community. *Taylor* expressed the idea that the legitimacy of our system of justice depends upon the representation of all segments of the community on juries.

9.10.2 The Batson *rule*

More recently, the Supreme Court prohibited lawyers from using their peremptory challenges to strike jurors because of their race (*Batson v. Kentucky* [1986]). *Batson* was later extended to cover civil as well as criminal cases, to prohibit race-based challenges by the defense as well as the prosecution, and to prohibit sex-based challenges as well as race-based challenges. Prior to *Batson,* it was common for prosecutors to exercise their peremptory challenges to strike all black jurors, particularly in cases involving black-on-white crime. As a result, such defendants faced all-white juries. Certainly *Batson* and subsequent cases are a giant step toward legitimizing the jury system.[12]

Batson in practice. The *Batson* doctrine is difficult and time-consuming to administer. Consider this example. A prosecutor challenges several black jurors in a case of black-on-white crime. The prosecutor offers apparently plausible, nonracial reasons for her decisions. One juror, she claims, seemed hostile to law-enforcement because he had been in trouble with the law himself. Another was poorly educated and might have trouble following DNA evidence in the case. Another was extremely young, and young people are likely to be rebellious. How, exactly, can a trial judge decide whether the lawyer is being truthful in these claims, especially if she also chal-

lenged some white jurors along with black ones? Note also that *Batson* and its progeny do not reach discrimination based on religion, national origin, education, political views, age, disability, sexual orientation, or economic class. However such discrimination is common because the lawyers entertain stereotypical beliefs about how various classes of jurors are likely to vote.

<div style="text-align:right">

9.10.3 Jury consultants

</div>

Jury consultants have become increasingly common. They are employed both in major criminal cases (either by prosecutors or by defendants, if they can afford it) and in high-stakes civil cases. Indeed, jury consulting is a significant growth industry (with revenues estimated at $200 million during the mid-1990s). The consultants are paid by one or both sides to assist counsel in choosing the jury and deciding whom to strike off the jury. The consultants may do studies of the backgrounds of potential jurors in the jury pool if this information is available. They also form opinions about which ethnic group, class background, age, occupation, or gender is good or bad for one side or the other in a given case. They help lawyers frame questions to be asked during *voir dire,* hopefully predisposing the jury panelists toward the position that their client will be advocating at the trial. They also assemble mock juries on which the lawyers can test out arguments before actually using them at the trial. *Runaway Jury* (2003) features Gene Hackman playing Rankin Fitch, the jury consultant from hell. Does the practice of jury consulting enhance the public's respect for the criminal and civil justice processes?

9.11 Seeing the witnesses, finding the facts

One important role for jurors is to resolve credibility conflicts among different witnesses. Frequently, witnesses will tell contradictory stories; one of them has to be lying (sometimes both). It is up to the jury to decide who is telling the truth. Are juries good at doing this? Obviously, our entire system is based on the idea that the finders of fact (whether judge or jury) must see and hear the witnesses in order to decide which ones are truthful.

Evidence in the psychology literature suggests that people who hear and see witnesses are not good at resolving credibility conflicts. These studies are discussed by Wellborn (1991). One ingenious study relied on the old television show *To Tell the Truth.* On this show, three contestants each claimed to work at a specific and unusual job, such as a snake charmer. One was telling the truth, the other two were lying. A panel of celebrities questioned each of the contestants and then decided which one was the real snake charmer. The experimenters obtained tapes of the show.

They showed the tapes to one group of experimental subjects and asked them to decide who was telling the truth and who was lying based on their observations of the demeanor of the people answering the questions. The second group of subjects did not see and hear the tapes; instead, they read written transcripts of the questions and answers.

Which group, do you suppose, had a better record of deciding who was telling the truth and who was lying? The second group (who read transcripts but not seen the tape) did much better! How can this be? The experimenters explain that the first group was thrown off by misleading visual clues. Whether someone fidgets, sweats, or fails to make eye contact actually tells you nothing about whether that person is telling the truth. Skillful liars look you in the eye and sound great; nervous truth-tellers look like they are concealing something. What are the implications of this research for the jury system?

9.12 Jury nullification

A criminal jury has the power to acquit the defendant regardless of the law and facts of the case, because the prosecution cannot appeal a jury verdict for the defense. The term *jury nullification* refers to a jury's ability to refuse to enforce the law against a defendant because it believes the law or the particular prosecution is unjust—or for any other reason.

There are celebrated examples of jury nullification in American history, both before and after the Revolution. In 1735, for example, a jury struck a blow for freedom of the press by refusing to imprison New York printer John Peter Zenger for publishing libelous attacks on royal officials, even though Zenger was clearly guilty of the crime of seditious libel. Zenger's lawyer, Andrew Hamilton, admitted that his client had published material the presiding judge ruled to be libelous, but Hamilton explicitly urged jurors to engage in nullification. Several centuries later, in 1990, a Washington, DC, jury acquitted Mayor Marion Barry of one drug charge, convicted him on a minor charge, and deadlocked on twelve other charges, despite overwhelming evidence, including a videotape of the Mayor smoking cocaine. Jury nullification was clearly at work here.

The ugly face of jury nullification. For many years, white jurors in the South regularly refused to convict whites of committing violent crimes (including lynching) against blacks or against civil rights workers. As late as 1954, as the celebrated case of 14-year-old Emmet Till suggested, it was impossible to get an all-white jury to hand down a murder conviction against white defendants, even ones who all but admitted their guilt.

As mentioned above (¶9.06), until some time during the nineteenth century, jurors exercised the power to determine the law as well as the facts of a case. The Supreme Court finally decided in 1895 that jurors did not have power to determine the law. When jurors could determine both law and fact, jury nullification was clearly appropriate. Once jurors lost that power, jury nullification became legally dubious; and it acquired a bad name because of its role in sustaining southern racism.

Present law strongly discourages nullification. Jury instructions never state that the jurors have the power to ignore the law, so many jurors are unaware of this power. In addition, each juror must take an oath to follow the law. If, during jury deliberations, a juror appears to the other jurors to be violating this oath, the other jurors can approach the judge. In some states, if the judge agrees that a juror intends to ignore the law and practice nullification, that juror will be disqualified from the jury and replaced by an alternate juror. Nevertheless, it is likely that jury nullification occurs quite frequently in courts all over the country.

9.13 Review questions

1. Select a particular scene (other than those described in ¶9.02) in *12 Angry Men*. Discuss how the camera is used in this scene or how the scene is edited. Give a reason why the director, cinematographer, or editor might have made this choice.

2. ¶9.03 discusses intertextuality and the way that viewers expect film stars (like Henry Fonda, Paul Newman, or Clint Eastwood) to play similar roles from one film to another. Select a different example in a film you have seen in which a particular star is called upon to play a role similar to earlier movies (or an example in which a star is called on to play "against type.")

3. Did the jury reach the right verdict in *12 Angry Men*? Why or why not?

4. Would you favor an amendment to the U.S. or the state constitution to restrict or abolish the right to jury trials in civil or criminal cases? Why or why not?

5. Should the jury be allowed to ask questions to the witnesses or the judge during the trial?

6. Would you favor abolishing peremptory challenges of jurors? Limiting them to one or two per side? (This question assumes that if peremptory challenges were abolished, the court would still entertain challenges to jurors "for cause." This means that the judge would disqualify jurors who knew the lawyers or parties to the case, had personal knowledge of the facts, or could not judge the issues fairly.)

7. As a juror, would you practice jury nullification if you felt that convicting the defendant in a criminal case was unjust? Should jurors be instructed that they have the power of jury nullification?

Constitutional Rights in Criminal Cases
Assigned film: The Star Chamber *(1983)*[1]

10.01 Filmic analysis of **The Star Chamber**

The Star Chamber was directed by Peter Hyams, a former news anchorman turned writer and director. Better known as a proficient director of action movies, such as *Capricorn One* (1978), Hyams would seem an unlikely choice to direct a legal thriller. In actuality, however, the film is an amalgam of plot elements from some of the most popular genres of the 1970s, such as the vigilante film, the conspiracy thriller, and the cop film, almost all of which Hyams had previously tried his hand at.

10.01.1 The conspiracy thriller

Perhaps the most important of these genres from the point of view of the film's visual style is the conspiracy thriller. Thanks in part to events such as Watergate and the Church committee's revelations about the CIA, the decade of the 1970s was the hey-day of the conspiracy thriller. Films such as *The Parallax View* (1974), *Three Days of the Condor* (1975), *Marathon Man* (1976), and *All the President's Men* (1976) not only defined the genre but uncannily captured the *Zeitgeist* of the mid-1970s — paranoid, cynical, and pessimistic.

10.01.2 Color and lighting in conspiracy thrillers

The visual design of these films was a key ingredient in their success. The visual design of a film is the product of many factors, including the cinematography, the lighting, and the production design. As one might expect, the lighting in the conspiracy thrillers of

the 1970s tended to be *low-key*, i.e., a lighting scheme that leaves large parts of the frame in darkness and shadow. As a result, even the most innocuous scenes would have a menacing, foreboding quality. Adding to the alienating atmosphere of these films was their production design. In order to create a cold and sterile world, the production design of these films consisted almost wholly of *desaturated colors* (such as mixed or muted colors like gray or silver) and cool colors. In addition, scenes would sometimes be drained of color entirely by using too much light and filming in a nearly all-white or virtually colorless environment such as buildings made of glass and steel.

The Star Chamber uses many of these techniques. The colors are largely desaturated, and the lighting is generally low-key, even in many of the daytime scenes. Consider, for instance, the first time we see Judge Hardin's courtroom. Despite the fact that a trial is going on, the courtroom is shrouded in darkness. The overhead lights are either off or dimmed to the point of imperceptibility. Instead, the principal source of lighting is the sunlight coming in from the windows. As a result, most of the characters are lit from the side. Sidelighting causes the actors' faces to be split down the middle—one side is lit, the other side is not. This is particularly noticeable when Judge Hardin hands down his decision to exclude the gun retrieved from the bin of the garbage truck. His face is split right down the middle—one side lit, the other side not—a lighting technique often used to suggest a character's internal division.

Unlike his courtroom, Judge Hardin's chambers are amply lit. This duality—dark courtroom, bright chambers—is reversed, however, after Hardin discovers that Monk and Cooms are innocent. Judge Hardin is in his chambers late at night, desperately trying to find a way to save Monk and Cooms when Judge Caulfield drops by to dissuade him. In the foreground, we see Hardin in his chambers—the room is completely dark except for a desk lamp. In the background, we see his courtroom, which is now brightly lit. This reversal in how the rooms are lit suggests that Hardin's chambers (which are associated with his legal education and training) are now a place of powerlessness. Nothing in the law books that line Hardin's shelves will save Monk and Cooms from the hit man hired to kill them.

The scenes in which the members of the Star Chamber meet also illustrate the film's use of lighting. The principal source of lighting in these scenes is an array of overhead lights with green shades. Overhead lighting is a particularly unflattering type of lighting. It tends to blanch a person's face, whitening the complexion of even the fairest-skinned person. As a result, the judges' faces are drained of color, giving them a cold and unforgiving appearance. However, in the first meeting of the Star Chamber that Hardin attends, Hardin is seated next to the fireplace. The warm light cast by the fire adds color to his face. As a result, he appears somewhat warmer and less severe than the other judges. In the subsequent meetings of the Star Chamber, however, Hardin is nowhere near the fireplace. Consequently, his face is now just as cold and stony as the others'.

Television screens in *The Star Chamber*. A notable aspect of the film's visual design is its repeated use of images on television screens. The film opens with an extreme close-up of a television screen—and a news anchorman's nose. The camera is so close to the screen at first that the news anchorman's nose is barely recognizable. We simply see multicolored pixels of light. As the camera zooms back, however, it becomes apparent that we are watching a news anchorman deliver the evening news. By rendering the image almost indecipherable at first, Hyams estranges us from an image that is an omnipresent part of our everyday lives. The oddly unsettling effect of seeing something so familiar in such unfamiliar terms is diluted somewhat through sheer repetition (it becomes a motif that the film repeats again and again), but its initial effect is disquieting. It serves to create an unnerving mood the rest of the film tries—somewhat unsuccessfully—to maintain.

10.02 The Star Chamber *and skeptical postmodernism*

The Star Chamber depicts a legal world out of control. Vicious killers walk free because of seemingly absurd technicalities. Judicial proceedings seem to have no meaning or logic. Judges betray their oaths and act as vigilantes. Judge Hardin finds out what really happened by acting as a detective rather than as a judge. He saves the lives of innocent men (whom he has set up for assassination) by rescuing them in person instead of by issuing a legal decree. Films like *The Star Chamber* are likely to inspire intensely negative feelings about law, lawyers, judges, and the legal system as a whole.

The Star Chamber and many other legally themed films reflect what Richard Sherwin, in his book *When Law Goes Pop* (2000), describes as "radical disenchantment" or "skeptical postmodernism."[2] Pointing to films such as Martin Scorsese's remake of *Cape Fear* (1991), Sherwin states: "We see how the outbreak of powerful but blind irrational forces—such as chance, fate, rage, and desire—undercut human agency, making meaningful action and judgment all but impossible. The implications of this movement for law are nothing short of devastating. Put simply, skeptical postmodernism leads to law's vanishing point. The all-encompassing chaos it depicts leaves no way out." (172)

Sherwin attacks such aspects of modern legal practice as litigation public relations (which consists of the creation of propaganda to influence jurors and the general public about issues to be determined in court), trials that turn into media spectaculars, televised trials, and the abuse of communications technology in the courtroom (such as by videos that purport to reenact the events that are the subject of the trial). He believes that law and popular culture have converged, that law has "gone pop." As a result, people respond to lawyers and judges with justified skepticism and detached irony. When law turns into the competition of images rather than reflective judgment and common

sense, Sherwin argues, the legal system has lost its ability to check popular passions and to deliver truth and justice. Even worse, law will lose its legitimacy (meaning that people will no longer accept the authority of the law without being forced to). This is the sort of "radical disenchantment" or "skeptical postmodernism," in Sherwin's terms that we see dramatized in films like *The Star Chamber* and many others.

10.03 The real Star Chamber

The original Star Chamber was an English court formed in 1347 to deal with complex cases. It was so named because of gilded stars in the ceiling of its courtroom. Later, in the reign of Henry VIII, the court began to try criminal cases without juries, especially unpopular political cases. It specialized in such punishments as slitting noses and severing ears. It was widely detested and ultimately abolished. The words "star chamber" are still used to describe unfair and arbitrary judicial procedures, and the vigilante "court" in this movie certainly falls within that tradition (although the film never actually refers to it as the "star chamber").

10.04 Constitutional rights in criminal cases[3]

The Bill of Rights (the first ten amendments to the U.S. Constitution) contains numerous provisions relating to criminal procedure. Except as noted, all of these rights apply to state as well as federal prosecutions.

The Sixth Amendment's right to trial by jury was discussed in chapter 9. The Sixth Amendment also provides that a criminal defendant has a right to a speedy and public trial, the right to be confronted with the witnesses against him, the right to have compulsory process for obtaining witnesses in his favor, and the right to have the assistance of counsel for his defense. The Fifth Amendment protects a criminal defendant against being tried more than once for the same crime ("double jeopardy"). It also provides that no person shall be "deprived of life, liberty, or property, without due process of law." This "due process" clause (which is specifically applied to the states in the Fourteenth Amendment) guarantees a fair trial. A fair trial includes proper notice of the charges, an impartial judge, and an opportunity to call witnesses and to cross-examine opposing witnesses. The Fifth Amendment also provides that no person can be charged with a serious crime without being first indicted by the grand jury; this provision applies against the federal government but not the states. The Eighth Amendment prohibits excessive bail and cruel and unusual punishments.

Most importantly, the Fifth Amendment provides that no person "shall be compelled in a criminal case to be a witness against himself." This protection against self-incrimination permits any person to refuse to answer questions in any sort of investi-

gation or legal proceeding (criminal or civil) if the answer might be incriminating. It also allows defendants in criminal cases to remain silent at their own trial by refusing to take the stand. The prosecution is not permitted to comment on a defendant's exercise of this privilege, and the jury is instructed not to draw any inferences from it.

This chapter focuses on the Fourth Amendment, which prohibits unlawful searches and seizures. The Fourth Amendment provides "The right of the people to be secure in their persons, houses, papers, and effects, against unreasonable searches and seizures, shall not be violated, and no warrants shall issue, but upon probable cause, supported by oath or affirmation, and particularly describing the place to be searched, and the persons or things to be seized."

10.05 The law of search and seizure[4]

The basic elements of search and seizure law were introduced in ¶8.09.2. The Fourth Amendment is brief but ambiguous and has been interpreted and applied in countless decisions by the U.S. Supreme Court as well as lower federal courts and state courts. The law is complex, is constantly changing, and is highly political (conservative judges often try to narrow Fourth Amendment protections while liberal judges resist such narrowing and sometimes try to broaden its protections). We provide a bird's-eye view of search and seizure law here.

10.05.1 Background of the Fourth Amendment

The Fourth Amendment grew out of the colonists' bitter experience with writs of assistance and general warrants that were commonly used both in England and in America. Popular and legal resistance to these writs was an important part of the events leading up to the American Revolution. A writ of assistance authorized the Crown's agents to conscript local officials to forcibly enter and search a colonist's house (or any other place) for smuggled goods; once issued, it remained in effect perpetually. General warrants were particularly used to discover seditious publications; they empowered officials on very little basis to enter and search (indeed ransack) homes looking for books and papers or anything else and to arrest anyone in the process. The language of the Fourth Amendment was obviously designed to prevent such practices.

Today the Fourth Amendment is viewed less as protection for the right of private property and more as protection for people's reasonable expectations of privacy. Thus, it applies not only to physical searches of houses or business property but also to wiretapping or other electronic surveillance or reading one's mail. In *Katz v. United States* (1967), the Supreme Court held that the police engaged in a "search" by attaching an electronic listening device to the outside of a phone booth from which a defendant

made calls. The defendant had a subjective expectation of privacy in his phone calls that society is prepared to recognize as reasonable. In contrast, persons would have no such expectation for a conversation held on a public street. Thus, the question is often whether the defendant had a reasonable expectation of privacy in the place that was searched. That was the issue involving the garbage truck in the Andujar case in *The Star Chamber*.

If a particular investigatory technique is considered a "search," the police can legally proceed to seize evidence either through a search warrant or a "reasonable search" when it is not practical to obtain a search warrant.

10.05.2 Search warrants

The police must apply to a judge or a magistrate to obtain a search warrant. The application must be made under oath (the police officer seeking the warrant is called the "affiant"). The warrant must particularly describe the place to be searched and the persons or things to be seized. No warrant shall issue without "probable cause." Probable cause exists when the facts within the affiant's knowledge (either information the affiant secured by personal observation or reasonably trustworthy information obtained from an informant) would cause a reasonable person to believe that the item will be found in the place to be searched. The item to be seized can include not only the fruits of crime (such as stolen property) or instrumentalities of crime (such as a gun) but also evidence for which there is probable cause to believe that it will aid in apprehension or conviction. "Probable cause" is a central concept in Fourth Amendment law; in addition to the search warrant requirement, probable cause is also required to obtain an arrest warrant or to arrest someone without a warrant.

10.05.3 Warrantless searches

The police can conduct a search without first obtaining a warrant when it is "reasonable" to do so, and it is not practical to seek a warrant. There are numerous situations in which a warrantless search is permitted.

10.05.3.1 Search incident to arrest. The most important such situation arises at the time of an arrest. The police can search a suspect when they make a valid arrest and take the suspect into custody. The reason for this exception is concern that an arrestee might have a concealed weapon or might destroy evidence before a warrant is obtained. This exception also allows a search of the area within the arrestee's control and the immediately adjacent area (such as a closet). When the arrestee is in a car, the police may (at the time of the arrest) search the passenger compartment of the car and all containers found therein (including the glove compartment or baggage) but not the trunk.

10.05.3.2 Exceptions relating to cars. Another example of warrantless searches also involves cars. A police officer can search a car if he has probable cause to believe it contains evidence of a crime. This exception arises if the officer stops the car on the highway or finds it stopped in a non-residential location (such as a gas station or parking lot). The officer can search the car (including the trunk) at the scene or seize it and search it later. The officer can search containers found in the car even if they are locked.

10.05.3.3 Plain view rule. Under the "plain view" rule, if the police are lawfully in a location, and they see, hear, or smell something that they immediately realize is evidence of a crime, they are authorized to seize it. For example, if a police officer is lawfully searching a garage for drugs because she is executing a search warrant, and she sees a car that matches the description of one used in an unrelated murder, she can seize the car. The same rule applies if police officers are making a lawful arrest and are searching for a suspect in the house and they spot evidence in plain view.

10.05.3.4 Consent searches. If a person who is apparently in control of a house or a car voluntarily consents to the search, the police may enter and seize evidence found in plain view, even if the evidence belongs to another resident of the house who did not give consent.

10.05.3.5 Stop and frisk. Under the "stop and frisk" rule of *Terry v. Ohio* (1968), police officers may stop a person and question him without arresting him (and without probable cause to arrest him). The police can do this if they have a "reasonable suspicion" that he is engaged in criminal activity because he is acting suspiciously. When they stop and question a person under this rule, they can "frisk" the individual by patting him down to make sure he is not carrying a concealed weapon. If during the frisk, they feel something that might be a weapon or other contraband (such as drugs) they can reach into the person's pockets, purse, or backpack and remove the item. If this discovery provides probable cause to make an arrest, the police can arrest the suspect and conduct a search incident to the arrest.

10.06 The exclusionary rule

Fourth Amendment law represents a cultural conflict between two objectives we all share. On the one hand, we want to be secure from police intrusions into our private spaces; nobody wants the police snooping on our private phone calls or e-mails or searching our houses or arresting us on mere suspicion of wrongdoing. On the other hand, we want the police to catch dangerous criminals and the courts to convict them. How to reconcile these two goals has given rise to the immensely complicated set of rules described in ¶10.05.

10.06.1 How the exclusionary rule works

What happens if the police have engaged in an illegal search and seizure? This is the most fundamental and the most controversial part of Fourth Amendment law. *Weeks v. United States* (1914) held that *in federal courts* the evidence produced by an illegal search *must be excluded,* meaning that the prosecution cannot introduce it into evidence. *Mapp v. Ohio* (1961) applied that rule *to state courts.* A related rule provides that if, as the result of an illegal search or seizure, the police discover *additional* evidence, the additional evidence must *also* be suppressed. This is referred to as the "fruit of the poisonous tree" rule. The exclusionary rule requires that the judge decide issues of admissibility of particular items of evidence before the trial begins—as we see Judge Hardin doing in *The Star Chamber.* If evidence has been illegally seized, the judge must suppress it (together with additional evidence or confessions obtained as a result of the illegal search or seizure).

The "exclusionary rule" is highly controversial; it allows a guilty defendant to go free because the police made an error (and search and seizure law is so complicated and changes so rapidly that such errors are inevitable). Exclusion of the key evidence against a defendant is obviously a bad result; it sometimes allows a criminal to escape punishment. We see this happen twice in the early part of *The Star Chamber* as well as in one of the cases heard by the "Star Chamber" court. It seems strange that a minor error by the police can lead to a major, perhaps tragic consequence—freeing a guilty violent criminal.

Studies of the actual impact of the exclusionary rule suggest that the *Star Chamber* scenario is relatively rare. The exclusionary rule applies mostly in drug cases, seldom in cases of violent crimes. Overall, one study showed that the rule prevented the conviction of criminal defendants in no more than 1.4% of cases studied (Dressler 2002).

10.06.2 Exclusionary rule as deterrent of police misconduct

Some argue that the exclusionary rule is the only effective *deterrent* against police misconduct and thus is worth its obvious and severe costs. But for the exclusionary rule, police would undoubtedly violate search and seizure law much more frequently than they do now.

However, the effectiveness of the rule as a deterrent is questionable. Many violations occur in good faith (as in the cases described in *The Star Chamber*). In these cases, the police are trying to comply with the law, but they misunderstand it or the case presents a borderline application of probable cause or reasonable suspicion. The exclusionary rule obviously fails to deter police misconduct in these cases. In other cases, the police know the rules but decide to ignore them. Perhaps the officers plan to lie about the circumstances of the search or perhaps they just don't care whether the suspect is ultimately convicted. These police officers also are not deterred by the exclusionary rule.

Supporters of the exclusionary rule say that its effect is to professionalize police departments by training officers in how to conduct searches and seizures, getting rid of officers who violate the rules, and developing internal guidelines that reduce the likelihood of illegal searches. Thus, the exclusionary rule undoubtedly has improved compliance with the Fourth Amendment rules of search and seizure, even if it does not deter all violations.

10.06.3 Other remedies for police misconduct

The critics of the exclusionary rule argue that other remedies are sufficient, and the exclusionary rule should be abolished. For example, under existing tort and civil rights law, the victim of an unlawful search in most states can sue the police department and the individual police officers for damages. If the plaintiff wins this kind of case, the defendant must pay the plaintiff's attorney's fees as well as damages. However, others say that tort remedies are ineffective; juries tend to be unsympathetic to plaintiffs who are suspected, or even convicted, of crimes who are suing police officers who have been overzealous in investigating a crime. Besides, it is often difficult to prove damages.

Another possibility would be for the courts to allow the introduction of evidence from any search that was made in a good faith belief that it was lawful, even if the police officers turn out to be wrong in that belief. That rule would probably allow introduction of the evidence from the various illegal searches described in *The Star Chamber*. In fact, present law already allows a "good faith" exception to the exclusionary rule in cases of defective search warrants but not other kinds of Fourth Amendment violations. Under *United States v. Leon* (1984), if a reasonably well-trained officer would have believed that the warrant was valid, evidence seized under the warrant is admissible. *Leon* would probably have changed the result in the case of the defective search warrant described in one of the cases considered by the "Star Chamber" court in the film. Still another possibility is to encourage police departments to discipline officers who engage in bad faith unlawful searches. Perhaps a civilian review board could be installed for this purpose. Others doubt that these internal remedies are practical or politically feasible.

10.06.4 Bottom line

If you were on the U.S. Supreme Court, would you vote to abolish the exclusionary rule?

10.07 The searches in **The Star Chamber**

Judge Hardin's reluctant rulings illustrate how technical the Fourth Amendment can be—and how difficult it is for police to keep up with it.

In the Andujar case, Judge Hardin suppressed the gun that the police found in the defendant's garbage after it had been picked up but was still separated from other garbage. That ruling was probably correct under California case law at the time the movie was made. California courts had held that persons have a reasonable expectation of privacy in their trash before it is mixed with other trash. Later the U.S. Supreme Court overruled the California cases. It held that once a person puts trash outside to be picked up, it can be searched by the police even before it is mixed with other garbage (*California v. Greenwood* [1988]).

Note that the decision in the Andujar case involved the "fruit of the poisonous tree" rule. The police found the gun by means of an illegal search. Consequently, they did not have probable cause to arrest Andujar, or to obtain a warrant to search his home, or to seize his property; his confession was also inadmissible because the arrest was unlawful.

In the Monk and Cooms case, the police stopped the van because the computer informed them of outstanding traffic tickets. However, the tickets had been paid. Once they stopped the van, they claimed that they smelled marijuana, searched the van, and found the bloody tennis shoe, which was not in plain sight. The legality of the search depends on whether they had probable cause to stop the van in the first place.

Judge Hardin's ruling was correct at the time it was issued. The police lacked probable cause to stop the van just because it was driving too slowly in a high-crime area. As to the parking tickets, under former California law, the police had no probable cause to stop the van and make an arrest if the computerized information on which they relied was incorrect. However, the U.S. Supreme Court has since ruled that if the police make an arrest in good faith reliance on information in a computer database, the arrest is valid, even though the computerized information was wrong (*Arizona v. Evans* 1995). Thus, if the Monk and Cooms case came up today, the bloody tennis shoe could be admitted into evidence.

Another theory that might have worked in the Monks and Cooms case is based on *Terry*, the stop-and-frisk case mentioned in ¶10.05.3.5. If the police had reasonable suspicion that the occupants of the van were engaged in criminal activity (because they were driving too slowly in a high crime area), they could stop the van and question the occupants. If they smelled marijuana while doing so, they would have probable cause to search the van and would have found the shoe. Of course, the cops may have been lying when they claimed to smell marijuana.

10.08 Popular justice[5]

In theory, the state has a monopoly on the use of force to implement public policies. If crime is to be punished, the state should administer the punishment according to

the proper legal forms. The events that occur in *The Star Chamber* should be viewed as an exaggerated example of "popular justice," a way of seeking justice that undermines the state's monopoly on the use of force.

The Star Chamber is about a group of judges who take the law into their own hands by executing people they think escaped appropriate punishment because of some legal technicality. Vigilantism, administered by public officials outside the law, has a long history in America and is a well-established tradition around the world. In many countries, the police or the army simply cause undesirable people to "disappear." The "dirty wars" in Argentina, Chile, and El Salvador are just a few of many such examples.

The police and popular justice. The police have sometimes meted out a less well-organized form of popular justice. The police may be convinced of a suspect's guilt but unable to prove it. As a result, they may fake or plant evidence or lie on the stand to validate an illegal search. Alternatively, they may simply beat up or torture a suspect and turn him loose rather than bother with formal law enforcement. Police vigilantism has often been celebrated in film. Movies like *Dirty Harry* (1971) glorify police officers who are frustrated by legal technicalities and decide to wipe out criminals on their own.

Popular justice is often administered by private bodies. For example, plenty of crime victims have sought their own revenge out of frustration with the legal system, as in the films *In the Bedroom* (2001) or *A Time to Kill* (1996). Urban gangs and organized crime bodies such as the Mafia administer their own brand of justice against interlopers or against those who have violated their codes. Local people sometimes band together and burn down crack houses or drive away prostitutes when they perceive that the police are neglecting or ignoring the problem. A movement called "common law courts" involves ordinary people (often members of so-called "militias") forming themselves into "courts" for the purposes of resisting government agencies (particularly the IRS) and of harassing government officials.

Vigilante justice administered by organized community groups has often cropped up in America. On the American frontier, there was a long tradition of assembling a posse and rounding up suspected murderers or thieves and executing them on the spot. *The Oxbow Incident* (1943) is a famous film involving a posse turned lynch mob that hangs the wrong people. All too often, popular justice was administered by lynch mobs of the sort depicted in *To Kill a Mockingbird*. Thousands of African Americans (and sometimes members of other races) were victims of mob violence dispensed by the Ku Klux Klan and other groups in the American South and to a lesser degree elsewhere. Sometimes these mobs sought to short-circuit the legal process and kill accused criminals; sometimes they wanted to intimidate African Americans who tried to exercise civil rights or were economically successful. Even today, it is not uncommon

for mobs to try to drive unwanted people out of the neighborhood or intimidate women who are seeking abortions. In short, the law's monopoly on the use of force to implement legal norms has often been contested by various forms of popular justice.

10.09 Judges in film

The adversarial system used in American and British commonwealth countries places heavy reliance on the contest between the lawyers. In a majority of American criminal cases (and in a significant percentage of serious British criminal cases), a jury rather than a judge takes responsibility for the ultimate decision. Thus, most courtroom films focus heavily on the attorneys and decenter the judge.[6] Normally the judge sits on an elevated bench, rules on evidentiary objections, and threatens to clear the courtroom if the spectators will not behave. Perhaps the judge is allowed to deliver some good lines (as in *Anatomy of a Murder*) but usually little more than that. *Judgment at Nuremberg* (1961) is the rare exception; it is a film about judges judging judges. It explores in considerable depth the psychology of both the judges who implemented Nazi laws and the American judges who were called on to determine their fate. *The Star Chamber* is also an exception; we see the judge called on to make painfully difficult legal rulings.

Many recent films have portrayed the justice system and the lawyers in a strongly negative light. Judges have not escaped this harsh scrutiny. Numerous films have involved crooked, arrogant, lazy, or biased judges, and some judges have been criminals themselves. *The Star Chamber* carries the filmic trashing of judges to a new level.

10.10 Judicial independence—And the appointment process

The Star Chamber is about judges—conscientious ones like Steven Hardin (at least in the first half of the film) and bad ones like Benjamin Caulfield and the other members of the vigilante "court." The hallmark of our justice system should be *independent* and *courageous judges*. We revere judges who are willing to apply the law in the face of pressure to bend or ignore it. Many judges qualify as quiet heroes, following the law when it is unpopular to do so or using the law to protect the civil liberties of unpopular people.

The ideas underlying our system of justice are captured by the phrase "the rule of law," as opposed to the "rule of man." The rule of law posits that law must be made by a democratically responsible legislature. The law must be knowable and reliable. It must be applied by neutral, impartial judges without fear or favor. The rule of law is embodied by the figure of Justitia, discussed in ¶1.05.3—the traditional statue embodying the blindfold, the sword, and the scales. Unfortunately, the rule of law is not always carried out in practice. Judges often face intense pressure to do what is popular

or what is politically expedient. In part, these pressures arise out of the process by which judges are appointed to the bench, retain their positions, and are promoted from lower to higher courts.

10.10.1 Political appointment

In a few states, judges are appointed through a form of merit selection that minimizes political considerations. In most states, however, judges are appointed by the governor, a system that generally requires that their political views be compatible with the governor's. Indeed, the governor's staff may well exact commitments from potential judges about how they will decide politically sensitive issues (such as the death penalty or abortion). It is not uncommon to require that aspiring judges have been politically active and have contributed to the governor's campaign. Other judges may be political hacks who are appointed to the bench in return for past political favors; they may be the dregs of the profession. Many judges are qualified and competent, but the process of selecting them surely does not guarantee this outcome. Moreover, if trial court judges want to be elevated to the appellate bench (and many of them do), their judicial record will be closely scrutinized. Politically unpopular decisions may be the death knell for the prospects of elevation.

10.10.2 Judicial elections

Almost all of the states employ some kind of electoral check on judges. In these states, accountability to the voters is considered more important than judicial independence or objectivity. Those who believe in the accountability model stress the fact that American judges are frequently policy makers and law creators, not just people who mechanically apply existing law. Also, they observe that judges have so much power that they sometimes tend to become autocratic and start acting in an arbitrary or haughty manner or pursuing personal agendas. Under the accountability view, the voters should be able to elect (and throw out) judges in the same way the voters elect governors and legislators.

In many states, judges are directly elected, sometimes in partisan elections. Lawyers can run against each other for open seats or against incumbent judges. Such campaigns often lead to all-out (and often quite vicious) debates about the judge's record on the bench.

Retention elections. In many states the law requires that voters be asked whether they wish to retain a judge in office at the end of the judge's term; if they vote no, the judge is off the bench. This system provokes citizens who are angry about a judge's decisions to mount a nonretention campaign against the judge. In a particularly notorious example, three justices of the California Supreme Court were removed by the voters in

1986. The voters perceived the justices as hostile to capital punishment (which they definitely were), but the money that fueled the campaign came from business interests angered by the justices' rulings in tort cases against big business and insurance companies.

The result of subjecting judges to an electoral check is that they must consider the political implications of their decisions—which is contrary to the basic ideal of the rule of law. The kinds of decisions confronting Judge Hardin in *The Star Chamber* are a nightmare for judges who must face the voters. That issue is not raised in the film, but it certainly could have been. Another problem with judicial elections is that judges often have to solicit and accept campaign contributions when they are running for election or re-election. They must take money from lawyers or other groups (such as plaintiffs' trial lawyers or big business or insurance companies), who may well be before them in future cases. The amount spent on judicial elections is rising rapidly.

10.10.3 Federal judges

The president appoints federal judges who must be confirmed by majority vote of the Senate. This system has produced many well qualified judges who are satisfactory to both political parties. However, in recent years, presidents have sometimes been viewed as nominating judges who are extremely liberal or extremely conservative in order to satisfy their political base. Consequently, the confirmation process has become highly politicized. When the president comes from one political party and the Senate is controlled by a different party, the president's choices are often delayed, sometimes indefinitely; some of them are voted on and defeated by the Senate. Others have been filibustered (under Senate rules it takes 60 votes to close debate so a determined minority can often prevent a vote). Some confirmation fights have become extremely bitter (the charge that Clarence Thomas sexually harassed Anita Hill was the ultimate example of a truly dirty confirmation fight).

Once confirmed, however, federal judges have life tenure. Their pay cannot be decreased while they are in office, and they cannot be removed from the bench except through the cumbersome process of impeachment by the House and conviction by the Senate (a few federal judges have been successfully removed through the impeachment process). Thus, federal judges are more likely than state judges to ignore popular sentiment and render politically unpopular decisions. Still, the desire of lower-court federal judges to be elevated to the Court of Appeals or the Supreme Court may tempt the judge to make politically popular decisions.

Judges in other countries. The American system of appointing judges should be contrasted with the systems in other countries. In most European countries, a judge is on a separate career track from that of lawyers. Judges are civil servants who have been promoted to the judiciary on the basis of merit and competitive examinations. Indeed, law

graduates compete heavily to become judges or prosecutors (because these are lifetime jobs); only those with the best exams are admitted into the training program for judges. Judges receive extensive training (a minimum of twenty-eight months in France). In Britain, judges are not a separate career track, but the judges are selected from the most distinguished and able barristers. No other country appoints judges in a fashion that remotely resembles the politicized way Americans select their state and federal judges.

10.11 *Judges as vigilantes*

The premise of *The Star Chamber* is that a group of fed-up trial judges form an execution squad. These judges have nothing to gain and everything to lose by doing this; they are acting out of a misguided sense of community responsibility. As we have seen, there is a long tradition of vigilante justice in America and judges may be no more immune to this temptation than the police or others. Plenty of judges colluded in the lynch-mob mentality of old-time Southern justice and plenty of western judges went along with vigilante justice on the frontier. The film *The Life and Times of Judge Roy Bean* (1972) is an amusing treatment of this subject.

As ¶10.10 points out, the process by which Americans judges are appointed or elected does not insure that the most capable and qualified persons will be picked for the job. It is conceivable that a judge who must sit on the bench every day, frequently being compelled to turn loose abhorrent criminals under Fourth Amendment or other legal technicalities, might decide to cross the line into extreme vigilantism.

Trial judges have relatively little ability to change the law as compared to appellate courts. Where the law is clearly established by a precedent or a statute, trial judges must follow that law and most of the time, they do. Still, trial judges have plenty of opportunities to get around established law. In many situations, the law allows trial judges broad discretion; within that zone of discretion, a judge can get away with making a decision based on political or personal preference rather than legally permissible factors (although the judge's opinion would have to conceal the real reason for the decision). For example, a judge might set bail at a level much higher than appropriate to keep someone in jail whom the judge finds personally repulsive or obnoxious.

Even when the law is clearly established, trial judges often have the ability to fudge or otherwise get around that law. For example, a trial judge might choose to believe police officers, who, the judge thinks, are lying about the circumstances surrounding a search and seizure. Or a judge might simply ignore the applicable law and rule that a search and seizure was valid, leaving it up to the appellate court to reverse him; the appellate court, in turn, might avoid the issue by summarily affirming the trial court's decision. When judges knowingly ignore or twist clearly established law, or choose to believe witnesses they suspect are probably lying, they have engaged in a mild form of vigilantism.

How likely is it that trial judges would go beyond mild vigilantism and take the law into their own hands, as the judges do in *The Star Chamber*? In reality, it is much less likely that judges would do that as compared to the police, aggrieved citizens, or crime victims. First, they have more to lose if they are caught. Their legal careers are over and they will find themselves in jail along with a lot of convicts (some of whom the judges might personally have sent to prison). In addition, they stand a good chance of getting caught. As judges, they are well aware of how difficult it is to keep a conspiracy secret (as *The Star Chamber* illustrates!). Second, judges (especially trial judges) become socialized into the norms of their profession. While they can sometimes get around established law, as discussed above, they nevertheless have to find and apply that law every day. When they misapply the law, they risk reversal by appellate courts (something that all trial judges hate) and risk receiving professional criticism from their colleagues. Judges are trained to be passive, to respond to legal claims or evidence objections made by the lawyers, to revere the rule of law. Their shared culture and the community's expectations all require them to follow the rule of law, instead of carrying out their personal preferences. All this tends to predispose judges against taking the law into their own hands.[7]

10.12 Review questions

1. Select a particular scene in *The Star Chamber* (other than those in ¶10.01.2) and discuss either the use of color or lighting in the scene. What effects are the director and cinematographer trying to achieve?
2. Richard Sherwin argues that law is "going pop" and that films like *The Star Chamber* tend to delegitimate the legal system. Do you share this concern?
3. Recall how the study group in *The Paper Chase* outlined their courses to get ready for final exams. Can you make an outline of search and seizure law based on the rules outlined in ¶10.05?
4. If you were on the U.S. Supreme Court, would you vote to abolish the exclusionary rule? What would you put in its place?
5. Can you identify an instance of "popular justice" either in film (other than the ones described in ¶10.08) or in real life?
6. How are judges portrayed in film (aside from *The Star Chamber)* or on television legal dramas?
7. Should the U. S. follow the European system whereby people enter the judging profession immediately on graduation from law school and stay in that profession for their entire careers?
8. Would you abolish judicial elections? How should state judges be selected? Should they have any accountability to the voters?

CHAPTER 11

The Death Penalty
Assigned film: Dead Man Walking (1996)[1]

11.01 The book and the movie

The film *Dead Man Walking* was adapted from the book of the same name published by Sister Helen Prejean in 1993.[2] The character of Matthew Poncelet is a composite of two different death row prisoners with whom Sister Prejean worked in New Orleans. Susan Sarandon won an Oscar for best actress, Sean Penn was nominated for best actor, Tim Robbins for best director, and Bruce Springsteen for best song. Considering how dark it is, the film did well at the box office, grossing about $39 million on an original budget of about $11 million.

11.02 Filmic analysis of **Dead Man Walking**

11.02.1 Camera placement in Dead Man Walking

One of the challenges every filmmaker faces is how to communicate visually the emotional and mental states of the characters. Of course, a character's emotions and thoughts are communicated through dialogue and performance, but filmmakers generally strive to communicate them through visual means as well.

In the 1920s, the German Expressionists experimented with using set design and lighting to convey emotional and mental states. Perhaps the most famous example of German expressionism is *The Cabinet of Dr. Caligari* (1919), which visualized the madness of its main character by having the entire film shot on sets that were painted

and designed in odd, irregular shapes and angles. In America, however, expressionism never caught on. Such flagrant disregard for realism is anathema in American cinema. Instead, American filmmakers generally try to visualize their characters' thoughts and emotions without radically altering or distorting the physical world around them. Thus, an American filmmaker will resort to an odd camera angle or an irregular lighting scheme to convey emotional and mental states before she will resort to oddly shaped sets and props. Even more typical, however, is the use of camera placement and movement to convey the characters' mental and emotional states. *Dead Man Walking* contains a particularly subtle but effective illustration.

The scene in question is the one in which Sister Helen first breaks through to Poncelet. The sequence begins with Poncelet talking about his father getting him drunk at an early age. Poncelet is filmed with the wire mesh cage between him and the camera. At first, the mesh is extremely visible and partially obstructs our view of Poncelet. As the scene progresses, however, the camera slowly zooms in on Poncelet, causing the mesh to become less visible. It is only when Poncelet asks Sister Helen about her lack of romantic and sexual experiences, however, that the mesh finally begins to disappear. "I've never experienced sexual intimacy," she tells Poncelet, "but there's other ways of being close. You sharing your dreams, your thoughts, your feelings."

As Sister Helen says these lines, the film cuts to a close-up shot of Poncelet. For the first time, he is filmed without the mesh cage in front of him. It is completely gone. The sudden disappearance of the mesh conveys Poncelet's emotional state in a concrete and visual way. Without this visual element, Poncelet's response to Sister Helen—"We got intimacy right now, don't we Sister?"—would lack emotional resonance. But by placing mesh between us and Poncelet and then removing it, director Tim Robbins is making us *experience,* not simply observe and intellectually grasp, the sense of closeness that Poncelet and Sister Helen experience at this moment.

11.02.2 Collision montage in Dead Man Walking

The Soviet filmmaker Sergei Eisenstein was one of the most important figures in the history of cinema. Among Eisenstein's many works are such masterpieces as *The Battleship Potemkin* (1925), *October* (1928), and *Strike* (1925).

Eisenstein was an important innovator in film editing, and is particularly known for a technique known as *collision montage.* Collision montage is the editing together of shots with contrasting formal or thematic properties. For instance, a sequence that cut back and forth between black-and-white and color shots would be an example of collision montage with contrasting formal properties. In contrast, a sequence that cut back and forth between soldiers dying on a battlefield and greedy industrialists on the home front counting their money and living high on the hog would be an example of collision montage with contrasting thematic properties.

According to Eisenstein, the editing together of shots with contrasting formal or thematic properties produces an intellectual and visceral reaction on the part of the spectator. First, the spectator (who is accustomed to continuity between shots) is jolted and taken aback by the discontinuity between the two shots. Second, the contrast produces an intellectual reaction as the spectator tries to intellectually grasp the meaning of the contrast. In the example involving the juxtaposition of the soldiers and the rich industrialists, for instance, the spectator realizes that the filmmaker is trying, somewhat heavy-handedly, to make the point that the industrialists are getting rich off of the war.

In American movies, collision montage is rarely used. When it is employed, it generally consists of contrasting thematic properties, not contrasting formal properties. Perhaps the most famous example of collision montage in the American cinema is the climax of Francis Ford Coppola's *The Godfather* (1972). At the film's climax, Coppola cuts between shots of a baptism that Michael Corleone is attending and shots of Corleone's gangland enemies being brutally gunned down by his henchmen. The sequence is a powerful one, for Coppola is contrasting images of birth and death. The meaning that spectators glean from the contrast is that Michael Corleone is a hypocrite. On the one hand, he pretends to be a pious Catholic. On the other, he is presiding over a murderous rampage.

The climax of *Dead Man Walking* also features an example of collision montage. At the film's climax, it cuts back and forth between Poncelet's execution and the raping and killing of the two victims. Although both scenes involve killing, there is an obvious contrast. Poncelet dies a bloodless, painless death that is meticulously planned and executed while the two young people die bloody, painful deaths that are perpetrated in a chaotic frenzy. Moreover, Poncelet's execution takes place in an execution chamber that is spotless, sterile, and blindingly white. The murders, on the other hand, take place in the middle of the woods at night. There is a potent visual contrast here: clean and white versus dirty and dark. Notice, too, that there is a contrast between an artificial, man-made environment (the glass and machinery of the execution chamber) and a natural one (the trees, foliage, and mud of the forest). If Robbins had situated the murders in a shack, there would not have been this contrast between the natural world and a man-made one.

Finally, there is a contrast in form. Poncelet's execution is filmed primarily in close-up—close-ups of Poncelet and Sister Helen, as well as close-ups of the needle being inserted, belts being buckled, arms being bound, buttons being pressed, and lights flashing on and off. The murders, on the other hand, are filmed mainly in long shot. The camera is at a considerable distance from the murderers and their victims. Moreover, trees are used to obscure our vision of the murders. The effect is one of distance: We are removed from the murders and the victims.

The contrast between the two killings obviously provokes a strong visceral reaction in the spectator, but what is the intellectual reaction that it provokes? What intellectual reaction do you think Tim Robbins was trying to provoke?

11.03 Personal redemption in death penalty movies

11.03.1 Political stance of death penalty movies[3]

From the earliest times, films have expressed the political views of their creators. These views may be conservative or hegemonic (in favor of the status quo and its various economic, gender, or ethnic power relationships), but they may also be liberal or even radical (in favor of moderate or drastic social change.) Legally themed films are particularly well suited to transmit political messages. Many of the films discussed in this book pack a powerful political charge: *To Kill a Mockingbird* (chapter 3) criticizes racism in society and the criminal justice process; *Indictment* (chapter 8) tells of prosecutorial overreaching; *12 Angry Men* (chapter 9) glorifies the jury system; *Philadelphia* (chapter 13) is about discrimination against AIDS victims. Whether consumers of these films accept, reject, or modify the political message is, of course, quite a different matter (see ¶¶1.05.5 and 4.06).

Perhaps most political of all are the numerous films about the death penalty. Some death penalty films take the popular stand in favor of society's right to claim retribution from those who committed terrible crimes. Older films were governed by the Production Code (see ¶2.04), which mandated that crime must never pay. Many such films ended in the villain going to the chair and treated this punishment as wholly appropriate. A classic example is *Angels with Dirty Faces* (1938) in which James Cagney plays a hardened mobster. To avoid influencing his youthful followers to adopt a life of crime, he pretends to "go yellow" when he is dragged off to the chair. Some modern law-and-order based films also seem to applaud the death penalty. A good example is *Just Cause* (1995) in which a Harvard law professor is shown to be a naïve do-gooder in trying to block his client's execution. Certainly, the vigilante pictures discussed in ¶10.08, such as *Dirty Harry*, applaud the death penalty whether it is administered judicially or extrajudicially.

Nevertheless, many modern films assume a political stance against the death penalty. The message is most overt when innocent people are executed (or spared just in time). *The Green Mile* (1999), *The Life of David Gale* (2003), and *A Lesson Before Dying* (a made-for-television film from 1999) are prominent examples of movies involving the execution of prisoners whom we know to be innocent. Indeed, in *The Green Mile*, John Coffey seems to be a Christ-like figure and his electrocution resembles the Crucifixion. (The other convicts executed in *The Green Mile* were undoubtedly guilty.)

Many death penalty movies involve similar casts of characters and recurring themes—all of which seem designed to convert viewers to an anti–death penalty stance. The defense lawyer at the trial is incompetent, unprepared, and uncaring. Prosecutors are bloodthirsty and politically ambitious. Biased judges influence the jury to vote the death penalty. Sadistic guards abuse helpless prisoners. Governors

deny clemency because it would be political suicide to grant it. Dedicated postconviction lawyers frantically push every possible legal button as the seconds tick off; sometimes there is a last minute stay, which is then lifted so execution can proceed. At the prison, pro– and anti–death penalty demonstrators stage a vigil. All of these are familiar moves and certainly convey an anti–death penalty message.

The anti-death penalty message is subtler in films involving the execution of guilty prisoners such as *Dead Man Walking* and similar films such as *The Chamber* (1996) and *Last Dance* (1996). In these films, viewers encounter a criminal already condemned to death for having committed a horrible crime. An intermediary comes to death row, forms an empathetic relationship with the suspicious prisoner, and assists the prisoner to achieve personal redemption. The condemned person takes responsibility for the crime, expresses remorse, acknowledges the agony of the victims, and apologizes to their families. The usual appeals fail, the governor denies clemency, and the prisoner is executed.

11.03.2 Redemption of the condemned

Recall the explicit treatment of the issue of responsibility in *Dead Man Walking*. Sister Prejean tells Poncelet: "Don't blame [your accomplice]. You blame him. You blame drugs. You blame the government. You blame blacks. You blame the Percys. You blame the kids for being there. What about Matthew Poncelet? Is he just an innocent, a victim?" Finally, Poncelet takes responsibility. "The boy. Walter. I killed him." Later, asked if he will take responsibility for both deaths, Poncelet says "Yes ma'am." Just before dying, Poncelet says to Delacroix: "I ask your forgiveness. It was a terrible thing I did taking your son away from you. I hope my death gives you some relief."

Austin Sarat (1999), writing primarily about *Dead Man Walking* and *Last Dance*, speculates that these films are intended to be powerful statements against the death penalty. The films place us in the same position as jurors at the penalty phase of the trial. We are called upon to make the same decision as the penalty phase jurors. One of the elements of that decision is a moral judgment about whether the death penalty is appropriate in this particular case. On that point, we have knowledge that the original jury didn't—the prisoner's death row epiphany. We have discovered that the prisoner has taken responsibility for the crime, expressed remorse, become human rather than a vicious monster; so we may be disposed, as surrogate jurors, to vote against the death penalty. Even so, we see the prisoner executed—something we might now believe to be a horrible mistake. This leaves us more doubtful about the morality of the death penalty than when we entered the theater. However, we might have the opposite reaction. Because the imminence of execution caused a prisoner to take responsibility and achieve personal redemption, we might decide that the moral case for the death penalty is strengthened.

In these films, the intermediary is also transformed by the experience. Sister Prejean reinforces her compassion for human beings and becomes a committed death penalty opponent. Similar personal transformations occur in *The Chamber, Last Dance, The Widow of St. Pierre,* and *The Life of David Gale.* In films involving innocent prisoners also, such as *The Green Mile, The Life of David Gale,* and *A Lesson Before Dying,* an intermediary is transformed by the experience. Thus, death row guard Paul Edgecomb in *The Green Mile* never works another execution and takes up work with youthful prisoners. The same thing happens to death row guard Hank Grotowski in *Monster's Ball* (2001) (a film premised on the execution of a guilty and unrepentant prisoner).

Sarat speculates that the personal transformation of the intermediary is also an anti–death penalty move by the filmmakers. To most of us, the death penalty is abstract; we don't know anybody who has been condemned to death and we have never set foot on death row. However, when confronted by the ghastly reality of the capital punishment process, these intermediaries have changed—some into death penalty opponents, some into new levels of personal maturity, some into a withdrawal from working on death row. Perhaps we identify with these intermediaries and ask ourselves whether we could show as much understanding and compassion as that person. Perhaps we too will be transformed in a way that makes us doubt our support for the death penalty.

Aside from its use as a political tactic by filmmakers, are there other reasons why the makers of death penalty films repeatedly use as thematic material the personal redemption of the condemned and the personal transformation of the intermediary? In short, why do we care about the redemption of vicious killers or the transformation of those who befriended them?

11.04 Pictures at an execution

Historically, executions in America and many other countries were public spectacles. In the nineteenth century, enormous, often festive crowds attended public hangings. In a number of countries, public executions still occur; perhaps such ceremonies are intended to demonstrate the power of the state and to terrify the citizenry into obedience. Ultimately, the states abolished public executions. The last known public execution in America occurred in 1937. Normally, executions today are viewed by a relatively small group of witnesses, mostly the press, prison officials, and families of victims, and photographs are prohibited.

Thus the only way that the general public can "witness" an execution is by viewing films or TV shows about the death penalty. As in *Dead Man Walking* and numerous

other films, we witness, in excruciating detail, the bureaucratized process, the numerous mechanical steps necessary to perform an execution by electrocution, in the gas chamber, or by lethal injection. We see the condemned prepare for death, walk to the place of execution, and suffer the death agony. Indeed, we see far more than the official witnesses to the execution. In *The Green Mile,* we witness no less than three electrocutions, one of them horribly botched.

Why do filmmakers show the executions in such gory detail? Is this depiction another political move or is it intended to respond to the same craving that once caused crowds of people to attend public executions? We could, of course, return to a form of the public execution by televising executions.[4]

11.05 The voice of the victims

In many death penalty films, especially including *Dead Man Walking,* we hear extensively from the families of the victims who are usually clamoring for the execution of the condemned. Once more, the movie serves as a retrial of the penalty phase of the trial—with us as the surrogate jurors. This time, we are receiving evidence that might cause us to vote in favor of, rather than against, imposing the death penalty.

How do you interpret the scenes at the end of the film involving Earl Delacroix and Sister Prejean?

In fact, victim testimony is now routinely admitted during the penalty phase of death penalty cases. In *Payne v. Tennessee* (1991), the Supreme Court (overturning a case decided only four years earlier) held that the families of murder victims could testify during the penalty phase. The jury is allowed to consider the magnitude of the survivors' loss and the victim's suffering as aggravating factors. Permitting the voice of the victims to be heard in a criminal prosecution fundamentally changes the proceedings. The victims testify in a very emotional manner about their loss (whereas most trial testimony is cold and unemotional). In addition, the use of victim statements changes a death penalty case from an action by the state to redress a violation of the norms of society into an action by the victims for revenge.

11.06 Purposes of the death penalty

11.06.1 Deterrence

Many people who support the death penalty believe that it deters criminals from committing murder (a utilitarian or consequentialist justification for the death penalty). They argue that if the death penalty saves the lives of innocent victims, it enhances net social welfare and is thus justified.

Obviously, it is difficult to prove whether this deterrence effect exists because one can only speculate how many murders are *not* committed because potential killers were deterred by the possibility of receiving the death penalty. Are there people who make a rational calculation and decide *not* to kill because their state has the death penalty but who *would have* killed if the only penalty for murder were life imprisonment?

Many homicides will not be deterred even by a strongly enforced death penalty because they are committed by people who are not making rational calculations at the time (such as barroom brawls or domestic abuse). Other homicides result from the felony murder rule (such as an unplanned death that occurs during a burglary or armed robbery), and many are committed by people who do not think they will get caught. Moreover, there are so many murders and so few executions that it is hard to believe that rational persons considering whether to commit murder would really change their plans because of the remote possibility that they might be sentenced to death, and the sentence might be carried out.

11.06.2 Studies of deterrence

There have been numerous statistical studies that seek to measure the presence or absence of a deterrent effect. Unfortunately, there are serious methodological problems in attempting to correlate murder rates and execution rates. The results depend heavily on fine points of statistical methodology as well as on the data set used by the researcher and the various assumptions the researcher makes. The studies conflict, and it is difficult for persons who are not experts in statistical methodology to make firm judgments about the validity of the various studies and their conclusions (Turow 2003).

Some studies indicate that homicide rates are *higher* where the death penalty is imposed (a possible result of the so-called "brutalization" effect of constant media discussion of the death penalty). For example, Harries and Cheatwood (1997) studied differences in homicides and violent crime in 293 pairs of contiguous counties. The counties were matched in pairs based on geographic location, regional context, historical development, and demographic and economic variables. The authors found no support for a deterrent effect at the county level. The researchers compared matched counties inside and outside states with capital punishment, with and without a death row population, and with and without actual executions. The authors found *higher* violent crime rates in death penalty counties. Many other studies on this question agree with Harries and Cheatwood and fail to establish the existence of a deterrent effect.

Conversely, some serious and careful econometric studies do find a deterrent effect. Dezhbakhsh, Rubin, and Shepherd (2003) studied murder rates in 3073 counties before, during, and after the suspension of capital punishment that occurred because of the Supreme Court decisions discussed in ¶11.07. They tried to crank into their equations every possible variable concerning demographics, gun ownership, and the probabilities of arrest, conviction, and execution in each county.

They identified a strong deterrent effect. In their opinion, every execution results in between eight and 18 fewer murders. Similarly, using different data and somewhat different statistical methodology, and comparing states with and without the death penalty, Mocan and Gittings (2001) estimated that each execution results in five to six fewer murders. They also estimate that three instances of clemency generate one to one and one-half additional murders.

<div align="right">

11.06.3 Incapacitation

</div>

Another consequentialist justification for the death penalty is that it prevents the offender from ever killing again. A prisoner sentenced to life imprisonment might ultimately get out of jail (either through parole or by escaping) and kill again. Also, a prisoner might kill another prisoner or a guard while serving a life sentence in the general prison population. Obviously, a prisoner who is confined to death row and ultimately executed is unlikely to be able to kill anyone.

The incapacitation rationale is weakened if a killer is sentenced to life without the possibility of parole, which is possible in most states. Nevertheless, death penalty proponents are skeptical about these statutes. The prisoner might still persuade the authorities to commute the sentence or the prisoner might escape. In addition, prisoners sentenced to life without parole might still kill another prisoner or a guard, although modern super-high security prisons make this unlikely.

<div align="right">

11.06.4 Retribution

</div>

Most arguments about the death penalty are based on one of two moral views. Many of those who favor the death penalty base their opinion on theories of retribution (and we hear from some of them in *Dead Man Walking*). In this view, justice requires that society punish by death a person who has killed, reserving the most extreme punishment for the most heinous crime. Biblical texts such as "an eye for an eye" are sometimes cited to support this view. This retributivist approach is based not on the consequences of punishment (such as deterrence), but on the nonconsequentialist rationale that the evildoer deserves it or that society must express its sense of communal outrage by exacting the ultimate penalty. Others, like Sister Prejean, take an opposing moral view. They argue that retribution is a primitive urge that has no place in modern society; they believe that killing is wrong, whether it is done by a criminal or by the state.

11.07 Judicial flip-flops on the death penalty

In *Furman v. Georgia* (1972), the U.S. Supreme Court held the death penalty as administered in Georgia was unconstitutional because it violated the cruel and unusual

punishment clause of the 8th Amendment. Although the justices differed somewhat in their reasoning, the primary rationale was the arbitrariness of imposition of the death penalty. Juries were given no guidance in deciding whether to condemn a defendant to death, and imposition of the penalty was highly unpredictable. The result of the *Furman* decision was to spare 629 persons then on death row.

However, Georgia and many other states were determined to retain the death penalty. They restructured their procedures by furnishing more guidance to the jury. The new death penalty statutes involve a double trial before the same jury. In the first trial, the jury must find the defendant guilty of murder. The second trial is called the "penalty phase." The statutes spell out specific aggravating factors (such as whether the defendant killed a policeman, whether the killing occurred in the course of a terrorist act, whether the defendant lay in wait, or whether the killing occurred during an armed robbery). During the penalty phase, the jury must find beyond a reasonable doubt that at least one of these aggravating factors is present before it can impose the death penalty. During the penalty phase, the defendant is entitled to introduce any mitigating evidence, such as evidence about character, personal history, mental ability, youth or other psychological factors, evidence concerning the defendant's culpability in the particular crime, or evidence that the defendant took responsibility for the crime. Supposedly this process guides the jury's decision making and reduces the chances of an arbitrary decision. Faced with a death penalty judgment under such a statute, the Supreme Court reinstated the death penalty (*Gregg v. Georgia* 1976).

The *Gregg* decision made the federal courts the ultimate authorities of the fairness of particular state death penalty procedures. As a result, the Supreme Court has been called on to decide numerous death penalty cases. One of the most important unresolved issues is whether the state can execute a person who was a juvenile at the time the crime was committed (and, if so, at what age can it do so). A number of juvenile murderers have been executed and many more sit on death row. In *Atkins v. Virginia* (2002), the Court held (5 to 4) that the state could not execute mentally retarded prisoners. A few days later, it held (7 to 2) that the aggravating factors must be found by a jury, not the judge (*Ring v. Arizona*). This important decision set aside procedures in a number of states that allowed the judge to impose the death penalty, even if the jury had refused to do so.

An important aspect of death-penalty law is that the courts, state legislatures, and Congress have severely limited a prisoner's ability to seek judicial review after exhausting direct appeals in the state courts (followed by a request for a hearing—called certiorari—from the U.S. Supreme Court). After this process is completed, a state prisoner gets into federal court by seeking a writ of habeas corpus. Habeas is the ancient writ that requires government to establish a legal reason for confining a prisoner. Habeas applies if the state committed a procedural error of constitutional dimensions or, in some cases, if new evidence proves the prisoner was innocent. The law relating to federal habeas is too complex to summarize here. However, as a result of various federal

statutes and court decisions all designed to limit the number of death penalty reviews, relatively few prisoners will secure any relief either through the appeal process or through federal habeas, even in cases in which they present new evidence of innocence.

11.08 The death penalty in the United States—Law and practice[5]

Following the Supreme Court's decision in *Gregg* that reinstated the death penalty, capital punishment became very popular. It is available in 38 states and for numerous federal crimes. Of the 38 states, 35 provide for the option of sentencing the defendant to life imprisonment without the possibility of parole. Since 1976 (the year of the *Gregg* decision) until fall 2003, 877 prisoners were executed. In the fall of 2003, 3,517 prisoners sat on death row. However, a trend away from the death penalty seems to be in process. In 2001 (the most recent year for which statistics are available), the number of prisoners entering death row was 155, the smallest since 1973. The decreased number of prisoners sentenced to death reflects, in part, declines in the homicide rate; it probably also reflects the difficult practical problems with the death penalty discussed below in this section (Liptak 2003; Death Penalty Information Center 2003).

The death penalty is popular with voters, but the support level is dropping because of publicity about innocent defendants wrongly sentenced to death. An ABC News poll in 2001, for example, found that overall support for the death penalty is 63%, down from 77% in 1996. Support drops further to 46% when respondents are given the option of choosing life without parole or the death penalty (ABCNews.com 2001).

Regardless of one's feelings about whether the death penalty is an effective *deterrent* or whether it is *morally* appropriate—see ¶11.06—most people agree that there are numerous troubling problems with the way it works in practice. In theory, the death penalty should be reserved only for "the worst of the worst," but it often fails to achieve that goal. Many of these practical problems are addressed in *Dead Man Walking* and in some of the other death penalty films released during the last decade. These practical and administrative problems might cause a utilitarian to oppose the death penalty even *if* that person is a retributivist and has no moral objection to executing "the worst of the worst."

11.08.1 The risk that an innocent person will be put to death

The problem that has received the most publicity is the significant number of apparently innocent people who have been sentenced to death and the possibility that some innocent people have been executed. Recently DNA evidence has proven the innocence of some condemned prisoners, and numerous others have been proven innocent by dedicated student and journalistic investigators. Since 1977, 111 people

in 25 states have been freed from death row on proof they were probably or at least possibly innocent. (Death Penalty Information Center 2003). Concern that innocent people might have been condemned to death led Illinois governor George Ryan (a law and order conservative) to impose a moratorium on executions in 2000. A commission appointed by Governor Ryan recommended numerous changes in the administration of the Illinois death penalty, but the legislature (concerned about the political implications of appearing soft on crime) adopted none of them. Finally, Ryan granted clemency to all Illinois death-row prisoners (about 150) before he left office in 2002 (Turow 2003). The American Bar Association also voted in 1997 in favor of a moratorium until various reforms in death penalty administration could be enacted.

11.08.2 Clemency

In theory the state's clemency process is supposed to provide one last chance for the defendant who might be innocent of the crime or whose case merits a lesser punishment than death. However, the political realities of the death penalty discourage governors who might otherwise be disposed to grant clemency. A decision to grant clemency would be political poison in a state where the death penalty is very popular with voters and the governor plans to stand for re-election.

11.08.3 Racial disparities

One serious problem with the death penalty involves racial disparity. Statistics show that blacks who kill whites are far more likely to be executed than other combinations (whites who kill blacks, whites who kill whites, or blacks who kill blacks). Of the persons executed for *interracial* murder from 1977 to 2000, 172 were black defendant/white victim, and only 12 were white defendant/black victim. Over 80% of completed capital cases involve white victims, even though nationally only 50% of murder victims are white.

Nevertheless, the Supreme Court in *McCleskey v. Kemp* (1987) held that a strong statistical showing of this sort was insufficient to establish that the death penalty in the aggregate denies equal protection of the law. Only a showing of intentional racial discrimination in the particular case would suffice. The Court was apprehensive that if it granted relief in a capital case based on a showing of aggregate racial discrimination, it would soon have to do the same for prison sentences; and it might also have to grant relief in the case of nonracial but equally arbitrary forms of discrimination.

Except for *The Green Mile* and *A Lesson Before Dying,* both of which involved innocent black men accused of black on white crime, the various films on the death penalty downplay the racial concern. In most of them, as in *Dead Man Walking,* the crime was white on white.

11.08.4 Class discrimination

Another problem is the class distinction in administration of the death penalty. Affluent defendants who can afford the best lawyers and a strong legal defense are seldom executed. The death penalty films accurately portray this element of the crime. Matthew Poncelet is exactly the sort of lower-class person who is the typical death penalty target.

11.08.5 Quality of legal defense

Another troubling problem is the poor quality of legal defense, particularly in much of the South. In many southern counties, there is no public defender system. Indeed, President George W. Bush, while Governor of Texas, vetoed legislation setting up a statewide public defender system for death penalty cases. Some public interest organizations, such as the Southern Center for Human Rights, do an excellent job of pro bono legal defense in capital cases, but their resources are far too small to cover all of the cases.

Instead, in many southern counties, the judge simply appoints local counsel to defend defendants in capital cases. However, the amount of money available to pay them is quite small (sometimes pitifully small—in Alabama, $20 per hour, not to exceed $1000, for out-of-court preparation). A lawyer wins no friends for vigorously defending a despised death penalty defendant—in fact he may be loathed. There are very few lawyers like Atticus Finch available to handle death penalty cases in the South. As a result, the lawyers are often incompetent and, even if competent, cannot afford to spend time preparing or investigating the crime.

Burdine. In *Burdine v. Johnson* (2001), the federal Court of Appeals reversed a decision imposing the death penalty because the lawyer slept through much of the case. (The Texas courts had upheld the conviction.) The Supreme Court denied review of this case in 2002. The sad fact is that this same lawyer had slept through numerous capital trials; at least a dozen of his former clients have been executed. Matthew Poncelet's lawyer wasn't that bad, but he was a tax lawyer who had never tried a capital case. He spent only four hours on jury selection (a process that if done well sometimes takes weeks), and he raised only a single objection during a five-day trial.

11.08.6 Delays

Another problem with the death penalty is the delay in actually carrying it out. In the year 2000, the average time spent on death row between sentence of death and execution was 137 months (134 for whites, 142 for blacks). During this time, the prisoner is typically isolated in a small cell with little chance for exercise, visitors, or even contact with other human beings.

These delays result from a number of factors. Obviously, there are numerous appeals between the time of conviction and the time of execution. Many times, there are stays of execution while counsel pursues new approaches, or reversals for retrial of the penalty phase. Often there is great difficulty in even finding lawyers who are willing and able to handle the appeals to which the prisoner is legally entitled.

11.08.7 Error rates

An important Columbia University Law School study by James S. Liebman and others looked at every death penalty conviction between 1973 and 1995 (Liebman 2000a, 200b, 2000c). It found that 68% of death penalty verdicts were reversed by appellate courts for serious errors. Liebman determined that 76% of these reversals were because defense lawyers had been egregiously incompetent, police and prosecutors had suppressed exculpatory evidence or committed other professional misconduct, jurors had been misinformed about the law, or judges or jurors had been biased. Of the cases sent back for retrials of the penalty phase, 82% ended in sentences of less than death.

Liebman and his coauthors blamed these appalling results on overuse of the death penalty. The death penalty should be reserved for the worst of the worst. The higher the rate at which a state imposes death verdicts (that is, uses it for less heinous murders), the greater the probability that any given death verdict will be reversed because of serious error. Some of the reasons for overuse of the penalty involve factors relating to race, politics, and poorly performing law enforcement systems. As to the latter, the lower the rate at which homicides are solved in a state, the higher their reversal rates. With regard to the judges, the more often and more directly they are subject to popular election, and the more partisan these elections are, the higher the state's rate of serious capital error. (See discussion of judicial elections in ¶10.10.)

11.08.8 Costs and strains on the criminal justice system

Contrary to what most people think, it is much more expensive to execute a prisoner than to keep that person in prison for life. One comprehensive study showed that the death penalty costs North Carolina $2.16 million *per execution over the costs of a nondeath penalty murder case with a sentence of imprisonment for life.* In Texas, a death penalty case costs an average of $2.3 million, about three times the cost of imprisoning someone in a single cell at the highest security level for 40 years.

The strain on the criminal justice system. Prosecutors, judges, and defense lawyers must spend far more time on death penalty cases than on any other kind of criminal prosecution. In California, for example, anyone condemned to death receives two assigned public defenders and an automatic appeal to the state Supreme Court (with-

out an intervening stop in the court of appeals). The California Supreme Court has to spend a huge proportion of its time on death penalty cases, but every year its backlog increases and it falls further behind.

The last hours of the life of a condemned prisoner are typically consumed by frantic last minute appeals and requests for stays. Sometimes the stays are granted at the last moment, then lifted, allowing the execution to proceed. These heroics are exhausting for the lawyers and the judges who must deal with them and torture for the prisoner and the prison officials who must administer the ultimate penalty.

11.09 The death penalty outside the United States[6]

Although the United States is committed to the death penalty, the rest of the world is moving strongly in the opposite direction. At the end of World War II, almost all countries practiced capital punishment. Beginning in the 1970s, an abolition movement took hold. The death penalty has now been abolished in all of the countries with which we would like to compare ourselves, including Canada, Australia, and Western Europe. A total of 105 countries have now abolished the death penalty or placed a moratorium on executions. The European Union (EU) treaty prohibits the death penalty and requires any country that wishes to join the EU to abolish it. Indeed, the death penalty is generally regarded by the international community as a gross human rights violation.

The number of executions carried out in countries that retain the death penalty is not entirely certain. China may have executed around 1000 people in 1998 of the total reported 1625 executions in the world. Other countries that executed large numbers of people in 1998 were Democratic Republic of the Congo (100), the United States (68), and Iran (66). Most of the Islamic states such as Iran, Pakistan, and Saudi Arabia retain the death penalty. Generally, most countries that have abolished the death penalty (including Britain, the EU, and Canada) will not extradite a criminal suspect to the United States unless American prosecutors clearly renounce the death penalty in the particular case.

11.10 Review questions

1. Select a scene in *Dead Man Walking* and describe what techniques (other than dialogue) the filmmakers use to convey the emotion of the characters.
2. What is your interpretation of the collision montage near the end of *Dead Man Walking* in which the filmmaker cuts back and forth between Poncelet's execution and the murder of the two teenagers?

3. What is your interpretation of the scene involving Sister Prejean and Earl Delacroix at the end of the film?

4. What political stance does *Dead Man Walking* take on the morality of the death penalty? How do you know? How does the film attempt to influence the spectator's opinion on this issue?

5. *Dead Man Walking* and other death penalty movies frequently involve a personal transformation of both the condemned prisoner and the "intermediary"—the person who befriends the prisoner. Why do filmmakers consistently include this element in their stories?

6. Both death penalty proponents and opponents are troubled by various practical problems in the process of determining whether a particular defendant should be sentenced to death. What changes, if any, should be made in this process?

7. Do you favor televising executions? Why or why not?

CIVIL JUSTICE

The Civil Justice System
Assigned film: Class Action *(1990)*[1]

12.01 *Classical narration in* Class Action

As described in ¶4.03.1, classical Hollywood films typically possess the following attributes:

- characters are defined by a set of consistent traits or behaviors that reveal their underlying psychology and personality;
- a protagonist is motivated to pursue a goal;
- the actions of the protagonist follow a cause-and-effect sequence;
- there is closure at the end of the film;
- a double-plot structure interweaves the generic storyline with a romantic one.

Class Action illustrates some of these attributes while at the same time offering interesting variations on others.

12.01.1 Conflict in personalities

As with most classical films, *Class Action* individualizes its main characters early on. The opening six minutes establishes the set of traits and behaviors that define Jed (Gene Hackman) and Maggie Ward (Mary Elizabeth Mastrantonio).[2] When we first see Maggie, she is standing rigid with her arms folded making dry, legalistic appeals to the judge ("appeals to the contrary based on emotion have no place in a court of law," "the law, not charity, must dictate our course here today"). When we first see Jed (we

actually hear him shouting "Objection!" before we see him), he is making an impassioned closing argument to a jury. In contrast to Maggie, Jed is a kinetic speaker. He traipses back and forth and gesticulates wildly. His arguments are anything but dry and legalistic. The first words we hear him say to the jury are: "This is *not* a court of law."

By cutting back and forth between the two courtrooms, the film emphasizes that Jed and Maggie have *conflicting* personalities. Jed is a flamboyant, rough-around-the-edges, rabble-rousing plaintiff's attorney; Maggie is a staid, slightly stiff, but highly competent big-firm attorney. The clash in personalities could not be clearer. However, it is only when the two run into one another in the elevator that we learn they are father and daughter. Their brief, frosty conversation (Jed: "It's a present for your mother. Anniversary. Hard to believe we've been together for 34 years." Maggie: "35.") communicates the status of their relationship in a few curt lines.

12.01.2 *Establishing motivation*

Having established the personality traits of the two main characters, the film establishes their goals and motivations. Jed is trying to win an apparently hopeless David versus Goliath-type case because he believes that Argo has wronged his client and should be made to pay for it.

Maggie's goal and motivation are somewhat more complicated. We first learn of Maggie's interest in the Argo case when she asks the two attorneys who accompanied her to the nonsuit motion if they have heard anything about it. Soon we learn why Maggie is so interested in the Argo case: she wants to make partner. "This is the partnership express," she tells Michael Grazier. Thereafter, we learn another reason why she wants the case. As her parents' anniversary party is winding down, she takes her father aside and tells him that she is considering taking the Argo case. In the argument that ensues, she says that she wants to take the case to prove to her father how good an attorney she is. Later, Maggie tells her mother that she is taking the case because she wants to get her father "someplace I can beat him" and that she won't drop the case because "[s]omebody has to fight him."

Thus, by the time Maggie's mother dies, the film has made it clear that Maggie has two desires: first, to make partner and, second, to show her father that she is as good a litigator as he is by beating him in court. The first of these desires motivates her to take the Argo case; the second motivates her to stay on the case despite her father's presence on the other side. Winning the Argo case thus becomes her goal, and in achieving that goal she hopes to satisfy both of her desires at once.

12.01.3 *The father-daughter subplot*

Although ostensibly a trial film, the bulk of *Class Action* is spent elaborating on the relationship between Jed and Maggie. This focus on a father-daughter relationship rep-

resents a departure from the norm of classical Hollywood films. The typical classical Hollywood film combines a generic storyline with a romantic one, but *Class Action* combines a legal storyline with a father-daughter subplot. As a bonus, there is a romantic storyline as well (the ill-fated affair between Maggie and Michael) embedded within the legal story.

Class Action's substitution of a father-daughter subplot for the more typical romantic subplot alters the narrative trajectory of the film. After all, if romantic storylines typically point toward the consummation of the romantic relationship, storylines about alienated parents and children (i.e., family melodramas) typically point toward reconciliation. This creates a narrative dilemma; if Maggie successfully defeats her father in the courtroom, *that* ending would have left the father-daughter storyline unresolved.

One way the film *could* have resolved the father-daughter conflict would be to have Jed die. Death is how many family melodramas resolve their parent-child conflicts. See, for example, *Imitation of Life* (1934, 1959) and *Hud* (1963). Instead, Maggie abandons her desire to become a partner. When she realizes that this desire can only be satisfied through complicity in unethical behavior, she decides to forgo it. This means, of course, that she must also abandon her goal of winning the case. This does not, however, mean that she has to give up on her desire of proving that she's just as good a litigator as her father. Instead of proving it by defeating Jed, she helps him win. She stays on the Argo case in order to trick Michael Grazier into implicating himself on the stand. While her conduct raised serious ethical issues (see ¶12.07.4), it solved the narrative problem by bringing closure to both storylines. Maggie proved that she was as good a litigator as Jed—indeed, he couldn't have won the case without her—and Maggie and Jed reconciled. Whether or not one considers this a "happy ending" is another question entirely.

12.02 Female lawyers in the movies

Women now fill about half of the slots in most law schools and perform every professional role. In the aggregate, they are no more or less competent, no more or less ethical, than their male counterparts. The movies contain many examples of tough, competent, hard-working, successful, and committed female lawyers. Nevertheless, these films abound with negative stereotypes about female lawyers. Indeed, the bad female lawyer has become almost a stock character.

12.02.1 Favorable portrayals of women lawyers

Women lawyers got off to a wonderful start in the delicious comedy, *Adam's Rib* (1949). There were a few female lawyers in movies before *Adam's Rib*, but the films

were insignificant. *Adam's Rib* had a major director (George Cukor), major writers (Garson Kanin and Ruth Gordon) and top stars (Katharine Hepburn, Spencer Tracy, Judy Holliday, and others). It made a big impact and is still fondly remembered.

Amanda Bonner (Hepburn) took a criminal case pro bono because she thought it raised an important issue of women's rights. Her client Doris Attinger (Holliday) had shot her husband after finding him with his mistress. Amanda contended that a man would not be prosecuted in such circumstances so a woman should not be either. Thus, the film is a disguised attack on the sexual double standard. Amanda did a great job of representing her client, even though her actions infuriated her husband Adam (Spencer Tracy) who was prosecuting the case. Amanda was a loving wife in a marriage of equals; however, she was also a dedicated and skillful lawyer. She risked her marriage in order to represent her client. This movie probably made legions of little girls want to go to law school.

A few female lawyers are treated favorably in modern movies. One is Reggie Love in *The Client* (1994). Love accepts a child's case pro bono and outsmarts all manner of wicked adversaries (although she succeeds only with the kid's guidance). Another is Gareth Peirce in *In the Name of the Father* (1993), who tirelessly works to free the wrongly imprisoned Guildford Four. Penelope Miller does an excellent job representing a corporate client in *Other People's Money* (1991). These are the exceptional films, however.

12.02.2 Female lawyers—Yesterday and today

Unfortunately, at the time of *Adam's Rib,* there were very few women lawyers or law students (or females in other professions, for that matter). During the 1800s, women were excluded from the profession entirely. In 1873, the U.S. Supreme Court upheld the exclusion of Myra Bradwell from the Illinois Bar with the statement "The family organization, which is founded in the divine ordinance, as well as in the nature of things, indicates the domestic sphere as that which properly belongs to the domain and functions of womanhood. The harmony, not to say identity, of interests and views which belongs, or should belong, to the family institution is repugnant to the idea of a woman adopting a distinct and independent career from that of her husband" (*Bradwell v. Illinois* 1872).

Until just a few years ago, the small scattering of female law students and lawyers encountered a heavy dose of educational and employment discrimination, sexism, and ridicule. Supreme Court Justice Ruth Bader Ginsburg, for example, was unable to find a job or a judicial clerkship after she graduated in 1960 at the top of her class from Columbia Law School. Justice Sandra Day O'Connor's first job was as a legal secretary. The rapid increase in female enrollment in law school did not begin until the 1970s and really took off in the 1980s and 1990s.

Even today, women have more difficulty than men in getting ahead in the profession. Rhode 2001 documents that female lawyers earn about $20,000 less than male

lawyers with similar experience and in similar positions. Men are at least twice as likely as similarly qualified women to obtain law firm partnerships. Women receive less mentoring and are often subject to sexual harassment. Women with parental responsibilities are seldom accommodated by flexible work schedules. Maggie in *Class Action* remarks that she cannot move in with Michael because "It's different for a woman. I don't want them saying I made partner for anything other than my work." Would the same thing have been true if Michael had been the associate and Maggie the partner?

12.02.3 Female lawyers in film—Rita Harrison

A typical example of the modern woman lawyer in the movies is Rita Harrison (Michelle Pfeiffer) in *I Am Sam* (2001). Harrison, a big-firm lawyer, is unethical, deceitful, and greedy. Her family life is a mess. True, she does change in the course of the narrative (as filmmakers say, she describes an arc). She is shamed into taking a pro bono child custody case for a retarded man (Sean Penn) and ultimately does a good job on his behalf. However, the movie's message is that female lawyers (except in the unlikely event that they are ensnared by a lovable pro bono client) are a complete disaster.

Rita Harrison's portrayal will resonate with many woman lawyers who are trying to succeed in the law firm environment and also nurture a marriage (or other intimate relationship) and raise children. In order to meet the demand for billable hours, attorneys often find themselves spending 12 hours a day, six or seven days a week, in the office (see ¶13.05.4). Nobody can sustain a satisfying relationship with a spouse or a lover or do an adequate job of raising children while working these kinds of hours. Given that the main child-care responsibility generally falls on the shoulders of women, it is easy to imagine that the life of many female lawyers is a disorderly and frustrating mess, not unlike Harrison's.

12.02.4 Negative treatment of women lawyers in contemporary film

The harshly negative treatment of Rita Harrison is typical of modern films involving female lawyers. Women lawyers are usually beautiful but personally unpleasant. Often, they are nasty, cold-hearted, and overambitious—like Grey Ellison in *Curly Sue* (1991) or Lael Rubin, as she is portrayed in *Indictment* (see chapter 8). They have poor judgment in the selection of sexual partners. Some are sleeping with their clients, which is an ethical no-no—as in *Jagged Edge* (1985) or *Defenseless* (1991). Maggie Ward is conducting an affair with the partner who supervises her work (and thus becoming the source of office gossip). In addition, they display poor judgment in selecting clients—as in *The Music Box* (1989) or *Guilty as Sin* (1993).

The personal lives of filmic female lawyers are a complete disaster—like Maggie Ward's or the female lawyers in *The Client* (1994), *Suspect* (1987), or *A Few Good Men*

(1992). They seem to have no friends, much less any romance in their lives. Rita Harrison is an exception because she is married and raising a child; most other female movie lawyers are single and childless (not necessarily by choice).

Sometimes, the narratives about female lawyers seem less concerned with their work and more with how they find a man and thus become fulfilled human beings. This story line occurs in numerous films such as *Suspect, The Big Easy* (1987), *Physical Evidence* (1988), or *Legal Eagles* (1986). The story in *Class Action* is similar, although Maggie Ward's is fulfilled by reconciling with her father rather than finding Mr. Right.

The ethics of female lawyers are often horrendous as in *The Verdict* (chapter 4) where a female lawyer essentially acts as a prostitute to steal information from the opposing side. The lawyer in *Defenseless* fails to disclose that she was a witness to the murder in question and the lawyer in *Liar Liar* (1997) is busy arranging for perjured testimony when she is not engaged in sexual harassment of associates. Some have slept their way to the top, as in *Presumed Innocent* (1990). Many are incompetent lawyers, as in *A Few Good Men* or *Philadelphia* (discussed in chapter 13). They are overly emotional and act irrationally in critical situations, as in *The Music Box, Jagged Edge,* or *In the Name of the Father*. They do not know how to talk to ordinary people, like Theresa Dallavale in *Erin Brockovich* (2000). Erin herself is terrific, of course, but she is a paralegal, not a lawyer.

12.02.5 Difference v. equality feminism

Feminist scholars split into two major camps. The "equality" faction believes that men and women are basically alike (aside from physiological differences) and should be treated alike. For decades, equality feminists have lobbied for passage of the Equal Rights Amendment, which would guarantee legal equality for women.

The "difference" group, however, asserts that women are different from men and society should value women's attributes equally with those of men. In particular, the law should take account of the differences between men and women, not ignore them. For example, law firms should treat lawyers (primarily women) with childcare responsibilities differently from lawyers without such responsibilities. In addition to the obvious—women can bear children—many studies have shown that women are more nurturing than men with greater focus on connections and relationship rather than on competition and aggression (see ¶14.08.2 for an example of the way these two versions of feminism play out in child custody law and ¶6.05.2 for discussion of feminist views in legal education).

Supporters of difference feminism should consider the model of the female lawyer presented in the successful comedy *Legally Blonde* (2001). Elle Woods is a law student, but she functions during the second half of the film as a lawyer. Initially portrayed as a rich airhead, she turns out to be a smart and clever law student and lawyer. Her characterization is highly favorable, but it stresses her *difference* from male law students

and lawyers, the ways in which she employs her femininity (and specialized female knowledge of fashion and hair dressing) in the interests of her client. She has emotions and does not try to suppress them in her personal or professional life. The film also contains strong portrayals of supportive female friendships—between Elle and her sorority sisters, between Elle and her beautician, between Elle and a female professor, and between Elle and her client (exercise guru and member of Elle's sorority). Elle Woods harks back to Amanda Bonner, Katharine Hepburn's classic role in *Adam's Rib*. Bonner was a great lawyer but still very feminine.

In the movies, female lawyers such as Maggie Ward try to act like male lawyers in their personal and professional lives; but they don't do it well and they usually fail. *Legally Blonde* says that women should not have to become like men to succeed as lawyers.

12.02.6 Female lawyers on television

On television female lawyers are normally treated in a sympathetic manner.[3] A number of positively portrayed female characters in nonlawyer series, such as *The Bill Cosby Show, Sex and the City,* or *Hill St. Blues* have been lawyers. The many women lawyers on *The Practice, L.A. Law, Law & Order, Judging Amy, Family Law, JAG,* and other shows, are all decent human beings and competent, dedicated lawyers. They confront ethical and personal dilemmas but handle them at least as well as their male counterparts. In this respect, female lawyers are like lawyers generally—their treatment on television is much more favorable than their treatment in film. This phenomenon is discussed further in ¶4.07.5.

12.02.7 Trying to explain the negative treatment of female lawyers in the movies

The field of feminist film criticism is huge (Stam 2000, 169–79).[4] Much feminist analysis begins with a famous article by Laura Mulvey (1975). In this article, Mulvey (drawing heavily on the work of Freud and Lacan) proclaimed that she wants to deconstruct and destroy the pleasure we take in watching movies. She argued that film produces pleasure by privileging the masculine "gaze." This gaze combines "scopophilia" (by which Mulvey meant viewing and eroticizing the female form) and identification by the viewer with the male figures in the film, who are acting upon the female.

As Mulvey sees it, films usually make men the active subject of the narrative and the female the passive object who is acted upon. Visual pleasure in film reproduces a structure of male looking and female to-be-looked-at, a binary structure that mirrors the asymmetrical power relations operative in the real social world. Women spectators have the unpleasant choice of identifying either with the active male protagonist or with the passive, objectified female antagonist.

Does Mulvey's analysis help us understand *Class Action* and other negative-female-lawyer films? In many scenes, Maggie is portrayed beautifully, allowing her to be the subject of an eroticized male gaze. Although Maggie could not be described as passive, nevertheless she is "acted upon" and manipulated both by Grazier and by Jed. In the end, Jed subdues her by bringing her around to his side of the Argo case. This sort of analysis seems to work on a great many of the negative female lawyer films.

What other explanations might be offered for the prevalence of negative female lawyer films?[5] Do these movies reflect public sentiment that women don't belong in the legal profession—that the jobs lawyers do are more appropriate for men? That doing such jobs will destroy the feminine side of women? (Recall the Supreme Court's *Bradwell* decision quoted in ¶12.02.2.) Discomfort with the meteoric increase in the number of female lawyers in the last few decades? Do they reinforce the dominant ideology that women should be subordinate to men?

Alternatively, is the stereotypical way in which women lawyers are treated really a backlash against feminism and the political, social, and economic gains women have made since the 1960s and 1970s? Does it reflect suspicion and distrust of smart, tough, aggressive, powerful women? Women who can make enough money to avoid dependence on men? Recall that Hillary Rodham Clinton was and is passionately hated by millions of people—did the fact that she had been a successful big firm lawyer have anything to do with it?

Is it a desire by filmmakers to appeal to a male demographic among ticket buyers, or is it an inability to see females as other than sex objects? From still another perspective, does it reflect the views of filmmakers (predominantly white males at all levels of the production process) that women should stay in the domestic sphere rather than the professional sphere? Do all these negative treatments of female lawyers have an impact on the way people in the world (such as male or female lawyers, judges, jurors, or clients) actually behave? (Recall discussion of the "cultivation effect" in ¶4.073.)

12.03 The civil justice process

(Law students who are already familiar with this material may wish to skip this part).

12.03.1 Civil cases—And class actions

The *civil justice process* resolves disputes that do not involve criminal sanctions. In a civil case, the *plaintiff* goes to court to seek some remedy (usually money) from the *defendant*. The vast majority of civil disputes are *settled* by the parties out of court or resolved by pretrial motions. Only a small minority of civil disputes actually result in trials. The majority of civil claims arise out of *torts* or *contracts*. A tort case is based on

an injury done by defendant to plaintiff for which defendant was at fault. Examples of tort cases are the routine auto accident case, a "products liability" case like that dramatized in *Class Action* or *Runaway Jury* (2003), a medical malpractice case as in *The Verdict* (chapter 4), or a civil rights case as in *Philadelphia* (chapter 13). Contract cases arise out of a deal between the parties that was broken by one of them.

A "class action" like *Kellen et al. v. Argo Motors* is brought by a single plaintiff to recover damages for injuries to an entire class of people in the same situation. The damages are split up among all victims (after subtracting the fee for the plaintiff's attorney). In one sense, a class action is efficient because the key issues (such as the technical evidence about the design defect of the Meridian and about Argo's decision-making process) would be the same in every case and would not have to be tried over and over again. In another sense, however, a class action is unwieldy since it is necessary to communicate with the entire class (which may be very large) and to allow class members to opt out of the lawsuit if they choose to. Bringing the case as a class action vastly complicates Jed's task (because he has to identify and communicate with all of the Meridian's victims). However, it would also greatly increase the possible damages he could recover (and thus the fee he might earn). Defendants usually try to decertify class actions (thus requiring them to be brought as separate cases) by arguing that individual issues in the case are more important than issues common to the entire class.

12.03.2 Lawyers in civil cases

In most civil cases, the parties are represented by lawyers, although they can represent themselves (in small claims court they must represent themselves). The cost of legal services is a serious problem for most litigants. In America, each side normally must pay its own lawyer, but in Britain the losing party must pay both lawyers. In most tort cases, the plaintiff's lawyer agrees to work for a "contingent fee," meaning that the lawyer is paid a percentage of whatever the plaintiff recovers. If the plaintiff loses, the plaintiff's lawyer gets no fee.

In a successful class action, the plaintiff's lawyer is paid out of the money recovered from the defendant before the remainder is split up among class members. Class actions represent an immense gamble for the lawyer. Even if the plaintiff wins and there is a large amount paid into the pot (and the odds are against either of these events), it will take many years before the appeals are exhausted and the lawyer gets paid. Meanwhile, the costs of bringing the suit—contacting the class, arranging for costly expert witnesses, often conducting scientific research—can be enormous. This scenario is effectively dramatized in the film *A Civil Action* (1998), involving a class action arising out of alleged toxic waste dumping. The costs of bringing the action nearly bankrupted the plaintiff's lawyers. In reality, most class actions are settled, not tried, and the settlement generally involves the payment of a fee to the lawyer.

The term *pleadings* refers to the documents filed by the parties at the beginning of a civil case. The plaintiff starts a civil case by filing a *complaint.* This complaint must be *served* on the defendant. The defendant must file an *answer* to the complaint. The defendant frequently files a motion to dismiss the case (sometimes called a *demurrer*) because the defendant contends that even if everything the plaintiff alleges in the complaint is true, the plaintiff still has no legal claim against the defendant. The judge will rule on this and many other motions before the trial begins.

Discovery helps the lawyers prepare for trial by eliminating the surprise factor and learning the strength of their opponent's case. Hopefully, this knowledge promotes settlement of the case without a trial. The discovery process tends to favor well-heeled litigants such as big corporate defendants because the costs of discovery can be enormous.

One type of discovery is called a *deposition.* Perhaps more than any other movie, *Class Action* dwells on the deposition process. In a deposition, one lawyer takes the sworn testimony of a party or of a witness who is expected to testify at the trial. Generally, the lawyer is hoping to tie the witness down to a particular version of the facts. Witnesses who testify differently at the trial will be *impeached* by their prior inconsistent deposition testimony and their credibility will be damaged.

Maggie Ward's deposition of Steven Kellen indicates how traumatic the process can be. The deposition was hard on Maggie too, as revealed by the scene showing her drinking alone in the bar. Basically, an attorney can ask almost any question in a deposition, regardless of relevance, and the deponent has to answer (unless the information is protected by some kind of privilege—see ¶12.03.6). Although lawyers can object to questions (in order to preserve the same objection to the testimony if it is used at the trial), generally the deponent must answer the question. When Jed and Nick pull Kellen out of the deposition, Maggie could get a court order forcing him to return and answer all of her questions. What was Maggie Ward's strategy in reducing Kellen to tears? Do you think she will bother to get a court order forcing him to return?

In big cases like the Argo Meridian or Ford Pinto litigation (¶12.05), there are certain to be many depositions. Lawyers feel they must depose anybody who might possibly testify or who has any knowledge about the events giving rise to the lawsuit. A number of lawyers attend every deposition, and depositions are a big reason for the enormous cost of conducting modern-day litigation.

In addition to depositions, each party can require the other to furnish documents or to answer written questions. These are called *interrogatories.* Responding to a huge set of interrogatories can be very burdensome (young lawyers spend a lot of time in

big document storage warehouses, as Maggie does in the movie). In *Class Action,* Jed's firm demands a large quantity of documents from the defendant, including test reports on the Meridian. As discussed below, the defense lawyers engage in some outrageous cheating in order to avoid producing a key test report.

12.03.5 Summary judgment and jury trial

Before trial, one or both parties may file a *motion for summary judgment.* This is a motion based on sworn affidavits of witnesses. If the affidavits show that there is no factual dispute, the judge will decide the case based on the affidavits. However, if the affidavits reveal that factual matters are in dispute, it will be necessary to hold a trial.

In most civil cases, the parties are entitled to a jury trial unless each of them agrees that the case should be tried by a judge. In *The Verdict* (chapter 4), the jury had to decide difficult questions involving standards of medical practice and what went wrong during childbirth. In *Class Action,* the jury must resolve a range of difficult and technical questions concerning the design of a complex product. If it decides that the design fails to meet the appropriate legal standard (discussed in ¶12.04), it must fix the amount of the plaintiff's damages (that is, the amount of the plaintiff's out of pocket cost such as lost wages or medical expenses and the value of his pain and suffering). In the Ford Pinto or Argo cases (and also *The Verdict* and *Philadelphia),* the jury could award *punitive damages* in order to punish the defendant for intentional misconduct and to deter it, and similar defendants, from repeating the offense.

Many question whether ordinary lay juries are up to the job of deciding technical engineering questions (or other sophisticated issues such as accounting, medical, or legal malpractice or antitrust issues). Even more, people wonder whether it makes sense to let juries decide whether to impose punitive damages and, if so, how much they should be.[6]

12.03.6 Witnesses and evidence

A key point in civil litigation is *burden of proof.* Generally the plaintiff must establish its right to recover by *a preponderance of the evidence*—meaning by a probability of more than 50%. If the evidence seems to be a tossup, the defendant wins. By contrast, in criminal cases, the prosecution must prove the defendant guilty beyond a reasonable doubt, which is a much more difficult burden to satisfy.

At a trial, the parties establish their case by putting witnesses on the stand and taking their sworn testimony. A *percipient* witness observed some of the events that gave rise to the lawsuit. For example, Kellen witnessed the accident and suffered horrible damages; Dr. Pavel wrote the key report about the Argo Meridian. An *expert witness* is called to establish some other element of the case. In *The Verdict* (chapter 4), both sides used expert witnesses to testify about the standards of medical practice. Jed would put

on experts about auto design to show the Meridian was unsafe and Argo would put on experts to show the contrary (see further discussion of expert witnesses in ¶8.10.5).

In most trials, the parties dispute whether particular items of evidence are admissible under the *rules of evidence*. For example, certain evidence is *privileged,* meaning that it cannot be introduced. One spouse cannot testify against the other spouse, for example, and an attorney cannot disclose what the client told the attorney in confidence. Moreover, evidence may be inadmissible as *irrelevant* because it would not assist the trier of fact to resolve the issues in the case, or the evidence might violate the *hearsay rule*. Hearsay is a statement by a witness of what someone else said outside of court (there are numerous exceptions to the hearsay rule that allow the introduction of many out of court statements). If one lawyer asks a question which the other lawyer thinks violates the rules of evidence (because it calls for an answer that is privileged, irrelevant, or hearsay), the other lawyer will *object*. The court will rule on the objection, either *overruling it* and allowing the witness to answer or *sustaining it*. Sometimes the witness has already answered the question before the objection is made; in that case, the judge will *strike out* the inadmissible evidence. The jury is supposed to ignore evidence that has been stricken, but, as trial lawyers say, you can't unring a bell.

12.03.7 Trial procedure

After the jury is selected, each party makes an *opening statement* which summarizes what the party intends to prove at the trial but is not supposed to consist of arguments. Then the plaintiff calls its witnesses. After each witness gives *direct testimony,* the opposing lawyer can *cross-examine* the witness. Cross-examination is limited to the issues raised on direct examination and is designed to reduce the impact of the direct or to raise doubts about whether the witness is reliable. The plaintiff's lawyer can then conduct *redirect* examination of the witness to repair the damage done on cross. The plaintiff will also introduce documents or other items supporting the case. These will be marked as *exhibits*. When the plaintiff is finished, it *rests its case*. Then the defense puts on its case and the process is repeated. Note that the attorneys are only supposed to ask questions, not make arguments, during this phase of the trial (a rule that is often ignored in movie trials).

The parties then give their closing arguments. The lawyers sum up the evidence that has been introduced at the trial and try to persuade the jury to accept the storyline that supports the lawyer's side of the case.

The judge then *instructs* the jury as to the law. The jury retires to the jury room and discusses the case until it reaches a *verdict*. In most civil cases, a unanimous verdict is not required. For example, in many states, the jury consists of 12 persons, and a verdict can be supported by nine votes. If the jury is deadlocked, this is called a *hung jury* and the case has to be retried.

The losing party may decide to *appeal.* In many states and in the federal system, there are two levels of appeal. The losing party is entitled to have the case considered by a three-judge panel in an intermediate appellate court (referred to as the Appellate Division in some states such as New York). The losing party before the intermediate appellate court can seek to appeal to the state supreme court (or in federal cases the United States Supreme Court). However, supreme courts exercise their discretion to consider only a small fraction of the cases brought to them. On appeal, each side files a *brief,* and there is usually an *oral argument* before the justices (appellate judges are often referred to as justices). Contrary to the film *Reversal of Fortune* (1990) (involving an appeal of the conviction of Claus von Bulow), no new evidence can be introduced on the appeal. The lawyers are limited to making arguments based on the transcript of the trial. The justices usually write an opinion explaining how they resolved the issues raised by the appeal.

If the plaintiff wins a money judgment, plaintiff will then try to collect it from the defendant (or, in many cases, the defendant's insurance company). If the defendant does not pay voluntarily, the plaintiff can seize the defendant's assets or *garnish* part of the defendant's paycheck until the judgment is paid. If the defendant cannot pay the judgment, the defendant may have to file *bankruptcy.* In bankruptcy, the bankrupt person's assets are sold to pay off creditors, including judgment creditors.

12.04 Products liability

Most tort cases are based on *negligence,* meaning the plaintiff must prove that an accident occurred because the defendant was careless. The standard generally used to measure negligence is whether the defendant failed to exercise the same level of care as would a fictitious reasonable person. Thus, in *The Verdict* the plaintiff seeks to prove that a doctor is liable for injuries caused during anesthesia because he failed to meet the standard of care that is taken by anesthesiologists in the community. The doctor responds that he took all possible care and the accident was simply one of the unavoidable risks of any medical procedure.

In the case of consumers injured by a defective product (such as a dead mouse in a Coke bottle or a collapsing ladder), most states allow the plaintiff to recover without proof that the defendant was negligent. The plaintiff needs to show only that the product failed to perform as safely as an ordinary consumer would expect when the product is used in a reasonably foreseeable manner.

In the Argo Meridian case, the tort claim is that the car was defectively designed, not that a particular car was defective. A design that causes an injury is considered defective

if the defendant fails to establish that the benefits of the design outweigh the risk of danger from the design. In striking this difficult balance, the jury must consider the mechanical feasibility of a safer design, the financial cost of the design, and the adverse consequences to the product and the consumer that would result from an alternative design. In the Argo Meridian case (and also the real Ford Pinto case discussed in ¶12.05) the jury found that the car's design flunked this test. It decided that the gas tank design should have been modified despite the extra costs and delays of doing so. Moreover, it held that the manufacturer's decision not to modify the gas tank, despite knowledge of its dangers, was so irresponsible as to justify an award of punitive damages.

Suppose you represent XYZ Tire Co. in a case arising out of an accident caused by the separation of the tread from the rest of the tire on an SUV. The evidence shows that the tire could have been made much safer but only by modifying the design in a way that would have increased the cost of the tire by about 1/3. Should you argue to the jury that XYZ should not be held liable because the cost of making the modification outweighs the safety benefits of doing so?

12.05 Class Action—And the Ford Pinto

The film *Class Action* was loosely based on the saga of the Ford Pinto.[7] Like the Argo Meridian, the Pinto was subject to the risk that its gas tank would rupture in a rear-end collision. The plaintiffs were killed or severely injured when a 1972 Pinto's gas tank ruptured and filled the passenger compartment with burning gasoline. In *Grimshaw v. Ford Motor Co.,* the jury awarded the plaintiff $2.5 million in actual damages and $125 million in punitive damages (that is, damages added on to punish the defendant and to deter future conduct). The punitive damage award was reduced to $3.5 million by the trial court, and this reduced amount was upheld on appeal.

There was considerable evidence in *Grimshaw* that Ford's management was well aware from crash-tests of the risk that the Pinto's gas tank was vulnerable to rupturing. It failed to modify the design for several reasons, one of which was the cost of doing so. Another reason was that Ford vice-president Lee Iacocca was anxious to get the Pinto (a light car that would sell for under $2000) into production quickly.

The Pinto jury was shocked by the evidence that a carmaker would balance costs against safety. That evidence caused it to punish the carmaker by awarding punitive damages to the plaintiff. However, should the evidence have been so shocking? Doesn't every manufacturer have to weigh the extra costs of building in safety precautions against possible hazards to consumers? If they did not balance costs against safety, cars would be armored vehicles like tanks (or Hummers). Probably, subcompact cars like the Ford Pinto could not be built at all.

12.06 The adversary system in civil trials—Is there a better way?

Class Action is a good example of the adversary system at work. A long, costly, bitter jury trial is needed to resolve the question of whether Argo was at fault in its design of the Meridian. The trial is an ordeal for all concerned. Very often, the litigants must wait several years to get to trial because of congested dockets; and, as the saying goes, justice delayed is often justice denied. The process of pretrial discovery, particularly depositions, is long, costly, and arduous.

Win or lose, the facts brought out at the trial reflect unfavorably on Argo. It will suffer bad publicity in the media and lose goodwill among consumers. Its executives are pulled out of their offices into depositions or the courtroom where they waste days and weeks. Argo will wind up paying a fee in the millions of dollars to the Quinn firm. The plaintiffs (and their attorneys) may get a huge windfall if they get really lucky (as in *Class Action, The Verdict, Erin Brockovich,* or *Runaway Jury*), but they also may get little or nothing at all despite having been severely injured (as in *A Civil Action*). They might also win the case but find the defendant bankrupt, as in *The Rainmaker* (1997). When a very large number of people suffer similar injuries (such as from asbestos or tobacco), the tort system fails catastrophically; huge attorney fees are generated, but few plaintiffs recover much. Meanwhile, the defendants are often driven into bankruptcy. So the question arises: Is there a better way to resolve such questions than duking them out in the courtroom?

Settlement. Remember that the vast majority of civil disputes are settled by negotiation rather than actually tried. Many litigation lawyers have never tried a case—they engage in discovery, argue pretrial motions, and then negotiate a settlement (often at the last minute "on the courthouse steps" or even during the trial). Many times, the parties employ a mediator (a neutral third party) to help them work out a settlement. Settling cases on terms agreeable to both parties is far better for everyone (including the taxpayers who have to supply the courtroom and the judge) than trying cases in court.

In arbitration, the parties engage an arbitrator (a third party who may or may not be a lawyer) to resolve their dispute. The arbitrator typically has expertise in the area being litigated (say auto design). As a result, the arbitrator will probably be better informed than a typical judge and certainly better informed than the jury. The arbitrator conducts the hearing at a private location such as a hotel room, at a time convenient for the parties; the proceedings are secret, and they are less formal than in court. As a practical matter, an arbitrator's decision is final and cannot be appealed in court. Arbitration is increasingly taking over the world of employment disputes; when you get a job at a big company, you often must agree to have any employment disputes (including antidiscrimination or sexual harassment claims) decided by an arbitrator instead of a jury.

Negotiation, mediation, and arbitration are referred to collectively as alternative dispute resolution—ADR. ADR is a fast growing industry and many lawyers now work as mediators or try more cases to arbitrators than to judges or juries. As litigation in court grows less satisfactory—because of delays, costs, publicity, uninformed juries, or whatever—ADR will continue to resolve an ever-higher percentage of disputes.

The administrative process. Another way to resolve disputes is through administrative agencies rather than courts. Compare what would happen if Kellen had been injured by an explosion at work instead of on the highway. He would not be permitted to go to court to sue for damages. Instead, he would make a claim for workers' compensation. Workers' comp pays for a work-related injury regardless of who was at fault—all the victim has to show is that he was an employee and injured on the job.

The employee might wind up better or worse off if compelled to take the workers' comp route. The amounts payable to injured employees are much less than the employee might get in a tort action in court, but the employee is much more likely to receive a workers' comp award because the employer has very few defenses. Also the employee will get the money much more quickly than in a long-drawn out tort case. Employers must take out workers' comp insurance, so the worker will be compensated even if the employer goes broke.

If there is a workers' comp dispute, the case is not heard in court but before an administrative tribunal staffed by specialized workers' comp judges. In fact, a very large number of disputes are resolved by administrative agencies rather than courts—unemployment compensation, Social Security disability, securities fraud, income tax, immigration, discipline of licensed professionals, just to name a few.

It should be possible to design an administrative claim system for compensating the victims of car defects such as rollovers, tire blowouts, or exploding gas tanks. Even better, there could be an administrative compensation system for the victims of mass torts such as injuries from asbestos, tobacco, or lead paint.

12.07 *Legal ethics in* Class Action

Serious violations of legal ethics abound in *Class Action.*[8]

12.07.1 *Destruction of the Pavel report*

Michael Grazier removed the Pavel report from the material transferred to the plaintiff in response to its document request. Then he destroyed it. Grazier committed a serious violation of criminal law (the crime is called "obstruction of justice" or sometimes "spoliation of evidence") and violated the rules of legal ethics. Model Rule 3.4 provides: "A lawyer shall not: (a) unlawfully obstruct another party's access to evi-

dence or unlawfully alter, destroy or conceal a document or other material having potential evidentiary value." In short, a lawyer must never take part in destroying evidence or in withholding evidence demanded by the other side.

If a lawyer (or a client) is found to have destroyed or withheld such material, several kinds of sanctions are available. The most severe are criminal prosecution and attorney discipline. In addition, a court may hold the attorney or his client in contempt of court (which is likely to produce a large monetary penalty) or preclude the client from offering evidence against the opposing party on the issue to which the destroyed evidence related. In addition, the jury is likely to punish the offending party severely (as occurs in *The Verdict, The Rainmaker,* or *Class Action*). In addition, it is probable that the document disaster would expose the law firm to malpractice liability to its client. Had the Argo report been routinely disclosed during discovery, Argo would have been prepared to counteract it in court. The damage to Argo would not have been nearly as severe as the damage from concealing the document.

12.07.2 The paper blizzard

At Quinn's instruction, Grazier and Maggie Ward send truckloads of useless paper to Jed Ward in hopes that he will not have time to dig through it all and find the Pavel report. This ploy does not violate legal ethics, but is part of the uncivil, no-holds-barred, scorched-earth litigation tactics that are unfortunately all too common today. Normally, the response to this tactic is to ask for some kind of sanction from the trial judge. Perhaps the plaintiff is entitled to a delay of the trial in order to provide time to get through all the paper. Perhaps the defendant should have to pay the extra attorneys' fees the plaintiff incurred from having to process all the extraneous paper.

Before removing and destroying the Pavel report, Grazier told Maggie that he had mis-indexed the critical document. This sort of sleazy behavior is a serious abuse of the discovery process and the rules of ethics as well.

12.07.3 Confidentiality

Normally, an attorney must preserve the confidentiality of all information obtained from a client. However, ABA Model Rule 3.3 sets forth an important exception to confidentiality: "A lawyer shall not knowingly . . . fail to disclose a material fact to a tribunal when disclosure is necessary to avoid assisting a criminal or fraudulent act by the client." Such disclosure is also not a violation of the attorney-client privilege.

The withholding and destruction of the Pavel report is a criminal act (although committed by the attorney, not by the client) and a fraud on the court because it will affect the upcoming trial. After Maggie finds out about the document destruction, and gets nowhere with Grazier or Quinn, she probably should have gone to the Argo management, requesting their permission to disclose the report (or the facts about its

destruction). If the client also insists on stonewalling, Maggie would probably be required to disclose the document destruction to the judge.

One of the most basic of all the rules of ethics is that a lawyer must be loyal to his or her client. ABA Model Rule 1.7(a) states: "A lawyer shall not represent a client if the representation of that client will be directly adverse to another client. . ." The comment to Rule 1.7 begins: "Loyalty is an essential element in the lawyer's relationship to a client."

Maggie literally switches sides. She asked Michael Grazier a question, knowing he would commit perjury in his response. Incidentally, this is itself a violation of legal ethics; a lawyer should never knowingly elicit perjured testimony. Maggie had worked out a scheme with Jed so that he would then call another witness who would discredit Grazier. Jed turns down Quinn's desperation settlement offer and obtains a jury verdict for $100,000,000. At the end, Maggie celebrates the plaintiff's victory in the Argo case as she dances with her father. In her actions, Maggie has, in effect, represented the plaintiff when this is directly adverse to her client Argo. While disclosure of the destruction of the key document to the judge (or even conceivably to Jed's firm) may have been required by the Model Rules, Maggie is not allowed to enter into a conspiracy with opposing counsel to disclose the document with maximum devastating effect to her own client.

Realistically, what *could* Maggie Ward have done when she discovered that partners in her firm planned to deep-six the Pavel report? Model Rule 5.2(a) provides that a lawyer is bound by the rules of professional conduct "notwithstanding that the lawyer acted at the direction of another person." Thus, there is no "following orders" defense. At the same time, Rule 5.2(b) provides that a subordinate lawyer does not violate the rules if that lawyer "acts in accordance with a supervisory lawyer's reasonable resolution of an arguable question of professional duty." However, in *Class Action,* Maggie knew that Quinn and Grazier were not planning a "reasonable resolution of an arguable question," but were instead committing a gross violation of the rules of discovery, legal ethics, and criminal law.

Obviously, Maggie was in a very difficult position because people senior to her in the law firm were making the key decisions. In most big law firms today, there is an ethics committee to which an associate in Maggie's position can go for help. The ethics committee—which is very concerned to keep the law firm out of trouble—would handle the problem and require disclosure of the document. However, apparently Quinn, Califano, & Lunt had no ethics committee. Quinn blew Maggie off when she tried to persuade him to disclose the test report. Now what?

It is very hard to be a whistleblower, and the usual fate of the whistleblower (such as Jack Tagalini, Jed Ward's previous client) is not a happy one. Maggie tried to persuade them not to do it and she tried to get Quinn to disclose the destruction—and that is realistically about all she could have done. Probably she should have appealed to the client to disclose the information. If that did not work, and she proceeded with her job, she would probably be in violation of the rules of legal ethics.

Maggie could quit, of course; or she could refuse to keep working on the Argo case, which would have probably cost her any chance at making partner. She could have (and probably should have) told everything to the judge. Perhaps she could have reported Grazier and Quinn to the Bar ethics committee.[9] None of these are good career moves. Realistically, one cannot expect low-level associates to do very much when people senior to them are determined to commit gross ethical abuses like destroying evidence or suborning perjury.

12.07.6 Emotional involvement

It is inappropriate for Maggie Ward to take part in representing Argo in a case in which her father represents the plaintiff, even though the conflict has been disclosed and clients on both sides have consented. Maggie refuses to stop working on the case, even though others at her law firm are anxious to do the work, and both her father and mother urge her to step aside. She seems dominated by the desire to defeat her father in the arena in which he has been most successful (see ¶12.01.2).

Even so, lawyers must be objective about their cases and their clients. Near the end of the film, Maggie (who has already decided to betray her client) says "An emotional lawyer is a bad lawyer." She's right. A lawyer can, and should, care deeply about her clients and try to do the best job possible. However, the lawyer must always retain objectivity and distance from the case to help the clients (who often have no objectivity at all about their own case) make the right decisions. It is a terrible mistake for a lawyer to become so emotionally committed to a client's case that the lawyer cannot give wise advice.

12.08 Review questions

1. Would you want Maggie Ward as your friend? As your lawyer? (See ¶4.06.) Explain.
2. How do you interpret the two scenes with which the movie opens (in which Maggie and Jed Ward are litigating in adjacent courtrooms)? Do you think these scenes are intended to invert normal expectations about how men and women approach questions of law and justice?
3. Pick any female lawyer appearing on a legally themed television drama. Examples are Lindsay Dole, Elinor Frutt, Rebecca Washington, Helen Gamble, Jamie

Stringer, or Claire Wyatt (*The Practice*); Serena Southerlyn (or the other female prosecutors who have appeared on *Law & Order*); Ally McBeal or Georgia Thomas (*Ally McBeal*); or Sarah MacKenzie (*JAG*). You can also use female lawyers in the soaps or those in *L.A. Law*. Compare this character to Maggie Ward as a human being and as a lawyer.

4. Apply the analysis of Laura Mulvey (¶12.02.7) to any female character in the movies—not necessarily a lawyer (but other than Maggie Ward). Does Mulvey's analysis help us understand the representation of the female character?

5. What is your explanation for the prevalence of negative portrayals of female lawyers in film?

6. The portrayal of Elle Woods in *Legally Blonde* (2001) or *Legally Blonde 2: Red, White & Blonde* (2003) offers a positive, empowering portrayal of women in the law. Do you agree or disagree?

7. Would you favor moving products liability or mass tort cases out of court and into an administrative system such as workers' compensation?

8. Put yourself in Maggie Ward's shoes. What would you have done when you discovered that Grazier and Quinn destroyed the Pavel report?

CHAPTER 13

Civil Rights
Assigned film: Philadelphia (1993)[1]

13.01 Philadelphia—*The real case*

The film was based primarily on the case of a New York City lawyer named Geoffrey Bowers who was fired by the mega-law firm of Baker & McKenzie. Seven years after his death from AIDS at the age of 33, Bowers's family won a $500,000 award from the New York State Department of Human Relations. Baker & McKenzie appealed the decision, but the dispute was settled in 1995 for an undisclosed sum.

Meanwhile, Bowers's relatives sued Tristar, claiming that the filmmakers had promised to compensate the family members for providing details of Bowers's life. Tri-Star contended that the film was based on several cases, including Bowers, and that the details had come from sources in the public domain. The version of the Bowers family was supported by producer Scott Rudin, who interviewed family members in 1988 and later sold the project to Mark Platt at Orion. In 1996, five days into the trial, Tri-Star settled the case for a figure in the "mid-7 figure range" and acknowledged that the film was inspired in part by Bowers's life.

Cain v. Hyatt. The film was also based on a real case in Philadelphia. *Cain v. Hyatt* (1990). The case concerned a provision in the Pennsylvania Human Relations Act that prohibited discrimination on the basis of disability. *Cain* held that this provision protected an attorney with AIDS from being discharged when he could still do the job. The employer was Hyatt Legal Services, a law firm with 150 offices offering low-cost, relatively standardized legal services to low and moderate-income clients. In 1987, Cain's supervisors discovered that he had AIDS; they believed that he would be able to work only part-time and that he would soon die. In addition, they thought that Cain

might communicate the disease to others in the workplace (such misinformation on the transmission of HIV was common at the time). The court's pathbreaking opinion declared that being HIV-positive or having full-blown AIDS qualified as a disability under the Pennsylvania act and declared that prejudices and misinformation about how the disease is spread could not be the basis for discrimination.

Philadelphia grossed over $200 million worldwide. Tom Hanks won the Oscar for best actor and Bruce Springsteen won best song. The film was nominated for three other awards—best makeup, another song composed by Neil Young, and best original screenplay (Ron Nyswaner).

13.02 Gay lawyers in the movies

13.02.1 Gay, lesbian, and bisexual lawyers

An increasing number of law students and lawyers are openly gay (we use the term "gay" to include male and female homosexuals and bisexuals). The number of students and lawyers who are gay but conceal their sexual orientation is unknown, but the numbers must be quite substantial. According to the National Association of Law Placement Directory (www.nalpdirectory.com), the number of openly gay lawyers at major law firms in most major cities is relatively small. In the San Francisco office of Morrison and Foerster, there are four openly gay partners out of a total of 89 (4.5%) and 21 associates out of a total of 174 (12%). Outside San Francisco, the percentage of openly gay lawyers is even smaller. The New York office of Skadden, Arps, Slate, Meagher, & Flom, has three openly gay partners out of a total of 164 (1.8%) and 19 openly gay associates out of a total of 606 (3.1%). The Washington, DC, office of Covington & Burling has two openly gay partners out of a total of 112 (1.8%) and four openly gay associates out of a total of 203 (2%).

These statistics do not necessarily mean that major law firms are homophobic. Indeed, most major law firms prohibit sexual orientation discrimination (or are situated in states that do so by law). Most law schools require firms to sign a pledge that they will not discriminate on this basis. There are undoubtedly many gay partners and associates who prefer not to identify themselves as "openly gay" at work, even though they lead uncloseted lives. One study found that although 70% of gay attorneys did not come out on their resume, nearly 88% were out to some coworkers and nearly 60% were out to most coworkers (Rubenstein 1998, 394). The fact that many gay lawyers choose not to be identified as "openly gay" says something about the culture of major law firms.

Hiring discrimination does not seem to be the main concern of most gay and lesbian attorneys. Rather, it is the need to remain closeted. As William Rubenstein has

noted, a "major component of the suffering that lesbian, gay, and bisexual attorneys endure is the emotional anxiety that attends the performance of their sexual orientation. They must constantly scrutinize how much to reveal and how much to conceal of their personal lives in their myriad day-to-day interactions" (Rubenstein 1998, 393–94).

Still, discrimination based on sexual orientation remains a persistent problem in legal employment. A report of the Los Angeles County Bar Association (1995) was based on a random sample of 1634 Bar Association members (and 550 attorneys belonging to local gay attorney associations). The survey concluded that at least 6% and perhaps as many as 10% of L.A. County lawyers are gay, although serious methodological problems arise in trying to estimate how many lawyers are gay. According to the report, these attorneys face many barriers and hurdles that their heterosexual peers do not. Among other findings, the report discovered that

- Almost two in five attorneys reported witnessing or experiencing some kind of sexual orientation discrimination against an attorney in a professional setting.
- Roughly one in seven attorneys reported that his or her employer engages in some form of antigay discrimination in the recruitment and hiring of attorneys.
- Over half of the attorneys believe that their work environment is less hospitable to gay attorneys than to heterosexual attorneys, with over two-thirds reporting that attorneys in their office make antigay comments and jokes.
- Among lawyers with less than ten years in practice, heterosexual attorneys in law firms are almost three times more likely to become partners than their gay peers.
- Roughly a quarter of gay attorneys reported that their employers advised them to be "closeted" or criticized them for "bad judgment" in being "out."

Methodological problems. The L.A. County Bar study is subject to methodological criticisms. Among other problems, gay attorneys (other than those who are openly gay) are not readily identifiable and thus difficult to survey. Besides, sexual orientation is highly variable (and cannot be superficially divided into gay and straight). Furthermore, the study was done in the early- to mid-1990s, and things may be different now. Still, the study suggests that discrimination based on sexual orientation is persistent and represents a serious professional problem for gay lawyers.

13.02.2 The representation of gays, lesbians, and bisexuals in film[2]

The Hays Code contained a strictly enforced provision prohibiting any treatment of "sex perversion." (We discuss various aspects of the Hays Code in ¶¶2.04, 14.05 and 14.06.) This provision was understood to prohibit any treatment of homosexuality and, as a result, all explicit treatment of homosexual themes was removed from the movies for about 30 years.

During this period, film adaptations of plays or novels that dealt with homosexuality had to skirt explicit references to that theme. Film adaptations of books with homosexual themes include Lillian Hellman's *The Children's Hour* (released in 1936 as *These Three*), Robert Anderson's *Tea and Sympathy* (1956), Mayer Levin's *Compulsion* (1959), and Tennessee Williams's *Cat on a Hot Tin Roof* (1958). Of course, characters could still be coded as gay (the term "coded" means that characters could be endowed with traits perceived as stereotypically gay or with traits that gay viewers would pick up on). In addition, oblique references to homosexuality could occasionally be slipped past the censors. Russo (1987) discusses the many gay characters and themes in the movies of this era. The references were subtle and were usually overlooked by the censors and by straight audiences, but gay audiences understood them. Russo's book was made into an outstanding documentary on gays in the movies entitled *The Celluloid Closet* (1995).

In 1961 the Hays Code provision proscribing "sex perversion" was changed. Homosexuality and other sexual "aberrations" became permissible subjects if treated with "care, discretion, and restraint." By that time, Joseph Breen had retired from the Production Code Administration (PCA), and his successors were more flexible about depicting sexual matters in the movies. Besides, the studios were pressing the PCA to allow them to deal openly with gay themes because homosexuality had become a hot topic. *Suddenly Last Summer* (1959) was released prior to the change, and several other high-profile studio films were waiting in the wings. These included *The Best Man* (1964), *Advise and Consent* (1962), and *The Children's Hour* (1962).

Victim. A British film called *Victim* (1961) made it onto American screens before the release of the American gay-themed films of the early 1960s. *Victim* is widely considered to be a breakthrough in the frank portrayal of homosexuality on the screen. It starred Dirk Bogarde as an English barrister trying to expose a ring of extortionists who are blackmailing closeted gays like himself. The film was widely acclaimed and is credited by many with triggering the movement to reform England's homosexual laws. Until *Philadelphia,* however, Bogarde's character in *Victim* was the only important gay lawyer in the movies.[3] A few gay lawyers had appeared on television including characters on *L.A. Law, An Early Frost* (a 1985 TV movie about AIDS), and *Citizen Cohn* (a 1992 HBO movie about lawyer Roy Cohn). Recently, another gay lawyer has emerged on the TV show *Will and Grace*.[4]

In 1968 the Production Code was repealed and replaced with the ratings system that is still in effect. The following year, gays and lesbians resisted harassment by the New York police at the Stonewall Rebellion. The late 1960s and 1970s witnessed the most explicit portrayals of gays (again using this term to cover male and female homosexuals and bisexuals) in the history of American film up to that time. Films such as *The Staircase* (1969), *The Fox* (1968), *The Killing of Sister George* (1968), *The Boys in the*

Band (1970), *Sunday, Bloody, Sunday* (1971), *Cabaret* (1972), and *Dog Day Afternoon* (1975) were among the many movies that featured explicitly gay characters.

However, not all portrayals of gay people were sympathetic. One downside of the new freedom to portray homosexuality was the ability to depict gay people in crudely homophobic terms. Gay characters were often used for comic relief or portrayed in grossly stereotypical terms. Moreover, a surprising number of movies featured gay or transgendered killers. In films such as *Freebie and the Bean* (1974), *Looking for Mr. Goodbar* (1977), and *Windows* (1980), gays were portrayed as murderous psychopaths.

The late 1970s and early 1980s witnessed the emergence of concerted campaigns by feminists against films perceived to be misogynistic or antifeminist. Following their example, gay activists began orchestrating their own campaigns against films perceived to be antigay. *Cruising* (1980) and *Windows* were among the most notorious of the films they targeted. In 1992, the smash hit *Basic Instinct,* which involves a lesbian killer, inspired a similar campaign.

In retrospect, these campaigns appear to have succeeded, because the portrayal of gay people became decidedly less offensive. The horrible AIDS epidemic also had something to do with raising the consciousness of filmmakers and changing the way that gays were represented. The 1980s saw the release of several important and sympathetic films, including *Personal Best* (1982), *Lianna* (1983), *Making Love* (1982), *Prick Up Your Ears* (1987), *Parting Glances* (1986), and *Torch Song Trilogy* (1988). A number of foreign films dealing positively with homosexuality also received distribution in American art-house theaters, including Jaime Humberto Hermosillo's *Dona Herlinda and Her Son* (1986) and Pedro Almodovar's *Laws of Desire* (1987).

In the 1990s, gay characters entered the cinematic mainstream in such features as *The Birdcage* (1996), *In and Out* (1997), *The Mexican* (2001) and, of course, *Philadelphia*. A string of romantic comedies paired a gay man with a straight woman, including *My Best Friend's Wedding* (1997) and *The Object of My Affection* (1998).

The New Queer Cinema.[5] Of equal importance to the emergence of mainstream gay characters was the emergence of a gay independent cinema. The "New Queer Cinema," as it is usually termed, is a film movement spearheaded by gay independent filmmakers who make gay centered films for largely gay audiences. In the 1990s, gay independent films like *Longtime Companion* (1990), *Swoon* (1992), *Go Fish* (1994), *The Incredibly True Adventures of Two Girls in Love* (1995) and *Love and Death on Long Island* (1997) became a fixture of the gay independent film market that thrived in major metropolitan areas. Finally, the 1990s also witnessed the emergence of a number of important openly gay directors, including Gus Van Sant (*My Own Private Idaho, Even Cowgirls Get the Blues*), Todd Haynes (*Poison, Far from Heaven*) and the defiantly non-mainstream Gregg Araki (*The Living End, The Doom Generation*).

The emergence of queer film theory is one of the most important recent developments in film studies. Queer film theory is to be distinguished from what might be called gay film studies. Queer film theorists are not primarily concerned with the representation of gays in film. Indeed, queer theorists want to question the attempt to construct a stable category called "gay." Thus, a film such as *Philadelphia* might not be of interest to a queer theorist since the film has a stake in creating a stable category called "gay." Queer film theorists are particularly interested in issues of reception and spectatorship: How are ostensibly gay and ostensibly straight films received and consumed by gay and nongay spectators?

The basic tenet of queer film theory is that a surprisingly large number of Hollywood films elicit "queer" responses from gay and nongay spectators alike. What queer film theorists mean by a queer response is one that calls into question the stability of sexual and gender categories. Thus, queer film theorists will seize on seemingly straight films that are consumed in a nonstraight way by gay (or even nongay) audiences.

For instance, a queer film theorist might write about the way in which gay audiences responded to Bela Lugosi's Dracula in *Dracula* (1931), the Maximus-Commodus relationship in *Gladiator* (2000), or the relationship between Captain Kirk and Mr. Spock in *Star Trek* (1979). By the same token, queer theorists might try to problematize the seemingly straight image of stars like Doris Day or Marilyn Monroe by writing about the ways in which gay men and women (it is important here to distinguish between them) responded to them.

Conversely, queer film theorists might draw attention to the non-straight ways in which straight audiences respond to seemingly straight films. For instance, a queer theorist might argue that straight audiences respond to characters like Anthony Hopkins's Hannibal Lector or Jack Nicholson's The Joker in a way that can only be characterized as queer or nonstraight. Finally, queer theorists explore the ways in which gay women sometimes respond to films in a way assumed to be more characteristic of gay men (e.g., by admiring the body of a muscular male actor) and the ways in which gay men sometimes respond to films in a way assumed to be characteristic of gay women (for example by being attracted to Madonna).

The underlying project of queer film theory (as well as queer theory generally) is to challenge the naturalness of the heterosexual-homosexual distinction. Queer theorists want to question this distinction by drawing our attention to cultural phenomena that belie the distinction either by destabilizing it or by revealing the multiplicity of sexual identities and positions that it obscures.

13.03 Black lawyers in the movies

13.03.1 African Americans and the legal profession

Within the last three decades, the number of African Americans entering law school and law practice has increased sharply. However, relatively few black lawyers work in large law firms. Thus, it is not surprising that Joe Miller is a solo specializing in personal injury cases. Undoubtedly, there are few black associates and even fewer black partners at Wyant, Wheeler (although we do see one black lawyer seated at the counsel table). It is estimated that about 6% of practicing lawyers are black, but blacks constitute only about 4% of the lawyers in big firms and 1% of the partners. In contrast, about 9% of staff attorneys working for government agencies are black; 5% of government supervising attorneys are black. (These figures are drawn from a January 2002 study published at the Web site of the National Association of Law Placement, http://nalp.org.) By one estimate, close to one-third of all black lawyers work for government agencies (Wilkins & Gulati 1996).

13.03.2 Black lawyers in the movies and television

While there are numerous prominent and talented black actors, few of them have played movie lawyers. Joe Miller (Denzel Washington) is probably the most prominent African American trial lawyer in movie history. Samuel L. Jackson played a trial lawyer in *Losing Isaiah* (1995), Howard E. Rollins played a tough army lawyer in *A Soldier's Story* (1984), Laurence Fishburne played backup to Gene Hackman in *Class Action,* and there have been a handful of others. One finds even fewer Hispanic or Asian American attorneys. For whatever reason, filmmakers don't seem to think that audiences will accept non-whites as lawyers. There are plenty of minorities in legally themed movies—as defendants, witnesses, police, investigators, journalists (such as Denzel Washington's role in *The Pelican Brief),* secretaries, or judges (as in *Primal Fear* 1996 or *Presumed Innocent* 1990)—but few attorneys.

Note, however, that black lawyers have been much more prominent on television than in the movies. Eugene Young (Steve Harris) and Rebecca Washington (Lisa Gay Hamilton) had leading roles on *The Practice* and Jonathan Rollins (Blair Underwood) had a long-time role on *L.A. Law* (though he does not appear in the pilot). Victor Sifuentes (Jimmy Smits) on *L.A. Law* was one of the few Hispanic actors to appear as a TV lawyer.

13.03.3 Blacks in the movies and television—1930 to 1970[7]

The underrepresentation of black lawyers in film mirrors the way that blacks have historically been represented in film as well as on radio and television. In older films,

black characters were played by talented actors, but the roles almost always represented painful stereotypes derived from the days of slavery. They often spoke in what was supposed to be a Negro dialect rather than correct English.

Typically black actors played oversexed savages (as in *Birth of a Nation* 1915), idiotic buffoons, or happy, loyal servants. (Bogle 2001b exhaustively documents these endlessly repeated stereotypical roles.) The classic slave roles were played by Hattie McDaniel as Mammy and Butterfly McQueen as Prissy in *Gone with the Wind* (1939). (McDaniel, who won a Best Supporting Actress Oscar for her portrayal, is reported to have said, after people criticized her for accepting roles as maids, that considering the unavailability of better roles, she would rather play a maid than be one.) However, according to Cripps (1993), David Selznick, who produced the film, went to great lengths to avoid the negative racial material contained in Margaret Mitchell's book. The roles played by black actors in *Gone with the Wind* were considered at the time as some of the most favorable toward blacks in movie history; there was hardly any criticism of these roles, even in the black press.

Stepin Fetchit was the most successful black comedian of the 1930s (he played a supporting role in John Ford's legally themed *Judge Priest* 1934). The publicity releases for one of Stepin Fetchit's films said: "Baffled and bewildered by the mere thought of moving fast, shuffling and mumbling his way to resounding laughter at every appearance . . ." (Doherty 1999, 177–78). In addition, there were numerous minstrel-style films in which white actors in burned cork makeup played black characters. Minstrel characters continued to be popular up to about 1950. (The very first black character in the movies, Uncle Tom in *Uncle Tom's Cabin* [1903] was a white man with a blackened face.)

Guess Who's Coming to Dinner. In this 1967 film, Sidney Poitier plays a handsome black doctor who is engaged to marry a white woman. The woman's relatively progressive parents (played by Katharine Hepburn and Spencer Tracy, in his last film) are completely unable to deal with this event for which nothing in life has prepared them. The film had a major impact because Poitier's character (a sophisticated black professional) was unusual even in films of the late–civil rights era, as was the theme of interracial marriage. Poitier played a number of roles of this kind as the token dignified black making it in a white institution. In fact, he won an Oscar for the inspirational *Lilies of the Field* (1963) playing a handyman in a convent.

Even where black characters have dignity and substance in older films, they are often passive; their fate is determined by whites (the character of Tom Robinson in *To Kill a Mockingbird* is an example). In another group of movies, such as *Pinky* (1949) and *Imitation of Life* (1934, remade in 1959), light-colored Negro characters (usually women) shed their undesirable racial identity and pass as whites, usually with tragic results. In the 1970s, however, the "blaxploitation" films challenged the notion that blacks were either passive or respectable.

Amos 'n' Andy. On the radio and early television, one of the most popular and successful programs was *Amos 'n' Andy*, a racist comedy that emphasized every sort of vicious stereotype, portraying blacks as lazy, stupid, and greedy. Although African American actors appeared often on television series in the 1960s and 1970s (many of them in comedy roles), perhaps not until *The Cosby Show* in the 1980s was a mainstream, primetime television series built around a successful and appealing upper middle-class black family.

Undoubtedly, all these constantly repeated stereotypical roles in the movies as well as television became a powerful signifier of black inferiority and white superiority. The portrayals of blacks in the movies reinforced the ideology of racism and thus were quite damaging to the prospects for racial equality. They must also have negatively affected the picture that blacks had of themselves.

13.03.4 Blacks in contemporary film

In modern films, blacks seldom play savages, fools, or servants, but nevertheless they are often cast as vicious thugs, gangsters, criminals, prostitutes, or drug addicts. Quentin Tarantino's film *Pulp Fiction* (1994) is a prime example. Often they are depicted as athletes, entertainers, or musicians, as if they could succeed in no other line of work (recall Cuba Gooding's character as the greedy football player who keeps yelling "show me the money!" in *Jerry Maguire* 1996). Typically, their family and personal lives are dysfunctional, with *Waiting to Exhale* (1995) or *Losing Isaiah* (1995) being examples. Of course, there are many highly positive representations of black characters in current films, but relatively few in which they play professionals.

Philadelphia stands out as the rare movie in which a black character is nuanced (having good and bad traits), successful in his business or profession, and enjoying a normal, loving family life. However, the black Joe Miller is subordinate to the white Andrew Beckett. Contrast their law practices: Miller has an undignified, scrambling type of law practice (plaintiff's personal injury work, with dubious ethics). Beckett has a glossy, exciting big-firm corporate practice, and he obviously makes a lot of money.

Grand Canyon. This 1991 film also involves black-white interaction. It centers on the relationship between the affluent and successful Kevin Kline and Danny Glover, a black small businessman with a normal family life. Glover is a tow-truck operator living in a lousy neighborhood who comes to Kline's aid; Kline then helps Glover's family move to a nicer neighborhood. Although Glover's character is very sympathetic, the class differences between the two characters carry forward traditional racial stereotypes.

13.04 Law firms[8]

13.04.1 Philadelphia *and the hemispheres of law practice*

If your only source of information about law practice was old movies like *Anatomy of a Murder* or *Counsellor at Law,* you would probably conclude that most lawyers practice by themselves or with one other lawyer. This arrangement is still true of criminal defense lawyers who mostly practice solo or in very small partnerships. Like Joe Miller, most plaintiffs' personal injury lawyers also practice alone or in a very small firm. Today, however, most lawyers, especially those in big cities, practice in significantly larger law firms. Indeed, the law firm has come to be the dominant vehicle through which legal services are delivered, especially to corporate clients.

Recall the discussion of the "hemispheres" of law practice in ¶4.09. The first hemisphere consists mostly of small firms or solos that handle the problems of ordinary individuals or small business. Joe Miller is definitely located in the first hemisphere. The second hemisphere consists mostly of large firms that represent big business or big institutions—like Wyant, Wheeler in *Philadelphia.*

13.04.2 Why law firms have grown so large

During the last thirty years or so, second-hemisphere law firms have become much larger and much more profitable. For example, in 1980, 7% of lawyers in private practice worked in firms having 101 or more lawyers; in 1995, the figure was 23%. According to another survey, in 2000, 19% of lawyers were in firms of 51 to 200 lawyers and 21% were in firms of more than 200 lawyers. In 1983 the average size of the 250 largest firms was 138 lawyers; in 1991 the figure was 273; in 1998 it became 305. Today, there are law firms with thousands of lawyers, and many of them have offices all over the world.

There are a number of reasons why law firms have become so large. These include *specialization, flexibility, economies of scale, and leverage.* Specialization means that a large firm employs an array of highly specialized lawyers. This huge staff enables the firms to offer clients quick access to sophisticated, experienced lawyers covering the entire range of the clients' needs. Economies of scale means that large firms can afford to purchase costly technologies and employ large staffs of nonlawyer staff members (such as word processors and paralegals). Flexibility means that the firm is prepared to handle the largest matters brought to them by clients, even those requiring the immediate services of dozens or hundreds of lawyers, without having to involve other firms. Specialization, economies of scale, and flexibility give the large firm a major competitive advantage over smaller firms.

The most important reason why firms are so large is leverage. Leverage means that the partners profit from having a large group of associates, who work for a fixed wage, but who bill their time at a much higher rate. Suppose, for example, that Firm F pays

Associate A $150,000 per year. Associate A's time is billed at $300 per hour and A manages to bill 2000 hours a year. That means that A brings in $600,000 per year but is only paid $150,000. After taking account of overhead costs (such as the rent on A's office, wages of her assistant, and all the other costs of operation), Firm F is still making a very substantial profit on Associate A. This profit is divided among the partners. The broader the pyramid at the bottom (that is, more associates) and the narrower on top (that is, fewer partners), the larger the profit shares of the partners arising out of leverage.

Because a certain number of associates must make partner each year (otherwise the associates would all leave and the firm could not hire good new ones), the firm must hire more associates to replace the new partners and keep the bottom of the pyramid much broader than the top. It seems like a good deal for the associates; those who make partner will become rich and those who don't get excellent training and can usually switch to good jobs at smaller firms. The whole process is described with analytical precision in Galanter and Palay (1991).

13.04.3 *Two models of law practice: Professionalism and business*

The switch to ever-bigger law firms was accompanied by fundamental changes in the legal profession. Scholars of the legal profession identify two competing models of law practice: the professionalism model and the business model. Many observers think there has been a definite swing away from the professionalism model and toward the business model.

Historically, law was considered a *profession,* meaning that lawyers had specialized training and knowledge and were protected from competition by nonlawyers. Lawyers had an obligation to place the interests of the client ahead of their own interests, were governed by a code of ethics (including many aspirational, non-binding rules), and were self-regulated rather than government-regulated. Professionalism means a certain degree of autonomy and independence, both from government and from clients, and includes some form of public service responsibility. It is assumed that lawyers will make a living practicing law, but extreme profitability is not part of the professionalism model.

Under the competing business model, law is a profit-making business, no different from any other service business such as advertising. The business model predicts that lawyers will seek profit by any means short of violating civil or criminal laws or binding rules of ethics. Lawyers and law firms compete to provide the services clients want most. Under this model, lawyers have no public responsibilities and no autonomy from clients; the lawyer is simply a hired gun paid to do what the client wants (short of actually violating the law).

Of course, these models are oversimplified. The practice of law always has and always will have strong elements of both professionalism and business. However, many observers think that the business model is much more prominent than in years past.

Today, law firms compete vigorously (often ruthlessly) for clients and frequently hire lawyers from other firms who can bring clients with them.

Lawyers' incomes are much higher than in the past. Starting salaries at top firms, for young lawyers just out of law school, often approach the amazing figure of $150,000 per year. Salaries of more senior associates rise sharply from that level, and many partners make more than $1 million per year. Both partners and associates hop from one firm to another far more often than in the past. Associate attrition rates at big firms have also risen sharply (some firms lose 25% of their associates every year).

As a result of these high salaries and partner profit shares, billing rates to clients have increased sharply. Hourly rates of $600 to $800 an hour for top partners are becoming common. Meanwhile, it appears that pro bono activity has greatly declined. Most lawyers just cannot afford to sacrifice billable hours for nonbillable hours, and most firms cannot afford to have lawyers spending much time on pro bono.

13.04.4 Billable hours

During the last twenty or thirty years, the number of hours lawyers are expected to work has increased dramatically. This is a function of the economic trends discussed in ¶13.04.3—the much higher starting salaries of lawyers, the need to pay senior associates more than junior associates, and the ever-increasing profit demands of the partners. Aside from raising billing rates, the only way to generate the necessary cash flow is to work more hours. And the lawyers at the biggest firms work the longest hours. For example, according to one survey, in firms of one to four lawyers, only 6% of lawyers billed more than 2050 hours per year; the figures were 12% for firms of 5 to 15 lawyers, 19% for firms of 16 to 50 lawyers, 17% for firms of 51 to 200 lawyers, and 37% of firms of more than 200 lawyers.

This is not the whole story. Generally, in order to bill two hours, most lawyers must spend about three hours in the office. The extra hour consists of things that cannot be billed to clients—personal needs and phone calls, keeping up on the law, recruiting new lawyers, holding management meetings, or just schmoozing with colleagues. The morning staff meetings on *L.A. Law* (chapter 7), in which everyone reviews their cases, are wholly fictitious. The meetings are a convenient framing device for each show, but don't occur in real law firms because they would be a waste of everyone's precious time.

Hours at work. To bill 2000 hours per year (which is the minimum commonly expected in big firms), lawyers typically spend close to 3000 hours in the office. That means 60 hours per week, 50 weeks per year. To spend 60 hours a week, the lawyer must be in the office *10 hours a day, six days a week* (and that does not count commuting time or lunch). In other words, a typical lawyer who has a 30-minute commute to work each way and eats lunch at her desk while working, must leave the house at 8

a.m. and return at 7 p.m., *Monday through Saturday,* 50 weeks a year. If she does not want to work a full day Saturday, she must be out of the house even longer hours during the week or work Sunday as well. When there is a crisis, lawyers work 24/7s, and crises occur frequently and unpredictably in the life of lawyers. No time is left for a personal life, much less a lifestyle. The glamorous lifestyle of the lawyers at McKenzie, Brackman (chapter 7) is a myth.

With these kinds of work demands, it is no wonder that young lawyers report serious problems of physical illness, alcohol or drug abuse, and depression (Schiltz 1999). In the view of many young lawyers who feel trapped in the big firm environment, their very high salaries do not compensate for the lack of personal time. They must stay, however, because they need the big bucks to pay their student loans. Parents with child care responsibility find these kinds of hours absolutely unbearable.

13.04.5 Quality of work life

Most of the work lawyers do in law firms helps corporate clients, not ordinary people, and much of the work is anything but challenging or glamorous. Big firms thrive on major litigation and major corporate transactions and each of these involves massive amounts of sheer drudgery. Much of the work is extremely stressful.

The life of a young associate in a big New York firm was described by Keates (1997). Keates (not his real name) left a prestigious New York law firm after less than two years of high-paid misery, totally burned out and disillusioned. His book, most of which is in diary form, was written to warn law students about what they are letting themselves in for if they choose the big-firm career path.

Keates says he became a lawyer because of the influence of TV shows like *L.A. Law* and *Perry Mason,* and books and movies like *To Kill a Mockingbird* and *The Firm.* In fact, he discovered, the actual practice of law is nothing like these pop culture representations. Among the various myths he shatters are that the work is exciting (he found it unbearably tedious most of the time) and that it achieved some useful social goal (in fact he represented mostly polluters trying to get somebody else to pay the cost of cleaning up toxic sites). He worked unbearably long hours (often all night or right through the weekend) and found the partners and associates could not care less about him as a person.

13.05 Law firms in the movies

Since 1980, almost all the law firms shown in the movies have been very bad places. Their lawyers are vicious, greedy, and dishonest. Virtually the only good law firms in recent films have been small ones up against much larger ones, as in *A Civil Action*

(1998), *Erin Brockovich* (2000), or *Class Action* (1991). In *Philadelphia,* a big firm fires an associate with AIDS and commits perjury to cover it up.

Let's look at the litany of bad law firms:

- In *The Verdict* (1982) (chapter 4) a big firm engages in a whole range of unethical conduct including hiring a sexual spy to steal the plaintiff's secrets and paying an expert witness to disappear.
- In *Class Action* (1991) (chapter 12) a firm hides and destroys documents that should have been turned over to the plaintiff.
- In *The Firm* (1993), a tax law firm turns out to be an arm of the mob. Any associates who want to leave the firm are murdered.
- In *The Rainmaker* (1995), a firm defending an insurance case makes employees disappear before their depositions are taken, taps the phones in the offices of the plaintiff's lawyer, and turns over manuals with the critical pages removed.
- In *Regarding Henry* (1991) a law firm defending a malpractice case against a hospital knowingly puts on perjured testimony.
- In *Changing Lanes* (2001) a law firm loots a charitable trust and covers it up with forgery and perjury.
- In *The Devil's Advocate* (1997), a big firm engages in sleazy deals such as weapons smuggling, drug dealing, and document shredding. The managing partner is Satan himself and the various lawyers are devils.

What could account for the consistent trashing of big law firms in the films of the last twenty years? Which of these explanations, if any, do you agree with?

- About two-thirds of all lawyers portrayed in the movies are negative, whether they practice alone or in firms (see ¶4.06). Historically, law firms were always portrayed in a less flattering light than solo lawyers. Because law firms are just collections of lawyers, it is not surprising that law firms would be portrayed even more negatively than individual lawyers.
- Historically, the movies have used big business as a punching bag. Films like *The Insider* (1999) or *Runaway Jury* (2003) are current manifestations of filmmakers' long-time antagonism toward business. The depictions of coldhearted corporate killers in *Class Action* or polluters in *Erin Brockovich* (2000) or *A Civil Action* (1998) are good examples of this familiar theme. The anti-big business slant of the movies is a double whammy for law firms because they mostly represent big business (and thus share in the hostility filmmakers feel toward their clients) and because large law firms have become big businesses themselves.
- Movies hold up a mirror to the beliefs and attitudes of ordinary people. See ¶¶1.041, 4.07.1. Polls show that most people despise lawyers and that they distrust

law firms even more than individual lawyers. Thus, the Harris Poll in 1997 asked for the public's opinion of the leadership of various institutions. Law firms came in at the very bottom of the list, behind such frequently disliked bodies as Congress, labor unions, or the military. Given this, it is not surprising that filmmakers would single out big law firms for harsh treatment.

Another interesting issue is why law firms on television are treated so much more favorably than law firms in the movies. Can you think of any explanations for the difference?

13.06 Employment law and civil rights

Philadelphia is about a civil rights action arising out of employment. A brief summary of employment and civil rights law may clarify the legal issues raised by the film.[9]

13.06.1 At-will employment

A large number of jobs in the United States are "at-will." This means that the employer can fire the employee for any reason at any time—or for no reason at all. Similarly, the employee can quit at any time for no reason. Andrew Beckett's job as a law firm associate was an at-will job. He had no protection if the employer decided to fire him. The same thing is true of most jobs in the service sector and many in the goods sector (particularly in retail stores or restaurants).

At-will employment emerged as the background norm in England and America around the end of the nineteenth century. The presumption that a job is at-will is often referred to as the "Wood rule" because it seems to have been invented by a text writer named Horace G. Wood in 1877. Many writers have tied the emergence of the at-will rule to the industrial revolution and the rise of capitalism. It gave employers maximum flexibility in choosing their labor force and allowed them to immediately get rid of any employees who failed to please the employer (particularly any who seemed to be trying to organize a union).

Interestingly, the at-will rule is not followed in most countries. Throughout Europe and Latin America, just the opposite is true. Once an employee has worked for a probationary period (say, six months), the employee cannot be fired without good cause. The result is that, in most cases, once employees are hired, they can keep the job until retirement, regardless of whether the employer wants to get rid of them. Thus, employees in these countries have far more job security than do employees in the United Kingdom or the United States, but employers have much less flexibility in changing their labor force to adjust to altered market conditions or in getting rid of poorly performing employees.

13.06.2 Exceptions to the at-will rule: Good cause discharge

A great many employees are not at-will. If an employee is represented by a union, the contract between the union and the employer undoubtedly protects employees from discharge without good cause. Under civil service laws, government employees cannot be discharged without good cause. Civil service laws were first enacted to get rid of the "spoils system" in which a new administration would fire all the workers and hire new ones from the political party of the winners. Today, civil service laws make government jobs secure, but also make it difficult for governments to get rid of poorly performing employees. Similarly, teachers at all levels, up through and including universities, are protected by a tenure system. Finally, many employees are protected from discharge by an employment contract with their employer. This is particularly true of senior managers but may apply to other employees as well.

13.06.3 Public policy and at-will employment

Another important exception to the at-will rule is that an employee cannot be discharged for reasons that violate public policy. For example, the employer may tell the employee to lie to federal inspectors about environmental violations or the employer may fire a whistle-blowing employee (one who discloses that illegal activities have occurred). These are examples of discharges that violate public policy. In many states, employees who are subject to this sort of discharge can get their jobs back but also can get damages (including punitive damages) for the violations.

13.06.4 Civil rights protection

A variety of antidiscrimination laws modify the at-will rule. If an employee (even an at-will employee) is discharged because of a forbidden form of discrimination, the discharge is illegal. Employment discrimination is prohibited by both federal and state laws, but these laws are not always identical. For example, the federal civil rights laws—Title VII of the Civil Rights Act of 1964 and the Americans with Disability Act—cover only employers with fifteen or more employees. The law of most states fills the gap by covering employers with less than fifteen employees. Wyant Wheeler had far more than fifteen employees and was covered by both federal and state antidiscrimination laws.

Under federal law and the law of most states, an employer cannot discriminate in hiring, promotion, or discharge by reason of:

- Race
- Gender
- Religion

- National origin
- Pregnancy
- Disability
- Age

Under the laws of many states, discrimination on the basis of sexual orientation is prohibited. However, Title VII (the primary federal civil rights law) does not prohibit discrimination because an employee is homosexual (or, for that matter, because an employee is heterosexual). Thus, gay rights advocates still have a long way to go in protecting the rights of homosexual employees in the workplace.

Notice that this list does not exhaust all forms of discrimination. For example, it is legal to discriminate on the basis of obesity (unless the obesity is so severe as to constitute a disability as discussed below) or on the basis of personal appearance. If an employee is at-will, the employee remains vulnerable to many forms of discrimination that may seem objectionable but are still legal.

A person who believes he or she has been the victim of prohibited discrimination is required to report it first to an administrative agency—either the federal Equal Employment Opportunities Commission (EEOC) or a state antidiscrimination agency. The agency will investigate the claim and attempt to mediate the dispute by working out some compromise. If that fails, the employee can generally choose to go to court (as in *Philadelphia* and in *Cain v. Hyatt*) or have the dispute adjudicated by the state agency (as in *Bowers*) (see ¶13.01 for discussion of *Cain* and *Bowers*). However, the EEOC is not empowered to adjudicate complaints under federal law (except against the federal government). Thus, the victims of nongovernmental employment discrimination who proceed under federal law must go to court if the case cannot be settled. (Increasingly, employees are required to sign arbitration agreements in which they agree that all claims, including those relating to discrimination, will be determined by arbitrators rather than by the courts.)

13.06.5 Disability discrimination

Wyant, Wheeler discharged Beckett not because he was gay but because he had AIDS. This form of discrimination is prohibited by the federal Americans with Disabilities Act of 1990 (ADA). A disability means a medically recognized physical or mental impairment that substantially limits a major life activity. Because a person who is HIV positive cannot procreate without risk to a sexual partner or to the unborn child, the person is limited in a major life activity; thus being HIV positive or having full-blown AIDS counts as a disability.

To qualify for protection under ADA, a disabled employee must be able to perform "essential" job duties, with or without reasonable accommodation of the disability. If the employee can do the job with reasonable accommodation, the employer must

provide such accommodation. At the time he was fired, Beckett was still capable of performing as a lawyer. However, if he could not have worked the hours expected of a full-time lawyer, Wyant, Wheeler probably would not have been required to provide a reduced work schedule for him. Conversely, if Beckett could work full time but needed some time to see the doctor or receive medical therapy, Wyant, Wheeler would probably have been required to provide a more flexible work schedule.

Disability discrimination is also prohibited by the laws of many states such as New York and Pennsylvania (as ¶13.01 explained, the film is based on cases involving New York and Pennsylvania anti-discrimination laws). The lawsuit in *Philadelphia* was apparently brought under Pennsylvania state law, not federal law (the courthouse we see in the film is a state facility, six-person juries are used in federal courts in civil cases, and unanimous verdicts are required in federal court).

Beckett qualified for protection under both the ADA and Pennsylvania law. However, the law firm could legally fire him for reasons other than disability, such as doing sloppy work. Thus, the lawsuit required the jury to determine whether the firm fired him because he had a history of mediocre work, topped off by losing the Hi-Line complaint, or because he had AIDS. The jury, of course, bought Beckett's story that the decision to fire him was based on the partners' terror of AIDS (with a strong dose of homophobia). It disbelieved the law firm's story that the discharge was based on poor work performance and it disbelieved the firm's testimony that the partners did not know Beckett had AIDS.

In the jury room. The brief scene in the jury room in *Philadelphia* was telling. The juror who spoke was involved in military aviation. The Wyant, Wheeler lawyers undoubtedly thought this juror would be good for them because he would probably be conservative in outlook and likely to distrust discrimination claims. However, the juror heaped scorn on Wyant, Wheeler's story. He asked—would you send a pilot in whom you lacked confidence on a dangerous combat mission as a test? Of course not—you would send your best and most trusted pilot. Consequently, the jurors simply did not believe that the firm assigned the important Hi-Line case to Beckett to see whether he could cut the mustard.

Wyant, Wheeler made a disastrous tactical error by deciding to take this high-visibility and deeply embarrassing case to trial rather than settling it quietly before trial. As a result, the firm is stuck with a huge punitive damages award and boatloads of terrible publicity. Yet Wheeler was a lawyer who ordinarily had great judgment and mature wisdom in dealing with the problems of his clients. Beckett was sincere when he testified to his admiration of Wheeler's skills as a lawyer. Wheeler's poor decision in the Beckett case suggests that lawyers often make poor judgments in matters where they lack objectivity and distance.

Although not involved in *Philadelphia,* we should not leave the subject of civil rights without some comments about how the law protects employees against discrimination on the basis of race or of gender. This kind of discrimination remains rampant in the work force (although it is usually concealed). The federal and state laws that protect employees against race and sex discrimination are of immense importance in the daily work lives of millions of people. On the other side of the coin, the laws create difficulties for employers who want to avoid hiring workers who they believe cannot do the job (or who want to fire workers who are doing a poor job) when those workers happen to be members of minority groups, women, or other classes protected by the antidiscrimination laws.

Many race or sex discrimination cases raise issues similar to Andrew Beckett's AIDS discrimination case. Was a particular employee not hired (or not promoted or paid too little or discharged) for discriminatory reasons or because of some appropriate, nondiscriminatory reason? What was the employer's real motive in making the disputed decision? Here the fact-finder must decide who is telling the truth and who is lying. As in Beckett's case, the evidence of discrimination is often circumstantial; there are no smoking guns (such as memos or emails about favoring white employees over black employees). Moreover, in many cases, the employer turns out to have mixed motives—both discriminatory and nondiscriminatory reasons motivated the decision. Then the fact-finder must decide whether the decision would have been the same even if the employee were not a member of the protected class.

An important category of race and sex discrimination cases involve "disparate impact" analysis. What if we discover that 30% of white applicants are hired and only 5% of black applicants are hired by a particular employer? What if we find out that 30% of male applicants are hired and only 5% of female applicants, or that in an area with a 50–50 population balance, the workforce is 98% white, 2% black?

The plaintiff must come forward with an explanation showing that the disparities are produced by some particular hiring practice. For example, the employer may be relying on an objective test on which whites tend to perform better than blacks or the employer may require a high school diploma or a college degree. Another possibility is that the employer may disqualify anyone with a criminal conviction, or, in sex discrimination cases, the employer may impose restrictions of height, weight, or strength that disproportionately affect women. Then the employer must establish a "business necessity" for the particular hiring practice, meaning that it serves in a significant way the employer's legitimate job-related goals. For example, the employer might establish that educational background (such as a college degree) was really important to the particular job, or that a height-weight requirement was essential to safety on the job.

Sex discrimination cases are often based on sexual harassment in the workplace. The classic case involves quid-pro-quo harassment—you must date the boss if you want a promotion. However, sexual harassment can also be established by showing of a hostile work environment. A hostile environment involves repeated unwelcome and offensive practices, such as hazing or telling offensive jokes or subjecting a female employee to pornographic photos or graffiti. The employer becomes responsible for harassment carried on by co-workers if there have been complaints that the employer ignored.

13.07 Strange doings in Philadelphia

The makers of *Philadelphia* dealt with a very critical social issue—discrimination against AIDS victims—and undoubtedly did a great service in humanizing and winning public sympathy for AIDS victims. However, by attempting to hype its entertainment value, the film goes over the top in its treatment of legal issues and trial procedures.

Recall that evidence is not admissible unless it is "relevant," meaning that it would assist the trier of fact to resolve an issue in the case. As a result, the judge should probably not have allowed Belinda Conine to ask Beckett to hold up a mirror to his face to see if there were any visible lesions (because the presence of lesions at the time of trial tells us nothing about whether he had lesions when he was fired). Furthermore, the judge should not have allowed Conine to ask Beckett about visiting the Stallion Cinema or whether he had sex with a stranger there because these questions have nothing to do with the case. For the same reasons, the judge should not have allowed Miller to ask Burton whether the firm had ever discriminated against her. Obviously, Miller's rant about gay stereotypes was completely improper.

Should a film that contains a courtroom trial be criticized because it contains gross inaccuracies, or is this irrelevant, given that the film is a purely commercial product intended to entertain or persuade viewers rather than to educate them about trial practice?

13.08 Review questions

1. Choose a gay character (defining gay to mean male or female homosexual or bisexual) in film or television and compare that character to Andrew Beckett.
2. Apply "queer theory" to a film or television show or character.
3. What characteristics does the film *Philadelphia* ascribe to Joe Miller as a lawyer and as a human being? When we first meet him? By the end of the film? Note that Miller's character describes what screenwriters describe as an "arc." This means that his character undergoes a marked personality change as the film goes along.

4. Select an African American character in the movies, not necessarily a lawyer (other than Joe Miller in *Philadelphia*). Does the representation of this character include racial stereotypes?

5. If you were a second-year law student at a top-25 law school trying to figure out what to do with your future law degree, would you apply for a summer job at a big firm? Generally summer jobs between the second and third years of law school result in offers for permanent employment after graduation. Why or why not?

6. From legally themed films or TV shows you have seen (whether or not in this seminar), select a lawyer or law firm that personifies the "professional" model. Select another that personifies the "business" model. Explain.

7. Law firms on television (such as those on *L.A. Law* or *The Practice* or such short-lived shows as *The First Years* or *Century City*) seem to be depicted more favorably than law firms in the movies. Why is this?

8. As ¶13.07 suggests, the judge in *Philadelphia* allowed a large amount of irrelevant (but entertaining) evidence to be admitted at the trial. Should the film be criticized because it is legally inaccurate or is this irrelevant given that the purpose of the film is to entertain?

CHAPTER 14

Family Law
Assigned film: Kramer vs. Kramer (1979)[1]

14.01 The book and the film

Kramer was based on a low-key but deeply felt novel by Avery Corman published in 1977. The film, written and directed by Robert Benton, won the Academy's Best Picture Award in 1979. Dustin Hoffman and Meryl Streep won Oscars for best actor and best supporting actress, respectively, and Benton won both best direction and best adapted screenplay. There were additional acting nominations for Justin Henry and Jane Alexander. Nestor Almendros (for cinematography) and Gerald B. Greenberg (for editing) were also nominated.

14.02 Cinematic technique in **Kramer vs. Kramer**

Kramer vs. Kramer is a work of striking cinematic simplicity. In contrast to, say, *Anatomy of a Murder* or *12 Angry Men,* there are no complex camera movements or elaborate compositions. Instead, the camera is typically at eye level, there are usually only one or two characters in a shot, and the camera is mainly stationary. In short, *Kramer vs. Kramer* utilizes the simplest of devices to convey the most complex of human emotions.

Consider, for instance, the two scenes between Ted Kramer and his boss that take place early in the film. The first scene occurs immediately prior to Joanna's leaving. The second occurs the next day. In the first scene, Ted and his boss are in the same frame together for most of the scene. This is called a *two-shot* because two people are in the same frame together. Moreover, despite the difference in rank between Ted and

his boss, Ted props his legs on his boss's desk. Visually, this gesture suggests that they regard one another as equals. In contrast, in the scene following Joanna's departure, Ted and his boss are framed separately. They never share the same frame. Visually, this isolates Ted from his boss. This sense of isolation is reinforced by the fact that Ted is sitting on the sofa on the opposite side of the room. Indeed, even when Ted tells his boss "I love you, you bastard," he says it from *across* the room; he makes no attempt to approach his boss. If their physical proximity in the previous scene suggested chumminess, their physical distance here suggests emotional distance. Indeed, it is not even clear at the beginning of the scene that Ted is talking to his boss. At first, we simply see Ted sitting on a sofa talking to the camera. We do not know who he is talking to, but because he is sitting on a sofa and cannot seem to maintain eye contact with his interlocutor, it appears as if he's talking to a psychiatrist. We soon learn that he is actually talking to his boss, but the sense of emotional distance and formality that is conveyed by the opening shot lingers throughout the scene.

It is unlikely that many viewers notice the subtle differences between the two scenes when they watch the film. Nonetheless, viewers are certainly aware of Ted's discomfort. Partly this is the result of the dialogue and Hoffman's performance, but it is also the product of the sensitive staging and framing of the two scenes.

14.03 Robert Benton

Benton, the writer and director of *Kramer vs. Kramer,* was born in Waxahachie, Texas. While working as a contributing editor at *Esquire,* he collaborated with David Newman on the screenplay to *Bonnie and Clyde* (1967), one of the seminal films of the 1960s. Newman and Benton were nominated for an Oscar for their script, a remarkable achievement for first-time screenwriters.

Benton moved into directing in the early 1970s with the realist western *Bad Company* (1972). *Bad Company* went largely unnoticed, but Benton's next foray, *The Late Show* (1977), was widely praised by critics. Benton received an Oscar nomination for his original screenplay. *Kramer vs. Kramer* was the third film Benton directed. He walked away with Oscars for his direction and his adaptation of Avery Corman's book.

Benton has directed seven films since *Kramer vs. Kramer,* including such films as *Places in the Heart* (1984), *Nobody's Fool* (1994), and *The Human Stain* (2003). *Places in the Heart* brought Benton an Oscar for his screenplay and an Oscar nomination for his direction. Benton's screenplay for *Nobody's Fool* earned him an Oscar nomination as well.

Kramer vs. Kramer is typical of Benton's work. In an era dominated by big-budget, special-effects laden blockbusters, Benton makes intimate character-driven films. Aside from a few attempts at genre filmmaking, Benton's films have largely been

quiet, understated films that deal with the prosaic problems faced by ordinary people. Even *Bad Company*, Benton's only western, depicts the old West in distinctly deglamorized, demythicized terms.

Ciritics consider Benton as an "actor-centered," rather than an "image-centered" director. The distinction was suggested by Robin Wood (2002) in a famous essay on the films of Alfred Hitchcock. In actor-centered films, the position and movement of the actor within the frame is dictated by the actor's gut instincts as to where she should stand, not by the director's vision of where the actor should be standing in order to create a particularly striking composition. In contrast, practitioners of image-centered cinema tend to use actors to execute a preconceived plan or idea. The actors' every move and position within the frame is carefully plotted out by the director in advance. Otto Preminger, director of *Anatomy of a Murder* (chapter 2), is generally considered an image-centered director. Still, as the discussion in ¶14.02 of the scenes involving Ted Kramer and his boss suggest, even an actor-centered director like Benton often composes his scenes very carefully to produce a particular effect.

14.04 The cultural context of Kramer vs. Kramer

In a year that saw such blockbusters as *Alien* and *Star Trek: The Motion Picture*, *Kramer* was the highest grossing film. In fact, it ultimately grossed over $106 million in the United States alone. For a film that had no action or special effects and was not based on a best-selling novel or hit television series, this was an extraordinary showing. Obviously, the film touched a cultural nerve. The question is, which nerve? And why?

Like any film, *Kramer vs. Kramer* responded to the cultural climate of its time. That climate was shaped by several important cultural trends — the rise in the divorce rate, the backlash against feminism, and changing notions of masculinity. In trying to understand how *Kramer vs. Kramer* responded to these trends, however, we need to look at these phenomena in contemporary popular culture in the broad sense (see ¶1.02.1 for definition of this phrase). After all, the way in which a film deals with social issues will invariably be influenced by the way that these same issues are framed by the various discourses taking place in the society that will consume the films.

14.04.1 Divorce

Owing in part to the changes in divorce law and in part to changes in moral and social values brought about by the tumult of the 1960s, the divorce rate exploded in the 1970s. While there were 479,000 divorces in 1965, there were over 1 million in 1975. As a proportion of the population, the divorce rate nearly doubled, going from 2.5 out of 1,000 in 1965 to 4.9 out of 1,000 in 1975.

Many contemporary self-help books portrayed divorce as an opportunity for personal growth and self-discovery. In Gail Sheehy's best-selling *Passages: Predictable Crises of Adult Life* (1978, 208), for instance, divorce is portrayed as a rite of passage, one especially important to women. "Is this ritual necessary," Sheehy asks rhetorically, "before anyone, above all herself, will take a woman's need for expansion seriously?"

In *The Courage to Divorce* (1974, 45), Susan Gettleman and Janet Markowitz claimed that divorce is positive for both spouses: "It has been our experience with patients and friends that both spouses, after an initial period of confusion and depression, almost without exception look and feel better. They act warmer and more related to others emotionally, tap sources of strength they never knew they had, enjoy their careers and their children more, and begin to explore new vocations and hobbies." Similarly, in *Creative Divorce: A New Opportunity for Personal Growth* (1973), Mel Krantzler described the break-up of his marriage as "the beginning of an enriching and enlivening voyage of self-discovery that has made me a happier and stronger person than I was before." Divorce, according to Krantzler, is a "creative" act that allows one to develop new ways of relating to people. Among other things, divorce forms "the basis for more satisfying relationships between fathers and children."

Although it initially seems to take a less cheerful view of divorce, *Kramer vs. Kramer* ends up dramatizing Ted and Joanna Kramer's divorce in strikingly similar terms to these contemporary self-help books. As a result of his separation from Joanna, Ted becomes less career-oriented, develops a closer bond with his son, and becomes a better father and human being. Joanna also seems much happier with and more in control of her life than during her marriage.

14.04.2 The backlash against feminism

Feminism won a series of victories in the early 1970s, the most dramatic of which was the Supreme Court's decision in *Roe v. Wade* (1973), which constitutionalized the right to have an abortion. However, feminism went on the defensive in the late 1970s. The Equal Rights Amendment (ERA), which Congress sent to the states for ratification in 1972, had been ratified by 35 of the required 38 states by 1977. Only three more states were needed to make it the 27th Amendment to the Constitution. Thanks to the grassroots politicking of conservative opponents such as Phyllis Schlafly, however, no other state ratified the amendment, and in 1982 it expired.

Many film critics saw *Kramer vs. Kramer* as emblematic of this backlash against feminism. Rebecca Bailin called *Kramer vs. Kramer* a "well crafted, beautifully acted backlash movie" (1980, 4–5). Michael Ryan and Douglas Kellner (1988, 159) faulted the film for "saying that a man can both mother and work successfully" while implying that a woman can't do the same. Thomas O'Brien (1981, 91–92) complained that in both *Ordinary People* and *Kramer vs. Kramer* "the villain is Mom." He noted that the narrative pattern of both films "involves the rejection or reduction of women's sig-

nificance, their dismissal as emotionally superficial." Molly Haskell (1983, 673) lambasted the "open misogyny" of films such as *Ordinary People* and *Kramer vs. Kramer,* characterizing them as "man-child paradises," in which "women are either relegated to the wings or expelled altogether." Eileen Malloy (1981, 5) wrote: "Single mothers should be incensed by the injustice done to the difficulty of their position by the trivial way that Hoffman's single-parents are dealt with." Malloy describes Margaret as a "Benedict Arnold." Papke (1996b, 1204) said "The gaze at legal process is almost always biased, and viewers are invited to adopt the male perspective."

Do you agree with these criticisms? Some critics concede that these criticisms may be valid as far as the film's representation of Joanna Kramer is concerned (but are they true of the film's representation of Margaret Phelps?), but they fail to address the film's representation of Ted Kramer. After all, by the end of the film Ted Kramer has acquired a newfound respect and understanding for the burdens and responsibilities women typically shoulder within the family structure. As such, he is something of a poster child for male feminism.

14.04.3 The "sensitive male movement"

The 1970s witnessed the emergence of a new vision of masculinity. Partly as a result of feminism, and partly in reaction to the Vietnam War (which many critics believed had been fueled by "macho" ideas of masculinity), the traditional image of masculinity, embodied most famously by John Wayne, came under ferocious attack. Numerous books[2] blamed traditional notions of masculinity for everything from heart disease to the Vietnam War. In its place, they championed what was variously described as the free male, the liberated male, and, most commonly, the sensitive male.

Alan Alda. The person who most personified this new image of sensitive manhood was Alan Alda, star of the hit TV series *M*A*S*H*. In various articles in and interviews with magazines like *Ms.* and *Redbook,* Alda berated traditional notions of masculinity while celebrating traits traditionally associated with women.

Although *Kramer vs. Kramer* portrays Joanna Kramer in distinctly unflattering terms, the film initially portrays Ted Kramer negatively too. He is a career-oriented, self-absorbed father who spends little or no time with his family. Moreover, the film leaves little doubt that Ted stifled Joanna. Nonetheless, Ted is ultimately portrayed more positively than Joanna because he takes on responsibilities and traits that are typically associated with mothers and women. Ted becomes, in other words, the prototypical sensitive male.

As Thomas O'Brien (1981, 91) has written of *Kramer vs. Kramer* and *Ordinary People,* "Central to both films is the way a father evolves from being a mere breadwinner or standard-bearer to becoming a caring, involved friend of his son." Indeed, Ted even

joins the "sisterhood" when he befriends Margaret, the woman whose friendship with Joanna he had snidely dismissed as the "sisterhood." Moreover, despite what viewers may at first expect, there are no romantic connotations to Ted's relationship with Margaret—it is a true male-female *friendship*.

14.05 Divorce under the Hays Code[3]

Marital trouble and divorce are unpleasant but ever-present realities of modern life. These days, approximately one of every two marriages in America and Europe ends in divorce.

Marital breakdown generally precedes divorce. The parties become increasingly incompatible and unhappy in their lives together. Frequently, there are complex and clandestine love affairs outside of marriage; deception, jealousy, and betrayal; emotional upheaval; disruption of the lives of children; and economic warfare. The routine of everyday life is shattered. Divorce is often followed by physical and emotional isolation for one or both parties, or it may be followed by promiscuity. Forced out of the shelter of the household, some spouses who had worked in the home find satisfying new careers; others find that the world of work holds nothing for them. Often one ex-spouse's standard of living rises while the other's plummets. One partner's true personality blooms when freed from the stifling constraints of marriage; another's joy of life is snuffed out. A high divorce rate insures that there are plenty of complex blended families with multitudes of stepchildren and former spouses.

This is very dramatic material. It would seem that marital breakdown and divorce should appear as thematic material in movie narratives almost as often as those reliable standbys of romance, marriage, and childbirth. These days, movies routinely dwell on the emotional and financial prequels and sequels to divorce. However, it was not always like that. Divorce figured prominently in many silent films of the 1920s and in the films of the early 1930s, such as Alfred Hitchcock's *Easy Virtue* (1928) or Robert Leonard's *The Divorcee* (1930). Then, for thirty or forty years, serious treatment of divorce was blotted off the screen.

As discussed in ¶¶2.04 and 13.03.2, the Production Code Administration (PCA) administered the movie industry's system of self-censorship from 1934 to 1968. No film could be released without a PCA certificate; the PCA bureaucrats scrutinized every word of every film (as well as song lyrics and costumes). The Hays Code provided that "the sanctity of the institution of marriage and home shall be upheld." The censors interpreted those words to mean that divorce was mostly off limits as thematic material in film.

What little movies were allowed to say about divorce during the censorship era was wildly wrong. When the story line included divorce during the Code era, it was usually in romantic remarriage comedies like *The Awful Truth* (1937) (Cavell 1981). In

these films, a couple gets divorced at the beginning of the film but gets back together in the end. Needless to say, divorced couples in real life seldom remarry. Other couples went to the brink of divorce but came to their senses, as in *Penny Serenade* (1941). In a few films, such as *Dodsworth* (1936), the censors allowed a spouse entrapped in a truly ghastly marriage to get and stay divorced. The other spouse (normally an adulterer) was punished by a life of misery. Annulment and death (whether natural, violent, or self-imposed) were the preferred ways to dispense with inconvenient spouses.

Crime and sex. Note that the Hays Code treatment of divorce was quite different from the way it treated subjects like crime and sex. Crime and sex remained permissible thematic elements—how could it be otherwise? The Code required only that sex be handled with extreme discretion. It also required that criminals and those who practiced sex outside of marriage be appropriately punished. In the case of divorce, however, the subject could not be dealt with at all (except within such narrow conventions as comedies about divorce and remarriage). A few other subjects, such as homosexuality, abortion, and miscegenation (that is, interracial sex) were similarly forbidden. Why do you suppose that the PCA virtually wiped the subject of divorce off the screen?

14.06 From the Hays Code to Kramer vs. Kramer

After steadily weakening through the 1950s and 1960s, the Hays Code finally fizzled out in 1968, replaced by the ratings system that remains in effect today. In the late 1960s and 1970s, divorce themes crept back into the movies, but it took ten years before American film treated the subject seriously and in depth.

In the late 1970s and early 1980s, many filmmakers discovered the dramatic potential of divorce stories. In addition to *Kramer vs. Kramer,* a number of other memorable films addressed seriously the whole range of issues posed by marital breakdown and divorce. One of the best remembered is *An Unmarried Woman* (1978). In that film, Erica seems happily married to Martin until he announces his affair. After some false starts, Erica hooks up with Saul, an abstract artist. Their 15-year-old daughter Patti struggles with her relationship to her father and to Saul. Perhaps most startling to viewers accustomed to the mandatory remarriage scenario, Erica refuses to take Martin back when he pleads for forgiveness. Of course, not everything about *An Unmarried Woman* is realistic. Erica remains in her gorgeous New York apartment despite holding a low-paying art gallery job. Martin has plenty of money and uncomplainingly uses it to support his ex-wife and daughter in the style to which they have become accustomed. Generally, these films have little or nothing to say about the legal process of divorce or about the family lawyers who helped pave the way to singlehood.

14.07 Ingredients of a classic divorce movie

A film that wants to take seriously the process of marital disintegration and divorce should, like any other picture, have a strong story and empathetic characters. It should treat both spouses with understanding and insight; neither should be perfect but neither should be a demon. In addition, the film should engage most of the following issues:

- The reasons for the fundamental breakdown of the marital relationship, including treatment of gender issues.
- The economic aspects of splitting one household into two.
- The effect of the divorce on children.
- Single parenthood and noncustodial parenthood.
- Social and relationship problems encountered by newly divorced spouses.
- Perverse and outdated family law doctrines (see ¶14.08).
- The legal process of divorce (see ¶14.09).
- The problems of lawyer-client relationships in family law (see ¶14.10).

Remarkably, *Kramer* tackles all of these issues. (Asimow 2000b, 250–67). The film lit a path for the many films and television shows of the last twenty years that grapple forthrightly with the human drama of divorce as well as with the legal institutions and processes of family law.

14.08 Kramer *and the tender years doctrine*

Classic movies about law often grapple with outdated or perverse legal doctrines, institutions, or procedures. Very few movies relating to divorce focus on the antiquated doctrines of family law that divorcing couples used to endure.

14.08.1 Fault divorce

Until the early 1970s, divorce law was heavily oriented toward determining which of the spouses was at fault. The petitioning spouse had to prove abandonment, adultery, or physical or mental cruelty, depending on the state, in order to be awarded a divorce. Some states, such as New York, permitted divorce only in cases of adultery. The law in action, however, was entirely different from the law in the books. In the vast majority of cases, divorce actions were collusive affairs based on perjured or rigged testimony. These cases were embarrassing to the parties and to the legal system. One spouse (usually the woman) came to court with perjured evidence (including rigged photos) about her spouse's supposed adultery; the other spouse defaulted by not

showing up. Judges knew the cases were phony but waved them through. Affluent spouses who did not want to go through this charade traveled to Nevada (or some other divorce haven) where one could get divorced without proof of fault after six weeks of residence—but only if the other spouse consented.

Friedman's article on fault divorce (2000) begins with an account of *Kreyling v. Kreyling* (New Jersey 1942). Anna wanted children, Daniel did not, so he insisted on using contraceptives. Anna objected to contraceptives, so the couple had no sexual relations and Anna moved to a separate bedroom. After a year and a half, Anna sued for divorce. Anna won, on the grounds that Daniel has "deserted" her (a ground for divorce under New Jersey law). The court remarked that Daniel's conduct was "a violation of both human and divine law . . . [his] willful, obstinate, continual refusal . . . to have natural, uncontracepted intercourse" constituted desertion as a matter of law. Ironically, *Kreyling* was actually a progressive decision. If the court had not found that Daniel's conduct was "desertion," neither party would have been entitled to a divorce, and they would have remained stuck with each other in this horrendous marriage.

Fault was important for reasons beyond establishing entitlement to divorce. Fault played an important role in determining the division of marital property and the award of alimony. If the man was found to be at fault, the woman would get most of the marital property and might get considerable alimony; if the woman was at fault, she likely came away with little or nothing. Considerations of fault were often taken into account in child custody determinations as well; parents guilty of adultery were judged unfit custodians.

During the last three decades, an entirely new vision of marriage termination has swept away most relics of the older family law doctrine. Today the emphasis is on removing any consideration of fault, mediating instead of litigating, and treating the ownership of marital property as a partnership. California sparked the no-fault revolution with its 1969 statute allowing divorce upon the petition of either spouse on a simple showing of irreconcilable differences.[4] Fault was no longer considered in determining spousal or child support. Most of the states swiftly followed suit. In addition, joint physical and legal custody of children has become the norm in many states instead of the earlier system which gave all custodial rights to one parent and considered fault in determining child custody.

Very few films zeroed in on fault divorce. In *One More River* (1934), the parties conducted a scorched-earth trial to determine whether the wife had committed adultery (she hadn't but got convicted anyhow). This film, which unfortunately is not yet available on video or DVD, managed to get approved just as the PCA came into existence; its mature treatment of divorce would never have been acceptable later on. Generally, however, films about divorce (even those produced before 1934) ignored divorce law entirely. A few films, such as George Cukor's *The Women* (1939), followed divorcing wives to Reno, but they never questioned the absurdity of that practice.

In contrast to most earlier films, which ignored the perversities of family law, *Kramer* foregrounds family law doctrine by leveling a withering attack on the "tender years presumption." (Asimow 2000b, 261–64; Schepard 2003, ch. 2). A "presumption" as used in the law of evidence establishes a fact (in this case that maternal custody is in the best interest of the child) unless it is rebutted by the other party. In some states, the father could rebut the presumption only by showing the mother was unfit (which often meant at fault); in others, the father could rebut the presumption by showing that paternal custody would better serve the child's developmental needs.

The tender years presumption was universally applied in the United States from the middle of the nineteenth century through the 1960s. (Before then, the child was considered the property of the father, who normally received custody.) By the late 1970s, the presumption was in decline but was still very much alive in a number of states. It was occasionally still employed in New York at the time *Kramer* was set. Today it has virtually disappeared, usually in favor of a vague "best interests of the child" standard. In general, whatever the legal standard, mothers won a very high percentage of contested custody cases during the era in which *Kramer* took place.

The tender years presumption was and remains the subject of considerable dispute. Feminist theoreticians who pursue the "equal treatment" approach (see ¶12.02.5 and ¶6.05.2) tend to oppose the presumption because they believe that the tender years doctrine is based on stereotypes of women as instinctive child-rearers inherently unsuited for worldly pursuits. These writers tend to favor a gender-neutral standard.

However, feminist writers that pursue the "difference" approach (also discussed in ¶12.02.5 and ¶6.05.2) tend to favor the presumption or some variation of it. Under the difference approach, laws that recognize actual differences between men and women are appropriate. In the view of a number of writers, mothers have better ability to nurture small children than do fathers. Proponents of the tender years presumption also believe that it takes away a common tactic used by fathers who threaten to contest custody unless mothers decrease their financial demands.

Application of the tender years doctrine in *Kramer*. The tender years doctrine was applied incorrectly in the film. In no event should the presumption be applicable to a *modification* of custody (as opposed to an initial determination of custody at the time of divorce). Moreover, Ted clearly rebutted the presumption. The most important point is that Ted, not Joanna, had been Billy's primary caretaker for a year and a half. Ted had formed a close emotional bond with Billy and had been an excellent and caring parent. Changing custody could only be terribly disruptive to Billy. At a minimum, Billy would suffer short-term trauma; he might well suffer long-term damage. The court was impressed with none of this. As the judge saw it, assuming that a mother of a young child is not somehow unfit, she gets custody.

Kramer deserves credit for identifying a dubious family law doctrine, as well as abuse of discretion by the judge, and subjecting both to criticism. In this respect, *Kramer* blazed a path for future movies in which child custody disputes illuminated major social or legal issues. These films include *Losing Isaiah* (1995), which involved the question of transracial adoption; *I Am Sam* (2002), questioning whether a retarded father can be a fit custodian; *Evelyn* (2002), pitting the Irish Catholic Church against a single father; and *The Good Mother* (1988), in which a mother loses custody of a child because of a trivial indiscretion by her boyfriend.

14.09 The family law process

In order to get divorced in the fault era, and often in the no-fault era as well, a couple must endure the family law process. While the vast majority of divorce-related disputes are successfully negotiated or mediated (so that the court proceedings are a brief formality), the fact remains that numerous divorce cases are still litigated. When one or both spouses want to fight, the process can be excruciatingly long and costly.

That process often constitutes a grueling ordeal for the human beings enmeshed in it. In the fault era, family law doctrine required the disclosure of intimate details of one's private life. A judge had to decide who cheated on whom, who was more cruel, who walked out on whom. The trial process became acrimonious, and the testimony often was vicious, intrusive, and humiliating. In the no-fault era, mercifully, such material is not relevant. (Some states still cling to vestiges of the fault system, particular in setting alimony and dividing property.) Even in states that have abolished consideration of fault, it is not unusual to see long, hard-fought trials on property issues, such as valuing the goodwill of a law firm or pension rights.

Kramer gets credit for showing what a miserable experience adversarial family law processes can be. The trial itself is marked by vicious mudslinging. Joanna's attorney smears Ted with the playground incident, implying he was a careless father, and mercilessly explores Ted's downward job mobility. Ted's attorney smears Joanna by asking whether she has been a failure at her marriage and at everything she has ever tried. He insists on asking how many lovers she has had and whether she currently has a boyfriend. He uses a patronizing tone and at times yells at her.

In its understandable zeal to show how destructive family court litigation can be, *Kramer* goes over the top. The question about whether Joanna has been a failure at everything she has tried is improper; her lawyer should have objected to this question as argumentative or unduly vague. Whether Joanna has a boyfriend, or the number of her lovers, has nothing to do with the issues at the trial, absent a showing that she is indiscreet. Whether Ted has downward economic mobility counts for little, given that he lost his previous job because he put parenting ahead of job duties. The attorneys

cut off witnesses, demanding yes or no answers. This seems unrealistic; in a trial to the judge, a witness should be allowed to give a complete answer to the question.

In the real world, Judge Atkins would never have decided the custody issue cold. He would have considered reports of a social worker on Billy's family situation. He might well have gently interviewed Billy in his chambers, asking him questions about his daily life with his dad. When Ted's lawyer Shaunessy tells Ted that in the event of an appeal he would have to put Billy on the stand, this is nonsense; an appeal is based on the written record, not on new evidence. Even if a new trial were ordered, seven-year-old Billy surely would not be made to take the stand.

The attorneys never discuss mediating the custody dispute rather than duking it out in court. (A great many such disputes are resolved by the parties with the help of a third-party mediator.) They also fail to consider joint custody solutions or other ways of avoiding zero-sum results. Thus, the actual courtroom battle in *Kramer* was not very realistic, but the film still gets good marks for showing how unpleasant and how costly family law litigation can become.

14.10 Lawyer-client relationships in family law

To get divorced or dispute support, property, or custody, parties who can afford it must hire lawyers. Family lawyers are very expensive. In *Kramer,* the custody fight costs Ted $15,000 (not counting an appeal). In current dollars, the cost would certainly be three or four times that amount and probably much more.

Because of the high cost of legal services, a majority of family court litigants today represent themselves in court (self-representation is often referred to as "pro se"), because most states provide little or no free legal services for indigent litigants. Pro se litigants often do not know what they are doing and thus increase court congestion. If one party has a lawyer and the other does not, a mismatch occurs and an unjust result (either through negotiation or litigation) becomes quite likely.

Fanning the flames. Sometimes family lawyers exacerbate the problems, turning a relatively friendly divorce into a take-no-prisoners brawl which can only benefit the lawyers. A prime example of an irresponsible family lawyer is Miles Massey in the Coen Brothers' *Intolerable Cruelty* (2003). The *New Yorker* once ran a cartoon with two women having lunch and talking about their divorces. One remarks that her lawyer got the summer house and her husband's lawyer got the Mercedes. Responsible family lawyers, however, do not fan the flames but instead work to cool down their clients and avoid unnecessary litigation.

The vicious trial in *Kramer* reveals how family lawyers often must play harsh, destructive roles in the courtroom (regardless of whether they are nasty people in their

private lives). As Ted's lawyer Shaunessy makes clear, Ted's only hope is to destroy Joanna on the stand. Joanna's lawyer played the same game. However, these are good lawyers; they are doing their job in an ethical, competent, professional way. It is the system for litigating child custody disputes that is bad, not the lawyers.

14.11 Review questions

1. The text states that *Kramer* uses the simplest cinematic "devices to convey the most complex of human emotions." Discuss examples in the film (other than those mentioned in ¶14.02) of camera placement or movement designed to convey the characters' emotions.

2. *Kramer* contained no action sequences or special effects, no violence, no significant sex scenes, and it was not based on a bestseller. However, it grossed over $100 million in the United States alone. What accounts for this success at the box office?

3. Some feminist critics have taken sharp issue with *Kramer* (see ¶14.04.2). Do you agree with their criticisms?

4. Some writers have said that Hollywood made many of its greatest movies (such as *Gone with the Wind, Casablanca, The Big Sleep, Citizen Kane,* or *It's a Wonderful Life*), while the Production Code was in effect. They suggest that filmmakers produced better films when they had to work around the Code's restrictions on the depiction of sex, crime, and violence. Do you agree?

5. Identify a signifier in *Kramer* (see ¶1.05.2) and provide your interpretation of this signifier.

6. The text states in ¶14.07 that *Kramer* tackles all eight of the relevant issues about the family law process. Select one of these eight issues. What position does the film take on that issue and is the film's treatment fair?

7. Cavell (1981) believes that the final scene of the movie suggests that Ted and Joanna are going to get back together (which would place *Kramer* into Cavell's category of divorce-remarriage pictures). Do you agree with Cavell?

Notes

Chapter 1

1. See Cullen 1996, 13.
2. For works about law and popular culture, see Bergman & Asimow 1995; Black 1999; Denvir 1996; Chase 2002; Greenfield, Osborn, & Robson 2001; Silbey 2001.
3. For enlightening treatments of film and cultural theory see Gitlin 2002; Grossberg et al. 1998; Mukerji & Schudson 1991; Staiger 1992; Stam 2000; Storey 1996. For a brilliant and readable summary of the vast field of literary theory, see Eagleton 1996.
4. For treatment of the cultural study of law, see Kahn 1999; Berman 2001; Sarat & Simon 2001; Binder & Weisberg 1997.

Chapter 2

1. Any classic legal film can be substituted for *Anatomy of a Murder*. We suggest other films from the "golden age" of courtroom movies such as *Witness for the Prosecution* (1957), *Inherit the Wind* (1960), *A Man for All Seasons* (1966), or *To Kill a Mockingbird* (1962), if the latter film is not going to be used elsewhere in the course. Consider also *Reversal of Fortune* (1990) which presents the appeal of an interesting criminal case (Claus von Bulow) and is as ambiguous as *Anatomy* about what really happened. For discussion of *Anatomy of a Murder,* see Bergman & Asimow 1996, 232–38; Harris 1987, ch. 5; Perkins 1972.
2. For treatment of the courtroom movie genre, see Bergman & Asimow 1995; Chase 2002; Greenfield, Osborn, & Robson 2001, 14–24; D. Black 1999; Krutch 1955; Papke 2001; Silbey 2001.
3. See G. Black 1997 and 1994; Doherty 1999; Leff 1990; Walsh 1996.
4. See Greenfield, Osborn & Robson 2001, 93–96.
5. The leading theoretical work on the meaning of justice is Rawls 1971.
6. See Frank 1969; Frankel 1978; Kagan 2001; Landsman 1984; Strier 1996.

7. For discussion of stories in trial practice, see Sherwin 2001, ch. 8.
8. See Asimow 2004.
9. See Damaska 1986; Langbein 1985; Langer 2003.

Chapter 3

1. Numerous films depict lawyers in heroic roles. Among more recent films, consider *Philadelphia* (1992) (the subject of chapter 13), *In the Name of the Father* (1993), or *Ghosts of Mississippi* (1996). You might also consider *Erin Brockovich,* although the protagonist is a paralegal rather than a lawyer. Among older films, consider *Inherit the Wind* (1960) (based on Clarence Darrow and the Scopes monkey trial), *A Man for All Seasons* (1966) (about the trial of Sir Thomas More for treason against King Henry VIII), or *Young Mr. Lincoln* (1939). The latter is a classic film directed by John Ford; it shares many elements with *Mockingbird*.

 As to films involving lawyers and black-white racial issues, we suggest *Intruder in the Dust* (1949), *Pinky* (1949), *A Time to Kill* (1997), *Amistad* (1997), or *Ghosts of Mississippi* (1996). *Scottsboro: An American Tragedy* (2000) is a powerful televised documentary on the Scottsboro case that has promoted controversy for the way in which it represents the left-wing politics surrounding the Scottsboro episode.
2. See Brooks 1976; Fiske 1996; Singer 2001; Williams 1998.
3. See Goodman 1994; Sundquist 1995.
4. For discussion of lawyers as heroes, see Clark 1993; Rosenberg 1991; Greenfield 2001.
5. See Hoff 1994 (symposium on *Mockingbird* and Atticus Finch); Asimow 1996; Atkinson 1999; Lubet 1999; Osborn 1996; Phelps 2002; Shaffer 1981 (Shaffer has written repeatedly about the character of Atticus Finch).

Chapter 4

1. Numerous films of the last twenty-five years or so paint attorneys in a very ugly light. Alternatives to *The Verdict* include *Intolerable Cruelty* (2003), *Body Heat* (1981), *Carlito's Way* (1993), *Liar Liar* (1997), or *The Firm* (1993).
2. For discussions of the book and film, see Bergman & Asimow 1996, 301–6; Bergman 2001; Chase 2002, ch. 4; Greenfield, Osborn & Robson, ch. 4.; Weisberg 2000.
3. See D. Black 1999; Bordwell, Staiger, & Thompson 1985; Thompson 1999.
4. See Fiske 1994 and 1987; Kellner 1995; Machura & Ulbrich 2001; Pfau 1995; Podlas 2001; Shrum 1988.
5. See Grossberg, Wartella, & Whitney 1998; Jenkins 1992.
6. See Abel 1989; Heinz & Laumann 1982.

Chapter 5

1. See Herman 1995, 114–19.
2. The stage play of *Counsellor-at-Law* can be found in Schiff 1995. Schiff's book furnished the biographical material on Elmer Rice which appears in this section.
3. For discussion of films showing Depression life, see Doherty 1999, ch. 3.

4. On Jewish characters in film, see L. Friedman 1987; Levinson 1993; Pearce 1993; Hornblas 1993. This part is based on Feldman 2001.

Chapter 6

1. Additional films on legal education at Harvard are mentioned in ¶6.03. *The Pelican Brief* is set at Tulane Law School. *Legally Blonde* would be a good (and more up-to-date) substitute for *The Paper Chase.* That film would be particularly useful if the instructor wanted to focus on equality v. difference feminism. Instructors might also consider *Soul Man* (1986), especially if they wish to concentrate on racial issues.
2. See Anderson 1986 (explaining rationale for teaching methods used in law school); Davis & Steinglass 1997 (discussing what Socrates and Langdell actually did); Frank 1969 (scathing criticism of Langdell and case method of teaching); Friedland 1996; Granfield 1992; Hess 2002 (empirical study of law school stress); Sheldon & Krieger (empirical study of decline in 1L's sense of well-being).

Chapter 7

1. See Jarvis & Joseph 1998 (thirteen separate chapters about TV law shows of past and present).
2. On *L. A. Law,* see Gillers 1989; C. Rosenberg 1989 (Rosenberg was a technical adviser for the show); Simon 2000 (discussing situational ethics on *L. A. Law* and other shows); Newcomb 1993; Stark 1987.
3. See Papke 1998.
4. Bounds 1996; N. Rosenberg 1998; Asimow 2004.
5. The first Perry Mason film was *The Case of the Velvet Claws* (1933).
6. See Joseph 2003.
7. See Feuer et al. 1984; Gitlin 2000; Taylor 1986; R. Thompson 1996.

Chapter 8

1. There are countless films and television shows involving the criminal justice process. Instructors might consider *Night Falls on Manhattan* (1997) (which shows all aspects of the process and treats both prosecutors and defense lawyers in nuanced fashion), *Presumed Innocent* (1990) (excellent treatment of criminal law, very tough on prosecutors and judge), *And Justice for All* (1979) (presenting a wildly caricatured view of the process), *The Glass Shield* (1994) (focusing on police corruption and racism), *Call Northside 777* (1948) (documentary-style narrative of famous case in which a journalist uncovered a false conviction), or *The Wrong Man* (1956) (Hitchcock's treatment of a true story in which a wrongly identified and wholly innocent man became enmeshed in the coils of the criminal law). Like *Indictment,* the documentary *Capturing the Friedmans* (2003) concerns child abuse convictions and raises very serious issues about the criminal justice system and the difficulties of proving or disproving child abuse.
2. See Hallam & Marshment 2000; Nichols 1991; K. Thompson 1988, 197–244; Grossberg et al. 1998, ch.7; Stam 2000, 140–45.

3. See Bernstein 2000; L. Butler 1995; Carnes 1995; Greenfield, Osborn, & Robson 2001, ch. 3; Lebel 2002 (discussing *Amistad* and *JFK*); Mnookin & West 2001; Rosenstone 1995.
4. See E. Butler 2001; Eberle 1993; Nathan & Snedeker 1995, ch. 4; Safian 1989; Reinhold 1990.
5. For treatment of prosecutors in popular culture see Corcos 2003; Epstein 2003.
6. For additional detail see Dressler 2002. For treatment of the criminal process in film, see Rafter 2001.
7. See Sherwin 2000, ch. 6.
8. For discussion of pre-trial publicity, see Chemerinsky 1998 (arguing that restrictions on pre-trial publicity violate freedom of speech).
9. For discussion of the responsibilities of prosecutors, see Griffin 2001; Zacharias 2001.
10. For discussion of the difficulties of child molestation prosecutions see Askowitz & Graham 1994; Mosteller (2002) (a symposium consisting of articles relating to molestation prosecutions).
11. See also *Capturing the Friedmans* (2003) a stunning documentary about the convictions of a father and son for abusing much older children than the preschoolers in *Indictment*. The prosecution employed questionable methodologies such as hypnosis to recover the memories of the alleged abuse victims.

Chapter 9

1. For discussions of the film see Clover 1998; Garbicz & Klinkowski, vol. 2, 251–99; Harris 1987, ch. 1.
2. Other films about the jury system: *Runaway Jury, Jury Duty, The Juror, Trial by Jury, The Jury* (Masterpiece Theater mini-series).
3. For further discussion of director Sidney Lumet, see ¶4.01.
4. See N. Rosenberg 2002.
5. The ideas in this section were suggested by Clover 1998.
6. See Abramson 1994.
7. See Vidmar 1998.
8. See King 1999 (issue contains numerous articles about juries in other countries); Bradley 1999; Ivkovic 2003.
9. See also Abbott 1999, 21–5; Adler 1999.
10. See also Kalven 1964.
11. See King 1996 (numerous articles on reforms of jury system).
12. See Marder 2002 (gender diversity on juries improves juror satisfaction and thoroughness of deliberation).

Chapter 10

1. Another excellent film which involves a judge confronted with a difficult Fourth Amendment problem during an election campaign is *The Penalty Phase* (1986). This film is discussed in Nevins 2001. On themes of popular justice, in addition to those mentioned in the text, see Fritz Lang's films *M* and *Fury.*
2. See also Silbey 2002.
3. Law students who are already familiar with this material may wish to skip ¶¶10.04 and 10.05.
4. See Chase 2002 (analyzing numerous criminal justice films as presenting conflict between the crime control and due process models); Dressler 2002, ch. 5–21; Levy 1999, ch. 7.

5. For discussion of vigilantism see Brown 1975; L. Friedman 1993, ch. 8.
6. For discussion of judges in film, see Greenfield, Osborn & Robson 2001, 141–60.
7. For discussion of the psychology of judicial decision-making and the shared culture of judges, see Cross 1997; Gillman 2001; Stout 2002; Whittington 2000.

Chapter 11

1. For discussion of *Dead Man Walking,* see Sarat 1999; Shapiro 1996.
2. There have been many outstanding death penalty films, most of which are referred to in the text. From an earlier era, consider *I Want to Live* (1958), starring Susan Hayward and involving the first woman executed in California's gas chamber.
3. See discussion of death penalty movies, see Dow 2000; Sarat 1999.
4. See Lesser 1993.
5. For discussions of death penalty law, practice and history see Banner 2002; Abramson 1994, ch. 6; Avio 1998, 1:201–6; Yunker 2001.
6. See Steiker 2002 (this issue of Oregon Law Review contains numerous valuable articles about the death penalty).

Chapter 12

1. Other films that illustrate the civil justice process include *A Civil Action, Class Action, The Rainmaker, Runaway Jury* . Numerous films with women lawyers are mentioned in the text. Instructors who wish to take a strongly feminist orientation toward the material should consider the independent production *Female Perversions* (1996).
2. See Tushnet 1996.
3. See Klein 1998.
4. See also Haskell 1987 for in-depth treatment of women in the movies.
5. Various writers (Graham and Maschio 1995–96, Miller 1994, Caplow 1999, Shapiro 1998 and 1994) offer different explanations for this peculiar phenomenon.
6. In *State Farm Mutual Co. v. Campbell* 2003, the U.S. Supreme Court limited the ability of juries to award punitive damages that seem out of proportion to the amount of compensatory damages in the case.
7. Schwartz 1991; see *Grimshaw v. Ford Motor Co.* (Calif. Court of Appeal 1981).
8. See Menkel-Meadow 2001; Fox 2000.
9. Model Rule 8.3 requires a lawyer to inform the appropriate professional authority when the lawyer knows that another lawyer has violated the ethical rules in a way that "raises a substantial question as to that lawyer's honesty, trustworthiness or fitness as a lawyer."

Chapter 13

1. Instructors who wish to concentrate on gender discrimination should consider the Australian picture *Brilliant Lies* (1996). It concerns sexual harassment and contains an administrative hearing designed to uncover the truth in a he-said-she-said situation. It is quite explicit in dealing with the harassment. Much less satisfactory is *Disclosure* (1994), which featuring female-on-male sexual harassment.

2. See Barrios 2003; Bourne 1996; Dyer 2003; Russo 1987.
3. See Greenfield, Osborn & Robson 2001, 123–24.
4. For discussion of gay roles on television see Tropiano 2002.
5. See Allen 2003, 151–55; Levy 1999, 442–93; Merritt 2000, 337–38, 390–93.
6. See Doty 1993; Butler 1999.
7. See Bogle 2001a, 2001b; Cripps 1993; Doherty 1999, 274–93; Fiske 1994; Hooks 1996; Lipsitz 1998; Rogin 1998; Snead 1994.
8. See Asimow 2001.
9. See Player 1999; Rothstein 1999.

Chapter 14

1. In addition to films about divorce discussed in this chapter, instructors might consider *Scenes from a Marriage* (1973); *An Unmarried Woman* (1978); *Manhattan* (1979); *Losing Isaiah* (1995); *War of the Roses* (1989); *Intolerable Cruelty* (2003).
2. See Farrell 1974; Goldberg 1976; Fasteau 1974; Friedman & Rosenman 1974.
3. See Asimow 2000b, 224–37.
4. The Coen Brothers' film *Intolerable Cruelty* (2003) concerns various family law disputes. The film is set in California in the present, but it inaccurately represents California as a fault jurisdiction. In several of the divorces discussed in the film, the issue is who committed adultery. In fact, such evidence is never permitted in California and divorce is granted on a showing of irreconcilable differences. Nor is fault considered in dividing property or setting support. Had the film been set in New York in 1960, it would have more representative of actual family law.

References

Abbott, Walter F. 1999. *A Handbook of Jury Research.* Chicago: American Law Institute.

ABCNews.com. May 2, 2001. *Death Penalty Ambivalence: Poll Points to Support for Execution Moratorium in U. S.*

Abel, Richard L. 1989. *American Lawyers.* Oxford: Oxford Univ. Press.

Abramson, Jeffrey. 1994. *We, the Jury: The Jury System and the Ideal of Democracy.* New York: Basic Books.

Adler, Stephen J. 1999. *The Jury.* New York: Times Books.

Allen, Michael. 2003. *Contemporary U.S. Cinema.* New York: Longman.

American Bar Association. 1999. *Perceptions of the U.S. Justice System.* Chicago: American Bar Association.

———. 2003. *Annotated Model Rules of Professional Conduct.* Chicago: Center for Professional Responsibility.

Anderson, Alison. 1986. Lawyering in the Classroom: An Address to First Year Students. *Nova Law Review* 10:271.

Asimow, Michael. 1996. When Lawyers Were Heroes. *Univ. of San Francisco Law Review* 30:1131.

———. 2000a. Bad Lawyers in the Movies. *Nova Law Review* 24:531.

———.2000b. Divorce in the Movies: From the Hays Code to *Kramer vs. Kramer. Legal Studies Forum* 24:221.

———. 2001. Embodiment of Evil: Law Firms in the Movies. *UCLA Law Review* 48:1339.

———. 2004. Popular Culture and the American Adversarial Ideology. In *Law and Popular Culture.* Ed. Michael Freeman. Oxford: Oxford Univ. Press.

Askowitz, Lisa R., and Graham, Michael H. 1994. The Reliability of Expert Psychological Testimony in Child Sexual Abuse Prosecutions. *Cardozo Law Review* 15:2027.

Atkinson, Rob. 1999. Liberating Lawyers: Divergent Parallels in *Intruder in the Dust* and *To Kill a Mockingbird. Duke Law Journal* 49:601.

Avio, Kenneth L. 1998. Capital Punishment. In *The New Palgrave Dictionary of Economics and the Law.* Ed. Peter Newman. London: Macmillan Reference.

Bailin, Rebecca A. Oct. 1980. Kramer vs. Kramer vs. Mother-Right. *Jump Cut* 4–5.

Banner, Stuart. 2002. *The Death Penalty: An American History.* Cambridge: Harvard Univ. Press.

Barrios, Richard. 2003. *Screened Out: Playing Gay in Hollywood from Edison to Stonewall.* New York: Routledge.

Baty, S. Paige. 1995. *American Monroe: The Making of a Body Politic.* Berkeley: Univ. of California Press.

Bergman, Paul. 2001. The Movie Lawyers' Guide to Redemptive Legal Practice. *UCLA Law Review* 48:1393.

Bergman, Paul, and Asimow, Michael. 1996. *Reel Justice: The Courtroom Goes to the Movies.* Kansas City: Andrews & McMeel.

Berman, Paul Schiff. 2001. Approaches to the Cultural Study of Law: Telling a Less Suspicious Story. *Yale Journal of Law & Humanities* 13:95.

Bernstein, Richard. 2000, Jan. 18. Playing Fast and Loose with Historical Facts. *New York Times,* B1.

Binder, Guyora, and Weisberg, Robert. 1997. Cultural Criticism of Law. *Stanford Law Review* 49: 1149.

Black, David A. 1999. *Law in Film: Resonance and Representation.* Urbana: Univ. of Illinois Press.

Black, Gregory D. 1994. *Hollywood Censored: Morality Codes, Catholics, and Movies.* New York: Cambridge Univ. Press.

———. 1997. *The Catholic Crusade Against the Movies, 1940–1975.* New York: Cambridge Univ. Press.

Bogdanovich, Peter. 1997. *Who the Devil Made It: Conversations with Legendary Film Directors.* New York: Alfred A. Knopf.

Bogle, Donald. 2001a. *Primetime Blues: African Americans on Network Television.* New York: Farrar, Straus & Giroux.

———. 2001b. *Toms, Coons, Mulattoes, Mammies and Bucks.* 4th ed. New York: Continuum.

Bordwell, David. 1985. *Narration in the Fiction Film.* Madison: Univ. of Wisconsin Press.

Bordwell, David, Staiger, Janet, and Thompson, Kristin. 1985. *The Classical Hollywood Cinema: Film Style and Mode of Production to 1960.* New York: Columbia Univ. Press.

Bounds, J. Dennis. 1996. *Perry Mason.* Westport: Greenwood Press.

Bourne, Stephen. 1996. *Brief Encounters: Lesbians and Gays in British Cinema 1930–1971.* New York: Cassell.

Bradley, Craig M., ed. 1999. *Criminal Procedure: A Worldwide Study.* Durham: Carolina. Academic Press.

Brooks, Peter. 1976. *The Melodramatic Imagination: Balzac, Henry James, Melodrama, and the Mode of Excess.* New Haven: Yale Univ. Press.

Brown, Richard Maxwell. 1975. *Strain of Violence.* Oxford: Oxford University Press.

Butler, Edgar. 2001. *Anatomy of the McMartin Child Molestation Case.* Lanham, MD: Univ. Press of America.

Butler, Judith. 1999. *Gender Trouble: Feminism and the Subversion of Identity.* 10th anniv. ed. New York: Routledge.

Butler, Lisa. 1995. The Psychological Impact of Viewing the Film *JFK:* Emotions, Beliefs, and Political Behavior Intentions. *Political Psychology* 16:237.

Caplow, Stacy. 1999. Still in the Dark: Disappointing Images of Women Lawyers in the Movies. *Women's Rights Law Reporter* 20:55.

Cavell, Stanley. 1981. *Pursuits of Happiness: The Hollywood Comedy of Remarriage.* Cambridge: Harvard Univ. Press.

Chase, Anthony. 2002. *Movies on Trial.* New York: New Press.

Chemerinsky, Erwin. 1998. Silence is not Golden: Protecting Lawyer Speech under the First Amendment. *Emory Law Journal* 47:859.

Clark, Gerald J. 1993. The Lawyer as Hero? In *The Lawyer and Popular Culture: Proceedings of a Conference.* Ed. David Gunn. Littleton, CO: F. B. Rothman.

Clover, Carol J. 1998. God Bless Juries! In *Refiguring American Film Genres*. Ed. Nick Browne. Berkeley: Univ. of California Press.

Corcos, Christine. 2003. Prosecutors, Prejudices, and Justice: Observations on Presuming Innocence in Popular Culture and Law. *University of Toledo Law Review* 34:793.

Corman, Avery. 1977. *Kramer vs. Kramer*. New York: Random House.

Cripps, Thomas. 1993. *Making Movies Black*. Oxford: Oxford Univ. Press.

Cross, Frank B. 1997. Political Science and the New Legal Realism: A Case of Unfortunate Interdisciplinary Ignorance. *Northwestern Univ. Law Review* 92:251.

Cullen, Jim. 1996. *The Art of Democracy*. New York: Monthly Review Press.

Damaska, Mirjan. 1986. *The Faces of Justice and State Authority: A Comparative Approach to the Legal Process*. New Haven: Yale Univ. Press.

Davis, Peggy Cooper, and Steinglass, Elizabeth Ehrenfest. 1997. A Dialogue about Socratic Teaching. *New York Univ. Review of Law and Social Change* 23:249

Death Penalty Information Center. www.deathpenaltyinfo.org (last visited Oct. 20, 2003).

Denvir, John. 1996. Introduction. *Legal Reelism: Movies as Legal Texts*. Ed. John Denvir. Urbana: Univ. of Illinois Press.

Dezhbakhsh, Hashem, Rubin, Paul H., and Shepherd, Joanna M. 2003. Does Capital Punishment Have a Deterrent Effect? New Evidence from Postmoratorium Panel Data. *American Law & Economics Review* 5:344.

Dixon, Thomas. 1970. *The Clansman: A Historical Romance of the Ku Klux Klan*. Lexington: Univ. of Kentucky Press.

Doherty, Thomas. 1999. *Pre-Code Hollywood*. New York: Columbia Univ. Press.

Dolovich, Sharon. 1998. Making Docile Lawyers: An Essay on the Pacification of Law Students. *Harvard Law Review* 111: 2027.

Doty, Alexander. 1993. *Making Things Perfectly Queer: Interpreting Mass Culture*. Minneapolis: Univ. of Minnesota Press.

Dow, David R. 2000. Fictional Documentaries and Truthful Fictions: The Death Penalty in Recent American Film. *Constitutional Commentary* 17:511.

Dressler, Joshua. 2002. *Understanding Criminal Procedure*. 3d ed. Newark, NJ: LexisNexis.

Dyer, Richard, and Pidduck, Julianne. 2003. *Studies on Lesbian and Gay Film*. London & New York: Routledge.

Eagleton, Terry. 1996. *Literary Theory: An Introduction*. Minneapolis: Univ. of Minnesota Press.

Eberle, Paul. 1993. *The Abuse of Innocence: The McMartin Preschool Trial*. Buffalo, NY: Prometheus Books.

Epstein, Michael M. 2003. For and Against the People: Television's Prosecutor Image and the Cultural Power of the Legal Profession. *University of Toledo Law Review* 34:817.

Farrell, Warren. 1974. *The Liberated Man*. New York: Random House.

Fasteau, Marc Feigen. 1974. *The Male Machine*. New York: Signet.

Feldman, Sam. 2001. The Jewish Lawyer in Popular Culture: In Character and Appearance. Available from asimow@law.ucla.edu.

Feuer, Jane, Kerr, Paul, and Vahimagi, Tise, Eds. 1984. *MTM: "Quality Television."* London: BFI Publishers.

Fish, Stanley. 1980. *Is There a Text in This Class?* Cambridge: Harvard Univ. Press.

Fiske, John. 1987. *Television Culture*. London: Routledge.

———. 1994. *Media Matters: Everyday Culture and Political Change*. Minneapolis: Univ. of Minnesota Press.

———. 1996. Admissible Postmodernity: Some Remarks on Rodney King, O. J. Simpson, and Contemporary Culture. *University of San Francisco Law Review* 30:917.

Fox, Lawrence J. 2000. I'm Just an Associate . . . At a New York Firm. *Fordham Law Review* 69:939.

Frank, Jerome. 1963. *Courts on Trial.* New York: Atheneum.

Frankel, Marvin. 1978. *Partisan Justice.* New York: Hill & Wang.

Friedland, Steven. 1996. How We Teach: A Survey of Teaching Techniques in American Law Schools. *Seattle University Law Review* 20:1.

Friedman, Lawrence M. 1989. Law, Lawyers & Popular Culture. *Yale Law Journal* 98:1579.

———. 1993. *Crime and Punishment in American History.* New York: Basic Books.

———. 2000. A Dead Language: Divorce Law and Practice Before No-Fault. *Virginia Law Review* 86:1497.

Friedman, Lester D. 1987. *The Jewish Image in American Film.* Secaucus, NJ: Citadel Press.

Friedman, Meyer, and Rosenman, Ray H. 1974. *Type A Behavior and Your Heart.* Greenwich, CT: Fawcett Publications. .

Gabler, Neal. 1989. *An Empire of Their Own: How the Jews Invented Hollywood.* New York: Doubleday.

Galanter, Marc, and Palay, Thomas. 1991. *Tournament of Lawyers: The Transformation of the Big Law Firm.* Chicago: Univ. of Chicago Press.

Garbicz, Adam, and Klinowski, Jacek. 1983. *Cinema, the Magic Vehicle: A Guide to Its Achievement.* Metuchen, NJ: Scarecrow Press.

Gardner, Erle Stanley. 1933. *The Case of the Velvet Claws.* New York: Morrow.

Gerbner, George. 2002. Growing Up with Television: The Cultivation Perspective. In *Media Effects: Advances in Theory and Research.* 2d ed. Ed. Jennings Bryant and Dolf Zillman. Hillsdale, NJ: L. Erlbaum Associates.

Gettleman, Susan, and Markowitz, Janet. 1974. *The Courage to Divorce.* New York: Simon & Schuster.

Gillers, Stephen. 1989. Taking L. A. Law More Seriously. *Yale Law Journal* 98:1607.

Gilligan, Carol. 1993. *In a Different Voice: Psychological Theory and Women's Development.* Cambridge: Harvard Univ. Press.

Gillman, Howard. 2001. What's Law Got to Do with It? Judicial Behavioralists Test the "Legal Model" of Judicial Decisionmaking. *Law & Social Inquiry* 26:465.

Gitlin, Todd. 2000. *Inside Prime Time.* Berkeley: Univ. of California Press.

———. 2002. *Media Unlimited.* New York: Owl Books.

Goldberg, Herb. 1976. *The Hazards of Being Male.* New York: Signet.

Goodman, James. 1994. *Stories of Scottsboro.* New York: Vintage Books.

Graham, Louise Everett, and Maschio, Geraldine. 1995–96. A False Public Sentiment: Narrative and Visual Images of Women Lawyers in Films. *Kentucky Law Review* 84:1027.

Granfield, Robert. 1992. *Making Elite Lawyers.* London & New York: Routledge.

Greenfield, Steven. 2001. Hero or Villain? Cinematic Lawyers and the Delivery of Justice. In *Law and Film.* Ed. Stefan Machura and Peter Robson. Oxford: Blackwell.

Greenfield, Steven, Osborn, Guy, and Robson, Peter. 2001. *Film and the Law.* London: Cavendish.

Griffin, Leslie C. 2001. The Prudent Prosecutor. *Georgetown Journal of Legal Ethics* 14:259.

Grossberg, Lawrence, Wartella, Ellen, and Whitney, D. Charles. 1998. *MediaMaking: Mass Media in a Popular Culture.* Thousand Oaks, CA: Sage Publications.

Guinier, Lani. 1997. *Becoming Gentlemen: Women, Law School, and Institutional Change.* Boston: Beacon Press.

Gulati, Mitu, Sander, Richard, and Sockloskie, Robert. 2001. The Happy Charade: An Empirical Examination of the Third Year of Law School. *Journal of Legal Education* 51:235.

Hallam, Julia, and Marshment, Margaret. 2000. *Realism and Popular Cinema.* Manchester: Manchester Univ. Press.

Harries, Keith D., and Cheatwood, Derral. 1997. *The Geography of Execution: The Capital Punishment Quagmire in America.* Lanham, MD: Rowman & Littlefield.

Harris, Thomas J. 1987. *Courtroom's Finest Hour in American Cinema.* Metuchen, NJ: Scarecrow Press.

Haskell, Molly. May 28, 1983. Lights . . . Camera . . . Daddy! *The Nation,* 673–75.

———. 1987. *From Reverence to Rape: The Treatment of Women in the Movies.* 2d ed. Chicago: Univ. of Chicago Press.

Heinz, John P., and Laumann, Edward O. 1982. *Chicago Lawyers: The Social Structure of the Bar.* Chicago: Northwestern Univ. Press and American Bar Foundation.

Herman, Jan. 1995. *A Talent for Trouble: The Life of Hollywood's Most Acclaimed Director, William Wyler.* New York: Putnam.

Hess, Gerald F. 2002. Heads and Hearts: The Teaching and Learning Environment in Law School. *Journal of Legal Education* 52:75.

Hoff, Timothy, ed. 1994. Symposium: *To Kill a Mockingbird. Alabama Law Review* 45:389–584.

Holmes, Oliver Wendell. 1881. *The Common Law.* Boston: Little Brown & Co.

hooks, bel. 1996. *Reel to Real: Race, Sex, and Class at the Movies.* London & New York: Routledge.

Hornblass, Jerome. 1993. The Jewish Lawyer. *Cardozo Law Review* 14:1639.

Ivkovic, Sanja Kutnjak. 2003. An Inside View: Professional Judges' and Lay Judges' Support for Mixed Tribunals. *Law & Policy* 25:93.

Jarvis, Robert M., and Joseph, Paul R., eds. 1998. *Prime Time Law.* Durham: Carolina Academic Press.

Jenkins, Henry. 1992. *Textual Poachers: Television Fans and Participatory Culture.* London & New York: Routledge.

Joseph, Paul R. 2003. Saying Goodbye to *Ally McBeal. University of Arkansas at Little Rock Law Review* 25:459.

Kagan, Robert A. 2001. *Adversary Legalism: The American Way of Law.* Cambridge: Harvard Univ. Press.

Kahn, Paul. 1999. *The Cultural Study of Law: Reconstructing Legal Scholarship.* Chicago: Univ. of Chicago Press.

Kalven, Harry. 1964. The Dignity of the Civil Jury. *Virginia Law Review* 50:1055.

Kalven, Harry, and Zeisel, Hans. 1966. *The American Jury.* Chicago: Univ. of Chicago Press.

Keates, William R. 1997. *Proceed with Caution.* Chicago: Harcourt Brace.

Kellner, Douglas. 1995. *Media Culture.* London & New York: Routledge.

Kerr, Orin S. 1999. The Decline of the Socratic Method at Harvard. *Nebraska Law Review* 78:113.

King, Nancy J, ed. 1996. The Jury: Research and Reform. *Judicature* 79:241. .

———. 1999. The American Criminal Jury. *Law & Contemporary Problems* 62:41.

Klein, Diane. 1998. Ally McBeal and her Sisters: A Quantitative and Qualitative Analysis of Representations of Women Lawyers on Prime-Time Television. *Loyola L. A. Entertainment Law Journal* 18:259.

Klinger, Barbara. 1994. *Melodrama and Meaning: History, Culture, and the Films of Douglas Sirk.* Bloomington: Indiana Univ. Press.

Krantzler, Mel. 1973. *Creative Divorce: A New Opportunity for Personal Growth.* New York: M. Evans.

Kronman, Anthony. 1993. *The Lost Lawyer.* Cambridge: Belknap Press.

Krutch, Joseph Wood. July, 1955. The Case for Courtroom Drama. *Theater Arts,* 39:69.

Landsman, Stephan. 1984. *The Adversary System: A Description and Defense.* Washington, DC: American Enterprise Institute for Public Policy Research.

Langbein, John H. 1985. The German Advantage in Civil Procedure. *University of Chicago Law Review* 52:823.

Langer, Maximo. 2004. From Legal Transplants to Legal Translations: The Globalization of Plea Bargaining and the Americanization Thesis in Criminal Procedure. *Harvard International Law Journal* 45:1.

LeBel, Paul A. 2002. Misdirecting Myths: The Legal and Cultural Significance of Distorted History in Popular Media. *Wake Forest Law Review* 37:1035.

Lee, Harper. 1999. *To Kill a Mockingbird.* 40th anniv. ed. New York: HarperCollins.

Leff, Leonard J., and Simmons, Jerold L. 1990. *The Dame in the Kimono: Hollywood, Censorship, and the Production Code Administration from the 1920s to the 1960s.* New York: Anchor Books.

Lesser, Wendy. 1993. *Pictures at an Execution.* Cambridge: Harvard Univ. Press.

Levinson, Sanford. 1993. Identifying the Jewish Lawyer: Reflections on the Construction of Professional Identity. *Cardozo Law Review* 14:1577.

Levy, Emanuel. 1999. *A Cinema of Outsiders: The Rise of Independent American Film.* New York: New York Univ. Press.

Levy, Leonard W. 1999. *Origins of the Bill of Rights.* New Haven: Yale Univ. Press.

Liebman, James S., et al. 2000a. *A Broken System: Error Rates in Capital Cases 1973–1995,* http://www.justice.policy.net/jpreport.

——. 2000b. Capital Attrition: Error Rates in Capital Cases 1973–1995. *Texas Law Review* 78:1839.

——. 2000c. The Overproduction of Death. *Columbia Law Review* 100:2030.

Lipsitz, George. 1998. Genre Anxiety and Racial Representation in 1970s Cinema. In *Refiguring American Film Genres.* Ed. Nick Browne. Berkeley: Univ. of California Press.

Liptak, Adam. Jan 11, 2003. Death Row Numbers Decline as Challenges to System Rise. *New York Times,* A 1.

Los Angeles County Bar Association Committee on Sexual Orientation Bias. 1995. *Report. Southern California Review of Law & Women's Studies* 4:295.

Lubet, Steven. 1999. Reconstructing Atticus Finch. *Michigan Law Review* 97:1339.

Machura, Stefan, and Ulbrich, Stefan. 2001. Law in Film: Globalizing the Hollywood Courtroom Drama. In *Law and Film.* Ed. Stefan Machura and Peter Robson. Oxford: Blackwell.

Malloy, Eileen. Dec. 1981. *Kramer vs. Kramer:* A Fraudulent View. *Jump Cut* 5–7.

Marder, Nancy S. 2002. Juries, Justice & Multiculturalism. *Southern California Law Review* 75:659.

Marquart, Jaime, and Byrnes, Robert Ebert. 2001. *Brush with the Law.* Los Angeles: Renaissance Books.

Menkel-Meadow, Carrie. 1985. Portia in a Different Voice: Speculations on a Women's Lawyering Process. *Berkeley Women's Law Journal* 1:39.

——. 1988. Feminist Legal Theory, Critical Legal Studies, and Legal Education. *Journal of Legal Education* 38:61.

——. 2001. Can They Do That? Legal Ethics in Popular Culture: Of Characters and Acts, *UCLA Law Review* 48:1305.

Merritt, Greg. 2000. *Celluloid Mavericks: A History of American Independent Film.* New York: Thunder's Mouth Press.

Miller, Carolyn Lisa. 1994. What a Waste. Beautiful, Sexy Gal. Hell of a Lawyer: Film and the Female Attorney. *Columbia Journal of Gender & Law* 4:203.

Miller, William Ian. 1998. The Shortcomings of Law in Popular Culture. In *Law and the Domains of Culture.* Ed. Austin Sarat and Thomas R. Kearns, Ann Arbor: Univ. of Michigan Press.

Mitchell, Margaret. 1936. *Gone with the Wind.* New York: Macmillan.

Mnookin, Jennifer L., and West, Nancy. 2001. Theaters of Proof: Visual Evidence and the Law in *Call Northside 777. Yale Journal of Law & the Humanities* 13:329.

Mocan, H. Naci, and Gittings, R. Kay. 2001. *Pardons, Executions and Homicide.* National Bureau of Economic Research.

Mosteller, Robert, ed. 2002. Children As Victims and Witnesses in the Criminal Trial Process. *Law and Contemporary Problems* 65:1–255.

Mukerji, Chandra, and Schudson, Michael. 1991. *Rethinking Popular Culture: Contemporary Perspectives in Cultural Studies.* Berkeley: Univ. of California Press.

Mulvey, Laura. 1975. Visual Pleasure and Narrative Cinema. *Screen* 16.3:6.

Nathan, Debbie, and Snedeker, Michael. 1995. *Satan's Silence.* New York: Basic Books.

Nevins, Francis M. 2001. Tony Richardson's *The Penalty Phase:* Judging the Judge. *UCLA Law Review* 48:1557.

———. 2004. When Celluloid Lawyers Started to Speak: The First Golden Age of Juriscinema. In *Law and Popular Culture*. Ed. Michael Freeman. Oxford: Oxford Univ. Press.

Newcomb, Horace. 1993. The Lawyer in the History of American Television—An Overview. In *The Lawyer and Popular Culture: Proceedings of a Conference*. Ed. David Gunn. Littleton, CO: F. B. Rothman Co.

Nichols, Bill. 1991. *Representing Reality: Issues and Concepts in Documentary.* Bloomington: Indiana Univ. Press.

O'Brien, Thomas. Summer 1981. Love and Death in the American Movie. *Journal of Popular Film and Television* 9:91.

Osborn, John J. Jr. 1996. Atticus Finch—The End of Honor: A Discussion of *To Kill a Mockingbird*. *Univ. of San Francisco Law Review* 30:1139.

Owens, John M. 2000. The Clerk, The Thief, His Life as a Baker: Ashton Embry and the Supreme Court Leak Scandal of 1919. *Northwestern Univ. Law Review* 95:271.

Papke, David Ray. 1996a. Myth and Meaning. In *Legal Reelism: Movies as Legal Texts*. Ed. John Denvir. Urbana: Univ. of Illinois Press.

———. 1996b. Peace Between the Sexes: Law and Gender in *Kramer vs. Kramer. Univ. of San Francisco Law Review* 30:1199.

———. 1998. The Defenders. In *Prime Time Law*. Ed. Robert M. Jarvis and Paul R. Joseph. Durham: Carolina Academic Press.

———. 2001. Law, Cinema, and Ideology: Hollywood Legal Films of the 1950's. *UCLA Law Review* 48:1473.

Pearce, Russell G. 1993. Jewish Lawyering in a Multicultural Society. *Cardozo Law Review* 14:1613.

Perkins, V. F. 1972. *Film as Film: Understanding and Judging Movies*. Baltimore: Penguin.

Pfau, Michael. 1995. Television Viewing and Public Perceptions of Attorneys. *Human Communication Research* 21:307.

Phelps, Teresa Godwin. 2002. Atticus, Thomas, and the Meaning of Justice. *Notre Dame Law Review* 77:925.

Player, Mack A. 1999. *Federal Law of Employment Discrimination*. St. Paul, MN: West Group.

Podlas, Kimberlianne. 2001. Please Adjust Your Signal: How Television's Syndicated Courtrooms Bias our Juror Citizenry. *American Business Law Journal* 39:1.

Prejean, Helen. 1994. *Dead Man Walking*. New York: Vintage Books.

Preminger, Otto. 1977. *Preminger: An Autobiography.* Garden City, NY: Doubleday.

Pudovkin, V. I. 1980. *Film Technique and Film Acting*. Memorial ed. Trans. Ivor Montagu. New York: Grove Press.

Rafter, Nicole. 2001. American Criminal Trial Films: An Overview of Their Development 1930–2000. In *Law and Film*. Ed. Stefan Machura and Peter Robson. Oxford: Blackwell.

Ramachandran, Banu. 1998. Note, Re-Reading Difference: Feminist Critiques of the Law School Classroom and the Problem with Speaking from Experience. *Columbia Law Review* 98:1757.

Rawls, John. 1971. *A Theory of Justice*. Cambridge: Harvard Univ. Press.

Ray, Robert. 1985. *A Certain Tendency of the Hollywood Cinema, 1930–1980*. Princeton: Princeton Univ. Press.

Reed, Barry. 1980. *The Verdict*. New York: Simon & Schuster.

Reinhold, Robert. Jan. 24, 1990. The Longest Trial—A Post-Mortem. *New York Times,* A 1.

Rhode, Deborah L. 2001. *The Unfinished Agenda: Women and the Legal Profession*. Chicago: American Bar Association.

Rogin, Michael. 1998. "Democracy and Burnt Cork": The End of Blackface, the Beginning of Civil Rights. In *Refiguring American Film Genres*. Ed. Nick Browne. Berkeley: Univ. of California Press.

Rosenberg, Charles. 1989. An L. A. Lawyer Replies. *Yale Law Journal* 98:1625.

Rosenberg, Norman L. 1991. Young Mr. Lincoln: The Lawyer as Super-Hero. *Legal Studies Forum* 15: 215.

————. 1998. Perry Mason. In *Prime Time Law.* Ed. Robert M. Jarvis and Paul R. Joseph. Durham: Carolina Academic Press.

————. 2002. Constitutional History after the Cultural Turn: The Legal-Reelist Texts of Henry Fonda. In *Constitutionalism and American Culture: Writing the New Constitutional History.* Ed. Sandra VanBurkleo. Lawrence: Univ. Press of Kansas.

Rosenstone, Robert A. 1995. *Visions of the Past: The Challenge of Film to our Idea of History.* Cambridge: Harvard Univ. Press.

Rothstein, Mark A. 1999. *Employment Law.* 2d ed. St. Paul, MN: West Group.

Rubenstein, William. 1998. Queer Studies II: Some Reflections on the Study of Sexual Orientation Bias in the Legal Profession. *UCLA Women's Law Journal* 8:379.

Russo, Vito. 1987. *The Celluloid Closet: Homosexuality in the Movies.* New York: Harper & Row.

Ryan, Michael, and Kellner, Douglas. 1988. *Camera Politica: The Politics and Ideology of Contemporary Hollywood.* Bloomington: Indiana Univ. Press.

Safian, Robert. 1989, Oct. McMartin Madness: Ten Days in the Life of the Longest, Most Gruesomely Difficult Criminal Trial Ever. *The American Lawyer* 9:46.

Samberg, Joel. 2000. *Reel Jewish.* Middle Village, NY: Jonathan David Publishers, Inc.

Sander, Richard, and Knaplund, Kristine. 2004. *Through the Gender Gap.* Unpublished manuscript. Available from Sander at sander@law.ucla.edu.

Sarat, Austin. 1999. The Cultural Life of Capital Punishment: Responsibility and Representation in *Dead Man Walking* and *Last Dance. Yale Journal of Law & Humanities* 11:153.

Sarat, Austin, and Simon, Jonathan. 2001. Beyond Legal Realism? Cultural Analysis, Cultural Studies, and the Situation of Legal Scholarship. *Yale Journal of Law & the Humanities* 13:3.

Sayles, John. 1995. Interview. In *Past Imperfect: History According to the Movies.* Ed. Mark C. Carnes. New York: Henry Holt.

Schepard, Andrew. 2003. *Kids, Courts and Custody: Models for the Twenty-First Century.* Cambridge: Cambridge Univ. Press

Schiff, Ellen, ed. 1995. *Awake & Sing: 7 Classic Plays from the American Jewish Repertoire.* New York: Mentor Books.

Schiltz, Patrick J. 1999. On Being a Happy, Healthy, and Ethical Member of an Unhappy, Unhealthy, and Unethical Profession. *Vanderbilt Law Review* 52:871.

Schwartz, Gary T. 1991. The Myth of the Ford Pinto Case. *Rutgers Law Review* 43:1013.

Shaffer, Thomas L. 1981. The Moral Theology of Atticus Finch. *University of Pittsburgh Law Review* 42:181.

Shapiro, Carole. 1994. Women Lawyers in Celluloid: Why Hollywood Skirts the Truth. *University of Toledo Law Review* 25:955.

————. 1996. Do or Die: Does *Dead Man Walking* Run? *Univ. of San Francisco Law Review* 30:1143.

————. 1998. Women Lawyers in Celluloid, Rewrapped. *Vermont Law Review* 23:303.

Sheehy, Gail. 1978. *Passages: Predictable Crises of Adult Life.* New York: Dutton.

Sheldon, Kennon M., and Krieger, Lawrence S. 2004. Does Legal Education Have Undermining Effects on Law Students? *Behavioral Sciences and the Law* 22:261.

Sherwin, Richard K. 2000. *When Law Goes Pop.* Chicago: Univ. of Chicago Press.

Shrum, L. J. 1998. Effects of Television Portrayals of Crime and Violence on Viewers' Perceptions of Reality: A Psychological Process Perspective. *Legal Studies Forum* 22:261.

Silbey, Jessica. 2001. Patterns of Courtroom Justice. *Journal of Law & Society* 28:97.

————. 2002. What Do We Do When We Do Law and Popular Culture? *Law & Social Inquiry* 27:139.

Simon, William H. 2000. Moral Pluck: Legal Ethics in Popular Culture. *Columbia Law Review* 100:421.

Singer, Ben. 2001. *Melodrama and Modernity: Early Sensational Cinema and Its Contexts.* New York: Columbia Univ. Press.

Snead, James A. 1994. *White Screens/Black Images.* New York: Blackwell.

Staiger, Janet. 1992. *Interpreting Films.* Princeton: Princeton Univ. Press.

———. 2002. *Perverse Spectators.* New York: New York Univ. Press.

Stam, Robert. 2000. *Film Theory: An Introduction.* Oxford: Blackwell.

Stark, Steven D. 1987. Perry Mason Meets Sonny Crockett: The History of Lawyers and the Police as Television Heroes. *University of Miami Law Review* 42:229.

Steiker, Carol A. 2002. Capital Punishment and American Exceptionalism. *Oregon Law Review* 81: 97.

Stout, Lynn A. 2002. Judges as Altruistic Hierarchs. *William & Mary Law Review* 43:605.

Stowe, Harriet Beecher. 1995. *Uncle Tom's Cabin.* New York: Knopf.

Strier, Franklin. 1996. *Reconstructing Justice: An Agenda for Trial Reform.* Chicago: Univ. of Chicago Press.

Sundquist, Eric. 1995. Blues for Atticus Finch: Scottsboro, Brown, and Harper Lee. In *The South as an American Problem.* Ed. Larry Griffin and Don Doyle. Athens: Univ. of Georgia Press.

Taylor, Ella. 1986. *Prime Time Families: Television Culture in Postwar America.* Berkeley: Univ. of California Press.

Thompson, Kristin. 1988. *Breaking the Glass Armor: Neoformalist Film Analysis.* Princeton: Princeton Univ. Press.

———. 1999. *Storytelling in the New Hollywood: Understanding Classical Narrative Technique.* Cambridge: Harvard Univ. Press.

Thompson, Robert. 1996. *Television's Second Golden Age: From Hill Street Blues to ER.* Syracuse: Syracuse Univ. Press.

Traver, Robert [John Voelker]. 1983. *Anatomy of a Murder.* 25th Anniversary ed. New York: St. Martin's Press.

Tropiano, Stephen. 2002. *The Prime Time Closet: A History of Gays and Lesbians on TV.* New York: Applause Theatre & Cinema Books.

Turow, Scott. 1988. *One L.* New York: Warner Books.

———. 2003. *Ultimate Punishment.* New York: Farrar, Straus & Giroux.

Tushnet, Mark. 1996. *Class Action:* One View of Gender and Law in Popular Culture. In *Legal Reelism.* Ed. John Denvir. Urbana: Univ. of Illinois Press.

Vidmar, Neil. 1998. The Performance of the American Civil Jury: An Empirical Perspective. *Arizona Law Review* 40:849.

Walsh, Frank. 1996. *Sin and Censorship: The Catholic Church and the Motion Picture Industry.* New Haven: Yale Univ. Press.

Weisberg, Richard H. 2000. "The Verdict" Is in: The Civic Implications of Civil Trials. *De Paul Law Review* 50:525.

Wellborn, Otis Guy, III. 1991. Demeanor. *Cornell Law Review* 76:1075.

Whittington, Keith E. 2000. Once More unto the Breach: Postbehavioralist Approaches to Judicial Politics. *Law & Social Inquiry* 25:601.

Wightman, Linda. 1996. *Women in Legal Education: A Comparison of the Law School Performance and Law School Experiences of Women and Men.* Newtown, PA: Law School Admissions Council.

Wilkins, David, and Gulati, Mitu. 1996. Why Are There So Few Black Lawyers in Corporate Law Firms? An Institutional Analysis. *California Law Review* 84:496.

Williams, Linda. 1998. Melodrama Revised. In *Refiguring American Film Genres.* Ed. Nick Browne. Berkeley: Univ. of California Press.

———. 2001. *Playing the Race Card: Melodramas of Black and White from Uncle Tom to O. J. Simpson.* Princeton: Princeton Univ. Press.

Wood, Robin. 2002. *Hitchcock's Films Revisited.* New York: Columbia Univ. Press.

Yeazell, Stephen C. 1990. The New Jury and the Ancient Jury Conflict. *Univ. of Chicago Legal Forum* 1990:87

Yunker, James A. 2001. A New Statistical Analysis of Capital Punishment Incorporating U.S. Post-moratorium Data. *Social Science Quarterly* 82:297.

Zacharias, Fred C. 2001. The Professional Discipline of Prosecutors. *North Carolina Law Review* 79: 721.

Movies and Television Shows

Movies

Absence of Malice. 1981. Dir. Sydney Pollack. Perf. Paul Newman, Sally Field. Columbia Pictures.

Adam's Rib. 1949.Dir. George Cukor. Perf. Spencer Tracy, Katharine Hepburn. MGM.

Advise and Consent. 1962. Dir. Otto Preminger. Perf. Henry Fonda, Don Murray, Charles Laughton, Walter Pidgeon. Columbia Pictures.

Alien. 1979. Dir. Ridley Scott. Perf. Tom Skerritt, Sigourney Weaver. Twentieth Century-Fox.

All the President's Men. 1976. Dir. Alan Pakula. Perf. Robert Redford, Dustin Hoffman. Warner Brothers.

Amistad. 1997. Dir. Steven Spielberg. Perf. Morgan Freeman, Anthony Hopkins, Matthew McConaughey, Djimon Hounsou, Nigel Hawthorne. DreamWorks.

Anatomy of a Murder. 1959. Dir. Otto Preminger. Perf. James Stewart, George C. Scott, Lee Remick, Ben Gazzara. Columbia Pictures.

. . . And Justice for All. 1979. Dir. Norman Jewison. Perf. Al Pacino. Columbia Pictures.

Angels with Dirty Faces. 1938. Dir. Michael Curtiz. Perf. James Cagney, Pat O'Brien. Warner Brothers.

Attorney for the Defense. 1932. Dir. Irving Cummings. Perf. Edmund Lowe, Evelyn Brent. Columbia Pictures.

The Awful Truth. 1937. Dir. Leo McCarey. Perf. Irene Dunne, Cary Grant. Columbia Pictures.

Baby Doll. 1956. Dir. Elia Kazan. Perf. Carroll Baker, Karl Malden, Eli Wallach. Warner Brothers.

Bad Company. 1972. Dir. Robert Benton. Perf. Jeff Bridges, Barry Brown. Paramount Pictures.

Basic Instinct. 1992. Dir. Paul Verhoeven. Perf. Michael Douglas, Sharon Stone. TriStar Pictures.

The Battleship Potemkin. 1925. Dir. Sergei Eisenstein. Goskino.

A Beautiful Mind. 2001. Dir. Ron Howard. Perf. Russell Crowe, Jennifer Connelly. Universal Pictures.

Ben-Hur. 1959. Dir. William Wyler. Perf. Charlton Heston. MGM.

The Best Man. 1964. Dir. Franklin Schaffner. Perf. Henry Fonda, Cliff Robertson. United Artists.

The Best Years of Our Lives. 1946. Dir. William Wyler. Perf. Frederic March, Dana Andews, Harold Russell, Myrna Loy, Teresa Wright, Virginia Mayo. RKO.

The Big Easy. 1987. Dir. Jim McBride. Perf. Dennis Quaid, Ellen Barkin. Columbia Pictures.

The Big Sleep. 1946. Dir. Howard Hawks. Perf. Humphrey Bogart, Lauren Bacall. Warner Brothers.

The Birdcage. 1996. Dir. Mike Nichols. Perf. Robin Williams, Gene Hackman, Nathan Lane. United Artists.

The Birth of a Nation. 1915. Dir. D.W. Griffith. Perf. Lillian Gish. Mutual Film Corporation.

Body Heat. 1981. Dir. Lawrence Kasdan. Perf. William Hurt, Kathleen Turner. Warner Brothers.

Bonnie and Clyde. 1967. Dir. Arthur Penn. Perf. Warren Beatty, Faye Dunaway. Warner Brothers.

The Boys in the Band. 1970. Dir. William Friedkin. Perf. Kenneth Nelson, Peter White, Leonard Frey, Cliff Gorman. National General Pictures.

Cabaret. 1972. Dir. Bob Fosse. Perf. Liza Minnelli, Michael York, Joel Grey, Helmut Griem, Fritz Wepper. Allied Artists.

The Cabinet of Dr. Caligari. 1919. Dir. Robert Weine. Perf. Werner Krauss, Conrad Veidt. Decla-Bioscop AG.

Call Northside 777. 1948. Dir. Henry Hathaway. Perf. James Stewart. Twentieth Century-Fox.

Cape Fear. 1991. Dir. Martin Scorsese. Perf. Nick Nolte, Robert DeNiro, Jessica Lange. Universal Pictures.

Capturing the Friedmans. 2003. Dir. Andrew Jarecki. Magnolia Pictures.

Carlito's Way. 1993. Dir. Brian De Palma. Perf. Al Pacino, Sean Penn. Universal Pictures.

Casablanca. 1942. Dir. Michael Curtiz. Perf. Humphrey Bogart, Ingrid Bergman, Paul Henreid, Claude Rains. Warner Brothers.

The Case of the Howling Dog. 1934. Dir. Alan Crosland. Perf. Warren William. Warner Brothers.

The Case of the Velvet Claws. 1933. Dir. William Clemens. Perf. Warren William. Warner Brothers.

Cat on a Hot Tin Roof. 1958. Dir. Richard Brooks. Per. Paul Newman, Elizabeth Taylor, Burl Ives. MGM.

The Celluloid Closet. 1995. Dir. Rob Epstein, Jeffrey Friedman. Sony Pictures Classics.

The Chamber. 1996. Dir. James Foley. Perf. Chris O'Donnell, Gene Hackman. Universal Pictures.

Changing Lanes. 2001. Dir. Roger Michell. Perf. Ben Affleck, Samuel L. Jackson. Paramount Pictures.

A Child Is Waiting. 1963. Dir. John Cassavetes. Perf. Burt Lancaster, Judy Garland. United Artists.

The Children's Hour. 1962. Dir. William Wyler. Perf. Audrey Hepburn, Shirley MacLaine, James Garner. United Artists.

Citizen Kane. 1941. Dir. Orson Welles. Perf. Orson Welles, Joseph Cotten. RKO.

A Civil Action. 1998. Dir. Steve Zaillian. Perf. John Travolta, Robert Duvall. Buena Vista Pictures.

Class Action. 1990. Dir. Michael Apted. Perf. Gene Hackman, Mary Elizabeth Mastrantonio. Twentieth Century-Fox.

The Client. 1994. Dir. Joel Schumacher. Perf. Susan Sarandon, Tommy Lee Jones. Warner Brothers.

Compulsion. 1959. Dir. Richard Fleischer. Perf. Orson Welles, Dean Stockwell, Bradford Dillman. Twentieth Century-Fox.

Cool Hand Luke. 1967. Dir. Stuart Rosenberg. Perf. Paul Newman. Warner Brothers.

Counsellor at Law. 1933. Dir. William Wyler. Perf. John Barrymore. Universal Pictures.

The Court Martial of Billy Mitchell. 1955. Dir. Otto Preminger. Perf. Gary Cooper. Warner Brothers.

Cradle Will Rock. 1999. Dir. Tim Robbins. Perf. Hank Azaria, Ruben Blades, Joan Cusack, John Cusack, Cary Elwes. Buena Vista Pictures.

Cruising. 1980. Dir. William Friedkin. Perf. Al Pacino. United Artists.

Curly Sue. 1991. Dir. John Hughes. Perf. James Belushi, Kelly Lynch, Alisan Porter. Warner Brothers.

Daisy Kenyon. 1947. Dir. Otto Preminger. Perf. Joan Crawford, Dana Andrews. Twentieth Century-Fox.

Daniel. 1983. Dir. Sidney Lumet. Perf. Timothy Hutton, Mandy Patinkin, Lindsay Crouse, Edward Asner. Paramount Pictures.

Dead End. 1937. Dir. William Wyler. Perf. Sylvia Sidney, Joel McCrea, Humphrey Bogart. United Artists.

Dead Man Walking. 1996. Dir. Tim Robbins. Perf. Susan Sarandon, Sean Penn. Gramercy Pictures.

Devil's Advocate. 1997. Dir. Taylor Hackford. Perf. Al Pacino, Keanu Reeves. Warner Brothers.

Defenseless. 1991. Dir. Martin Campbell. Perf. Barbara Hershey, Sam Shepard. New Line Cinema.

Dirty Harry. 1971. Dir. Don Siegel. Perf. Clint Eastwood. Warner Brothers.

The Divorcee. 1930. Dir. Robert Z. Leonard. Perf. Norma Shearer, Chester Morris. MGM.

Dodsworth. 1936. Dir. William Wyler. Perf. Walter Huston, Ruth Chatterton, Mary Astor. MGM.

Dog Day Afternoon. 1975. Dir. Sidney Lumet. Perf. Al Pacino, John Cazale. Warner Brothers.

Dona Herlinda and Her Son. 1986. Dir. Jaime Humberto Hermosillo. Perf. Arturo Meza, Marco Antonio Trevino. Cinevista.

The Doom Generation. 1995. Dir. Gregg Araki. Perf. Rose McGowan, James Duval. Trimark Pictures.

Dracula. 1931. Dir. Tod Browning. Perf. Bela Lugosi. Universal Pictures.

Easy Rider. 1969. Dir. Dennis Hopper. Perf. Peter Fonda, Dennis Hopper, Jack Nicholson. Columbia Pictures.

Easy Virtue. 1927. Dir. Alfred Hitchcock. Perf. Isabel Jens. World Wide Distributors.

Employees' Entrance. 1933. Dir. Roy del Ruth. Perf. Warren William, Loretta Young. Warner Brothers.

Erin Brockovich. 2000. Dir. Steven Soderbergh. Perf. Julia Roberts, Albert Finney. Universal Pictures.

Evelyn. 2002. Dir. Bruce Beresford. Perf. Pierce Brosnan, Sophie Vavasseur. MGM.

Even Cowgirls Get the Blues. 1993. Dir. Gus Van Sant. Perf. Uma Thurman, Lorraine Bracco. Fine Line Features.

The Exorcist. 1973. Dir. William Friedkin. Perf. Ellen Burstyn, Max Von Sydow, Jason Miller, Linda Blair. Warner Brothers.

Far From Heaven. 2002. Dir. Todd Haynes. Perf. Julianne Moore, Dennis Quaid, Dennis Haysbert. Focus Features.

Fear Strikes Out. 1956. Dir. Robert Mulligan. Perf. Anthony Hopkins, Karl Malden. Paramount Pictures.

A Few Good Men. 1994. Dir. Rob Reiner. Perf. Tom Cruise, Jack Nicholson, Demi Moore. Columbia Pictures.

The Firm. 1993. Dir. Sydney Pollack. Perf. Tom Cruise, Gene Hackman. Paramount Pictures.

The Fox. 1968. Dir. Mark Rydell. Perf. Sandy Dennis, Keir Dullea. Claridge Pictures.

Freebie and the Bean. 1974. Dir. Richard Rush. Perf. James Caan, Alan Arkin. Warner Brothers.

Fury. 1937. Dir. Fritz Lang. Perf. Spencer Tracy, Sylvia Sidney. MGM.

Gentleman's Agreement. 1947. Dir. Elia Kazan. Perf. Gregory Peck, Dorothy McGuire, John Garfield, Celeste Holm. Twentieth Century-Fox.

Ghosts of Mississippi. 1996. Dir. Rob Reiner. Perf. Alec Baldwin, Whoopi Goldberg, James Woods. Columbia Pictures.

Gladiator. 2000. Dir. Ridley Scott. Perf. Russell Crowe, Joaquin Phoenix. DreamWorks.

The Glass Shield. 1994. Dir. Charles Burnett. Perf. Michael Boatman, Lori Petty, Ice Cube. Miramax Films.

Go Fish. 1994. Dir. Rose Troche. Perf. V.S. Brodie, Guinevere Turner. Samuel Goldwyn Company.

The Godfather. 1972. Dir. Francis Ford Coppola. Perf. Al Pacino, Marlon Brando, James Caan, Robert Duvall. Paramount Pictures.

Gone with the Wind. 1939. Dir. Victor Fleming. Perf. Clark Gable, Vivien Leigh, Leslie Howard, Olivia de Havilland. MGM.

The Good Mother. 1988. Dir. Leonard Nimoy. Perf. Diane Keaton, Liam Neeson, Jason Robards. Buena Vista Pictures.

Goodbye, Columbus. 1969. Dir. Larry Peerce. Perf. Richard Benjamin, Ali MacGraw. Paramount Pictures.

The Graduate. 1967. Dir. Mike Nichols. Perf. Dustin Hoffman, Anne Bancroft, Katharine Ross. Embassy Pictures Corporation.

Grand Canyon. 1991. Dir. Lawrence Kasdan. Perf. Danny Glover, Kevin Kline, Steve Martin. Twentieth Century-Fox.

The Grapes of Wrath. 1939. Dir. John Ford. Per. Henry Fonda. Twentieth Century-Fox.

The Green Mile. 1999. Dir. Frank Darabont. Perf. Tom Hanks, Michael Clarke Duncan, David Morse, Bonnie Hunt. Warner Brothers.

Guess Who's Coming to Dinner. 1967. Dir. Stanley Kramer. Perf. Spencer Tracy, Katharine Hepburn, Sidney Poitier. Columbia Pictures.

Guilty as Sin. 1993. Dir. Sidney Lumet. Perf. Rebecca De Mornay, Don Johnson. Buena Vista Pictures.

Hud. 1963. Dir. Martin Ritt. Perf. Paul Newman, Patricia Neal, Melvyn Douglas, Brandon de Wilde. Paramount Pictures.

The Human Stain. 2003. Dir. Robert Benton. Perf. Anthony Hopkins, Nicole Kidman, Ed Harris, Gary Sinise. Miramax Films.

The Hurricane. 1999. Dir. Norman Jewison. Perf. Denzel Washington, Vicellous Reon Shannon. Universal Pictures.

I Am Sam. 2001. Dir. Jessie Nelson. Perf. Sean Penn, Michelle Pfeiffer. New Line Cinema.

Imitation of Life. 1934. Dir. John Stahl. Perf. Claudette Colbert, Warren William, Louise Beavers, Fredi Washington. Universal Pictures.

Imitation of Life. 1959. Dir. Douglas Sirk. Perf. Lana Turner, John Gavin, Sandra Dee, Juanita Moore, Susan Kohner. Universal Pictures.

In and Out. 1997. Dir. Frank Oz. Perf. Kevin Kline, Joan Cusack, Tom Selleck, Matt Dillon. Paramount Pictures.

In the Bedroom. 2001. Dir. Todd Fields. Perf. Tom Wilkinson, Sissy Spacek, Marisa Tomei, Nick Stahl. Miramax Films.

In the Name of the Father. 1993. Dir. Jim Sheridan. Perf. Daniel Day-Lewis, Pete Postlethwaite. Universal Pictures.

The Incredibly True Adventures of Two Girls in Love. 1995. Dir. Maria Maggenti. Perf. Laurel Holloman, Nicole Parker. Fine Line Features.

Inherit the Wind. 1960. Dir. Stanley Kramer. Perf. Spencer Tracy, Frederic March, Gene Kelly. United Artists.

The Insider. 1999. Dir. Michael Mann. Perf. Al Pacino, Russell Crowe, Christopher Plummer. Buena Vista Pictures.

Intolerable Cruelty. 2003. Dir. Joel and Ethan Coen. Perf. George Clooney, Catherine Zeta-Jones, Geoffrey Rush. Universal Pictures.

Intruder in the Dust. 1949. Dir. Clarence Brown. Perf. David Brian, Juano Hernandez. MGM.

It's a Wonderful Life. 1946. Dir. Frank Capra. Perf. James Stewart. Donna Reed, Lionel Barrymore. RKO.

Jagged Edge. 1985. Dir. Richard Marquand. Perf. Jeff Bridges, Glenn Close. Columbia Pictures.

Jerry Maguire. 1996. Dir. Cameron Crowe. Perf. Tom Cruise, Cuba Gooding, Jr., Renee Zellweger. TriStar Pictures.

JFK. 1991. Dir. Oliver Stone. Perf. Kevin Costner, Kevin Bacon, Tommy Lee Jones, Sissy Spacek. Warner Brothers.

Judge Priest. 1934. Dir. John Ford. Perf. Will Rogers. Fox Film Corporation.

Judgment at Nuremberg. 1960. Dir. Stanley Kramer. Perf. Spencer Tracy, Burt Lancaster, Richard Widmark, Maximilian Schell, Marlene Dietrich, Judy Garland, Montgomery Clift. United Artists.

The Juror. 1996. Dir. Brian Gibson. Perf. Demi Moore, Alec Baldwin. Columbia Pictures.

Jury Duty. 1995. Dir. John Fortenberry. Perf. Pauly Shore. TriStar Pictures.

Just Cause. 1995. Dir. Arne Glimcher. Perf. Sean Connery, Laurence Fishburne, Ed Harris. Warner Brothers.

The Killing of Sister George. 1968. Dir. Robert Aldrich. Perf. Beryl Reid, Susannah York. Cinerama.

Kramer vs. Kramer. 1979. Dir. Robert Benton. Perf. Dustin Hoffman, Meryl Streep. Columbia Pictures.

The Landlord. 1970. Dir. Hal Ashby. Perf. Beau Bridges, Lee Grant, Diana Sands, Pearl Bailey, Louis Gossett, Jr., Susan Anspach. United Artists.

Last Dance. 1996. Dir. Bruce Beresford. Perf. Sharon Stone, Rob Morrow, Randy Quaid. Buena Vista Pictures.

The Last Picture Show. 1971. Dir. Peter Bogdanovich. Perf. Timothy Bottoms, Jeff Bridges, Cybill Shepherd. Columbia Pictures.

The Late Show. 1977. Dir. Robert Benton. Perf. Art Carney, Lily Tomlin. Warner Brothers.

Law of Desire. 1987. Dir. Pedro Almodovar. Perf. Eusebio Poncelo, Carmen Maura, Antonio Banderas, Miguel Molina. Cinevista.

Lawyer Man. 1932. Dir. William Dieterle. Perf. William Powell, Joan Blondell. Warner Brothers.

Legal Eagles. 1986. Dir. Ivan Reitman. Perf. Robert Redford, Debra Winger, Daryl Hannah. Universal Pictures.

Legally Blonde. 2001. Dir. Robert Luketic. Perf. Reese Witherspoon, Luke Wilson. MGM.

Legally Blonde 2: Red, White & Blonde. 2003. Dir. Charles Herman-Wurmfeld. Perf. Reese Witherspoon, Sally Field. MGM.

The Letter. 1940. Dir. William Wyler. Perf. Bette Davis, Herbert Marshall. Warner Brothers.

Lianna. 1983. Dir. John Sayles. Perf. Linda Griffiths, Jane Hallaren. United Artists Classics.

Liar Liar. 1997. Dir. Tom Shadyac. Perf. Jim Carrey. Universal Pictures.

The Life and Times of Judge Roy Bean. 1972. Dir. John Huston. Perf. Paul Newman. National General Pictures.

The Life of David Gale. 2003. Dir. Alan Parker. Perf. Kevin Spacey, Kate Winslet, Laura Linney. Universal Pictures.

Lilies of the Field. 1963. Dir. Ralph Nelson. Perf. Sidney Poitier, Lilia Skala. United Artists.

The Little Foxes. 1941. Dir. William Wyler. Perf. Bette Davis, Herbert Marshall, Teresa Wright. RKO.

The Living End. 1992. Dir. Gregg Araki. Perf. Mike Dytri, Craig Gilmore. Strand Releasing.

Longtime Companion. 1990. Dir. Norman Rene. Perf. Stephen Caffrey, Patrick Cassidy, Brian Cousins, Bruce Davison, Campbell Scott. Samuel Goldwyn Company.

Looking for Mr. Goodbar. 1977. Dir. Richard Brooks. Perf. Diane Keaton, Richard Gere. Paramount Pictures.

Losing Isaiah. 1995. Dir. Stephen Gyllenhaal. Perf. Jessica Lange, Halle Berry. Paramount Pictures.

Love and Death on Long Island. 1997. Dir. Richard Kwietniowski. Perf. John Hurt, Jason Priestley. Lions Gate Films.

M. 1931. Dir. Fritz Lang. Perf. Peter Lorre. Paramount.

Making Love. 1982. Dir. Arthur Hiller. Perf. Michael Ontkean, Kate Jackson, Harry Hamlin. Twentieth Century-Fox.

A Man for All Seasons. 1966. Dir. Fred Zinnemann. Perf. Paul Scofield, Wendy Hiller, Leo McKern, Robert Shaw, Orson Welles. Columbia Pictures.

The Man with the Golden Arm. 1955. Dir. Otto Preminger. Perf. Frank Sinatra, Eleanor Parker, Kim Novak. United Artists.

Manhattan. 1979. Dir. Woody Allen. Perf. Woody Allen, Diane Keaton, Michael Murphy, Mariel Hemingway, Meryl Streep. United Artists.

Marathon Man. 1976. Dir. John Schlesinger. Perf. Dustin Hoffman, Laurence Olivier, Roy Scheider, William Devane, Marthe Keller. Paramount Pictures.

Marked Woman. 1937. Dir. Lloyd Bacon. Perf. Bette Davis, Humphrey Bogart. Warner Brothers.

The Mexican. 2001. Dir. Gore Verbinksi. Perf. Brad Pitt, Julia Roberts, James Gandolfini. DreamWorks.

Monster's Ball. 2001. Dir. Marc Forster. Perf. Billy Bob Thornton, Halle Berry, Peter Boyle. Lions Gate Films.

The Moon Is Blue. 1953. Dir. Otto Preminger. Perf. William Holden, David Niven. United Artists.

Moulin Rouge. 2001. Dir. Baz Luhrman. Perf. Nicole Kidman, Ewan McGregor, John Leguizamo. Twentieth Century-Fox.

The Mouthpiece. 1932. Dr. Elliott Nugent, James Flood. Perf. Warren William. Warner Brothers.

Music Box. 1989. Dir. Costa Gavras. Perf. Jessica Lange, Armin-Mueller-Stahl, Frederic Forrest. Tri-Star Pictures.

My Best Friend's Wedding. 1997. Dir. P. J. Hogan. Perf. Julia Roberts, Dermot Mulroney, Cameron Diaz, Rupert Everett. TriStar Pictures.

My Own Private Idaho. 1991. Dir. Gus Van Sant. Perf. River Phoenix, Keanu Reeves. Fine Line Features.

Nashville. 1975. Dir. Robert Altman. Per. Henry Gibson, Lily Tomlin, Ronee Blakely, Keith Carradine, Geraldine Chaplin, Barbara Harris, Karen Black. Paramount Pictures.

Natural Born Killers. 1994. Dir. Oliver Stone. Perf. Woody Harrelson, Juliette Lewis, Robert Downey, Jr., Tommy Lee Jones. Warner Brothers.

Night Falls on Manhattan. 1997. Dir. Sidney Lumet. Perf. Andy Garcia, Richard Dreyfus, Lena Olin, Ian Holm. Paramount Pictures.

Nixon. 1995. Dir. Oliver Stone. Perf. Anthony Hopkins, Joan Allen. Buena Vista Pictures.

Nobody's Fool. 1994. Dir. Robert Benton. Perf. Paul Newman, Jessica Tandy, Bruce Willis, Melanie Griffith. Paramount Pictures.

The Object of My Affection. 1998. Dir. Nicholas Hytner. Perf. Jennifer Aniston, Paul Rudd. Twentieth Century-Fox.

October. 1927. Dir. Sergei Eisenstein. Sovkino.

On Trial. 1928. Dir. Archie Mayo. Perf. Pauline Frederick, Bert Lytell, Lois Wilson. Warner Brothers.

On Trial. 1939. Dir. Terry Morse. Perf. Margaret Lindsay, John Litel. Warner Brothers.

One More River. 1934. Dir. James Whale. Perf. Diana Wynyard, Colin Clive, Frank Lawton. Universal Pictures.

Ordinary People. 1980. Dir. Robert Redford. Perf. Donald Sutherland, Mary Tyler Moore, Judd Hirsch, Timothy Hutton. Paramount Pictures.

Other People's Money. 1991. Dir. Dir. Norman Jewison. Perf. Danny DeVito, Gregory Peck, Penelope Ann Miller, Piper Laurie. Warner Brothers.

The Ox-Bow Incident. 1943. Dir. William Wellman. Perf. Henry Fonda, Dana Andrews. Twentieth Century-Fox.

The Paper Chase. 1973. Dir. James Bridges. Perf. Timothy Bottoms, Lindsay Wagner, John Houseman. Twentieth Century-Fox.

The Parallax View. 1974. Dir. Alan Pakula. Perf. Warren Beatty. Paramount Pictures.

Parting Glances. 1986. Dir. Bill Sherwood. Perf. John Bolger, Richard Ganoung, Steve Buscemi. Cinecom International.

The Pelican Brief. 1993. Dir. Alan Pakula. Perf. Julia Roberts, Denzel Washington. Warner Brothers.

Penny Serenade. 1941. Dir. George Stevens. Perf. Irene Dunne, Cary Grant. Columbia Pictures.

The People v. Larry Flynt. 1996. Milos Forman. Perf. Woody Harrelson, Courtney Love, Edward Norton. Columbia Pictures.

Personal Best. 1982. Dir. Robert Towne. Perf. Mariel Hemingway, Scott Glenn, Patrice Donnelly. Warner Brothers.

Philadelphia. 1993. Dir. Jonathan Demme. Perf. Tom Hanks, Denzel Washington, Jason Robards, Antonio Banderas. TriStar Pictures.

Physical Evidence. 1989. Dir. Michael Crichton. Perf. Burt Reynolds, Theresa Russell. Columbia Pictures.

Pinky. 1949. Dir. Elia Kazan. Perf. Jeanne Craig, Ethel Barrymore, Ethel Waters. Twentieth Century-Fox.

A Place in the Sun. 1951. Dir. George Stevens. Perf. Montgomery Clift, Elizabeth Taylor, Shelley Winters. Paramount Pictures.

Places in the Heart. 1984. Dir. Robert Benton. Perf. Sally Field, Lindsay Crouse, Ed Harris, John Malkovich, Danny Glover. TriStar Pictures.

Poison. 1991. Dir. Todd Haynes. Perf. Edith Meeks, Larry Maxwell, Chris Singh, Millie White. Zeitgeist Films.

The Postman Always Rings Twice. 1946. Dir. Tay Garnett. Perf. Lana Turner, John Garfield. MGM.

Presumed Innocent. 1990. Dir. Alan Pakula. Perf. Harrison Ford, Brian Dennehy, Raul Julia, Bonnie Bedelia, Greta Scacchi. Warner Brothers.

Prick Up Your Ears. 1987. Dir. Stephen Frears. Perf. Gary Oldman, Alfred Molina, Vanessa Redgrave. Samuel Goldwyn Company.

Primal Fear. 1996. Dir. Gregory Hoblit. Per. Richard Gere, Laura Linney, Edward Norton. Paramount Pictures.

Prince of the City. 1981. Dir. Sidney Lumet. Perf. Treat Williams, Jerry Orbach, Bob Balaban, James Tolkan. Orion Pictures Corporation.

Pulp Fiction. 1994. Dir. Quentin Tarantino. Perf. John Travolta, Samuel L. Jackson, Uma Thurman, Harvey Keitel, Ving Rhames, Tim Roth. Miramax Films.

Q&A. 1990. Dir. Sidney Lumet. Perf. Nick Nolte, Timothy Hutton, Armand Assante. TriStar Pictures.

The Rainmaker. 1997. Dir. Francis Ford Coppola. Perf. Matt Damon, Danny DeVito, Claire Danes, Jon Voight. Paramount Pictures.

Regarding Henry. 1991. Dir. Mike Nichols. Perf. Harrison Ford, Annette Bening. Paramount Pictures.

Reversal of Fortune. 1990. Dir. Barbet Schroeder. Perf. Glenn Close, Jeremy Irons, Ron Silver. Warner Brothers.

Runaway Jury. 2003. Dir. Gary Fleder. John Cusack, Gene Hackman, Dustin Hoffman. Twentieth Century-Fox.

Saving Private Ryan. 1998. Dir. Steven Spielberg. Perf. Tom Hanks, Edward Burns, Tom Sizemore, Jeremy Davies, Vin Diesel, Adam Goldberg, Barry Pepper, Giovanni Ribisi, Matt Damon. Paramount Pictures.

Scenes from a Marriage. 1973. Dir. Ingmar Bergman. Perf. Liv Ullmann, Erland Josephson, Bibi Andersson. Cinema 5 Distributing.

Schindler's List. 1993. Dir. Steven Spielberg. Perf. Liam Neeson, Ben Kingsley, Ralph Fiennes. Universal Pictures.

Ship of Fools. 1965. Dir. Stanley Kramer. Perf. Vivien Leigh, Oskar Werner, Simone Signoret, Jose Ferrer, Lee Marvin. Columbia Pictures.

A Soldier's Story. 1984. Dir. Norman Jewison. Perf. Howard E. Rollins, Jr., Adolph Caesar, Dennis Lipscomb, Art Evans, Denzel Washington, Robert Townsend, Larry Riley. Columbia Pictures.

Soul Man. 1986. Dir. Steve Miner. Perf. C. Thomas Howell, Arye Gross, Rae Dawn Chong, James Earl Jones. New World Pictures.

The Sound of Music. 1965. Dir. Robert Wise. Perf. Julie Andrews, Christopher Plummer, Eleanor Parker. Twentieth Century-Fox.

Staircase. 1969. Dir. Stanley Donen. Perf. Richard Burton, Rex Harrison. Twentieth Century-Fox.

The Star Chamber. 1983. Dir. Peter Hyams. Perf. Michael Douglas, Hal Holbrook, Yaphet Kotto. Twentieth Century-Fox.

Star Trek: The Motion Picture. 1979. Dir. Robert Wise. Perf. William Shatner, Leonard Nimoy. Paramount Pictures.

State's Attorney. 1932. Dir. George Archainbaud. Perf. John Barrymore, Helen Twelvetrees. RKO.

The Sting. 1973. Dir. George Roy Hill. Perf. Robert Redford, Paul Newman. Universal.

The Strawberry Statement. 1970. Dir. Stuart Hagmann. Perf. Bruce Davison, Kim Darby, Bud Cort, Bob Balaban. MGM.

Street Scene. 1931. Dir. King Vidor. Perf. Sylvia Sidney. United Artists.

A Streetcar Named Desire. 1951. Dir. Elia Kazan. Perf. Vivien Leigh, Marlon Brando, Kim Hunter, Karl Malden. Warner Brothers.

Strike. 1925. Dir. Sergei Eisenstein. Goskino.

Suddenly, Last Summer. 1959. Dir. Joseph Mankiewicz. Perf. Elizabeth Taylor, Katharine Hepburn, Montgomery Clift. Columbia Pictures.

Sunday, Bloody Sunday. 1971. Dir. John Schlesinger. Perf. Glenda Jackson, Peter Finch, Murray Head. United Artists.

Suspect. 1987. Dir. Peter Yates. Perf. Cher, Dennis Quaid, Liam Neeson. TriStar Pictures.

The Sweet Hereafter. 1997. Dir. Atom Egoyan. Perf. Ian Holm, Sarah Polley. Fine Line Features.

Swoon. 1992. Dir. Tom Kalin. Perf. Daniel Schlachet, Craig Chester. Fine Line Features.

Tea and Sympathy. 1956. Dir. Vincente Minnelli. Perf. Deborah Kerr, John Kerr, Leif Erickson. MGM.

These Three. 1936. Dir. William Wyler. Perf. Miriam Hopkins, Merle Oberon, Joel McCrea. United Artists.

They Won't Forget. 1937. Dir. Mervyn LeRoy. Perf. Claude Rains. Warner Brothers.

The Thin Man. 1934. Dir. W.S. Van Dyke. Perf. William Powell, Myrna Loy. MGM.

Three Days of the Condor. 1975. Dir. Sydney Pollack. Perf. Robert Redford, Faye Dunaway, Cliff Robertson. Paramount Pictures.

A Time to Kill. 1996. Dir. Joel Schumacher. Perf. Sandra Bullock, Samuel L. Jackson, Matthew McConaughey, Kevin Spacey. Warner Brothers.

Titanic. 1997. Dir. James Cameron. Perf. Leonardo DiCaprio, Kate Winslet, Billy Zane. Paramount Pictures.

To Kill a Mockingbird. 1962. Dir. Robert Mulligan. Per. Gregory Peck, Mary Badham, Philip Alford, Brock Peters. Universal Pictures.

Torch Song Trilogy. 1988. Dir. Paul Bogart. Perf. Anne Bancroft, Matthew Broderick, Harvey Fierstein. New Line Cinema.

Trial by Jury. 1994. Dir. Heywood Gould. Perf. Joanne Whalley-Kilmer, Armand Assante, Gabriel Byrne. Warner Brothers.

12 Angry Men. 1957. Dir. Sidney Lumet. Perf. Henry Fonda, Lee J. Cobb, Ed Begley, E. G. Marshall. United Artists.

Uncle Tom's Cabin. 1903. Dir. Edwin S. Porter. Edison Manufacturing Company.

Unforgiven. 1992. Dir. Clint Eastwood. Perf. Clint Eastwood, Morgan Freeman, Gene Hackman, Richard Harris. Warner Brothers.

An Unmarried Woman. 1978. Dir. Paul Mazursky. Perf. Jill Clayburgh, Alan Bates. Twentieth Century-Fox.

The Verdict. 1982. Dir. Sidney Lumet. Perf. Paul Newman, Charlotte Rampling, James Mason. Twentieth Century-Fox.

Victim. 1961. Dir. Basil Dearden. Perf. Dirk Bogarde, Sylvia Sims, Dennis Price. Pathe-American Distributing Company.

Waiting to Exhale. 1995. Dir. Forest Whitaker. Perf. Whitney Houston, Angela Bassett, Loretta Devine, Lela Rochon. Twentieth Century-Fox.

War of the Roses. 1989. Dir. Danny DeVito. Perf. Michael Douglas, Kathleen Turner, Danny DeVito. Twentieth Century-Fox.

The Widow of St. Pierre. 2000. Dir. Patrice Leconte. Perf. Juliette Binoche, Daniel Auteuil, Emir Kusturica. Lions Gate Films.

Wild Boys of the Road. 1933. Dir. William Wellman. Perf. Frankie Darro, Edwin Phillips, Rochelle Hudson. Warner Brothers.

Windows. 1980. Dir. Gordon Willis. Perf. Elizabeth Ashley, Talia Shire. United Artists.

The Winslow Boy. 1999. Dir. David Mamet. Perf. Nigel Hawthorne, Rebecca Pidgeon, Jeremy Northam, Matthew Pidgeon, Gemma Jones. Sony Pictures Classics.

Witness for the Prosecution. 1957. Dir. Billy Wilder. Perf. Charles Laughton, Marlene Dietrich, Tyrone Power. United Artists.

The Women. 1939. Dir. George Cukor. Perf. Joan Crawford, Norma Shearer, Rosalind Russell. MGM.

The Wrong Man. 1956. Dir. Alfred Hitchcock. Perf. Henry Fonda, Vera Miles. Warner Brothers.

Wuthering Heights. 1939. Dir. William Wyler. Perf. Merle Oberon, Laurence Olivier. United Artists.

Young Mr. Lincoln. 1939. Dir. John Ford. Perf. Henry Fonda. Twentieth Century-Fox.

The Young Philadelphians. 1959. Dir. Vincent Sherman. Perf. Paul Newman, Barbara Rush. Warner Brothers.

Zabriskie Point. 1970. Dir. Michelangelo Antonioni. Perf. Mark Frechette, Daria Halprin, Rod Taylor. MGM.

Television Series and Shows

A.U.S.A. 2003. NBC.

All in the Family. 1971–79. CBS.

Ally McBeal. 1997–2002. Fox.

Amos 'n Andy. 1951–53. CBS.

The Atlanta Child Murders. 1985. CBS.

Barney Miller. 1975–82. ABC.

Ben Casey. 1961–66. ABC.

The Beverly Hillbillies. 1962–71. CBS.

Buffy The Vampire Slayer. 1997–2003. WB.

Cheers. 1982–93. NBC.

Citizen Cohn. 1992. HBO.

The Cosby Show. 1982–92. NBC.

The Court. 2002. ABC.

Dallas. 1978–91. CBS.

The Defenders. 1961–65. CBS.

The Defenders: Payback. 1997. Showtime.

The Defenders: Choice of Evils. 1998. Showtime.

Doogie Howser, M.D. 1989–93. ABC.

Dragnet. 1951–59. NBC.

Dragnet. 2003. ABC.

Dynasty. 1981–89. ABC.

An Early Frost. 1985. NBC.

Ed. 2000–. NBC.

Family Law. 1999–2002. CBS.

First Monday. 2002. CBS.

The First Years. 2001. NBC.

General Hospital. 1963–. ABC.

Gideon's Trumpet. 1980. CBS.

The Girls' Club. 2002. Fox.

The Guardian. 2001–. CBS.

Hawaii Five-O. 1968–80. CBS.

Hee-Haw. 1969–92. CBS.

Hill Street Blues. 1981–87. NBC.

Indictment. 1995. HBO.

JAG. 1995–. NBC.

Judge Judy. 1996–. Paramount.
Judging Amy. 1999–. CBS.
The Jury. 2002. Granada.
King. 1978. NBC.
Kojak. 1973–78. CBS.
L.A. Law. 1986–94. NBC.
Law & Order. 1990–. NBC.
A Lesson Before Dying. 1999. HBO
Little House on the Prairie. 1974–83. NBC.
Lou Grant. 1977–82. CBS.
The Lyon's Den. 2003. NBC.
*M*A*S*H.* 1972–83. CBS.
Marcus Welby, M.D. 1969–76. ABC.
The Marcus-Nelson Murders. 1973. CBS.
Mary Tyler Moore. 1970–77. CBS.
Matlock. 1986–95. NBC.
Mayberry R.F.D. 1968–71. CBS.
Murder One. 1995–97. ABC.
Murderers Among Us: The Simon Wiesenthal Story. 1989. Citadel Entertainment.
N.Y.P.D. Blue. 1993–. ABC.
Night Court. 1984–92. NBC.
100 Centre St. 2001. A&E.
The Paper Chase. 1978–86. CBS (1978–83), Showtime (1983–86).
Perry Mason. 1957–66. CBS.
Police Story. 1973–77. NBC.
The Practice. 1997–. ABC.
Queens Supreme. 2003. CBS.
Robert Montgomery Presents. 1950–57. NBC.
Roots. 1977. ABC.
Scottsboro: An American Tragedy. 2000. Social Media Productions.
Sex and the City. 1998–2004. HBO.
Six Million Dollar Man. 1974–78. ABC.
The Sopranos. 1999–. HBO.
St. Elsewhere. 1982–88. NBC.
Star Trek: Enterprise. 2001–. UPN.
Studio One. 1948–58. CBS.
Teamster Boss: The Jackie Presser Story. 1992. HBO.
To Tell the Truth. 1956–68. CBS.
12 Angry Men. 1997. Showtime.
The Waltons. 1972–81. CBS.
The West Wing. 1999–. NBC.
Will and Grace. 1998–. NBC.
The X-Files. 1993–2002. Fox.
Xena: Warrior Princess. 1995–2001. Universal TV.

Cases

Arizona v. Evans, 514 U.S. 1 (1995)
Atkins v. Virginia, 536 U.S. 304 (2002)
Bates v. State Bar of Arizona, 433 U.S. 350 (1977)
Batson v. Kentucky, 476 U.S. 79 (1986)
Bradwell v. Illinois, 83 U.S. 130 (1872)
Brady v. Maryland, 373 U.S. 83 (1963)
Brown v. Board of Education, 347 U.S. 483 (1954)
Burdine v. Johnson, 262 F.3d 336 (5th Cir. 2001)
Bush v. Gore, 531 U.S. 98 (2000)
Cain v. Hyatt, 734 F. Supp. 671 (E.D. Pa. 1990)
California v. Greenwood, 486 U.S. 35 (1988)
Chandler v. Florida, 449 U.S. 560 (1981).
Daubert v. Merrell Dow Pharmaceuticals, 501 U.S. 579 (1993)
Dickerson v. United States, 530 U.S. 428 (2000)
Furman v. Georgia, 408 U.S. 238 (1972)
Gregg v. Georgia, 428 U.S. 153 (1976)
Grimshaw v. Ford Motor Co., 119 Cal. App. 3d 757, 174 Cal. Rptr. 348 (1981)
Hawkins v. McGee, 146 Atl. 641 (New Hampshire, 1929)
Joseph Burstyn, Inc. v. Wilson, 343 U.S. 495 (1952)
Katz v. United States, 389 U.S. 347 (1967)
Kreyling v. Kreyling, 23 Atl.2d 800 (N.J. Chancery Ct. 1942)
Mapp v. Ohio, 367 U.S. 643 (1961)
McClesky v. Kemp, 481 U.S. 279 (1987)
Miranda v. Arizona, 384 U.S. 436 (1966)
Mutual Film Corp. v. Ohio Industrial Commission, 236 U.S. 230 (1915)
Norris v. Alabama, 294 U.S. 587 (1935)
Ohralik v. State Bar of Ohio, 436 U.S. 447 (1978)
Payne v. Tennessee, 501 U.S. 808 (1991)
Powell v. Alabama, 287 U.S. 45 (1932)

Ring v. Arizona, 536 U.S. 584 (2002)
Roe v. Wade (1973)
Schechter Poultry Co. v. United States, 295 U.S. 495 (1935)
State Farm Mutual Insurance Co. v. Campbell, 123 S. Ct. 1513 (2003)
Taylor v. Louisiana, 419 U.S. 522 (1975)
Terry v. Ohio, 392 U.S. 1 (1968)
United States v. Leon, 468 U.S. 897 (1984)
Weeks v. United States, 232 U.S. 383 (1914)

Index

Politics
Media &
Popular Culture

David A. Schultz, *General Editor*

This series is devoted to both scholarly and teaching materials that examine the ways politics, the media, and popular culture interact and influence social and political behavior. Subject matters to be addressed in this series include, but will not be limited to: media and politics; political communication; television, politics, and mass culture; mass media and political behavior; and politics and alternative media and telecommunications such as computers. Submission of single-author and collaborative studies, as well as collections of essays are invited.

Authors wishing to have works considered for this series should contact:

> Peter Lang Publishing
> Acquisitions Department
> 275 Seventh Avenue, 28th floor
> New York, New York 10001

To order other books in this series, please contact our Customer Service Department at:

> 800-770-LANG (within the U.S.)
> (212) 647-7706 (outside the U.S.)
> (212) 647-7707 FAX

or browse online by series at:

> WWW.PETERLANGUSA.COM